THE QUAY
BROTHERS

THE QUAY BROTHERS

BROTHERS

INTO A METAPHYSICAL PLAYROOM

SUZANNE BUCHAN

UNIVERSITY OF MINNESOTA PRESS

MINNEAPOLIS · LONDON

This publication was supported by the Research Fund, University for the Creative Arts, UK.

Published by the University of Minnesota Press
111 Third Avenue South, Suite 290
Minneapolis, MN 55401-2520
http://www.upress.umn.edu

Library of Congress Cataloging-in-Publication Data

Buchan, Suzanne.
The Quay Brothers : into a metaphysical playroom / Suzanne Buchan.
 p. cm.
Includes bibliographical references and index.
ISBN 978-0-8166-4658-6 (hc : alk. paper) — ISBN 978-0-8166-4659-3 (pb : alk. paper)
1. Brothers Quay—Criticism and interpretation. I. Title.
NC1766.G7B763 2010
791.4302'330922—dc22
 2010001662

Printed in the United States of America on acid-free paper

The University of Minnesota is an equal-opportunity educator and employer.

17 16 15 14 13 12 11 10 9 8 7 6 5 4 3 2 1

CONTENTS

ACKNOWLEDGMENTS

The writing of this book thrived on more than ten years of exchange and discussion with passionate individuals from many disciplines and walks of life who gradually configured into a network of inspiration, collusive mischief, and support. I proffer thanks to them here, in no particular order. Because of sheer numbers, names are missing from this list and I apologize for any I have inadvertently or otherwise left out. My deepest thanks go to the Quay Brothers, both for enriching my professional, personal, visual, and aural worlds and for their exemplary, selfless generosity to my impinging explorations of their creativity; and to Keith Griffiths, their producer, for his dedicated passion to this kind of filmmaking. I am indebted to my Ph.D. supervisor and friend, Christine Noll Brinckmann, for guiding me through the doctoral thesis on the Quay Brothers that was the prelude to this book, and to Fritz Senn at the Zurich James Joyce Foundation, who introduced me so inspiringly to Joyce's literary envisioning of the world (about whom T. S. Eliot in "'Ulysses': Order and Myth" wrote of *Ulysses* as a "book to which we are all indebted, and from which none of us can escape").[1] My dear friend Richard Weihe encouraged me throughout the lengthy writing of this project, and I benefited enormously from his astonishing interdisciplinary knowledge and insights into philosophy and aesthetics. I am grateful to Vivian Sobchack for her encouraging discussions early on in this project, for her undying and lucid

curiosity about simply everything, and for her remarkable ability to transform this into meaningful and passionate writing that has affected my thinking about cinematic experience. Mark Bartlett proved an acutely rigorous yet generous and sensitive critical reader of later drafts. The final manuscript owes much to his fresh eyes and superbly inquisitive, philosophical, and aesthetical mind, and many ideas in this book found a more articulate voice through his lucidity.

In the film and art curating communities, I am thankful for the persistence and unequaled curatorial efforts of Gareth Evans, Jayne Pilling, Otto Alder, Stuart Comer, and especially Edwin Carels to ensure audiences can experience independent animation. During the ten years of codirecting the Fantoche Animation Festival in Switzerland, I benefited from vibrant discussions about the Quays' work with countless filmmakers, scholars, and journalists who frequented the festival, notably Larry Sider, Marcin Gyzicki, and Stanislas Ulver. Andres Janser, with whom I curated the exhibition *Trickraum:Spacetricks*, provided me with an unequaled opportunity to undertake serious play with notions of animated space in an exhibition format that found their way into this book.

At the Seminar for Cinema Studies in Zurich, first ideas were hatched in discussions and feedback with my students and in excellent and rigorous doctoral colloquiums with many colleagues, especially Margrit Tröhler, Jan Sahli, Thomas Christen, and Marianne Lewinski. I also thank my UK colleagues Anthony Harrild, Manuel Alvarado, and especially David Campany for their stimulating ideas and support. For hospitality and sheltered research environments, I am grateful to the Green College Foundation at the University of British Columbia, where I was scholar in residence in 1999, and to the University for the Creative Arts in the United Kingdom for extended periods of research leave and for funding that made color images possible in the publication.

I am indebted to the long-term enthusiasm of my editors at the University of Minnesota Press: Jennifer Moore, who responded so enthusiastically when I approached her with my ideas; Andrea Kleinhuber, whose ongoing patience and support were outstanding; and Doug Armato, for taking the project on. I benefited enormously from the readers of the final manuscript, and my thanks go to Jason Weidemann and Danielle Kasprzak for accompanying the book in its final stages of publication. I am also grateful for the meticulous copyediting carried out by Michele Hodgson and Nancy Sauro, who kept a sharp eye out for my Germanisms. Any errors or shortcomings in this book are entirely my own. I hope *The Quay Brothers: Into a Metaphysical Playroom* stimulates more engagement with the kind of creativity the Quay Brothers and other artists offer to us.

On a personal note, gratitude is heartfelt toward Carola Fischer, whose misgivings about animation stimulated a number of ideas; to Jasmin Grego, for her inestimable support as friend and listener and for opening her home to me as a writing refuge for so many years; and to Jan Korvink, for encouraging me to pursue an academic path at a crucial point in time. Finally, this book is dedicated to my family: my mother, Helena, whose intellect is merged with a ravishing artistic sensitivity and loving humor, and who, I hope, will find some recognition here of what she spread before me; my sister, Jane, whose artistic vision and independence is a constant model; my father, George, who showed me how important it is to combine ethics, intellect, and honesty; and especially to my brother, Peter, whose unique and irreplaceable way of thinking and seeing the world permeates these pages. Metaphysically speaking, his mind lives on in mine.

London and Zurich, 2010

INTRODUCTION

Years ago, while writing a master's thesis on James Joyce's cinematic language, I watched a screening of the Quay Brothers' *Street of Crocodiles* (1986). I was immediately enthralled by the beauty of the images, but I could not pinpoint what was so striking and emotionally moving about the film. I was smitten by its complexity and poetry, but when I tried to describe what I thought was actually happening in the film's convoluted narrative, I was stumped in my attempts to communicate *exactly* what it was. I found cold comfort in a text from Michael Atkinson: "It wouldn't matter if every man, woman or child on earth saw *The Street of Crocodiles*. Only I would truly understand it—which is not to say that I literally understand it at all."[1] However, it was encouraging to realize that I was not alone in my inability to describe the film. Unlike most live-action cinema at that time (1991), before computer-generated imagery and digital animation flooded commercial and independent studios, these images and objects brought to life have a different relationship to my lived experience. The best way I could describe it at the time was as a Joycean epiphany, *visione animato all'fino de lo scoppio,* vision animated to the bursting point, illogical, oneiric, and exhilarating.[2] It was a phenomenon that I implicitly *understood* but could not adequately *describe.* I am fascinated, yes, by screws that are empowered and transport themselves offscreen over a stodgy layer of meticulously crafted dust. But what *of* the screws?

My quizzical epiphany engendered increasing interest on animation as a complex, special power of film. Vachel Lindsay's 1919 reflections on animation—the "trick film" as it was known in his era—are proposals about how inanimate objects can be usurped from their nonliving states using this technique:

> The ability to do this kind of a thing is fundamental in the destinies of the art. . . . Now the mechanical or non-human object, beginning with the engine . . . is apt to be the hero in most any sort of photoplay while the producer remains utterly unconscious of the fact. Why not face this idiosyncrasy of the camera and make the nonhuman object the hero indeed? Not by filling the story with ropes, buckets, firebrands, and sticks, but by having these four unique. Make the fire the loveliest of torches, the water the most graceful of springs. Let the rope be the humorist. Let the stick be the outstanding hero, the D'Artagnan of the group, full of queer gestures and hoppings about. Let him be both polite and obdurate. Finally let him beat the dog most heroically.[3]

Lindsay's prescient comments made almost a century ago about how fundamental animation—"this kind of thing"—is to destinies of art have been abundantly confirmed in the meantime, especially since the digital shift. The viewer of such films, then and now, is confronted with an illogical, yet comprehensible vision of objects that move, have intent and personality, and can be cunning. Yet besides the charm and stylistic elegance, what do these images affect in our perception that is different from the filmic actions and dialogues of living, sentient beings? How can a piece of metal be endowed with a gesture that moves us emotionally? In what kind of world can a screw "live"? Or for that matter, what entails the experiential difference between a screw animated on-screen and one that we twirl in our fingers?

The forays of Stephen and Timothy Quay (hereafter the Quays or Quay Brothers) into animation filmmaking have resulted in one of the most complex and rare oeuvres in cinema. Their films do not fall in the category of industrialized commercial production and they are fiercely idiosyncratic. They are exemplary visual excavations, an alchemical reworking of occluded but recognizable elements from other films and artworks, identified by a highly original style and poetic dialectical form. Like many independent animation films, the Quay Brothers' films are not for children: they are adult oriented, complex,

and experimental, and the experience of watching one of their works differs significantly from what is usually understood by the term "puppet animation film." At first glance, their inspirations are an eclectic mix: Lewis Carroll, Franz Kafka, E. T. A. Hoffmann, Marcel Duchamp, Hieronymous Bosch, Michel de Ghelderode, Władysław Starewicz, Bruno Schulz, Robert Walser, Giuseppe Arcimboldo, Raymond Roussel, Louis-Ferdinand Céline, Adolfo Bioy Casares, Stanisław Lem. On closer scrutiny, these artists and writers share an express interest in metaphysical and undercurrent worlds of the life of objects, a preoccupation with obsession, the fantastic, the banal, the miniature. In their stylistics they affirm Jacques Rancière's notion in his aesthetic regime of art that "the work of style was to affect the passivity of the empty gaze of reasonless things in its exposition of everyday actions," successful only "if [style] itself became passive, invisible, if it painstakingly effaced the difference between itself and the ordinary prose of the world."[4] In the Quays' films, these authors and artists become retrieved ghosts hovering out of frame, frames invested with their metaphysical afterlife of omnipotence, epiphany, sexual pathologies, and fantasy.

The Quays' affinity for music-led imagery seems to be compacted into the graphic stylization and rich textures of their films, which, in turn, become visual lyrics themselves—a poetic cinematic language. Besides literary and poetic texts, the films are also brimming with formal cinematic references to filmmakers working in animation and in live-action cinema that meld elements of surrealism, impressionism, poetic film, experimental film, and nonnarrative strategies in their works. Robert Bresson, Andrei Tarkovsky, Aleksandr Dovzhenko, and Akira Kurosawa are the filmmakers the Quays feel closely aligned to, and their early work is often compared to (and has been programmed with) films from David Lynch, Guy Maddin, and Peter Greenaway.

In the early 1990s I attended a lecture by Siegfried Zielinski, founding rector and 1994–2000 rector of the Academy of Media Arts in Cologne (Kunsthochschule für Medien Köln), one of Europe's most innovative media schools. He introduced his concept of the "an-archaeology" of technological vision (later published as an essay).[5] His two-hour talk was accompanied by images—not of highly developed technology or computer graphics, but slides and transparencies of images out of the sixteenth to eighteenth centuries, of romantic graphic representations of sunspots, cover pages of antique books on the *Magiae naturalis,* and handwritten lists of prominent and lesser known scientists and philosophers whom Zielinski deems crucial as forerunners of the current development of new media. On his list, Jan Švankmajer and Patrick Bokanowski were

two of the artists working in film; and the Quay Brothers were mentioned in a reference to Patrick Bokanowski's experimental film *L'Ange* (1982). Zielinski's reference to these four filmmakers in the context of an ahistoricization of digital media is relevant, in that all of them either incorporate animated sequences into their films or make films that are exclusively animated. They are cinema activists in the sense that they don't simply depict but also challenge conventional representations of reality and the neat boundaries of media genres.

There is a deeper relevance in Zielinski's inclusion of the Quays in a discussion of the origins of vision, its technical and perceptual machinations, and its potential use in the media of this century. How does animation film alter the difficult concept of cinematic reality? And what is the attraction of these films for an audience on the whole more accustomed to fictional or documentary representations of external reality, of the world they inhabit physically? These questions touch on ethics and aesthetics of cinema as a whole and on philosophical discourses around reality and perception. It is not surprising that the cinematic psychogeographer and variantologist Zielinski is befriended with the Quays' producer, Keith Griffiths, who also introduced them to Zielinski. What they share beyond this is an insatiable curiosity and conviction of the representations of dreams, of "worlds" and activities in other artistic fields. This rather anecdotal diachrony of events is perhaps one that is shared by others interested in the Quay Brothers' films, and this book hopes to unravel some of the complex interrelations between their modes of practice that result in an astonishing body of works.

Through the Critics' Eye

In his sensitive, critical, and self-reflexive analysis of the problematic status of writing about film, Paul Coates notes:

> Theory is a flyover that arches above the dilemma of the film critic. It occupies a privileged place among film-goers because theorizing is what one does in the barren intervals between good films: once one's enthusiasm for the last work has died down, one finds oneself stranded in an imageless wilderness, and, left with nothing to think about, one begins to think abstractly.[6]

Coates's idea of a barren interval might have been the motivation for starting this book: as the Quays turned to feature filmmaking and commercials, the films were

fewer and farther between. Starting to think theoretically about the Quays' films did not take place in Coates's "imageless wilderness"; I was barraged by them and, seeing many other very good films and works of art, discovered all kinds of relationships between them and the Quays' work that gave unarticulated mus-ings substance. More important, I realized that, as is often the case with films that present intertextuality and interdisciplinarity, I needed to consider other forms of creative practice. Most of the Quays' oeuvre belongs within a loose-knit, cross-discipline auteur network that is identified by a poetic and hybridized form of cinema, a form notoriously challenging to make summative, evaluative state-ments about. In a 1986 interview, drawing a distinction between commercialism and creativity, Gilles Deleuze responded to a question about the crisis around the concept of the cinematic auteur:

> A work of art always entails the creation of new spaces and times
> (it's not a question of recounting a story in a well-determined space
> and time; rather, it is the rhythms, the lighting, and the space-times
> themselves that must become the true characters). . . . A work of art
> is a new syntax, one that is much more important than vocabulary
> and that excavates a foreign language in language.[7]

Critics have grappled with a new syntax, the innovative visual language that is created by the melding of the Quays' excavations of the histories of cinema, literature, art, music, performance, and architecture. In the foreword to the 1997 translation of Jean Mitry's *Aesthetics and Psychology of the Cinema*, Brian Lewis sug-gests how personal engagement drives the critic:

> At the center of any critical theory lies a fundamental experience
> to which a critic remains devoted deep in his or her heart, a "what
> if" or "how come" or "why" experience, which goes on to generate
> a life's work of observation, rationalization, intellection, and theory.
> Underneath it all Jean Mitry was driven by the "wow" experience.
> He loved the experience of sitting in front of the screen. He loved the
> movies.
>
> Driven by the "wow," Mitry endeavoured to explain the "why,"
> "what if," and "how come": Why the world on screen was so compel-
> ling. Why, when leaving the theater, life could seem so pale and flat.
> Which films gave us this experience. Which films failed and why.[8]

Critics reacted to this "wow" of the Quays' first films, and many were not anima-tion specialists; rather, they were versed in art house and live-action filmmak-ing. Tracing the professional biographies of these critics, one sees that many of them were heavily engaged in professions and fields other than cinema criticism: director (Chris Petit and Peter Greenaway), art historian (Roger Cardinal), poet and librettist (J. D. McClatchy), media activist, professor, lecturer (Zielinski, Ian Christie, Raymond Durgnat), translator and surrealist critic, novelist (Paul Hammond, Steve Weiner). It is also indicative of the creative network that the Quays' producer, Griffiths, garnered since entering the world of film production; as an engaged producer, he knows most critics personally. His policy "has always been to get free marketing by winding up the critics to see the films."[9] Griffiths, unlike many producers, is engaged with the films beyond the end of production.

Most authorship to date on the Quays' films concentrates on their visual surface and the rich intertextuality that interweaves writers, artists, and music and results in their unmistakable style. The emphasis on the surface is due to the abundant aesthetic references in the films, from Renaissance theories of optics to Leopold Sacher Masoch; from Art Brut objects to surrealism, impres-sionism, and magic realism; from Igor Stravinsky to Karlheinz Stockhausen; from expressionist architectures to André Breton's romantic ruins. Well-informed critics respond to the embedded motifs and homages, no doubt motivated by the unusual opportunity to express their own breadth of knowledge in a single jour-nalistic text. The Quays' own favorite definition by a critic of their work remains Paul Hammond's 1986 "nudged nature morte."[10]

Reading critics' writings on the Quays, one sees that the "wow" experience seems to have motivated many of them. Ultimately, they are an initial attempt to grasp what a film is saying to its audiences. They can also be regarded as a first critical inquiry toward establishing more specific and detailed approaches to their films. Coates suggests that

> the film critic must be in perpetual transit between specialisa-tions, duplicating in himself the multiple authorship ascribed to the medium. Ambitious work in film is almost always fruitfully incoher-ent, arousing the will to speculate, and requires theoretical, hypo-thetical understanding.[11]

In articles on the Quays' films, certain rhetorical forms are taken on by later crit-ics, and as more and more articles are written on a particular film, the rhetoric

changes. Looking for the "why," "what if," and "how come" that Lewis suggested, many of these early texts delve deeper than descriptive admiration, more so than many other animation film reviewers.

Besides a plethora of popular commentaries, newspaper reviews, festival catalog texts, and program notes, most of which appeared in the 1980s and 1990s, academically inclined critical writings on the Quay Brothers' films position them in the contexts of experimental, surrealist, art house, and auteur filmmaking. What weaves this writing into a particular tapestry is an almost unanimous avowal of the seductive qualities of the visual surfaces of the films. Fortunately, besides the many short articles and reviews that have been written about the films in many languages throughout the world, some authors have engaged in closer and lengthier analyses.[12] Central to a number of them are psychoanalytic discourse, critical theory, architectonic features, and surrealism. Critical texts that engage with the Quay Brothers include a variety of disciplines and media formats that mirror the wide range of creative practice they reflect upon in developing their projects. Besides cinema studies, essays are available in publications serving diverse communities of architecture, fine arts, music, dance, and theater, and a host of excellent film reviews and profiles have appeared in journals and trade publications. The multilingual scholar looking for writings on the Quay Brothers is also well served with a number of publications produced for special screening events and festivals. Though unreliable and ephemeral, many Internet sites refer to a core of about fifteen key sites that have articles, filmographies, DVD and VHS sources, streamed Internet movies, and other information on the Quays. They are also useful for finding international newspaper and cultural critic reviews.

After 1990, the Quays were engaging with features and set design, and their production concentrated more heavily on commercials and pop promos that were often the trying ground for the imagery and mood that they were developing and ultimately refined for *Institute Benjamenta* (1994). It became relatively quiet for a time in terms of film criticism because they were making fewer shorts and becoming more involved in collaborating with choreographers on dance films, creating set designs, and preparing their second feature-film project. In an interview with André Habib, they were asked if they read critics' writings on their work:

> Sometimes, yes, because we learn things too. We're not writers but
> we respect writing. I think people often take things too far. It's very

hard to write about the intangible, to find a way to write more musically. You have to suggest and not just hammer nails into a subject, give it a category, fit it into a nomenclature. We do it ourselves in a certain way, but you have to know when to hold back and let it speak for itself. Knowing how not to know, to a certain degree.[13]

Later writings try to offer some explanation of Lewis's "wow" by providing some interpretations of the "why" and the "what if." This includes background information on the Quays, on their aspirations and inspirations, and on how their films relate to a larger community of art house filmmaking. Add to this the aesthetics, critical theory, and technical parameters of camera, set design, mise-en-scène, lighting, and sound that graduate students and academic authors engage with, then curiosity begins to evolve for the "why" and "how" of their particularly compelling world that this book hopes to satisfy.

What I want to describe is the *experience* of watching the Quays' works—to disentangle and highlight the formal and technical processes involved to reveal the devices that elicit apprehension and aesthetic pleasure during viewing. The subtle differences in obeying and violating particular conventions and norms reveals to what extent a film can be related to other works and also distinguishes a film from them. The Quays' films often do both, combining familiarity of certain conventions with new and defamiliarizing forms and devices. The mix of familiarity and novelty is part of the attraction of their work, providing cues for the viewers and at the same time confronting them with new and unfamiliar stylistic subsystems that challenge film comprehension. The parameters I discuss reveal aesthetic decisions made by the filmmakers. These can be precompositional (influences, sources, emulations, cinematic forms), compositional principles of combination and transformation (and chance discoveries) within a work, and postcompositional (effects, reception, varying responses in different contexts).[14] Besides technical parameters, since puppet animation uses so much artifice (but less than graphic 2-D animation), my analytical approach incorporates an interdisciplinarity that reflects on other creative practice.

Analysis of and reflection upon a nonconventional film is to some degree guided or influenced by certain attractions and irritations to the film as experienced on-screen. My analyses are based on a selection of film scenes and sequences that serve across a number of parameters and chapters. In foregrounding certain elements and giving others limited attention, the analysis is not wholly objective nor can it be comprehensive. This is in part due to the fact that films

like the Quays' are notoriously difficult to analyze.[15] My approach makes minimal reference to animation studies, in part because there is as yet not much written on puppet animation. While not intending to define the "problem" of puppet animation through its points of departure from other cinematic forms, other animation techniques, and indeed other art forms, I'll mention that this book obliquely seeks a reconciliation: to alleviate the tangential treatment from which academic study of this particular cinematic form has suffered. This is evident in the paucity of detailed formal analyses on puppet animation; critical, analytical texts mainly focus on the works of Jan Švankmajer and Władysław Starewicz or on commercial puppet animation.

In *On Criticism,* Nöel Carroll regards central activities of criticizing artworks to be description, classification, contextualization, elucidation, interpretation, and analysis.[16] While these categories are useful and comprehensive, Carroll emphasizes artistic evaluation as the *primus inter pares*[17] central to the critic's role, a term to which he dedicates an entire chapter. While there may be an evaluation implicit in this book, my intent is not to butterfly-pin the Quay Brothers' work, in part because it transgresses existing categories of art and draws on a multitude of noncinematic inspirations. I hope it is the reader who discovers what is valuable in the work as I describe and contextualize salient features of the films' images and their relation to the sound track. My analysis centers on description, elucidation, and interpretation. This may result in a form of disjunctive synthesis[18] rather than analytic analysis—shifting between objective description and subjective interpretation, conflating film with literature, architecture, and music—in both my methods and the organization of this book.

Gilles Deleuze and Félix Guattari's specific concept of disjunctive synthesis relates to their description of the *socius* body and the genesis of desiring-machines whereby "forces and agents come to represent a miraculous form of [the body's] own power: they appear as 'miraculated' (*miraculés*) by it."[19] The disjunction lies in the concepts that

> production is not recorded in the same way it is produced, however. . . . We have passed imperceptibly into a domain of the production of recording, whose law is not the same as that of the production of production. . . . The disjunctive synthesis of recording therefore comes to overlap the connective synthesis of production.[20]

I am not considering the terms "miraculated" and "disjunctive synthesis" in the complex contexts of psychoanalytic, social, and philosophical analytical theories proposed by Deleuze and Guattari in *Anti-Oedipus*. Rather, I am appropriating and redirecting them to explore the notion of a metaphysical, vital machine that is unique to the Quays' films and ways of working. There are a number of interpretations of "miraculated," and I refer to Daniel Paul Schreber's paranoid psychotic experiences in his *Memoirs of My Nervous Illness* (1955/1998) discussed by Deleuze and Guattari. Examples that Schreber cryptically describes are the influence of rays, which he called "miracles," and birds that have the facility of language that are "created by miracle."[21]

Puppet animation can create an analogous experience for the viewer of similar so-called miracles—nonorganic entities, machines, and objects that are materially extant in the phenomenal world but have qualities on-screen (cognizance, intention, ability to move independently, to react) that would otherwise reside only in the imagination. The Quays' nonanthropomorphic objects and machines are produced in the recording process of animation, a process that, in projection, results in a visual demonstration of laws that digress from the natural world, a disjunctive synthesis of permutations of inanimate form and materials and a life force that erupts from their animation. In other words, it is through single-frame animation of matter and light—the light of the film projector—that inanimate things are "miraculated."

The Quays' intermedia/blended media strategies are determined by what I call a disjunctive poetics. It is a poetics that seeks to combine the familiar with the unfamiliar while moving from states of synthesis to states of disjunction often modeled on pathological states of mind that Deleuze and Guattari have so brilliantly described. The Quays remark that they "grounded [*Street of Crocodiles*] around [Schulz's] very specific treatment of matter, certain metaphysical notions of 'degraded life' (as found in "Treatises on Tailors' Dummies" [in *The Street of Crocodiles*]), and his mythopoetic ascension of the everyday."[22] Schulz suggests that matter has a vitality in and of itself, and this nonhuman vitality is at the core of the Quays' disjunctive poetics and evident in their "metaphysical machines."

These conceptual bridges are also in keeping with the suspension of disbelief necessary for engaging with the perceptual unity of these films that lies in the simultaneous experience of their literary origins, mise-en-scène, sound track, and image. I will explore the Quays' poetics through related philosophical and aesthetic concepts around animism and especially vitalism, the latter being a central modernist concept that imbues Schulz's writings. This includes how disjunc-

tive poetics is expressed in film via the Quays' blending of media and how it is achieved by the animation of materials. My methods aim to clarify and reveal the process and features of the Quays' complex interworkings of artistic and stylistic creativity—an occasion of poetic (disjunctive) synthesis that allows me to explore the Quays' films as a haunting, elaborate, fascinating body of cinematic work.

The "Special Powers" of Film

The main task of this book is to explain how the Quays' films create visual neologisms in the particular animated space-times that are the true characters of the films. The Quays' puppet films present real spaces (sets) in the cinematic illusion, not drawn ones, and the idea of an animated realm created by the technique is central to my argument. Dudley Andrew's questioning of worlds elegantly joins these disparate threads: "What exists beyond the [film] text and what kind of description can be adequate to it? Here we encounter the exciting and dangerous term 'world.' A film elaborates a world which it is the critic's job to flesh out or respond to. But what is this cinematic world?"[23] What Andrew considers exciting and dangerous is exactly what attracts and is daunting at the same time: to describe the experience of the "worlds" of the Quays' films through a framework that takes into account the "lived" experience of the films. In terms of ways to approach the experience of the Quays' animated worlds, Andrew's formulations on the usefulness of experiential, phenomenological approaches to cinema, the spectator, and "the constitution of a cinematic world"[24] are helpful, as are a set of the issues and terms he considers relevant for his project. The oppositions in content between each element of these pairs of approaches (read horizontally) also informed the shift in cinema studies toward enabling the spectator and freeing individual films from corseted analyses based on systems, communication models, and the idea that objectivity is required.[25]

STRUCTURALISM/SEMIOTICS	PHENOMENOLOGY
Explanatory	Descriptive
Synchronic (System)	Diachronic (Origins)
Endistanced (Objective)	Immersed (Experimental)
Research Attitude	Research Attitude
(Rhetoric) Communications Model	(Art) Expression Model
Analytic (Revolutionary)	Synthetic (Revelatory)
Repositioning the Text	Repositioning the Self

My methods align for the most part with the right-hand column. Because animation film has so much to do with the spectator's imaginative engagement with worlds that she cannot experience otherwise, except perhaps in imaginative fantasy, an emphasis on personal experience is essential. As Andrew suggests,

> phenomenology is useful in that it relies on personal experience and avoids generalisations and codes that have been used to categorise cinema that . . . must not retard the far more pressing tasks of describing the peculiar way meaning is experienced in cinema and the unique quality of the experience of major films.[26]

In a sense, this shift (in which phenomenology plays a significant role) gives the film back to the viewer and allows the critic more freedom. Maurice Merleau-Ponty's description of phenomenology as something that describes rather than explains, and also that, as part of his greater philosophical agenda, "is not the reflection of a pre-existing truth, but, like art, the act of bringing truth into being," also influenced my methodologies, which are based primarily on analysis of artistic style.[27]

Despite the renaissance of phenomenology in cinema studies, heralded by Vivian Sobchack's philosophically dense and rich *The Address of the Eye: A Phenomenology of Film Experience* in 1992, surprisingly few authors have as yet embraced this approach in animation studies. Sobchack proffers a helpful explanation of the effectiveness of phenomenological approaches to describe cinema experience:

> Experience, nonetheless, seeks and is fulfilled by language even as language and experience are categorically incommensurable. This is something all marginalized peoples recognise. They desire a "new" language that will articulate the specificity of their experience, and the struggle to find the grounds on which they can speak it.[28]

Sobchack sees the appeal of phenomenology in "its potential for opening up and destabilizing language in the very process of its description of the phenomena of experience."[29] "Opening up and destabilizing" echoes Deleuze's earlier comment that "a work of art is a new syntax, one that is much more important than vocabulary and that excavates a foreign language in language."[30] This is a central notion in my analysis, which proposes how formal elements and functions in the

Quays' film excavations and reworkings destabilize our expectations of conventional cinematic language.

In his book, which skillfully outlines the problems film presents for philosophy, Ian Jarvie also contemplates the experience of film: "The attraction of the film to the viewer/listener is not a case of delusion. It is voluntary illusion."[31] In terms of addressing what he calls "the metaphysical problem of appearance and reality," Jarvie suggests we "test our sense of reality . . . by confronting ourselves, that is, playfully, with the seemingly real and thereby limning the boundary-line between the real and the unreal."[32] This is significant because the Quays' puppet animation films are made using materials that, as in live action, as materials, are what they represent photo-indexically. Because they are extant in the "real" world, their proximity to the real is closer, and the boundary line Jarvie describes is much more permeable than the one between drawn, painted, 2-D animation, and the real world. In this way, phenomenology is relevant to understanding the filmgoing experience of a type of film that animates inanimate materials because it transcends the empiricist practice of proposing psychological assumptions for human experience. Puppet animation evokes so many diverse phenomena in its reception that have little to do with our experience *in* the world, but that are presented as being *of* this world.

Jean Mitry offers some ideas about cinema I will challenge in the following, including that

> these [cinematic] forms are . . . as varied as life itself and, furthermore, one hasn't the knowledge to regulate life, neither has one the knowledge to regulate an art of which life is at one and the same time the subject and object.
>
> Whereas the classical arts propose to signify movement with the immobile, life with the inanimate, the cinema must express life with life itself. It begins there where the others leave off. It escapes, therefore, all their rules as it does all their principles.[33]

In animation, one does indeed have the (technical) knowledge not only to regulate life, but also to create a semblance of it, as do the Quays' animistic invocations of matter, matter that lives and moves. Later I will describe in more detail how their animated cinema (and, indeed, that of other filmmakers) challenges Mitry's demand that cinema "express life with life itself," because it creates an illusion of life without living organisms.

The recourse to phenomenology as a philosophical practice used to describe the phenomena of experiencing animation film is also promising because it is a practice that engages with all types of experiential phenomena—and for my project, forays into the experiences of literature, art, architecture, and sound are primary to articulate the aesthetic complexity that informs the Quays' style. Due to the fine-arts base of other techniques and styles of other kinds of animation, it could also be a model for inquiry into these forms as well.

My analysis, with few exceptions, uses models of art instead of communications models; it is transtextual, heuristic, descriptive, and explanatory in essence. It aligns mostly to interpretation and disjunctive synthetic evaluations that rely on experience and are inductive, developed from a set of questions that provide the viewer with new skills that may assist understanding the work.[34] I contextualize development of the Quays' stylistic excess as their praxis progresses because understanding this excess relies, in part, on knowledge of its manifold artistic and literary references. With extensive focus on *Street of Crocodiles,* chosen as an exemplary film midpoint in their short-film oeuvre that shares many aesthetic and formal qualities with their earlier and later work, my analysis teases out the formal defamiliarizing effects and illuminates the transformation of Bruno Schulz's source text into film. The central queries I articulate relate directly to the Quays' cinematic world (which is, quite literally, small scale), how we perceive this world, and to those models and theories of other creative practice that can be used to describe it.

To reveal how innovations in *Street of Crocodiles* that indirectly relate to the Quays' literary influences develop their poetics, Russian formalist analysis is pertinent (as is, as we will see, James Joyce's linguistic anarchy). The formalists were concerned with the individual's artistic expression and they aimed to develop a set of properties that, in their combination, explained the construction of poetic language. Formalism's main proponents were Viktor Shklovsky, Boris Eichenbaum, and Roman Jakobson, and their development of formalist approaches to works of art, mainly literature, has been adapted to other forms of creative practice. Shklovsky's concepts of defamiliarization and the device were originally used for literature, yet it is useful in the present context:

> The purpose of art is to impart the sensation of things as they are perceived and not as they are known. The technique of art is to make objects "unfamiliar," to make forms difficult, to increase the difficulty and length of the perception because the process of perception is an aesthetic end in itself and must be prolonged.[35]

These claims transmute into Sergei Eisenstein's writings on film form that become significant when I describe the Quays' unfamiliar and challenging cinematic objects, spaces, and sounds. My specific focus on formal devices and aesthetic features of *Street of Crocodiles* includes literary interpretations; mise-en-scène relationships between parameters of set design, architecture, and puppet design; camera, lenses, and lighting; montage; and music, sound, and noise. A reanimation of the dissected cinematic corpse of *Street of Crocodiles* attempts to explain what incites the spectator's active involvement in understanding the interplay between the film's visual, musical, and other motifs and cues. Andrew's suggestion that phenomenological approaches "reposition the self" instead of the text means that the spectator will be foregrounded in my analysis.[36] I offer information sets that draw on experience and knowledge of other creative practice—including architecture, literature, music—that can be used for inferential procedures and applied to the Quays' later films as well.

This book, then, will also inquire into such essential issues of puppet animation and cinematic experience. What is the ontological status of the animated object? What relations to our own lived, corporeal, tactile, and haptic experience do the spaces and objects in these films have? A slowly revolving screw rising out of its submerged existence in *Street of Crocodiles* is a complete machination by the artists: I can experience this moment only by watching the film. Of course, I can visit the Quays' atelier and hold the screw in my hand, bend over to look into the constructed set in which the scene is animated, and look through a viewfinder to regain a sense of proportion and framing that the film presents, but I will never be in the presence of that moving, animated object. These problems are aesthetic in nature, philosophical problems that arise in creation and appreciation of an imaginary unique to animation. Because many of the Quays' films offer unconventional narratives, a more culturally and fine art–informed co-creational participation by audiences can support comprehending the elliptical, referential, and fragmented narrative they obliquely suggest. And because the polysemic, polyaesthetic visual references the films use are enriched by familiarity with them and their cultural and artistic contexts, there are considerable divergences in viewers' descriptions of the Quays' films. My approach to their works does not make claims to be correct or unequivocal; it allows an individual and essentially idiosyncratic interpretation, valid insofar as it is supported by dominant formal devices and nonconventional elements that are explained and contextualized in relation to developing a poetics of their work to date. In his concept of historical film poetics, David Bordwell alludes to the Greek poiesis, or

active making.[37] I contend that nondigital animation is the most actively made kind of film, in that every single frame requires creation and manipulation of the profilmic artisanal materials used to create them.

The contributions I hope to make in this book develop methodologies and approaches to the Quays' films originating in a deliberately eclectic use of cinema theories of spectatorship and film analysis, with interdisciplinary excursions into art and architecture, linguistics, literature, narratology, phenomenology, and critical theory that reflect the Quays' creative contexts. Most of the approaches I use are not reliant on established, a priori, or prescriptive theories of cinema. They are much more related to the *experience* of watching the Quays' films, if you like, through a phenomenological and experiential filter, an analytic pursuit of their poetics in quest of the pleasure of apprehension (a term to which I will return).

I take a cue from Dermot Moran's reading of Jean-Paul Sartre's understanding of phenomenology as "allowing one to delineate carefully one's own affective, emotional, and imaginative life, not in a set of static objective studies such as one finds in psychology, but understood in the manner in which it is meaningfully lived."[38] The cinema is a place into which many of us recurrently slip to allow ourselves that most pleasurable experience of being moved intellectually, affectively, and emotionally by what unfolds on-screen. Watching an animated film always implies a different kind of spectatorial experience, and I am not expecting to solve the complex "problem" that animation presents as a unique form of cinematic illusion. Rather, I will reflect upon why the Quays' films are meaningful and have enriched and informed my own inner world, as they have, in different ways, for many others. The results and conclusions of my work do not assume to offer comprehensive and pat solutions to the manifold complexities of all forms of puppet animation. I hope this book will find readership among those who have left the cinema after seeing one of the Quays' films, those who wonder about their own unclarified attractions to the animated form and whether certain ideas posited here may justify and confirm them; and further, that it will encourage other filmgoers and academics to reassess their concepts about animation as an art form.

A few notes on the book's images and its working methods: It benefits enormously from the Quays' own artwork, which they generously made available for publication for the first time here. Images in this book from the films themselves are attempts to provide the reader with visual points of reference to the writing, but they are stand-ins for the results of the techniques described.

These can be fully appreciated only by watching the films themselves, and most extant copies of the 16 mm and 35 mm shorts bear the wear and tear of their many screenings around the world. While film projection remains the best way to see and appreciate the photochemical details of the works, this is not always possible, so the bibliography includes information of their works available internationally on VHS and DVD (some of which are out of print but are often available at library video collections). I would recommend the BFI's recently released DVD, including one with remastered versions of the short films overseen by the Quays themselves, which includes a number of tantalizing extra features and interviews.

The work of two filmmakers who seldom discern themselves from one another, and who in taped interviews augment, extrapolate, and complete each other's statements, bears certain implications in the understanding of the term "monograph." That the Quay Brothers are identical twins is a biological fact; yet their close relationship has definite implications in their aesthetic development, and the richness of their works has its source in two minds working in close concert. I have therefore chosen to approach their work as a synthesis of two individuals whose differences can be divined neither in the images they produce nor in the interview excerpts that appear here, nor in their own idiosyncratic approach to filmmaking. Each of them has an equally distinct if unidentifiable voice in the direction that any of their films take during the production process. One result of this is the fact that credits, interviews, articles, and almost all other material produced or made available by the Quays are accredited to both of them; thus a separation of them as individuals from their collaborative work is almost impossible. For this reason, I will mostly refer to the Quay Brothers as they refer to themselves: as a stereophonic single voice, as a set of four hands, four ears, and four eyes, and as an entity that has collectively and modestly continued to produce works of art without an identifiably divisible paradigm of responsibility, recognition, or signature.

AUTHENTIC TRAPPERS

IN METAPHYSICAL PLAYROOMS

1.

To watch any film from the Quay Brothers is to enter a complicity of furtive glances, choreographed shadows, and a mélange of motifs and tropes. Their opus exhibits an instantly recognizable and often emulated style, a shifting composite of chiaroscuro and an assemblage of obscure objects and fragmented, skeletal narrative structures. Their works are closer to music than to dialogue, closer to poetry than to literature, closer to experimental interior monologue than to conventional fictional narrative. The first-time viewer of any of the Quay Brothers' films is often baffled by what seems to be the filmmakers' apparent unconcern for coherence in location, continuity, plot, and narrative and may leave the cinema speechless or puzzled. Yet another is exhilarated by the break the films perform with many of the conventions governing most (animation) films. Or the viewer is enchanted, and her exegesis is a personal commitment to decipher and understand the elements of the film the Quays embed in their multitude of styles. The Quays have a distinct, complex aesthetic program. Whether a documentary on optics, an animation short, or the black-and-white feature *Institute Benjamenta* (1995), their imagery obeys—and sometimes intentionally transgresses—the laws particular to their idiosyncratic cinematic universe. Together they create a synesthetic, haptic world, a palimpsest of evocative sound and images that meld music, literature, dance, architecture, graphic design, the

sacred and the occult, pathology, and eroticism into often puzzling cinematic enigmas. The films are music driven, the images redolent with allusion and references; usurped materials and objects take on an uncanny echo of their past uses. Unencumbered by linear narrative, guided by a musical trajectory, viewers can immerse themselves in various levels of puzzlement or enchantment.

"Metaphysical Playroom" is an intertitle from *The Cabinet of Jan Švankmajer* (1984). The Quay Brothers describe a scene in the film in which a young puppet is initiated into the secrets of the older character he visits:

> We created an Arcimboldo-esque portrait of [Jan] Švankmajer as a librarian/alchemist along with a young child assistant (clearly the two of us, only not two-headed) set in a décor that was simultaneously the 16th and 20th century Prague of now. The film was an open homage to a "maestro."[1]

The mentor takes the youth through a series of exercises in which inanimate objects perform feats that skirt natural laws of physics. Balls bounce backward from reverse entropy inertia to high trajectories and travel up stairs instead of down; mysterious babushkalike drawers-in-drawers lining a wall open themselves of their own accord. It is easy to read this film as autobiographical, especially when the Quays acknowledge their indebtedness to Švankmajer's artistic and cinematic expertise. Yet Švankmajer is but one of an array of artists and filmmakers whom the Quays acknowledge as influences, and this film was not their first set of experiments. Inspired by impressions, words, and music, they transmute them into the images they create in their studio, itself the embodiment of a metaphysical playroom, brimming with the trappings and paraphernalia of the tools of their trade. More often than not, metaphysical concepts undergo a dual transformation: the first is when they are reified and given a physical form, and the second when these forms are animated.

The Quay Brothers have experimented continually in their own metaphysical playroom. Play is a form of experiment, and experimenting also means learning from the unexpected. Occasional formal irregularities have never irritated them; on the contrary, in the process of shooting they let themselves be inspired by "mistakes" and go on to develop these into exactly what makes their films unique. A lingering shot of an object or a movement that at first appears inconsequential or even banal is gradually transformed into a scene's central motif. The Quays: "We don't ever set off with sublime, pristine conceptions. . . . We embrace

both disaster and chance with the ambivalence of open arms. These accidents bend the work, and we've followed in their footsteps like authentic trappers."[2] This chapter tracks the Quays' early forays and progression through geographic and creative worlds and the transition from art students to animation filmmakers. It explains production contexts, inspirational pathways, and other information on the films' developmental processes. We will see that some of their best images and sequences are the result of trying to do one thing, and another happens. The metaphysical playroom is the locus from which the Quays' cinematic worlds originate.

"Twinema"

There is a phenomenon that seems to dog the Quays: the tendency of some critics and fans to speculate about the two of them as much as to review their films. Thyrza Nichols Goodeve's introduction to her 1996 interview with the Quays provides a sense of the mystery that enshrouds them:

> I half expected to find them a pair of wizened gnomes with rusty screws, butterfly dust, and cobwebs dangling from their hair. Nothing so exorbitant—only two disarmingly friendly, whirling persona of elegantly rumpled charisma, who just happened to have turned their accidental birthright as identical twins . . . into one of art's most ingenious and visionary collaborations.[3]

Nichols Goodeve's opinion of the ingenuity of their works is shared by many, and it is natural that critics are curious about the originators of this "visionary collaboration." This is fueled by the Quays' encompassing knowledge of the arts and literature, their sartorial flair, and the spoken and musical eloquence that transmutes into their films. According to Keith Griffiths, during their studies at the Royal College of Art (RCA) and after, they were very stylish, and he has photographs of them doing model shoots in white suits: "It was of course a very fashionable period, and one where we all 'posed' somewhat."[4] There is something Dorian Gray-ish persistent in their appearance over the years when one looks at the photographs that have appeared in publications. No doubt their cameo appearance as Ipson and Pullat Fallari (albeit as a set of still photographs) in one of the biographical vignettes in Peter Greenaway's enigmatic, metafictional *The Falls* (1980) also had an effect, and anecdotes have it that they were part of the inspiration for *A Zed and Two Noughts* (1985).

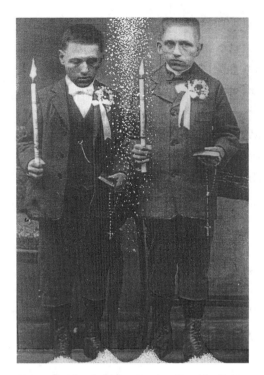

Figure 1. The Quay Brothers' collaged "self-portrait" that was used in a "personal letter" to Robert Walser, "Die Kinder Quay, wie sie zur Kommunion erscheinen [Schwyz]." The letter was published in Paul Hammond, "In Mystery, Shrouded: On the Quays' New Film," *Vertigo* 1, no. 5 (Autumn/Winter 1995). Copyright and courtesy of the Quay Brothers.

It is understandable that the Quays are reticent about these photographs; they document a private moment that has little bearing on their filmmaking. They playfully incited more conjecture with reworked images of themselves as choirboys (one of the few earlier portraits of them in circulation), stylized as much as their images. These images gently and playfully tease the fascination they hold for people as twins, but these are often collaged or altered in a way that reveals their subtle sense of self-irony (see Figure 1). An earlier preference for the shades, textures, and various states of disrepair notorious in vintage clothing made them look as if they belong in one of their films. They are nonetheless pragmatic about the interest they incite:

> We're totally ignorant and/or naïve about split personalities, inward turning natures of our relationship, or wishing to work independently of each other. These are not, and have never been, issues in the remotest sense, and it shows how fantasy bound others are about twins.[5]

There is something oddly uncomfortable about some of the earlier reviews, as if the frustration of not being able to unlock the secret of what makes the twins tick shimmers through the writing. Critics expound upon them in adoration or, in texts from less discreet critics who want their pound of flesh, deliver a nasty criticism of the twins themselves.[6] These texts read as though written by frustrated journalists who did not get past the Quays' "private doorman." The Internet is also a platform where Quay fans, often quite innocently, post information about them that the Quays state is simply not true:

All that about us being "reclusive" was spun from a Web site. Everyone buys into the waffle verbatim and then traffics it for [himself or herself]. There's nothing wrong with being aggressively modest and we won't suffer idiots or gossip, least of all without imagination.[7]

Critics' propensity to link the Quays' personal appearance with that of their films has lessened, most notably since their arrival in the "serious" field of live-action feature filmmaking in 1995. However, curiosity about them persists, possibly because earlier questions did not provide satisfying answers. One of the Quays' recent responses: "Of course our upbringing and environment are crucial, but [one] must also realise that being identical twins allowed us a much greater suspension or desertion of the real world."[8] In this remark lies a clue to their interest in a particular genre of literature that informs the origins of the stylized, hermetic realms and spaces of their films and the cinematic worlds they conjure.

Norristown to London Town

The Quays were born in Norristown, Philadelphia, in 1947. They enjoyed a relatively domestic upbringing, went to art college, and then, like many American graduates in the 1960s, ventured abroad. Far more interesting is the Quays' own account of themselves. In a letter to J. D. McClatchy published in a 1989 profile, they tongue-in-cheeked a dream list worth citing at length:

> What if we said we [were] born of a heavily tainted family, neurasthenic, encephalitic, each one with an atrophied testicle, a sly liking for geese, chicken, etc., pigtails in pillowcases, suffer from dry tongues, overly predisposed toward music and abandoned organ lofts, blah, blah, blah.[9]

They then counterpoint this with a bio that reads like any for someone growing up in 1950s America:

> No, we grew up sweating with obedience. Our father was a second-class machinist for Philadelphia Electric, our mother an impeccable housewife (who was a figure skater before marriage). On our father's side there were two grandfathers: one a tailor from Berlin who had

a shop in South Philly and the other who was apparently a cabinet-maker and we were told that the 5th floor of Lit Brothers [department store] in Philly has cabinets by the Quays. (Now we lived in Philly for some five years and never made that tiny little expedition to confirm it.) Our mother's father was excellent at carpentry and was also a chauffeur when Philly had only 5 automobiles to its name. So! In terms of puppetry it's surprisingly all there—carpentry, mechanisms, and tailoring—and figure skating to music to score any of our aberrant tracking shots.[10]

However, this did not and does not stop ruminations on the origins of their private cosmogony. Their genealogy is mainly Anglo-Saxon; the family name comes from the Isle of Man (the cabinetmaker mentioned above was Samuel T. Quay), and their paternal origins are Manx and Gaelic (the name was originally spelled MhicAoidh). Their Prussian paternal great-grandfather Paul Franzke (a tailor) married a peasant girl, Selma Uhlich, from Upper Silesia (on current cartography shared by both Poland and Czech Moravia) in Philadelphia in 1885. Their maternal origins include a great-great-grandmother, a Howard from England, and a maternal great-grandfather on her father's side: Linus Godfrey Smith (Schmitt), from Darmstadt, Germany, arrived in America in 1868 and worked for his brother in a butcher shop. It is of greater consequence to know that Philadelphia is a culturally heterogeneous mix inhabited by Italian, Greek, German, Ukrainian, Polish, and Irish immigrants and had a large Jewish expatriate population. This gives clues about an early infiltration of Eastern European culture in the Quays' own past, tangibly evident in box-littered sidewalks where one could easily imagine two boys rummaging through detritus or in the shops to which German watchmakers, kosher butchers, or Italian dressmakers transposed their private shadows and mythologies of distant Europe. A photo document also gives hints to a youthful interest in prosthetic apparatus that is later subsumed in puppet design (see Plate 1). The Quay Brothers' later migration (like that of many of the authors they admire) to a metropolis midpoint between modern America and shrouded Eastern European culture is a continuation of an artist's tradition in which identity is not geographically anchored.

The moving image was not the initial interest that brought the Quays to the Philadelphia College of Art (PCA) in 1965. Their artistic training and development was colored by excursions into worlds of art that were tangentially related with illustration. It was while at the PCA that the Quays had

their first turning point in terms of their gradual move eastward. Exposure to an exhibition of Polish film, theater, and opera posters from the 1950s and 1960s lubricated the visual machinery of their imaginations: "It utterly ravished us, particularly the power of the one, single image bristling with a painterly, almost ecstatic use of typography."[11] The unique graphic designs fueled their interest in all things Eastern European, from Jan Lenica's graphic animated shorts to the moody, austere alleyways and magical, dusty shop windows of Polish cities and sylvan villages.

Like that of some artists working with the static graphic image or sculpture, the Quays' interest in film was keen. At the PCA, they also took advantage of the chance to try out other fields and they began making films, experimenting with cinematic movement and narrative. They became aware of the possibilities of cinema, partly through screenings: films from Luis Buñuel, Andrei Tarkovsky, and Sergei Paradjanov, as well as early works from Carl Theodor Dreyer, had a profound influence on them. The potential of cinema opened to the Quays: "We did some live action—trivial. I [Stephen] was in the film department in final year. We worked on things together a few times, but it really was the animation that most intrigued us."[12] After a few live-action short films they ventured into experimenting with animation, as have many artists whose creative output is graphic or sculptural:

> At the beginning it was frustration with the frozen image, and not amplifying it by sound and rhythm and music and sequential time. I think that having done the first few films we realised you have that, and also our great love for music, and you realise that that dimension would always be missing until we could do animation.[13]

After the Quays graduated in illustration at the PCA in 1969, their kindled interest in Europe was not the only reason they wanted to go abroad; it was also a way to avoid the Vietnam War conscription, which they did by convincing the authorities not to draft them. They tried a number of ruses and in the end escaped, like so many artists at the time, by suggesting, among other things, that they were homosexual. Free of the draft, the twins set off for Europe, anticipating the worlds and forgotten corners that the films, posters, and books hinted at.

Exile and emigration take on many forms and expressions. Prague-born Franz Kafka wrote in German, while Robert Walser's life took him to Berlin, Paris, and Berne and eventually to the Waldau and Herisau sanatoriums

in Switzerland. It is fair to say that many artists live a self-imposed inner exile. In 1969 the Quays moved to London and enrolled in the Royal College of Art (RCA), a move that brought them closer to the literary and musical regions of Eastern Europe. And everywhere was music, music, and more music: Gustav Mahler, French and Italian chansons, Jean Sibelius, Anton Berg, and Leoš Janáček, who later became the subject of an artist's documentary for the British Film Institute (BFI). At the RCA, music deeply inspired the Quays' illustration (see Plates 2 and 3), anticipating the central role of music in their work to come. For the Quay Brothers, these and other artists created "a poetry of shadowy encounters and almost conspiratorial secretness."[14] They had hoped to enter the RCA's (now defunct) filmmaking program, which was not possible, so they continued their illustration training. This didn't keep them from pursuing their interest in the moving image. They gained access to filmmaking equipment during their master of art studies there and made further excursions into filmmaking:

> We'd always felt a strong pull towards cinema—both live-action and animation and because of our graphic formation it became quite a natural step to head towards animation. As we'd done a lot of collage work, our earliest animation efforts were in this form: already there was texture, light and shade and the school had a fantastic photocopy machine which had the most beautiful range of blacks and whites and greys. Puppets came much later—when we were 31 and this came about more as a wild dare.[15]

Der Loop der Loop, Il Duetto, and *Palais en Flammes* all were 16 mm animation films made during their studies (my requests to screen these early films were politely fended off). The early interest in monochrome ranges remains pervasive throughout much of the Quays' filmmaking. Le Fanu's 1984 article about their work as independent filmmakers and the early collaborations with Griffiths includes comments on these films. Perhaps because this was at a time when the Quays had not yet distanced themselves from the early films, Le Fanu was able to see two of them. He rather flatly describes an image that portends the recurring inclusion of two main protagonists in some of their early films: *"Der Loop der Loop* has a couple of acrobats tossing each other backwards and forwards under the big top, until the disintegration of limbs on one causes the proceedings to halt abruptly."[16] Griffiths describes the cutout film *Der Loop der Loop* as being heavily influenced by Walerian Borowczyk: "It was very graphic and two-dimensional.

For the sound track they used the same music as Walerian Borowczyk did for *Goto—L'île d'amour* [1968]—Handel's Organ Concerto." Contrary to what is often written about their influences, Borowczyk was the animator and filmmaker who made the greatest impression on the Quays early on. His starkly graphic cutout and puppet animation films impressed the twins so deeply that, as students, they organized film screenings of his works as part of the RCA Film Club they ran for a period, and their RCA final thesis was on his *Goto—L'île d'amour*. Griffiths has a particularly soft spot for their *Palais en Flammes*—"their Buñuel film. Insects in bottles—stop framed tennis racquets hanging over telephone wires, and images like that supported by Wagner. That's really their *L'Âge d'or* [Luis Buñuel, 1930]." Insects are a recurring motif in the Quays' later films (one I will return to), as are objects like the Dalí-esque limp tennis racquets. *Il Duetto* was another cutout film; the Quays had seen films by Lenica, whose work had a profound influence on their first animations, and Lenica, in turn, had made films with Borowczyk. Le Fanu: "In *Il Duetto,* slighter and more sinuous of line, a cellist and a lady opera singer slug out a trial by combat to the modernist music of Xenakis. Both films—pugnacious, clever, a touch sinister—share the economy and elegance that is the wit of the born cartoonist."[17]

There are differing opinions about the quality (and whereabouts) of these films. It is the Quay Brothers' prerogative to decide which of their works are seen, and like many filmmakers they regard these early ventures into animation as not relevant. Yet there are others (including this author) who would like to see the films to better contextualize the later ones and to get a sense of how they began animating while they were studying illustration. Griffiths wrote a "fictive essay" about

Figure 2. Pencil drawing, Philadelphia, 1975, for what the Quays describe as "an imaginative film poster for an imaginary film" titled "The Well-heeled Lovers." The drawing includes the name of French cinematographer Léonce-Henry Burel who worked with Abel Gance, Marcel L'Herbier, Robert Bresson, and Jean Epstein. Copyright and courtesy of the Quay Brothers.

the so-called lost films for the magazine *Afterimage* that fueled more curiosity about these early experiments at a time when the twins were looking to move on. As regular interlopers in the RCA's film department, the Quays were able to make the films in part because animation could be shot quite independently of the college's facilities, not drawing on the film department's resources that were prioritized for those enrolled in the program. The films were made with help from other students, and in the collaborative environment at art colleges the Quays also got involved in other students' projects. (They are listed in the credits for fellow student Lys Flowerdays's *Bal Masque* [1981], made after they graduated.)

After graduating from the RCA in 1972, the Quays looked for work in London. The situation for young graduates was very difficult, as funding for filmmaking was scarce. Unable to find work and as their student visas expired, they returned to the United States, to Philadelphia. This was to be an extended gulag away from where they truly wanted to be. They spent five years working at different jobs familiar to artists who need money to live and to be able to continue working on their craft: they waited tables, drove taxis, washed dishes, and lived sometimes on social benefits. Perhaps their continued appreciation of ruby and golden liquid inspiration was nurtured in the protracted, wine-imbibing halcyon periods of pre- and post-opening hours around the culinary hell of restaurant chaos. All the while they were devouring books, music, and film, applying for commissions, and doing illustrations for publications as diverse as *Playboy* and scientific journals while continuing to pursue and develop their own artistic interests (see Figure 2). Illustration, which was the Quays' original training, provided little satisfying work on the whole. Their particular style initially attracted book cover assignments, not for works by great European authors, but for "lowly" science fiction. This is an indication of North American conceptions of the European German and English romantic, gothic, grotesque, and fantastic authors—Samuel Coleridge, Mary Shelley, Jules Verne, Hoffmann, Kafka, Schulz—as singly a source of horror, magic, and utopian visions, disregarding the metaphysical and its place in European and other cultural histories. Victoria Nelson describes this as "garish store displays on this same American boulevard of trash," a realm she calls the "sub-Zeitgeist."[18] She provides an illuminating account of the diverse development of fantastic literature in Europe and North America that she dubs the ghettoization of the American fantastic, noting that "even though [America] had a rich supernatural—even apocalyptic—tradition in its popular religion, however, other cultural influences would severely limit the presence of the transcendental in the mainstream intellectual culture."[19] The Quays' strong affinities to these rich

traditions of European fantastic literature not yet integrated into an intellectual creative community was certainly a factor in their turning away from the United States and toward a Europe more receptive to works inspired by these authors.

In 1977, an unexpected grant from the National Endowment Fund for the Arts made a sojourn to England, Wales, and Scotland possible. They had included some of their illustrations and the grant allowed them to discover Celtic designs and contexts. After the funding ran out, they moved around Europe as best they could, eventually ending up in Holland, where they designed book covers for the Dutch publisher Meullenhof, for whom they have done a total of six Louis-Ferdinand Céline covers (see Figure 3). They continued to comb libraries, antiquarian stores, and junk shops, immersed in an architectural and cultural wealth and history of the places they visited. In 1979, the twins returned to London on one of their trips and met up with some of their old classmates from the RCA. One of these was Keith Griffiths, who had kept in touch after graduation; they sent each other postcards and news about what each of them was doing. Griffiths had a continuing interest in animation film, which had been sparked during the RCA film screenings that were included in the lectures of film critic and educator Ray Durgnat, whom both the Quays and Griffiths praise as a phenomenal tutor (the Quays discovered his writings on Buñuel, Bresson, and Georges Franju while at the PCA). Griffiths: "I was working on some animation, and the Quays were doing so too, but this coincidence is largely accidental. You carry those interests forward in different ways." Important for this meeting with the Quays was the fact that Griffiths was working in production at the British Film Institute (BFI) at the time.

Keith Griffiths, Conspirateur Extraordinaire

Filmmakers need producers that sustain and support their visions of cinema and who do not water down the original ideas. Since encouraging them to submit their first proposal to the BFI, Keith Griffiths has produced or coproduced almost all of the Quays' films except most commercials and *Stille Nacht* shorts. Besides his engagement in film producing, Griffiths wears many professional hats and is an untiring lobbyist for art house film. Author, curator, researcher, and critic, he is a welcome speaker at higher education institutions, is often invited as a jury member, has received numerous awards including a NESTA fellowship, and is on festival, film, and industry advisory boards. Griffiths has directed films on Michael Snow, Robert Breer, Jean-Luc Godard, Jon Jost, Hans-Jürgen Syberberg,

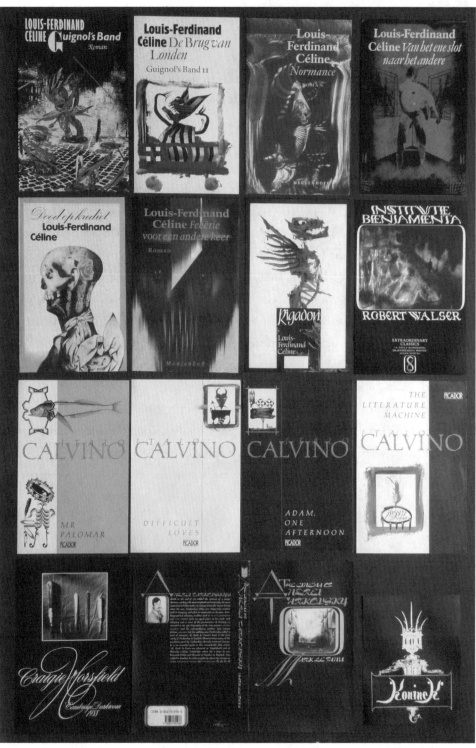

Figure 3. Selection of book covers 1978–1996
(Amsterdam and London) designed by the Quay
Brothers. Copyright and courtesy of the Quay
Brothers.

Jan Švankmajer, and Raul Ruiz. His extended coterie of auteur filmmakers, directors, and video and installation artists is impressive: Chris Petit, Iain Sinclair, Guy Maddin, Patrick Keiller, Steve McQueen, Apichatpong Weerasethakul, and Dave McKean all have worked or continue to work closely with him. Art house and auteur cinema have always been difficult to finance, and recent developments in UK funding schemes and coproduction financing have led to dwindling project support for his and other production houses. Illuminations Films, a sister company of the TV and media production company Illuminations Media, is managed by Griffiths and Simon Field. It is one of the most recognized production companies for this kind of filmmaking, though it was close to shutting its doors in 2001 due to the difficulty of raising finance for these largely niche films. However, focusing on coproductions has enabled the company to continue supporting work from a stable of visionary international filmmakers, most recently Weerasethakul's Cannes Palm d'Or winner *Uncle Boonmee Who Can Recall His Past Lives* (2010).

Griffiths also produced and often directed an array of animation filmmaker documentaries: *The Five and Dime Animator* (1985) on Robert Breer; *Doodlin': Impressions of Len Lye* (1987); *Oskar Fischinger* (1992); *Abstract Cinema* (1993), a fifty-two-minute interview-based documentary on abstract film; and *The Insect Affair: Starewicz Cinemagician* (1994). Griffiths doesn't separate animation from other filmmaking. He has some thoughts on a type of cinema that the Quays' hybrid form fits into that intersects with Zielinski's concept of cinema activism:

> I'm just interested in certain kinds of filmmaking, and in particular with animation, which can veer from the visceral excitement of the abstract, to a sort of surrealistic stream of images. . . . That is why I am interested in [Len] Lye and [Robert] Breer. I am also interested in, if you like, optical metamorphosis. Breer and Lye fit into that category too, as do people like [Charles] Bokanowski, who many might not consider an animator. I consider him an optical manipulator of images. This connects to my interest in Švankmajer, the twins [the Quays], people like [Juri] Norstein, [Piotr] Dumała, [Priit] Pärn, or Caroline Leaf, where metamorphosis is a major part of the image making process. Consequently, I have never considered myself to be interested in animation per se, just [in] a body of work, and that focuses on abstraction, metamorphosis and the meaning that the relationship of these images can stimulate. That, I suppose, is where one's so-called surrealistic interests intersect as well.[20]

Griffiths's attraction to this kind of filmmaking has been instrumental in the Quays' development. Early on he recognized originations of their unique talent in illustration and abilities to transfer this imagery into the moving image. His professional trajectory, not exclusively aligned with that of the Quays, gives insights into how their collaborations developed and why this working relationship of close to thirty years has persisted.

In 1976, the BFI was reshuffling its production department. Griffiths: "They promoted as Head of Production this 'maniac' (I say this in inverted commas and with both affection and mischievousness) who had been working in the past at BBC Film Acquisitions, and was heavily involved with 'left thinking' and aesthetics—Peter Sainsbury." Sainsbury had the political clout, strategic thinking, and expertise to be able to select a range of filmmakers whom he envisioned could create a radical change of direction for British cinema. However, he lacked some of the required knowledge for producing such a body of filmmaking and suggested that Griffiths apply for the post of deputy head of production. Griffiths: "He wanted a deputy sympathetic to the low budget films he wanted to see made, but also knew the logistics of how this might be achieved. Also, he wanted to start making more feature length films, and needed someone who could keep an eye on all that." Griffiths had—by luck, coincidence, and ability—become a producer, but one with an intimate knowledge of the filmmaking process. Griffiths got the job and was to become deeply involved in one of the most exciting periods at the BFI. This was the time when some of the fundamental discourses around film theory, politics, and aesthetics were embroiled and the influential film journal *Screen* was in full steam.[21] Between 1976 and 1980, Griffiths had departmental administrative responsibility and was production coordinator of British Film Institute Production Board Films. He produced five feature-length fiction films and numerous short films for the BFI and coproducers.

All of Sainsbury's projects had to be approved by a production board not unanimously sympathetic to many of his politically charged ideas. Griffiths was involved with all of these and recalls two of the most meaningful successes:

> There were some most horrendous rows. Two in particular stick in
> my mind. One was when Sainsbury pushed through Chris Petit's
> *Radio On* [1979], to be made in co-production with Wim Wenders,
> which I went on to produce, and according to the critic Geoffrey

Nowell-Smith, radically opened up the debate about low-budget independent art cinema in this country and how Britain was portrayed at that time. There was also a very good film editor who made rather eccentric personal short films, but all we had as a presentation was a set of his drawings. His name was Peter Greenaway. There was almost a stand-up row with some members of the Board, and in the end it got so heated that somebody said—"well, do what you bloody well like but this man will never, ever, ever be a filmmaker." That was *A Walk Through H* [1978].

Now that he was in a position to fund projects, Griffiths suggested the Quays submit a proposal for a short, and they put together what he called a "scrappy treatment with great Quay drawings on it." The BFI received hundreds of scripts, but it was Sainsbury who preselected what could be presented to the board for funding, and at one meeting the Quays' project was one of the short-listed films. Griffiths gives a flavor of how funding was allocated:

> There wasn't any real discussion about it at all. We just put the treatment forward, though we might have beefed up the application form in some way. We had been attempting to balance the constituency of the board and appoint some people who were more sympathetic to our "vision" and this included the film critic Tony Rayns. The meeting took place, and the money was carved up with the usual arguments. "OK, Bill Douglas, £25,000, so and so, Greenaway, £10,000." We added it all up—and there was around £7,000 left. But none of the other projects could possibly do anything with that sum. So Tony Rayns said, "Well, the Quay Brothers could make a film with that," and we got it!

Rayns's support for the project led to the first funded short the Quays made with Griffiths. He realized that it was different from anything the BFI had done, although they had funded a small number of animation films in the past. The Quays: "The British Film Institute said they would give us money for something experimental. We said, we've never done puppets, so why not—it was the most experimental thing we could think of."[22] This first project marks the beginning of the collaboration with Griffiths.

Koninck Studios

Koninck Studios was founded in 1979 by the Quays together with Griffiths as producer. The company name originates from a Belgian beer label: the symmetry of the letters and its graphic design appealed to Griffiths and the Quays, who embellished the typography with their own inimitable graphic style (see Figure 3 for an early version of the studio logo). Again, it was part circumstance, part coincidence. The three of them were in a bar in Brussels (in the brasserie A La Morte Subite, whose name appears in the homage titles in the first film), collected the beer mats of what they had drunk, wrote down the names, and sent them to the Belgian company registration office: "The only one they would permit was Koninck. That's why it's Koninck, there was no other reason. It was actually De Koninck." The Quays set up a small working space in South Kensington and proceeded to make their first post-RCA independent film. The prize-winning *Nocturna Artificialia: Those Who Desire Without End* (1979) was, in Griffiths's words, "fantastic . . . a luxury publicly subsidised film." They listed themselves as *Gebrüder Quaij* in the credits (which are in French), perhaps an indication of the artists' play with identity, perhaps a gesture to the German expressionist influences the film suggests.

Cryptically dedicated an "hommage a Ruede 1, Arbre Bénit 72 Gewijde-Boomstraat" (the address of the Styx art house cinema in Brussels), *Nocturna Artificialia* wavers at the threshold between consciousness and sleep. The poetic gesture initiated here displays traces of their interests in oneiric experience, labyrinths, and hermetic worlds that are revisited in their later films. As in the majority of their short films, the narrative in *Nocturna Artificialia* is unspectacular, at times nonexistent: a solitary figure gazes out a window, enters the nocturnal street, is transfixed by a passing tram, and, suddenly, back in his room, falls from

Figure 4. Puppet and a background drawing from the Quay Brothers in *Nocturna Artificialia,* 1979.

his chair and wakes. The film is about a love affair with a tram in the strange hours of the night, structured in eight sections. These are separated by the only language in the film: intertitles that hark back to silent film conventions, in English, Polish, French, and German, inserted between the main figure's somnambular wanderings. In shifting states of epiphany and hallucination, the figure's trajectory is constructed by the formal treatment of the images (camera angles, spatial organization, focus plane shifts, and dissolves) and by the music and sound track that synthesize the characteristically disturbing tension. The film introduces a number of motifs and formal principles that continue throughout the Quays' later works: puppets enmeshed in disorienting point-of-view structures; hermetic interiors; elaborate, sometimes animated graphics; complex orchestrations of light and shadow; invocations of Eastern European imagery and cultural artifacts; and sound tracks that both counterpoint and sustain the imagery (see Figure 4). Other elements revisited later include the use of natural objects sequestered from their origin (for instance, a dried, heavily thorned rose stalk is integrated into one of the set constructions), and offscreen space is insinuated by a marvelous sound and music track. The film is also saturated with a Kafkaesque transfixedness with the life of objects. There are scenes reminiscent of Borowczyk's masterpiece *Les jeux des anges* (1964) both in the surreal, uncannily long lingering of the camera on bizarre objects and spaces and in the use of organ music.

The Quays had not yet developed confidence in animating puppets. This may explain why sets and décors dominate in the film. Commenting on their early explorations in puppet animation, they remarked:

> We realized that with puppets and objects an entire universe and, above all, an exploration of space could be created at the level of the tabletop. This provided us with an intimate theater, a tight collaboration between the two of us, a learning of all the metiers and exploration of all their potentials.[23]

In *Nocturna Artificialia* this exploration of space and techniques is rampant. The title hints at what they intended to do: conjure a dream world in which artificial, carefully designed lighting creates a night world, where the light introduces oneiric fantasies of objects, spaces, and movement. Perhaps influenced by the black-and-white films they had seen (Bresson, Dreyer, Franju), they started to do unusual things with lighting, unusual in that the objects appear out of darkness in the tenebrous mood that prevails in the film:

We could not bear to just have the light on [the objects], we wanted the light to give them flux. In most [puppet] animation the light is just there. [Filmmakers] just blast it, light every corner of the set. We tend to be selective. *Nocturna Artificialia* was night lighting, all of it. It was entirely about the night, what came into the light and disappeared into the dark. The backgrounds were dark—it was "black" out there—we didn't have black walls. The walls outside the set were black, so there was nothing out there, it was just black.[24]

In the dark and the black of night in this film, sound and music effects are coconspirators with the visuals. Another reason the first project is so important is that it marked the Quays' first collaboration with sound track designer Larry Sider, a colleague from the BFI, introduced to them by Peter Wollen; Sider has since contributed to most of their films. His sensitivity to cinema's and materials' aural properties and his collaborative nature in developing unique soundscape counterparts are defining features of many a Quay film (most recently 2005's *The Piano Tuner of EarthQuakes*). He has continually refined his skills as an editor and sound designer, lectures on sound at institutions around the world, and heads the London-based School of Sound.

At the time, BBC television probably would not have considered broadcasting such an experimental short film, so its first screenings took place in the BFI's subsidized cinema circuit of regional film theaters, distribution then headed by the Marxist critic Colin MacArthur. He was very "interventionist" (Griffiths) in the programming and included *Nocturna Artificialia* in the packages proposed to the cinemas. A BFI promotional flier for the film already sets the tone for many articles written on the Quays' later work, relating primary imagery, techniques, and inspirations of the first film that are revisited in later films:

In one *possible* reading of [*Nocturna Artificialia's*] schematic narrative, the dreamer (a cataleptic figure recalling the Surrealists' fascination with dolls) is seduced by the mystery of the city at night, leaves his room and goes into the street, where a tram-car (which might be named "desire") carries him towards an obscure epiphany; after which he returns to/awakens in the room. The movement of the film, involving rapid, almost imperceptible dissolves within otherwise static tableaux, recalls the sadistic enigmas of Borowczyk's *Jeux des anges* (which also opens and closes with a train journey); while the

specific iconography evokes Paul Delvaux's nocturnal streets and trams (cf. *The Porte rouge tramway, Ephesus*), eerily traversing what Breton called "the great suburbs of the heart."[25]

The unnamed critic on the flier was Ian Christie, currently Anniversary Professor of Film and Media History at Birkbeck, University of London. The text was an excerpt from his enthusiastic review that appeared in the November 1979 *Monthly Film Bulletin* and set off a spate of criticism on the Quays' early work in short film (which includes authors Le Fanu, Greenaway, Durgnat, Terence Rafferty, Chris Petit, and Roger Cardinal). Considering the critics' enthusiastic response, it was a dramatic and unparalleled entrance into the arena of (animation) film. Almost a quarter century after it was made, the Quays had a different regard for the film: "*Nocturna Artificialia* simply doesn't bear any discussion at all. We've suppressed it mentally and are sorry now that we couldn't have trashed the neg. It's worse than any of our student films."[26] They regard this film as unsuccessful and more as a learning experience, one that enabled them to work with puppets, but this proved to be more difficult than they imagined. They had never had formal training in animation, and they learned mostly by watching others do it and by making their self-proclaimed "mistakes," which they later developed into some of the most remarkable aesthetic features of their films. Most likely they are their own staunchest critics; nonetheless, the film continues to be programmed at festivals and art house cinemas. It was, indeed, the film that opened the world of public-funded films to them.

The landscape of funding institutions was still relatively uncharted territory for the young filmmakers, so Griffiths again provided the financial

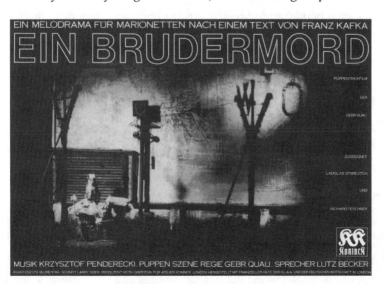

Figure 5. Publicity poster for *Ein Brudermord* (1980) with an image from the film. Copyright and courtesy of the Quay Brothers.

impetus for the next film project. Since he knew that asking the BFI for more funding would be futile, he considered other possibilities. He suggested his former employer, the Greater London Arts Association (GLAA), and helped the Quays put together an application. They were granted around £3,000 to make a short based on Franz Kafka's *A Fratricide,* for which they decided to retain the original title *Ein Brudermord* (1980) (see Figure 5). Kafka's diaries also had been instrumental in stimulating the Quays' interest in Eastern Europe, and this early film interprets the dream-form style Kafka employed for many of his texts. Completed in 1980, it reworks some of the imagery used in the RCA films *Il Duetto* and *Palais en Flammes.* Elliptical, tense, and disorienting in its disparate and disconnected set constructions, the film tells the story of a murder. Le Fanu describes the two protagonists, Schmar and Wese, as "scorpion-like puppets in a whirling five-minute battle—obvious comparison with Buñuel: the same entomological calmness and dispassionate scientific observation."[27] Griffiths, who has many prints of their illustration work, suggests that the style goes back to illustrations for science magazines and recalls that one of their tutors at the PCA in graphics may have been a scientific illustrator, and that this may explain the film's visual precision.

It was to prove an experience that conflated artistic success and bureaucratic failure. Like so many young filmmakers, the Quays and Griffiths were not yet versed in the intricacies and variations of national and international copyright law. While preparing to distribute *Ein Brudermord,* they received a letter from the Kafka estate's literary lawyers in the United States: Koninck was forbidden to show the film and would be sued for breach of copyright. The film was based on the American translation still protected under American copyright, which didn't count the years of war in its calculations. It was a small film made on a small budget that they had intended to send to festivals, and suddenly they were confronted with an apparatus of legal threats. Besides the Kafka disaster, the sound track incorporated music from Krzysztof Penderecki, for which they had not cleared rights. As a result, the film cannot be screened publicly. The experience has not lost its edge and was a slight bone of contention between Griffiths and the Quays. In a 2001 interview, they gave him the responsibility for not having cleared the rights.[28] Griffiths reflects on their response retrospectively, recalling the situation as it was more than twenty years before: "They should remember the pain, the struggle and the innocence that one went through in making these early films." But collaborations between filmmakers and producers are occasionally marred by such mistakes, and it was one they all learned from for planning future projects, many of them inspired by literary works.

At this point Griffiths had decided to move on from the BFI. A friend of his from the RCA asked him to work with him at James Garrett and Partners, one of the largest British advertising production companies at the time and which had made the first television advertisement broadcast. Griffiths: "I went to work as a commercial producer, to get some experience beyond public subsidy, low-budget moviemaking. I wanted to spend some money and see people with Mitchells, Technicolor, Panavision, things like that." In the company of British filmmakers the likes of Nicholas Roeg and Richard Lester, Griffiths learned the intricacies of commercial production and policies. It was also the first time he earned substantial amounts of money, which was to prove instrumental in the Quays' future development. He contacted the Quays to tell them he was able to subsidize Koninck Studios for two to three years, a time when he himself was learning how to run a business.

Griffiths continued to look for funding and was aware of a scheme of the Arts Council of Great Britain that considered proposals for films about artists and culture. He suggested making a documentary that integrated animation as a radical new way of presenting aspects of the documentary subject. They decided on a contemporary take on Punch and Judy and, according to Griffiths, wanted "to get at the historical blackness and truth of it . . . to take it to its most extreme, and away from the seaside [amusement park] Punch and Judy land." Griffiths became aware of Harrison Birtwistle's opera *Punch and Judy* (1968), which stretched conventional understanding of the play to its limits—perfect for the film's avant-garde concept. Because it was more an artistic interpretation than a straight historical documentary, Rodney Wilson at the Arts Council agreed to the proposal, as it aligned with the council's mandate. Griffiths undertook massive amounts of research and was successful in securing additional funding, including from the BBC. He was still working in commercials and started a production company to allocate the funds. The live-action sequences were filmed in theaters around London, and they used voice tapes that Griffiths had compiled with various "Punch and Judy men." In *Punch and Judy: Tragical Comedy or Comical Tragedy* (1980), the Quays' animated sequences, shot in their London flat's front room, were based on early drawings and illustrations that were integrated into the live-action documentary framework. In a review of the film, Le Fanu suggested that the film benefited from Griffiths's contribution to the script: "For the first time the collaborators mixed their elements: mime, masque, painting, archive footage, finally (most ingeniously) opera—puppet highlights of a one-act drama by Harrison Birtwistle."[29] *Punch and Judy* was a great success; it was broadcast

on the BBC arts program, which meant that the film accessed audiences most independent short-film directors could only dream of. It received a very positive review in *Time Out* by John Wyver, which was another coincidence, another piece of luck for Griffiths (and the Quays), as Wyver turned from criticism to producing programs on culture and art. Years later, in 1996, they agreed to fold some of the Koninck companies run solely by Griffiths to form Illuminations Films as a sister company to Wyver's Illuminations Television.[30] In 1983, *Punch and Judy* was screened at the Annecy Animation Festival in France, where it won the Emile Reynaud prize. In the film's credits, Griffiths was listed as *realisateur,* French for "director," which caused some misunderstandings in the multilingual community. Griffiths: "At this point, in terms of correcting history, we had to come up with the notion of how to credit it. The twins said—well, you realised the film, it was your realisation, why don't we just say credit: realisation Keith Griffiths, and we'll put down animation etc." Although he didn't direct the film, Griffiths was referred to as its director because of being credited as realisateur, a misconception that was to prove somewhat awkward.

22

In the early 1980s Koninck Studios had reached an impasse. Griffiths: "I was still working in commercials, and I couldn't see how we could continue to work. They'd been through the system—they had had their BFI film, they got a bit of money from GLAA, and at that time you weren't ever given more than one grant, really." By then the twins had been in London for a few years on yearly visas, and the Home Office had even caused some problems, threatening nonrenewal. As non-British artists, they had to prove they could support themselves. Griffiths helped them with their paperwork and engaged lawyers, and eventually they were granted permanent residency status. They started research on a new film, this time an artist documentary based on the avant-garde Belgian dramatist Michel de Ghelderode (1898–1962), whose sometimes unsettling works engage with folklore, puppets, and various forms of intense human experience. It was also the Quays' first funded work with actors, a young troupe run by a Polish director, who caused a few problems, since he wanted to direct them. The filmmakers incorporated imagery and set design that was inspired by Borowczyk's *Goto—L'île d'amour* (as was *Der Loop der Loop*). Griffiths: "It was a wonderful experience researching it. We had a great time finding archives, looking into the whole world of [James] Ensor and marionettes. It was the twins' idea, they had a huge book on Michel de Ghelderode." Again a coincidence: during his student theater days in Leicester, Griffiths's troupe had put on a de Ghelderode play, so he was keen on the project and managed to sell the idea to the Arts Council.

The Quays had seen the Marionette Theatre in Brussels and incorporated archival material about de Ghelderode into the film *The Eternal Day of Michel de Ghelderode, 1898–1962* (1981), as well as texts from his *Théatre Complet (I–V),* including interviews, letters, and prose. This foreshadows a script development method that was used in the later artists' documentaries and some of the shorts, drawing not only on prose fragments but also intertwining details about an author's life and concepts of the world. But the project may have been too ambitious. Griffiths:

> The film was a bit of a disaster. We technically screwed up. We shot it on reversal film in order to get brilliant Technicolor-type colours. We didn't expose it properly, neither in the live-action nor the animation. We didn't realise how little latitude we had. . . . It was an interesting experiment, but I think all the [artist documentary] films are interesting experiments.

The film is self-reflexive and mixes marionette theater with live action. As was to be the case with so many of the twins' films, the experimentation with live action would resurface later in more amenable conditions.

The Channel Four Artist Documentaries

The 1970s British film crisis and the resulting financial vacuum evoked a series of reactions that were to prove fortuitous for the Quays. The shrinking interest of international film audiences initiated attention to new and younger filmmakers and their independent and experimental approaches to the medium. Not an isolated development except in that it conquered the hegemony of realism, in the protest and counterculture years after 1968 a series of film collectives developed that were independent in a radical sense, and in 1974 the Independent Filmmakers Association (IFA) was founded. Although they remained isolated from the commercial mainstream, these collectives were to contribute to the development of new British cinema. They drafted a proposal for cultural film support and demanded a voice in defining the mandate for the new fourth public television broadcaster. Their radical efforts ensured that the Channel Four film department, established in 1982, set up a section dedicated to commissioning independent film and video productions. Margaret Dickinson notes that "by 1984 many IFA activists were working for, or funded by, the new Channel Four. . . . Within ten

years the IFA and nearly all the other structures which promoted oppositional film-making were gone."[31] This brief but intense climate of innovation prepared the way toward developing new methods and approaches to feature films; it also opened a new source of funding and broadcasting for short films. It was a combination of factors that provided new opportunities for new filmmakers, from which the Quays also benefited.

Public television's commissioning policies, and the political and social consequences of the Thatcher era and its politics of privatization, had a positive effect on British independent film production. The BBC and the commercial Independent Television network (ITV) received the order to commission external, independent film producers. And since ITV was to give a percentage of its advertising income to Channel Four, considerable funding flowed into the commissioning budgets. Channel Four's commissioning practice was to become an important factor for the Quays' first ventures into commissioned filmmaking. Griffiths has called Channel Four, when it began, "the most enlightened TV station on the planet, to put money in and not worry about the audience in terms of how many people might be watching these films." Because their works were broadcast to British homes, directors were able to access audiences and audience numbers that would have been sheer impossible to attain in art house cinemas. The audience's attention was captured by the innovative stylistic developments and by a shift from traditional British themes. Channel Four's financing politics supported animation film in an unprecedented way (see Kitson, 2008, for a history of this). The majority of independent British animation films were cofinanced by the broadcaster, and a fruitful partnership for the Koninck Studios had begun.

But again it needed more than good scripts to get commissioned. Griffiths had written an article for *Broadcast Magazine* (now *Broadcast Newspaper*) titled "The Television Laboratory," based on his experiences with the American public broadcaster WNET/13, which set up an experimental television lab in New York in 1972. Griffiths's interests and his engagement with the WNET film lab were taken up by Channel Four's chief executive, Jeremy Issacs, who had read his article: "Jeremy called me and said 'come and talk to me.' He said it was a really interesting idea and asked whether I thought Channel Four could have a laboratory like this." Issacs was convinced and, after ensuing discussions with others, including Wyver, he set up the department in 1981 that came to be called Independent Film and Video. Griffiths wrote a letter to Issacs stating that he would like to make animation films with the Quays. Issacs had been very impressed by *Nocturna Artificialia* and by *Punch and Judy* when it was

broadcast on the BBC. He suggested that Griffiths speak with Walter Donohue (later an editor of the Faber and Faber *Projections* publications series), whose job it was to find interesting ideas in the early setup days of the channel. Its new Knightsbridge location had as yet no offices to speak of; Griffiths remembers sitting on tea chests. Aware of the opportunity, but also that Channel Four would not commission an animation film as such at that time, he suggested to the Quays that they craft another concept for two artists' documentaries on composers, to take it further this time and plan a strategy for securing funding. They decided on Igor Stravinsky and Leoš Janáček.

Music rights were expensive, and a suggestion from music expert Gwyn Rhydderch to investigate other options, including piano rolls owned by British pianolist Rex Lawson, evolved into a financially feasible approach. They delved into the libraries and archives, drafted ideas, and put together a treatment. Griffiths approached Lawson, whom he knew from his RCA days and who was familiar with Griffiths's graduation film *The Music Machine* (1972), together with Colin Gregg, entirely about mechanical music apparatus. With a viable treatment in hand, Channel Four provided some funding for further research on both Stravinsky and Janáček, including trips to Brno, Czechoslovakia. Griffiths: "We decided very early that [the two films] should look very different. One should look Modernist, focus on the Paris of the period, and be amusing, and the other would be more atmospherically romantic." An animated biography for television, the first film takes a playful look at the private life of composer Igor Stravinsky, whose music had long been favored by the Quays.

Igor: The Paris Years Chez Pleyel (1982) loosely describes a humorous, chaotic encounter between composer Igor Stravinsky, painter Jean Cocteau, and poet Vladimir Majakovsky. More slapstick and personal than factual biography, it has a significant amount of absurd dialogue, with Majakovsky shouting Communist propaganda tirades intermittently throughout excerpts from his writings while in Paris. The character design is playful and unique in that most of the sets and puppets are a composition of found objects reminiscent of Hannah Höch's modernist collage artwork: cutouts of magazines, graphic illustrations, architectural lithographs and etchings, and photographs. The later films also use sculptural collage techniques, but the materials are mostly made by the Quays themselves. Cocteau is effete, and the puppets' plaster fingers are already fixed in the delicate gesture that many of their later puppets' hands have: fingers bent on one hand, extended and slightly apart on the other, almost pointing. The animation is intercut with Rex Lawson at the pianola, operating rolls of Stravinsky's

music. These scenes are in black-and-white and help remind us that the film is, in fact, about the composer. The film is interrupted with Stravinsky's dream, and the "Petruschka" marionette theater sequence was shot in live action without dialogue, with the three puppet cutout heads transposed on different marionette bodies and costumes. Stravinsky wakes and the film ends with Lawson at the pianola. The film is overall very colorful, unexpectedly playful, and relatively bright in its lighting, exhibiting the Quays' inventiveness of melding graphic design, illustration, and fanciful objects. It also reveals unusual camera skills that are refined in later films: calibrated tracking shots and a significant amount of camera movement for single-frame animated shooting.

The second artist film was more sober and structured. In *Leoš Janáček: Intimate Excursions* (1983) a monologue voice-over guides us through the thoughts and biographical account of Janáček, a puppet with a photograph of the composer's face standing in for a head. The film has distinct segments of seven pieces of music that are interpreted by using different sets and puppets. It begins with an animated tram passing from left to right; a photograph is approached with a mix of tracking shot and focus pull, followed by live-action shots of puppet and marionette sets, and then the film shifts to the animated realm. Most of the film takes place in Janáček's "home," and the musical pieces are flights of fancy that accompany insects, a drunken man beside a stylized image of a Czech village, an insectlike female singer upon an opera stage with feathers for her hands and on her head, a winged puppet and foxes beating on the window while Janáček sleeps. All are united in the forest at the end in the final piece of music. The technical elements of the film are already familiar: focus pulls, slow and patient tracking shots through the sets, moving mostly from right to left. The imagery is more subdued but the set design has elements from *Nocturna Artificialia:* thick, black, expressionistic calligraphed lines, diagonal windows and openings cut into walls, and again the use of chiaroscuro lighting all set a somber mood, unlike the bright lights and colors that dominate the Stravinsky film. In the television-commissioned documentaries and biographies directed together with Griffiths, the puppets that portray historically prominent artists are enhanced with gravitas and humor by the puppet constructions that represent them through their playful movements to music. In *Janáček,* for instance, the composite of a head made of an oversized bent portrait photograph and a floppy puppet body confronts us with an oddly burlesque death mask effect, yet also suggests clues to the inner life of the composer. Music rights for these films were cleared solely for television, and hence they are not available in distribution.

The Quays moved into a more spacious location in the early 1980s, a warehouse in London's Borough district, close to the South Bank on the Thames River (they later moved to their current studio, also in Borough). At this time, the area was a preferred location of filmmakers and production companies. In the meantime, like many of the neglected London boroughs, it is undergoing gentrification and urban renewal. Despite the surreptitious infiltration of posh newcomers in pockets of the neighborhood, the street the atelier is on has remained relatively unchanged. The move coincided with significant changes for Griffiths: he was having financial difficulties and was keen to move on. He was asked by Simon Hartog to join a co-op of radical filmmakers called Spectre and formed a subsidiary called Large Door, a verbal pun on Buñuel's *L'Âge d'or*. They won a contract with Channel Four for a regular magazine program called Visions, about international cinema (excluding North American film).

Griffiths and the Quays were in Prague around this time and interested in seeing the work of Jan Švankmajer, a Czech filmmaker and artist they had heard about. They were shown two films at a screening organized by the Czech government in a theater, then later introduced to Michael Havas, who knew Švankmajer and arranged for them to meet. Griffiths:

> Švankmajer was clearly interested and fascinated. We asked to see his films and he said—"of course, come by tomorrow to the Laterna Magica workshops and I show them to you. I have my own prints." The whole time we were talking I was transcribing Michael's translation and we said to him would you let us make a film about you. I think he said "no," initially, or "provided I'm not in it."

They visited the studio the next day; it was snowing, the electricity in Prague was intermittent. They were taken upstairs to an edit room with an old Steenbeck and piles of films on the floor. Švankmajer ran the films for them on the Steenbeck, a translator explaining the Czech words and translating Švankmajer's comments. At some point they looked up from the Steenbeck and saw that the room was filled with people who heard that Švankmajer was showing his films and came to look over the top of their shoulders. The Quays also describe their first meeting with Švankmajer:

> [Švankmajer] was rather suspicious and standoffish but that was very understandable for those times. (1983 Prague: still under a

communist regime.) Who was this trio from London? Subsequently having seen what we did with the material he relaxed, and over the years he's become increasingly warmer and warmer. The two of us know the profound experience this man's work—along with his friendship and that of Eva, his wife, a painter—has been for us. He and Eva have created ceaselessly and in virtual obscurity, often under great difficulty and outright suppression, an entire body of work of astonishing richness and variety.[32]

Back in London, exhilarated by what they saw, Griffiths and the Quays decided to make a documentary on Švankmajer for Channel Four's Visions cinema arts series. Animation was becoming recognized as a significant component absent from other broadcasters' schedules except in the form of children's series or holiday specials. Outsourcing independent-film production was part of Channel Four's remit, as was commissioning animation for adult audiences. (The station's innovative policy and risk-taking resulted in a renaissance of British animation that has been unparalleled since.)[33]

 The Quays contributed animated segments to a longer artist's documentary directed by Griffiths. *The Cabinet of Jan Švankmajer: Prague's Alchemist of Film* (1984) was a fifty-three-minute film broadcast in the UK and abroad. According to the Quays, Griffiths strategically drafted the project around one word—surrealism—strategic because Prague surrealism was alive and well.[34] It was scripted in nine episodes that included information about and interviews with Švankmajer, a leading figure in the Prague surrealist group that he joined in 1970, and it was drafted using extracts from Švankmajer's films and didactic inserts about surrealism (Rudolf II and Arcimboldo). Griffiths invited those whom he calls "wonderful surrealists"—Robert Benayoun, Paul Hammond, Roger Cardinal—to come into the studio and talk about Švankmajer in front of a blue screen. He arranged for them to see the films, directed the interviews, and edited them. The animation sequences were subcontracted via Large Door to Koninck Studios, and the Quays fabricated about fourteen minutes of puppet animation made up of vignettes. Introducing each extract of Švankmajer's that they had chosen based on specific Švankmajerian themes, these vignettes were interspersed with clips from Švankmajer's films and the talking heads to create the finished documentary.

 Griffiths's interest in Švankmajer did not end with this film; on the contrary, it was the beginning of a sustained collaboration. He related a fasci-

Figure 6. *The Cabinet of Jan Švankmajer* (1984). One of the Quays "anointing" the puppet with blood to set it into action.

nating tale of intrigue and somewhat dodgy financial practices, canny Swiss producers, visa problems, interrogations and surveillance, double agents, and unconventional border crossings of film material. It shall remain an unwritten account of the more difficult aspects of producing Švankmajer's first feature *Alice* (1987), made in a prerevolutionary time when Švankmajer was not allowed to make films in Czechoslovakia.[35] Griffiths: "It was a fait accompli." The adventure paid off for the production companies, the filmmaker, and audiences: since then, Griffiths has produced or coproduced most of Švankmajer's features, including *Faust* (1994), *The Conspirators of Pleasure* (1996), and *Little Otik* (2000).

The puppet animation segments were released as a short film: *The Cabinet of Jan Švankmajer,* also in 1984. The Quays consider their film a homage to Švankmajer, whose animation films delve into the surrealist unconscious using clay animation, live action, and collage. In the film, a pupil-teacher relationship unfolds; an Arcimboldo-esque alchemist (see Figure 6) pulls the toads and snails and puppy dogs' tails from his prodigy's cotton-wool-filled brain, pushing them off the table ledge with a sweep of his compass armature arm. What follows is a lesson in animated cinema: learning the camera's single-frame mechanism in the metaphysical playroom, deadness is brought to life in the drawer-lined workshop's *Sammelsurium,* filled with fragments of cloth, bird's eggs, powders, mysterious constructions. The spectator is walked through the various compartments and chambers—possibly what the Quays imagined to be the surrealist playrooms of Švankmajer's imagination.

The next film in the Quays' growing filmography was intended to be part of a longer film based on the epic of Gilgamesh. *Little Songs of the Chief*

Officer of Hunar Louse, or This Unnameable Little Broom (1985) was commissioned as a development by David Rose of Film Four, who had commissioned the Janáček and Stravinsky films. This was the first approach to developing a feature film together that required experience neither the Quays nor Griffiths had yet mastered. Griffiths:

> [We were] not fully comprehending the changes that [Derek] Jarman and [Peter] Greenaway were making in terms of narrative to get [their] films made. You might say *Caravaggio* [1986] and *The Draughtsman's Contract* [1982] are pretty wacky, but nevertheless the backbone, the spine, was much more conventionally narrative than [the Quays] were yet engaged with. So it took us much longer to make that transition.

Working from an original script by Alan Passes and the Quays, with contributions from Griffiths's own research of the epic, they developed a script for a longer film that included many ideas about live action and animation. At the start of the project, the Quays were not that interested in the subject, but as the project proceeded, it became more attractive. After the three artist documentaries, this was their first text-based narrative film. The Quays recount how they approached the project: "Gilgamesh is a legend, not a myth. It's an epic, 'The Epic of Gilgamesh.' We just narrowed it down. I suppose it can [be done] because of the imagery. We never set out to make the epic into a fairy tale—we said, 'Let's just make another movie.'"[36] It was one of a number of projects they were working on at the time, trying to expand them into feature-length projects, including Aleksandr Luria's *The Man with a Shattered World* (1972/1987). They did a treatment for this, and Griffiths says that the twins did some terrific imagery, but the Gilgamesh project was a priority. Rose suggested they make a pilot that integrated live action and animation, and they shot some dance and performance-based sequences with choreographer Kim Brandstrup, who Griffiths calls "their first dance/performance 'guru,' a serious choreographer, performer, and friend." As the live action and animation was a difficult fit, the animation became a self-contained film, and the feature could not be realized because of insufficient funding. The BFI Animation Catalogue includes the following synopsis: "A macabre tale with a theatrical mise en scène peopled with grotesque models and where savage, vindictive machines whirr, slice, decapitate and imprison the unwary. It has the cold articulation of malignancy and evil commonly associated with the horrific fantasies of children's

stories."[37] The actions of these bizarre and antagonistic puppets take place in what appears to be a room floating in space (see Plate 4). The Quays intended it to be a floating world, where they didn't feel the need to justify the organization of space: "We had four walls and the images. And originally, we thought, 'Oh gosh, it has to be on the ground, and you have to see some black around it.' Well, we said, 'No, make it an abyss.'"[38] They confirmed that it seemed there was no real effort on their part to explain anything in the film:

> And for ourselves we imagined that we were taking a huge risk, because even we weren't sure. But it actually freed us, and we made sure in the framing that we were conjugating a whole space by constantly moving around, underneath and above, and that you feel that there is black out there. When Enkidou arrives, he just flies in from the black, and there are wires going off. We felt that they were connected somewhere in outer space. And it was a good lesson, and that playing with space like that really helped us with [*Street of*] *Crocodiles*.[39]

The "Twist Point"

In Griffiths's opinion, *This Unnameable Little Broom* marked the end of a period of collaborative productions and a shift to more creative independence for the Quays that began with their next film:

> We haven't really reached the period that the Quays now define as the beginning of their work and that the rest of the work doesn't count—that it doesn't exist any more. We've come to the point [in this 2002 interview], where their confidence had developed to the point—where their creative confidence had developed to the point [of] clearly swim or sink, on their own unique collaborative work process and their strength as brothers. It's an interesting twist point.

The twist point is *Street of Crocodiles,* a film that continues to capture the imagination of filmgoers more than twenty years after its release. While the Quays may now regard some of the films described in this chapter as Griffiths's work—a point he disputes as "absurd"—his engagement, vision, and enthusiasm and his extraordinary ability for fund-raising and initiating projects is an important chapter in their work as filmmakers. Theirs is a complex, intellectual, aesthetic,

and intimate relationship based on mutual interests and convictions, and the films to this point in their filmography evince a shared vision of the world that their combined efforts in puppet animation have given to their audiences around the globe.

The Quays' work has inspired Griffiths to a longtime commitment, which continues to this day: "I just like backing the work and I don't totally know the reason for it, but in some way, it continues to surprise and provoke me, and as long as it still provokes me I want to find ways for it also to provoke an audience." Griffiths asserts that exceptionally distinctive and visionary work by filmmakers like the Quays needs not only "careful nurturing, but also follow-ing through until it is on the screen, and also beyond this point. It is like garden-ing." According to Griffiths, some people in the film business regard this sort of commitment from a producer as somewhat unusual: "I am very different from many UK producers. . . . I follow a film right the way through, and keep going when most producers stop. These films need to be continuously promoted. That's the nature of an independent and radical cinema." As a committed pro-

ducer of independent and auteur films, Griffiths continues to pursue his unique and dedicated philosophy and strategies to secure audiences and funding for this kind of filmmaking. He says that he always keeps in mind what Švankmajer once said to him: "However hard it gets, you must still keep looking for the rab-bit hole."[40]

Street of Crocodiles is the point where the filmmakers graduated from their metaphysical playroom to explore more complex expressive possibilities related to this term, one that persists as an attribute in writings on the Quays' films and for the authors upon whom they draw. Metaphysics is a complex branch of philosophy that ranges from a general science of all things to a Kantian exposition of notions and truths, the knowledge of which is transcendental, independent of experience. For my purposes, the term is too broad, and as it does not have a singular meaning, I will refer in most instances to related concepts that inform the apprehensive experience puppet animation can incite in viewers: animism and, especially, vitalism.

Writing on *Institute Benjamenta,* Laura Marks has described the Quays' attitude to objects, one they share with Robert Walser, as animistic,[41] and I will now introduce this attribute further as a useful concept for describing the dis-tinctiveness of viewer experience of the Quays' works. As a type of metaphys-ics, the animism that Victoria Nelson has described interests me: platonic and gnostic beliefs that inanimate and vegetal matter had a soul were superseded by

Aristotelian materialist worldviews. Nelson suggests there was a gnosis revival at the beginning of the nineteenth century in the form of the aesthetic movement of Romanticism that is pertinent for the authors I will discuss in chapter 2.[42] The technical cinematic properties of puppet animation allow these universals to be experienced on-screen as embodied forms of a type of existence that cannot otherwise be experienced by us.

Yet I am convinced that animism does not fully account for the visual and emotional power of the Quays' animated objects. The term "animism" is often used to describe animated forms, and its etymology addresses flora, fauna, and the biochemical, natural, living world. Instead, I will introduce and pursue the philosophical concept of vitalism, which interrelates with animism in that it rejects purely materialist, mechanistic explanations of human behavior and actions. But crucial for my interest is that animism *presupposes a soul* in distinction to the vitalism I am pursuing. I will show that one of the most striking features of the Quays' vitalist puppets is that, in distinction to most anthropomorphized animated puppets, they *do not* perform a soul. Their cinematic reification performs Aristotle's second entelechy (entelechy being "a hypothetical agency not demonstrable by scientific methods that in some vitalist doctrines is considered an inherent regulating and directing force in the development and functioning of an organism"[43]) of being in action, but *not* the soul, which is "the first entelechy of a natural body endowed with organs."[44] Aristotle's *De Anima* attempts to reconcile the dichotomy on soul and matter and "constitutes a comprehensive and convincing basis for an objective analysis of all the phenomena of vegetable and animal life [and its task is] to use the concept of the soul to explain the phenomena of life."[45] The Quays' films allow the viewer to experience a *non*human, *non*vegetable, *non*anthropomorphic form of vitalist spirit via a cinematic transmutation of matter—organic and inorganic—through Bruno Schulz's remarkable concept of the generatio aequivoca.

Vitalism was initially a reaction against the currents of materialism and mechanistic determinism in the eighteenth and nineteenth centuries. It was later taken up by Friedrich Wilhelm Nietzsche in his "will to power," by Henri Bergson in his metaphysical vitalist text *Creative Evolution* (1911), and, relevant for spectatorship theory, Freud's theory of the unconscious. One of the proponents of early forms of vitalism was Arthur Schopenhauer, and his *World As Will and Representation* takes cause with the conflict between the will, as a noumenal or unconscious manifestation, and representation, the phenomenal world. Theodor Plantinga summarizes:

For Schopenhauer, the thing-in-itself is more than a mere unknown which we posit as a limit on our knowledge. We have an intuition of it in our willing acts, for it is itself will. The ultimate reality is the Will, and the entire world of appearance must be regarded as its expression.[46]

This conflict is mirrored in our experience of the inanimate (material, mechanical, phenomenal) made animate (metaphysical, animistic, vitalistic) in the Quay Brothers' animation of organic and inorganic matter in *Street of Crocodiles* and later films that are examples of Vachel Lindsay's "mechanical, non-human" heroes: stick, rope, water, fire. In his metaphysics, Schopenhauer propounded the nonrational universal will as the ultimate reality, "the thing-as-such" *(das Ding an sich)*, and the driving force behind all manifestations of organic life as well as inorganic nature.[47] This is especially interesting in terms of puppet animation, since it can use organic and inorganic materials in contrast to computer or 2-D, which are renderings or artistic representations and not "the thing-as-such." Schopenhauer asserted that "the intellect is a mere superficial force, essentially and everywhere touching only the outer shell, never the inner core of things."[48] This description of the intellect's inability to comprehend the inner core of things deeply informs the notion of apprehension I will propose, and Schopenhauer's concept of the will and its manifestations will figure in chapter 3. I also aim to show how the experience of a vitalist dialectic of the living and concrete nonliving is made possible by the technique of puppet animation.

To prepare the reader for subsequent chapters' deeper engagement with this film, a brief synopsis of *Street of Crocodiles* attempts to describe what was a watershed for the Quays, not only in terms of recognition as artists, but also as a consolidation and refinement of many previous experiments. Not an analysis, the descriptive synopsis does not describe *the film;* it must be selective and summarizes actions, introduces figures and spaces, and attempts to describe a spatiotemporal relational depiction of these. It intends to provide the reader with a skeleton road map of a notably nonnarrative film. (The booklet that accompanies the BFI DVD contains the Quays' original treatment that was submitted with the funding bid to Channel Four, and it would be an illuminating companion to this synopsis.)

The film starts with a black-and-white graphic map titled "Ulica Krokodili" with a magnifying glass apparatus lens on it that flips down. Through a door an old man enters a theater, and after controlling the lighting and stage,

he approaches a wooden construction resembling a kinetoscope, looks through the magnifying glass at an area of the map, then spits into the wooden pulpit. This sets therewith an animated realm in motion, a spatial conundrum of pulleys, wires, and screws, of detritus, metal, wood, and of faded organic materials. The camera descends through this realm and cuts to a puppet, tied by a string to a street lamp. He is freed by a scissors held by the man's hand "outside" and tumbles into a stagelike room. On touching a tangled filament threaded through strange machineries, it detangles and begins to move; simultaneously, a semiopaque screen rises and the puppet ducks under it and out of sight. The puppet enters a realm pervaded with layers of velvety dust. Interspersed with vignettes of metaphorical machines, hermetic spaces, and a subplot involving a child with a hand mirror reflecting a beam of light to vivify objects, the puppet wanders through the decrepit alleys, surreptitiously appearing out of shops, concealing objects in a diagonally striped box, and gazing voyeuristically into peepholes and endless deep spaces (see Plate 5).

Lost in a labyrinth of murky glass and reflections, he responds to the subtly homoerotic beckoning gesture of a tailor and enters the tailor's shop. The tailor holds a darning needle and with a conductor's gesture sets in motion three female constructions, their lower halves composed of drawers set in elaborate wooden constructions suggestive of Dalí's *Anthropomorphic Cabinet* (1936). Delicate and unsettling, their hollow skulls are illuminated with a demonic inner light. The puppet's seduction in progress, the tailor busies himself with a map of Poland, lined with yellow thread sutures, and proceeds to pin paper to fit a new suit for a bloody slab of liver that he conjures atop the map. Simultaneously, the puppet, attended to by the tailor's shop assistants, receives a new head resembling theirs, and a colored cloth is wrapped around his shoulders. The tailor tenderly strokes the puppet's original head, which is cradled in his arms as he looks upon the scene. The puppet, reunited with his original head, is accompanied to the back room, which is lined with anatomical drawings and eroto-pathological objects. The three assistants and the puppet move through a labyrinth of walls and glass, finally gathering to gaze outside through a small window. In the Street of Crocodiles, objects begin to falter, fall apart; screws disengage and carve circular, pointless tracks in the dust; and the tailor's assistants, heads bowed, are unmoving except for a repetitive circular motion of one arm. After a disorienting traveling shot, the puppet is suddenly out of the realm and back in the space where we first saw him, back in front of the stage, but his neck is still draped with the colorful cloth he received in the tailor's shop. His finger touches the

string again that now moves in reverse to re-form its tangle. The music that has accompanied the visual images throughout the film fades, and murmuring voices and sounds rise. The sound track fades to silence and a blue text (in English) from Bruno Schulz's *The Street of Crocodiles* is superimposed above the puppet's head as the color fades and pales. A voice-over speaks the text in Polish, falteringly repeating the last line three times as the image, now a long shot of the entire stage set, fades to monochrome. The final shot returns to the magnified map section and the map the film began with.

In this film, the Quays developed significant formal visual and aural neologisms that, in spite of their complexity, became technical and narrative points of departure for the films made after 1986. This was also the first film completely independent of some form of external collaboration or imposed form—neither a suggested theme nor a commissioned documentary, not coscripted and not codirected. The distinctness of this film, this twist point in developments in the Quays' poetics, is the reason it is the focal point for four chapters that investigate their works' poetics. The Quays increasingly engaged with a specific type of literature; to understand the production concepts and processes from this point in their works and their relations to literary stylistics, chapter 2 provides a theoretical and conceptual framework for their aesthetic and stylistic explorations, followed by a focus on a triumvirate of authors discussed in terms of shared philosophical and stylistic tendencies.

PALIMPSESTS, FRAGMENTS,

2. *To say the poetic image is independent of causality is to make a rather serious statement. But the causes cited by psychologists and psychoanalysts can never really explain the wholly unexpected nature of the new image, any more than they can explain the attraction it holds for a mind that is foreign to the process of its creation.*

Gaston Bachelard, *The Poetics of Space*

VITALIST AFFINITIES

ow that we are equipped with a sense of the Quays' creative origins and their trajectory from the United States to London, from illustration to the moving image, this chapter will unfold some of the literary, thematic, and aesthetic origins that the later work commencing with *Street of Crocodiles* engages with: literature being a main instigator of the "twist point" that incited a significant shift in their aesthetics. What is striking about the Quays' films is the combination of references they choose, ranging from painting, early optical experiments, puppet theater, literature, surrealism, expressionism, and Baroque architecture to musical structures, Polish poster design, dance, and illustration. These references are primary motifs in many of the films, and often the sense of narrative develops out of how these isolated references are strung together. Not a compendium of their varied and wide-ranging interests in the arts, the aim here is more to illuminate some of what I regard as foundational literary influences that emerge in their films. This chapter explores specific literary techniques that transmute into many of their films and that are particularly suited to being interpreted via puppet animation, literary texts that have undercurrent metaphysical agendas. As early as 1984 they were aware of the difficulty these could pose to uninitiated viewers:

"Sometimes we are shocked by how few references people have to the literature and music that have driven us for fifteen years. It makes us feel elitist by default."[1] The Quays have accumulated a profound and yet intimate literary knowledge. In each of the films this knowledge is distilled into a different, sometimes novel style, more often an addition to the partial recombination of previous styles that each film embodies. The Quays comment on their approach to written texts:

> You read poetry in a very privileged moment, and you know you
> have to apply yourself, that intellectually you are in for a challenge,
> and that is the difference between people who would read a popular
> novel and those who would read poetry or Joyce or would tackle a
> South American writer.[2]

Similarities between each film and its predecessors, when considered together as an opus, suggest a continuum of development distinct from the earlier films.

At the end of *The Cabinet of Jan Švankmajer,* the little boy's hole on the top of his skull is filled with a pert sheaf of pages, a petite version of the larger one of the master, who places it there. The sheaf is a metonymic trope for what the boy has learned: knowledge is literally sprouting from his head. This is an apt analogy for the pages, passages, and short stories that the Quays have collected over the years, an *omnium gatherum* of the wisps and fragments resting on pages in dusty volumes and notebooks that line their studio walls. This scene may be a tribute to the Quays' occupation with and indebtedness to printed matter of all varieties—their studio walls, glass cabinets, shelves, and nooks are loaded with volumes of prose, poetry, history, pre- and post-Enlightenment scientific manu-

Figure 7. The Quay Brothers in their London studio, 1995. Copyright and courtesy of the Quay Brothers.

als, thick encyclopedias, antiquarian finds of French, German, and Latin American authors, oversized tomes on photography, painting, illustration, graphic design, cinema, and architecture (see Figure 7). Some of the humbler paperbacks have received new garments; the old covers have been replaced by new ones embellished in stark black, flowing ink in ornate Quay calligraphy. Leafing through the books, one finds richly illustrated pages of sexual pathology (Richard von Krafft-Ebing's 1903 *Psychopathia Sexualis*) and favorite artists and conceptual works (Bruno Schulz's drawings, *The Bachelor Machine/Le Macchine Celibi,* Harald Szeeman, 1975) that seep into their films, and early optical studies and cabbalistic science provide a clue to the themes of vision that the Quays' camera and lighting design creates. The metaphysical potential of animation film may be the art form most aptly suited to investigate these sixteenth- and seventeenth-century magical and scientific investigations. Their *De Artificiali Perspectiva, or Anamorphosis* (1991), an arts documentary on the eponymous technique of subverting vision, deals with some of these concepts. And these books, collected over years of bibliophile wanderings throughout the world, ultimately feed an idea, are inspiration for an image, a composition, a set, a puppet, a line of script, a sound, a gesture.

The Quays' filmmaking activity has been consistently interspersed with other artistic commissions. In the present context, it is not trivial to note that the ornate calligraphy/aesthetic sensibility gained during their training as illustrators found its way to magazine pages and book covers. Illustrations were how they began developing collage and graphic concepts that fed into the films' styles. Besides the unsatisfying Gothic and science fiction book cover commissions they did while in Philadelphia, the Quays have created suggestive designs for a variety of publications that seem to reflect not only their own interests in particular authors—covers for Italo Calvino, Paul Céline, and poet Mark Le Fanu (one of their first critics)—but also in themes and motifs that these books develop (see Figure 3). They designed the cover of Steve Weiner's novel *The Museum of Love,* published in 1994, an illustration of an antlered table with legs (an image from the *Stille Nacht III* [1993] short the Quays made as a preamble to the first feature). In "The Quay Brothers Dictionary," a booklet that accompanies the recent BFI DVD collection, Michael Brooke notes that as art students, the Quays designed an album cover for Karlheinz Stockhausen and later designed the cover for Jonathan Cott's *Stockhausen: Conversations with the Composer* (1973), almost three decades before working with the composer on *In Absentia* (2000).

The prowess in illustration and calligraphy seeps increasingly into many formal elements in their later films; this is evident as graphic embellishment

Figure 8. Metaphysical machine creating calligraphic swirls in *Rehearsals for Extinct Anatomies* (1987).

in the set decoration and their particular use of patterns in the puppets' costume design (see Plate 15 for an image from the BBC station identifier interlude *The Calligrapher*). Titles, intertitles, and credits appear in a variety of handwritten styles, from expressionistic, angled fonts in *Nocturna Artificialia* to the ornate curves and curls in *In Absentia*. An example of their illustration talents used for inventive cinematic graphic stylization using animation is in *Rehearsals for Extinct Anatomies* (1987) (see Plate 6). A caliper and compass-based metal figure cavorts and pirouettes throughout the room, leaving behind a trail of ink that develops spirals, curves, and varying thickness of calligraphic line (see Figure 8). The graphic ornaments escape and course throughout the décors that they also define. Instead of embellishing the visual image, they become what the Quays describe as self-reflective poetic vessels, drawing attention to the potential of animation to free the line and the geometric object from their static forms on paper.

Wisps and Fragments: Cinematic Transpositions of Literature

Mark Le Fanu's ornate praise in the mid-1980s initiated what became a literary-tinged metalanguage for describing the Quays' works. In a single article—"Modernism, Eccentrism: The Austere Art of Atelier Koninck," which is only partly concerned with Atelier Koninck—he issues the call to recognize the arts and literary origins of their animation. The attributes and terms "macabre," "nightmare," "anodyne," "metaphysical," "pathological," "grotesque," "compulsion," "alienation," "entomological," "lyricism," "haunted," "homage," and "excavation" are used to describe the Quays' films. These words have crept into almost any international review one can find of their work, whether in German, Polish, Spanish, French, or others outside the lingua franca. Later recurring words that can be added to the list include "Kafkaesque," "marginal," "uncanny," "phantom,"

"fragile," "obscure," "labyrinthine," "eroticism," "melancholia," "decay," "cinephilic," "unsettling," "surreal," "dreamlike," "mythic," "pathos," "poetic," "delirium."

Michael Atkinson's 1994 article in *Film Comment* summarizing the Quays' work gives one possible reason that critics' responses to the films have been inundated with this kind of phenomenological and metaphysical terminology:

> Street of Crocodiles, The Cabinet of Jan Svankmajer, Nocturna Artificialia, The [sic] Unnameable Little Broom, Rehearsals for Extinct Anatomies, The Comb from the Museum[s] of Sleep, and the Stille Nacht pieces are all ferociously hermetic films whose interface with everyday culture is both undeniable and nearly impossible to articulate. Nowhere else has film so leanly and effortlessly rippled the dark subconscious waters ebbing under the surface of our collective experience.[3]

While some of these terms have been heavily used in Quay-related film criticism, many of them are appropriate and precise attributes that allude to a palette of pathopsychological, aesthetic, perceptual, and art-historical literary themes that is mixed and remixed in their films. Of themselves they declare, "We always had a similar, literary interest. We constantly absorbed the same material."[4] The Quays' description of how they select writings they work with also gives an indication of their interdisciplinary sources and methods:

> The fact that we might use a literary source but transpose it into an imagistic/sound realm happens only if we intuitively feel that it can be transposed and then augmented, opened out. Musicians throughout history have taken literary sources to compose tone poems, symphonies, and even opera; and then on top of that music, a choreographer creates a ballet, and on and on it goes.[5]

Literary texts figure in their film projects, whether they serve as a point of departure for their own ideas or as a textual basis for filmic interpretation: "It's not like saying, here's a paragraph, and we're going to set this paragraph, we're going to film this paragraph. We never worked like that."[6] As almost all of the Quays' films after *This Unnameable Little Broom* are loosely based on literature, it is important to understand the particular features of how animation can be

particularly suited to transposition of written texts that converge on a character's experiences of things and surroundings via cinematic imagery and sound. As will become apparent, like some authors' writing, the Quays' films pay attention to isolated objects, sometimes more so than to relationships between puppets; figures are often at a loss to deal with the inner life of these objects as they move in intricate patterns in the spaces and soundscapes that surround them. These assemblages and material configurations are animated through the expressive realms of human thought, dream, and experience—in this case, from the world of literature.[7]

The Quays' cinematic transmutations of literature tend mainly to delve into the images of the mind, both psychological and pathological. They bear comparison with Antonin Artaud's aesthetic engagement with the sick mind and the sick body, or his concept of a Theater of Cruelty.[8] In a critique of Ludwig Tieck's "The Cup of Gold," Artaud suggests that Tieck's writing recalls a lost romanticism that is subsumed under what happens to our adult minds: "Perhaps we do live in the mind, but what a larval, skeletal, foetal life it remains, where all the simplest intellectual steps, sifted by our rotten minds, turn into some ominous dust, some grotesque posturing or other."[9] Some of the Quays' interpretations of literature recall not the romantic notions of innocence, but rather the images of the mind that Artaud describes. The life of the mind translates visually into the grotesque and expressionistic architecture and puppets in the films. Even the dust has a disturbing life of its own.

Cinematic Metaphor

In an interview about his collaboration with animation filmmaker David Anderson on the script for *Deadsy* (1989), author Russell Hoban speculates on the relation between animated film and human thought:[10]

> Animation, I think, lends itself to interesting word/picture combinations, and I think you can write with complete freedom, as if you're writing a poem, a little fragment of something, a short burst of ideas. . . . I think that more and more our ordinary perception has been speeded up and fragmented, so we are accustomed to taking in a whole lot more data and many more images than we ever did before. . . . The human mind works in a non-linear way. . . . A better harmony has to come about between the inner voices and the recog-

nised ones, between the unbidden pictures and the pictures we allow ourselves to see . . . animation and experimental film are very good for encouraging this sort of thing.[11]

Hoban succinctly describes the synthesis of word and image, the co-creational impulse generated by unbidden pictures and those we allow ourselves to see, in text and in film. Hoban has written a number of novels (including *Riddley Walker*, 1998) using a portmanteau technique (similar to that of James Joyce or Anthony Burgess) that deconstructs language and reworks extant vocabulary, idiom, and syntax into linguistic and semantic neologisms. As the Quays' animation films have virtually no spoken dialogue, it is pertinent that Hoban also stresses the creative process of writing and the relation between the nonlinear processes of thought and inner voice, a creative process similar to the intuition the Quays mention in their own methods. Rudolf Arnheim has some relevant thoughts on the creative process of writing and its inherent freedoms:

> The writer is not tied to the physical concreteness of a given setting; therefore, he is free to connect one object with another even though in actuality the two may not be neighbours either in time or in space. And since he uses as his material not the actual percept but its conceptual name, he can compose his images of elements that are taken from disparate sensory sources. He does not have to worry whether the combinations he creates are possible or even imaginable in the physical world. . . . *The writer operates on what I called the second or higher level, at which the visual and auditory arts also discover their kinship.* We understand now why the writer can fuse the rustling of the wind, the sailing of the clouds, the odour of rotting leaves, and the touch of raindrops on the skin into one genuine unity.[12]

The synesthetic effect Arnheim mentions is affectively available in animation as well, and his concepts also resonate with Hoban's word/picture combinations. The animator is also "not tied to the physical concreteness of a given setting."

The Quays work in dimensional animation, which means that the spaces and objects they use to create their elliptical narratives are materials from our everyday world. They can circumvent and bend laws of space, perspective, and continuity to a greater degree than possible in live-action set design, creating combinations and events that are not possible to experience in the lived, physical

45

world (I discuss this in more detail in chapter 3). Susan Stewart's delectable *On Longing: Narratives of the Miniature, the Gigantic, the Souvenir, the Collection* describes narratives as structures of desire. She defines three meanings of longing, and her third meaning is enlightening in the present context:

> The third meaning of *longing,* "belongings or appurtenances," continues this story of the generation of the subject. I am particularly interested here in the capacity of narrative to generate significant objects and hence to both generate and engender a significant other. Simultaneously, I focus upon the place of that other in the formation of a notion of the interior.[13]

The "notion of an interior," the trope of an inner world peopled or occupied by animistic objects that we cannot experience in the phenomenal world, runs through the writings the Quays declare as their inspirations. For instance, in *The Comb [From the Museums of Sleep]* (1990), the textual description of mood of Walser's 1916 "Dornröschen" is translated into the visual medium by stylization of objects in space. The "sleeping beauty" is mostly immobile except for the isolated and repetitive gesture of a finger that fitfully wiggles, a gesture repeated by a puppet's hand in the animated segments intercut with scenes of the reclined woman. Her dreamworld comes alive for the viewer: a colored, animated world is the physical and spatial equivalent of her dream imagery, populated by bricolaged fragments of matter and determined by a certain incoherence that is also a feature of dream states. Stewart offers a way of understanding narratives such as Walser and the Quays offer:

> By means of its conventions of depiction, temporality, and, ultimately, closure, narrative here seeks to "realize" a certain formulation of the world. Hence we can see the many narratives that dream of the inanimate-made-animate as symptomatic of all narrative's desire to invent a realizable world, a world which "works."[14]

The Quays' films enchant because they enable us to experience a miniature, visible world of the inanimate made animate, a world that works according to the rules the Quays invoke for the realm. Yet it is alienated from our experience of the phenomenal world and reveals the inherent animism of the literary texts they draw upon. The world of the inanimate made animate is also the world of the

fairy tale. The Quays propose "that perhaps not all fairy tales have to talk and that children can more readily tread water through narrative ellipses than the poor parents who are forever inflating the protective 'narrative' life preserver."[15] Walter Benjamin brilliantly draws analogies between children's fascination with waste objects and his concept of the fairy tale:

> Children are particularly fond of haunting any site where things are being visibly worked on. They are irresistibly drawn by the detritus generated by building, gardening, housework, tailoring or carpentry. In waste products they recognize the face that the world of things turns directly and solely to them. In using these things, they do not so much imitate the works of adults as bring together, in the artifact produced in play, materials of widely differing kinds in a new, intuitive [volatile] relationship. Children thus produce their own small world of things within the greater one. The fairy-tale is such a waste product—perhaps the most powerful to be found in the spiritual life of humanity: a waste product that emerges from the growth and decay of the saga. Children are able to manipulate fairy stories with the same ease and lack of inhibition they display in playing with pieces of cloth and building blocks. They build their world out of motifs from the fairy tale, combining its various elements.[16]

The Quays are no strangers to Benjamin: "When we read his *Reflections,* his texts on postage stamp collections, on his library, it released a world to us. This is a man who knew about Kafka, Walser. In the same way Gaston Bachelard does, he opens these little cupboards."[17] The way the Quays visualize fairy tale elements in their films is a collecting of material—the "detritus" Benjamin speaks of—and rearranging it in a way that transforms it into a world in which these materials' animistic properties prevail. In the translation above, Benjamin's German adjective *sprunghaft* is translated as "intuitive." English-German dictionaries more often include "volatile" for the English translation rather than "intuitive," and I prefer this adjective for my purposes.[18] Bringing together "materials of widely differing kinds" is a feature of the Quays' set and puppet constructions, and rather than intuitive this is indeed a volatile relationship they create with these new constructions, and the montage systems they use are part of the appeal their films have for spectators.

A way to explain this volatile relationship in the Quays' work between the medium of literary text and film text is through the concept of visual metaphor.

In his dialectical approach to film form through montage, Sergei Eisenstein suggests that a visual metaphor evokes a reaction in the viewer that is similar to the reader of a text that employs metaphoric tropes.[19] Describing the location of the Street of Crocodiles, Schulz creates imagery using similes and metaphor:

> Only a few people noticed the peculiar characteristics of that district: the fatal lack of color, as if that shoddy, quickly growing area could not afford the luxury of it. Everything was gray there, as in black-and-white photographs or in cheap illustrated catalogues. This similarity was real rather than metaphorical because at times, when wandering in those parts, one in fact gained the impression that one was turning the pages of a prospectus, looking at columns of boring commercial advertisements, among which suspect announcements nestled like parasites, together with dubious notices and illustrations with a double meaning.[20]

A reader of a passage such as this must necessarily involve her own powers of imagination to elicit the transformation inherent in the metaphor. The trope of the district's fatal lack of color, actually a figure of thought, allows the reader to create a visual image of the shabby street by insinuating a deathly pall that evokes associations with consumption and other poverty-related illness. Another feature of the passage's rhythm is the simile between a wandering through the city and leafing through a cheap magazine; its parasitic "suspect announcements" and "dubious notices" all contribute to a criminally anthropomorphic, malicious undertow that seems to lurk in the shadows and keep the reader figuratively looking over her shoulder. This creates a metaphorical trope by joining dissimilar ideas in such a way that it gives rise to a new figurative sense. An example of the Quays' transformation of this district is in the film's lighting and color scheme; the main *Street of Crocodiles* set is lined by old shops with musty-looking bizarre objects in their windows. The color palette is various tones and shades of sepia, brown, black, gray, and beige, the lighting is crepuscular; it is as if the film stock itself is aged and faded. I agree with Trevor Whittock's challenge that cinematic metaphor is not dependent on montage, that visual metaphor is created in "the link between the artist's conception and the spectator's cocreation of it. It posits the film image as mediating between the two."[21] The spectator's involvement in apprehending the meaning of the literary and cinematic imagery described above is enriched by familiarity with Schulz's writing, but it is not prerequisite to understanding the image.

Literary "Cineantics": James Joyce, Portmanteau, and Nonsense

There are other approaches that I regard as helpful toward understanding how texts relate to the Quays' cinematic images. Two in particular involve James Joyce's creative process and writing techniques, and they are of considerable significance in this study for a number reasons.[22] It is also interesting to note that in a 1924 interview carried out by Daniel Hummel concerning the French translation of *Ulysses,* Richard Ellmann notes that Joyce himself "had thought . . . the book could not be translated into another language, but might be translated into another medium, that of film."[23] In the text of Joyce's *Ulysses,* which he calls a "sketch for reading," Paul Ricoeur sees this sketch as consisting of "holes, lacunae, zones of indetermination, which . . . challenge the reader's capacity to configure what the author seems to take malign delight in defiguring."[24] These zones of indetermination can originate in metonymy and create a sense of intellectual uncertainty if the reader has no comprehension or sense of knowledge and experience of parts (I will explore this in later chapters on the Quays' poetic dialectics). Joyce's disdain for the reader, obvious in the text's temporal shifts, narrative ellipses, and hallucinatory style, bears comparison with the use of hiatus and nonnarrative style that some of the Quays' films present. Implementing approaches used to understand Joyce's texts helps develop analogies toward exegesis of how the Quays transform fragments of literary sources into their films.

One of the most enlightening ways of comprehending Joyce's experimental narrative, and one that helps us along in understanding how the Quays transform texts spatially, is Joyce savant Fritz Senn's interpretation of Joyce's "dislocutions." Senn remarks that dislocution is a Joycean feature

> of constant change, becoming something different, and it is language, locution. Every quote, for instance, takes you somewhere else, another locus, and other expression. From realism to whatever else, overtones, myths, ambivalences. It subsumes the various changes, metamorphoses, translations.[25]

It describes, among other things, Joyce's disruptions of space and time in his texts, and its value as a concept will be apparent in a discussion of montage of disorientation in chapter 5. In his essay "Dislocution," Senn describes what may be understood by the term:

[Dislocution] could be used, after all, for redescribing or (Joyce's cue) "transluding" (FW 419.25) what was provisionally verbalized as metamorphosis, alienated readings, an auto-corrective urge, metastasis, the disrupted pattern principle, or polytropy . . . it might even stand for all those effects that make us respond, spontaneously, with laughter.[26]

The spontaneous laughter Senn suggests is generated in part by a feeling of not having enough information at hand; in other words, it is the result of an apprehension caused by initial intellectual uncertainty that shifts to a pleasure at having decoded a sense of meaning—or meaningful nonsense—in the passage. He suggests that "it is, of course, the reader who—potentially—executes all the mental shifts."[27] The engagement Senn suggests gives credit to the reader's own co-creational ability to work with the text, configuring Ricour's zones of indetermination. Using specific montage and camera techniques, the Quays develop a visual dislocution in their interpretation of Schulz's and other texts (a dialectic I expand upon in chapter 5). These dislocutory instances are principal generators of a feeling of apprehension, as the viewer is forced to engage with something only partially comprehensible and not yet informed by developed mental models or a priori knowledge.

Joyce is unparalleled in his creative and inventive use of palimpsest, portmanteau words, and polyglot puns. These three literary techniques can be visualized in animation as in no other kind of visual media, and the Quays use similar techniques in their transformative working between text and images (and sound).[28] Instead of the graphic lexeme, their palimpsests are a combination of visual tropes, motifs, and descriptions from texts that are transmuted into a faint mood and loose narrative of the films, the "erased" layer of a palimpsest. Poststructuralist literary criticism uses the palimpsest as a model for how writing functions, in that there are always other authors and texts present in writings. In analogy, besides the literary inscriptions, the Quays use materials that not only signify the puppets themselves, but in the partial erasure of the materials' origins by using metonymic fragments of them, they also reinscribe the meanings contained within the used materials, themselves redolent with significations of past use. The new material that overlays this surface, the images, are composed to a great degree out of references to other artists and movements that the viewer may or may not recognize. Later chapters will explore how the puppet and metaphysical machines' composite constructions can also be understood as a kind

of palimpsest of Surrealism, Expressionism, Art Brut, and Polish graphics, and both extant and demolished architecture are reworked and fused together in the objects and spaces of the narrative world.

The aesthetic and literary technique of portmanteau—the combining of two or more words or lexemes to create a new meaning—can also serve as an analogy to help explain why it is possible to understand the Quays' puppets that are often constructed of fragments. There are many portmanteau words in *Ulysses* (1922) whereby, as Senn suggests, "the language itself becomes an object":[29] "contransmagnificandjewbangtantiality" (3.51), "pornosophical" (15.109), "shis," and "hrim" (15.3103) are portmanteau words that evoke multiple meanings and require a complex exegesis. Like the lexeme fragments of different words, the different meanings implicit in the fragments mean the reader must engage in a form of play to discover the artist's or author's intent of meaning in their particular combination. The technique also resonates with Eisenstein's montage of attractions in the textual collision of semes. In *The Logic of Sense,* Gilles Deleuze suggests that "it seems the portmanteau word is grounded upon a strict disjunctive synthesis. Far from being confronted with a particular case, we discover the law of the portmanteau word in general, provided we disengage each time the disjunction which may have been hidden."[30] Deleuze continues to say that each lexeme of a portmanteau is thought with the other lexemes: in our examples of "shis" and "hrim" male and female gender attributes "she" and "his" or "her" and "him" are disjunctive, but the reader thinks about them together. Besides Joyce's, perhaps the most familiar examples of portmanteau are Lewis Carroll's poem *Jabberwocky* (1872), Kurt Schwitters's Dada sound poems, and Arno Schmidt's German emulations of Joyce. In such phrases and words, Joyce found a fine balance between nonsense and logic, between semantics and language laws. While Joyce's later works, *Ulysses* and *Finnegans Wake* (1939), are not classified as nonsense literature (indeed, they remain for the most part unclassifiable as a genre), the abundance of neologisms, portmanteau words, and palimpsest phrases incite the reader to engage in the author's play between meaning and what can appear, on first reading, as nonsense. Two brilliant examples from the "Lestrygonians" chapter of *Ulysses* (in which the main figure, Leopold Bloom, is thinking about the struggle his wife, Molly, has to understand the word "metempsychosis"): "Met him pike hoses she called it until I told her about the transmigration" (8.112)[31] and later, when peckishly anticipating his lunch: "Ham and his descendants mustered and bred there" (8.742). The latter, especially when read aloud, is a formidable example of a parodic pun that takes the reader on a peripatetic journey

interlinking Babylon, Hamlet, cannibalism, Dublin pubs, and a hungry Bloom (it originates in an inner perspective passage of his in the chapter). In a literary analogy, like James Joyce's later texts, the Quays' film texts often resist unambiguous classification: they belong to a realm of oneirics, psychotopographic flaneurism, and metaphysics. The attraction of Joyce's later works is and remains his absolute mastery of the history of literature that he parodied and pastiched; in the Quays' films, a respect for their sources and an inherent modesty is evident in the beauty of their composite references and selective reassembling of inspirational material. Joyce achieved expression of preverbal thought with linguistic inventiveness. The Quays manage to do so with the animation of textures and objects and by revealing the impossible spaces their camera effortlessly traverses, intimating the secret relationships of spastic machinery, extinct architecture, occluded mirrors, and fetishized dust.

Deleuze discusses different functions of nonsense as exemplified by language use of what he calls "the grotesque trinity of child, poet, and madman," and the problems facing the logician:

> The problem is a clinical problem, that is, a problem of sliding from one organization to another, or a problem of the formation of a progressive and creative disorganization. It is also a problem of criticism, that is, of the determination of differential levels at which nonsense changes shape, the portmanteau word undergoes a change of nature, and the entire language changes dimension.[32]

The world of oneirics, illusion, and metaphor as the junction between inner, nonverbalized speech and perception and experience of the external world— in other words, the collision between vitalism, animism, and the phenomenal concrete—occupies a privileged position in the Quay Brothers' cinematic address to a literary work. Beginning with *Street of Crocodiles,* language, poetry, and prose became more prominently implicit in the subject matter of their independent works. And these worlds are prominent in the specific cosmogonies of Franz Kafka, Robert Walser, and Bruno Schulz. Discussing academics' tendencies toward sociopolitical readings of these three authors, Jordi Costa suggests that the Quays are

> quite indifferent to any possible reading of these referents into their historical context: in the first place they are drawn to the hypnotic

glow of their aesthetic context, and finally they sink (and lose themselves) in the inexhaustible cosmology of their subjective, timeless, eternal nightmares.[33]

While the Quays are not disdainful of their viewers, the "indifference" Costa suggests results in an aesthetic and narrative puzzle similar to the one Joyce presents his readers.

Vitalist Cosmogonies: Kafka, Walser, and Schulz

Certain literary genres and writing styles have an affinity with animation techniques, especially those with elements from fairy tales, romanticism, fantasy, and science fiction. There is a body of writing with a particularly fertile hub in Europe that includes E. T. A. Hoffmann, Friedrich Hölderlin, Witold Gombrowicz, Heinrich von Kleist, and Ludwig Tiecke and later Antonin Artaud, Franz Kafka, Robert Walser, and Bruno Schulz. Critical reflection on the scope, stylistics, and variety of this writing is expansive, so the focus here is on those authors whom the Quays favor and who invoke a leitmotif that lends itself in an astonishing way to the technique of puppet animation. It is a preoccupation with the imagined inner life of objects, puppets, and automata, often seen through the eyes of an omniscient author or a main protagonist who is enchanted by an imagined interaction with them. These objects, interpreted by the Quays and given material form, become cinematic equivalents of literary description, a deus ex machina, a theatrical device that is also a performative manifestation of the concept of vitalism. Machinery, in literary analogy, collectively refers to actants in a text.[34] The human figure is paired in binary opposition with the nonhuman creatures and inanimate objects. Central to the authors mentioned is the imaginary unity on the part of the human (or anthropomorphic puppet) actant with the inanimate objects and puppets; the former is faced with the impossibility of translating this perceived unity into a state of interaction that makes sense in his or her physical world. The result is often anticathartic and results in delirium, alienation, or tragedy (Hoffmann's Nathanael with the automaton Olimpia, Schulz's father and his wrestling with matter, Kafka's insectal metamorphosis of Gregor Samsa).

The authors the Quays (and their critics) mention most are Franz Kafka, Robert Walser, and Bruno Schulz. These authors mainly served as inspirations, not the source for a script or screenplay. The films based in literature are aesthetically motivated transformations of isolated elements of the texts, them-

selves more closely aligned with mythopoeia than with dominant ideologies. A philosophical notion that ties Kafka, Walser, and Schulz together in terms of the life of the object is a shared expression of vitalism in their writings. The vitalist philosophers, and especially Schopenhauer, posited that human beings are not purely physical but contain some kind of spiritual component or vital essence. The creative act—poiesis—is one outlet for expressing this vital essence. Many people are deterred by Schopenhauer's premise that to live means to desire and that this desire is to be avoided as it leads inevitably to suffering. Yet Schopenhauer offers a solution in asceticism, propounded throughout a variety of his publications, including the fifty "life rules" compiled in his occasionally joyful (as yet unavailable in English) aphorisms in *Die Kunst, Glücklich zu Sein: Dargestellt in fünfzig Lebensregeln,* published posthumously as a collection in 1999 (that could be translated as *The Art of Being Happy: Presented in Fifty Life Rules.*[35] Schopenhauer wavers between being irresistibly drawn to the pleasures of life and to devising methods of avoiding these pleasures. Paraphrasing his first life rule, he believed that happiness and pleasure are chimera and that it is best to avoid the pain and suffering they cause.[36] Schopenhauer's philosophy was a major contribution to German Romanticism and had an impact on literary and philosophical sages (including Nietzsche and Bergson) during and after his time. The three authors the Quays declare as major influences on their aesthetics lived various degrees of Schopenhauer's asceticism, but it is in their writings that, in a turnaround of Schopenhauer's causality, suffering transmutes into desire and the pleasure of writing and creating a world, which enables readers to access the enormous sensitivity these authors had to existence and descriptions of fantastic perceptions and metaphysical, vitalist phenomena. The author cannot realize or acquire his or her object, but the creative process of writing encourages epiphanic moments. This is the narrative longing Stewart refers to that generates significant objects and engenders a significant other,[37] and these moments can find their way to paper as metaphysical descriptions of their inner worlds. These moments, I'd suggest, are the ones the Quays sift from the texts and transpose onto the screen through the physical matter of objects, automata, and uncanny architectures, and I will discuss these more fully in later chapters. The Quays: "Our work is so close to us that it isn't work—it's a way of rendering life at its fullest. And in puppetry your hands do a lot of thinking."[38] They effect a cinematic permutation of these literary, metaphysical concepts of matter, concepts in these three authors' works that are informed by vitalism.

The writings of Kafka, Walser, and Schulz are singular records of the experience of increasing alienation from the surrounding world and its

inhabitants, wrought into an expression of an unlived life; in their suffering, albeit to different degrees, they are Schopenhauerian to the core. In his writings, Schopenhauer also explored how art objectifies the will and quiets the torment and struggle that are inherent to the will's nature. The pursuit of this object through writing seems to be the objective of the three authors. They share a fantastic, precise descriptive style that suggests a hypersensitivity and relentless need to understand both the objects and spaces their works contain and the contingency and psychology of their protagonists.

Catastrophe also is a common thread that unites them. Kafka's was his self-imposed increasing isolation from family and surroundings; Walser's was his psychological decline, ending in a sanatorium; and Schulz's was his murder. Schulz's writing and biography are often compared with Kafka's (it is conjectured that he translated Kafka's *The Trial* into Polish with a foreword),[39] and in this context there are a few relevant points that clarify why these authors hold a particular interest for the Quays. Schulz's withdrawal into childhood memories and fantasy may have been a response to the decline of patriarchal order after the dissolution of the Habsburg empire, which resulted in Poland becoming a nation-state again and simultaneously being swept away by a burgeoning industrial revolution.[40] Yet this despair is balanced by what I suggested earlier was a turnaround of Schopenhauer's causality of desire and suffering, and it must be said that these authors had an investment in satisfying a primary desire or longing. Jerzy Ficowski (who is thanked by the Quays in *Street of Crocodiles'* credits) suggests Schulz turned a "longing for the fullness of childhood [that] is as old as art itself" into the primary focus of his literary art.[41] In his writings on Herbert Marcuse, Charles Reitz points out that Marcuse theorizes that art can assuage alienation because it has a revitalizing, rehumanizing force. Reitz then balances this out:

> But Marcuse acknowledges that art can also contribute to an alienated existence. Alienation is understood in this second sense as a freely chosen act of withdrawal. It represents a self-conscious bracketing of certain of the practical and theoretical elements of everyday life for the sake of achieving a higher and more valuable philosophical distance and perspective. Marcuse contends that artists and intellectuals (especially) can utilize their own personal estrangement to serve a future emancipation.[42]

This idea of withdrawal and estrangement fits neatly on a number of levels with these three authors. Schulz's mother tongue was Polish yet, like Kafka, he was fluent in spoken and written German and he was also raised in a Jewish family. Schulz and Kafka both remained close to their geographic and cultural origins while distancing themselves from everyday engagement. Walser traveled throughout Europe, was true to his native Switzerland in his texts, and yet his writing was not in his native dialect. This may reflect what Theodor Adorno describes in the thirteenth aphorism in *Minima Moralia,* "Protection, help, and counsel":

> Every intellectual in emigration is, without exception, mutilated, and does well to acknowledge it to himself, if he wishes to avoid being cruelly apprised of it behind the tightly-closed doors of his self-esteem. . . . There is no remedy but steadfast diagnosis of oneself and others, the attempt, through awareness, if not to escape doom, at least to rob it of its dreadful violence, that of blindness.[43]

56

Schulz's estrangement was not geographical and was more a withdrawal into the magical perception and imagination of childhood, transforming objects and things into metaphysical and metaphorical creatures that exist in an imaginary time. He shares with Kafka a sense for the grotesque, and metamorphosis is also found in both writers' works. Unlike Kafka, Schulz was social and had long-term friendships, although his letters indicate he felt lonely, perhaps, again like Kafka. But he was more playful and less existentially afflicted, creating an atmosphere in his writing that provided solace from his own alienation. The estrangement and loneliness of these authors incited a fervent engagement with the worlds in their minds.

Although the Quays were drawn to these authors, their declared suspension of the real world was hardly inspired by the same motives, but was more of an opportunity to concentrate on shared aesthetic preferences and sensibilities. It may very well be that there lies a conceptual similarity in the respective withdrawals, but for the Quays it offered a fertile and creative nurturing to satisfy a gusto for exploring the many facets and cultures available outside geographic limitations of North America. Gustavo Costantini suggests of the Quays (and, it seems, of their viewers) that "only by being an 'outsider' can you see Europe the way they see it."[44] This seems a rather naive notion, and it may be a simplification to suggest that only other outsiders will understand the Quays' transformation of the European worlds of Schulz, Walser, and Kafka. It is not only cinephiles

who are drawn to their works; many other viewers share delight in seeing how these worlds are conjured.

Franz Kafka (1883–1924) was one of the first inspirational authors for the Quays. As students in Philadelphia, they chanced upon his *Diaries 1910-23,* while Kafka's "Ein Brudermord" ("A Fratricide") provided the stimulus for the Quays' homonymous short film. In an earlier comment in chapter 1, the Quays suggested that being twins allowed them "a much greater suspension or desertion of the real world." Although Kafka's development was also the result of a profound alienation as a German-speaking Czech Jew, this comment strongly echoes his own initial aesthetic and philosophical program and his astonishment at the secretive and terrifying nature of small things. The Quays' conscious desertion of the real world may have been more a turn toward a metaphysical and imaginary counterpart that appears more motivated by enchantment than by alienation and fear. McClatchy suggests that reading Kafka changed their thinking about art and that, "intrigued by the quiet intimacies of the artist's private life, they preferred the diary's format—its brief anecdotal entries, the fragment, the interval—to that of novels."[45] Kafka's diaries were one of the first intimate and fragmentary literary works they read followed by other authors whose attention focused on the life and inner world of the artist and its polar opposites of private despair and joyful epiphany.

Kafka's prose is microscopic in its description of everyday events and things. André Gide's opinion of Kafka's writing could easily be applied to the Quays' creative transformation of matter: "The realism of his images continually transcend the imagination and I cannot say what I admire more: The 'naturalistic' depiction of a fantastic world that becomes credible through the minutious exactness of the images, or the confident bravour of the turn to the secretive."[46] Kafka was fascinated by the life of objects, and this explains why he and Schulz are often compared. In his German biography of Kafka, Klaus Wagenbach points out that as an author in early 1900s Prague, Kafka stood out against his Prague School contemporaries Egon Erwin Kisch, Max Brod, Franz Werfel, and Rainer Maria Rilke, whose writings are characterized by an unspeakable, swollen style—mystagogical, bloodthirsty, and obscene.[47] Kafka remained outside these influences and lived his life as an author in an extreme, self-imposed isolation, mostly in Prague. His writing is an unparalleled record of the experience of increasing alienation from the surrounding world and its inhabitants, wrought into an expression of an unlived life. This is characterized by his ongoing ambivalence with, and ultimate failure to accept, opportunities to engage in the select community of

friends and lovers around him. Yet his writings record these alienations "with the singular instrument of a rigorous fanaticism for truth [and Kafka] attempted to record the results of these and his own situations."[48] In the Quays' works, this fanaticism translates into an exacting sense of formal detail and foregrounding the objects in their films, especially in their use of lingering close-ups and macro lenses. The ontological truth of the materials is phenomenologically rooted and inescapable, and their animation incites an apprehensive, vitalist, almost solipsistic world suggestive of Søren Kierkegaard's thinking that what Kafka wrote was so close to his own. Paraphrased, Kierkegaard describes a deep secretiveness of innocence that is simultaneously fear. The spirit, dreaming, mirrors its own reality, but this reality is nothing.[49] Another term for this simultaneity of innocence and fear is apprehension.

Perhaps less fearful than Kafka, but nonetheless sharing characteristics with his cosmogony, Robert Walser (1878–1956) was a Swiss writer who wrote prolifically for newspapers and journals and whose novels and short stories inspired a number of the Quays' films *(The Comb [From the Museums of Sleep]* and *Institute Benjamenta)*. Fragments and themes from Walser's writings are strewn throughout their opus. It is invaluable to consider unique aspects of Walser's writing style as the second author in the Quay triumvirate of Kafka, Walser, and Schulz, and to see how these three authors' writings speak to each other. In an afterword to *Institute Benjamenta,* the English translation of Walser's *Jakob von Gunten* (1909) and the textual inspiration for the Quays' *Institute Benjamenta,* Christopher Middleton (whose writing on Walser was an entry point for the Quays) comments, "In reality, the book is more like a capriccio for a harp, flute, trombone, and drums."[50] The musicality of Walser's writing has been repeatedly emphasized, and it is full of musical comparisons and metaphors. Peter Hamm provides some of the most fitting descriptions:

> The stars and sun sing, a room possesses a precious tone, a girl's gentleness is like a stream of notes. He compared nights to black sounds, someone enjoys his slowness like a melody or a city affects him like a symphony. In his essays, novels and microgrammes, the compositions and dialogues are reminiscent of musical inspirations, a quality that Walser himself often mentioned.[51]

Although his work may be rich in under-, over-, and middle tones, "[Walser's] deepest love was for the 'Eintönige,' the monotone."[52] This can be understood

in a variety of ways in Walser's writing—as a composite and musical wordplay on mediocrity, daily life, and empty routine. Walser's published complete works were divined in part out of hundreds of pages and fragments of prose, bits of dialogue and notes, some written in a tiny handwriting aptly classified as a "microgramme" in German. Middleton: "This script was not a cipher system, as some scholars have supposed, but a kind of personal shorthand."[53] Here is the intersection with the Quays' approach to visualization of Walser's literary music: elliptical, close-up views and poetic fragments of what Walser immortalized in his microscript handwriting—the searching, his self-denial, literary maps of frustrated desire and longing.

In her comparative analysis of H. P. Lovecraft and Schulz, Victoria Nelson asks, "What is the difference between a person describing his own madness and a writer obsessed with the notion of containing and controlling madness through art?"[54] This is a query that also links Kafka, Walser, and Schulz. Walser's dreamlike anti–fairy tales express an inner turmoil and astonishment at the exquisite and puzzling banalities of an unlived life. Committed to a psychiatric institution in 1929, he ceased writing in 1933. Schulz's descriptions of his father's obsessions are interwoven with the magical world of childhood. Kafka's literary accounts of paranoid behavior interlink as well. Nelson suggests that "madness is experienced as being *enacted on* the subject from without."[55] All three authors the Quays have drawn upon in their works have focused in one way or another on such madness: Walser's Jakob, trapped in the dreamworld of Institute Benjamenta; Schulz's narratives of his father's increasing withdrawal from the world around him into the life of objects; and Kafka's characters, who, though puzzled, seem to adapt to the contingencies of uncanny, illogical circumstances.

Bruno Schulz is the author who offered the most inspiration for the Quay Brothers' own cosmogony. Born in Drohobycz, Poland, in 1892, Schulz was killed there by the Gestapo in 1942. Despite having published relatively few texts, Schulz is described by David A. Goldfarb as the youngest member of Poland's interwar avant-garde, along with Stanislaw Ignacy Witkiewicz (1885–1939) and prosaist-dramatist Witold Gombrowicz (1904–1969), "who were all deeply invested in an idea like 'childhood.'"[56] *The Street of Crocodiles* was one of the short prose texts in Schulz's collection *Sklepy cynamonowe (Cinnamon Shops)*, first published in Warsaw in 1934. It has since been republished in different editions and in combination with other texts by the author and translated (for better or for worse) into a number of languages.[57] The Quays came across Schulz's writings through a Polish acquaintance who introduced him to them as the "Polish Kafka":

Then, naturally, we came to learn that it was not quite the case, that they were two people similar in many respects but also different in others. The first time we read [Schulz] he did not make a particularly striking impression. We found it interesting, but more from a strictly literary standpoint. Subsequently, after a second reading, it managed to make us understand animation as a type of metaphysics.[58]

The Quays' reflections on how the metaphysical content of Schulz's texts had implications for their own form of artistic creativity are elemental to understanding their formal treatment of objects. As a type of metaphysics, vitalism (see Introduction) might be a more apt term to describe both Schulz's and the Quays' conjuring of the world.

It was not only the text that fascinated the Quays. Schulz was a unique autodidactic artist who taught drawing at schools, and a book of his collected drawings, *The Booke of Idolatry,* was published in 1990 (and includes an introduction by Schulz scholar Ficowski). This appeared before *The Street of Crocodiles,* and the imagery suggests what was later to be transposed into his writing: stylistic elements of Francisco de Goya and Georg Grosz are in the graphic work. Ficowski suggests that "already here, in *The Booke of Idolatry,* there appear mythological affinities—a phenomenon which is inseparably connected with Schulz's work as a writer."[59] His drawings and writings may have further intensified the Quays' interest in Polish graphic design and its particular qualities. Schulz illustrated his own publications and also worked for other authors, illustrating the first edition of Gombrowicz's major novel, *Ferdydurke* (1937). Ficowski includes a photograph of Stryjska Street in Drohobycz that was the prototype of the Street of Crocodiles in *The Cinnamon Shops.*[60] The Quays made trips to Poland—to Kraków, Prague, Wrocław, Drohobycz, and Łódź—visual field trips that helped them piece together the fragments of Schulz's text and illustrations:

> We had always kept notebooks and 8 mm films, so we really knew the real textures quite well, so that when we read Schulz finally, it seemed we knew how to approach him. . . . A lot of Wrocław absolutely fascinated us—Kraków, too, a lot of dust and it was all in our notebooks. Wrocław is this sort of forgotten industrial town, which I suppose is the equivalent of Manchester—or saying you *like* Pittsburgh [laughter]—yes, *like* Pittsburgh, full of dust.[61]

In an interesting parallel to the effect the Quays' film had for cinephiles, Bruno Schulz's texts caused something of a whirlwind in literary and academic circles. Recalling the first critics—other filmmakers, poets, and artists who wrote about the Quays' early work—there is a further telling parallel. Most critical response to Schulz was initiated by contemporary authors: David Grossman (*See Under: Love,* 1989), Cynthia Ozick (*The Messiah of Stockholm,* 1987), and Philip Roth (*The Prague Orgy,* 1985). They also inscribe elements and tropes of Schulz and his texts in their own prose, as do the Quays in their film; in discussions, they occasionally refer to the main puppet in *Street of Crocodiles* as the "Schulz puppet." Overall, Goldfarb describes these texts succinctly:

> Schulz criticism, by and large, is broad, descriptive, and deals more with ethos and aftertaste than with actual text. Everyone wants to say something about Schulz, but it is quite difficult to figure out what to say. Schulz's stories are fragmented, elliptical, often without plot or seeming direction, indeed leaving us with more aftertaste than argument. But an aftertaste is not without components, meaning, and causes.[62]

A similar phenomenon around the Quays developed from the 1990s onward, when a number of animation films, mostly from students and graduates, began emulating the Quays' use of chiaroscuro, puppet and object construction, and uncanny soundscapes.[63] It was as if the films, especially *Street of Crocodiles,* touched upon something that led these filmmakers to explore the visual, tactile, and aural moods through a wish to understand the original film. Goldfarb's summary of Schulz criticism is reminiscent of Atkinson's admission that "it wouldn't matter if every man, woman, or child on earth saw *Street of Crocodiles.* Only I would truly understand it—which is not to say that I literally understand it at all."[64] Plumbing the essence of what to say about Schulz's short story and the Quays' film means entering into the worlds—one literary, one cinematic—that these texts evoke and express.

Bruno Schulz's "Ulica Krokodyli"

Street of Crocodiles draws on a longer piece of Schulz's prose writing. Yet besides the title (in English and Polish) and a text in English accompanied by a Polish

voice-over at the end of the film, there are no other written or aural textual or linguistic references to the story. When asked if they work with storyboards, a common method for developing film productions, the Quays replied, "No. Never. Only at gun point [laughter]."[65] Bearing this in mind, by extracting particular literary and aesthetic sources of the world of Schulz's text, this section explores how specific elements in *The Street of Crocodiles* serve as inspiration for the film's visual surface and experimental narrative structure. I lean in part on literature analysis, addressing the text's literary qualities; this is distinct from the queries involving cinematic parameters in the next four chapters. Following the previous discussion of literary techniques and styles, it serves as a linking preamble to these chapters. A passage from *The Street of Crocodiles* introduces the mood for the film's first moments:

> On that map, made in the style of baroque panoramas, the area of the Street of Crocodiles shone with the empty whiteness that usually marks polar regions or unexplored countries of which almost nothing is known. The lines of only a few streets were marked in black and their names given in simple, unadorned lettering, different from the noble script of the other captions. The cartographer must have been loath to include that district in the city and his reservations found expression in the typographical treatment.[66]

Schulz's descriptions take us from the surface of a baroque map to imaginary uncharted expanses and unmarked city areas and into the mind of a disdainful cartographer. Perhaps the most powerful image he incites is that of how the cartographer's attitude toward a part of town translates into its spare, graphic representation, a white blot, a gap that stains the map like a black hole. This metaphor—the empty whiteness that stands in for a part of the city that is compared to unknown polar regions—finds its way into the opening sequence of *Street of Crocodiles* (see Figure 9).

We hear the steady, rhythmic sound of a clock ticking. In close-up, an ornate magnifying apparatus rests on top of a black-and-white section of a map, its grids and curves indistinct, blended out by bright light. A gnarled hand enters the frame and flips the lens to focus on a small section of the map. The starkly illustrated black lines become thicker and distorted at the lens's curved edges. The ticking continues through the transition fade to black. This sequence serves as an example of how elements of the text can find their way into the film. Wollen's

description of the auteur's reworking of written texts foregrounds the process of how texts can make the transition to screen:

> Incidents and episodes in the original screenplay or novel can act as catalysts; they are the agents which are introduced into the mind (conscious or unconscious) of the *auteur* and react there with the motifs and themes characteristic of his work. The director does not subordinate himself to another author; his source is only a pretext, which provides catalysts, scenes which fuse with his own preoccupations to produce a radically new work.[67]

Figure 9. The bleak and stark map of the Street of Crocodiles.

Many of Schulz's textual elements acted as catalysts that merged with the Quays' own concepts about space, time, textures, music, and narrative. In our example, a metaphor for an area of a city becomes a psychotopographic link, an entry point into the Quays' version, the animated world that is accessed via the Wooden Esophagus as a screen rises, opening access to a fantastic realm, Bruno Schulz's *Street of Crocodiles.*

As diverse as these two artistic modes—literature and film—are, there is a set of stylistic features and devices they share. In her brilliant comparative analysis of Schulz, H. P. Lovecraft, and Daniel Paul Schreber, Nelson describes the psychotopographic imagination that she attributes to

> interior psychic regions as we find them projected onto an outer landscape. A psychotopographer is the artist who devotes herself to describing—with varying degrees of awareness about the true nature of the subject—the images of these inner regions as she discovers them in an imagined exterior landscape.[68]

Schulz's descriptions of the inner regions and his father's delirious withdrawal into madness express themselves through a hermetic psychotopography of the world within the walls of his family home, which extends to descriptions of the Street of Crocodiles and the cosmos. In *Street of Crocodiles,* interspersed with vignettes of metaphorical machines and a subplot involving a child who has

discovered that his mirror can transport a beam of light that vivifies objects, the puppet wanders through the decrepit alleys, surreptitiously appearing out of shops, concealing objects in a diagonally striped box (an obvious nod to Buñuel), and gazing voyeuristically into peepholes and endless deep spaces.

Schulz's is a world of imagination, myth, lost childhood regained, a world in which lowly creatures and matter gain a mythopoetical status. His text is redolent with the epiphanies of madness, demiurges, erotic undertones, automata, and the secret life of objects. Susan Stewart suggests domains that would seem to suit these inhabitants of Schulz's cosmogony:

> If authority is invested in domains such as the marketplace, the university, or the state, it is necessary that exaggeration, fantasy, and fictiveness in general be socially placed within the domains of anti- and nonauthority: the feminine, the childish, the mad, and the senile, for instance. In formulating the loci of authority and exaggeration in this way, we necessarily and nostalgically must partake in the lost paradise of the body and the myths of the margin, the outside.[69]

64

The Quays' transformation of Schulz's descriptions give them a concrete domain with dimensions, perspective, and texture, and these domains recall Deleuze's "grotesque trinity of child, poet, and madman"[70] specific to nonsense language and also Benjamin's description of the fairy tale as a "waste product." They provide us with a cinematic psychotopographic space populated by automata, metaphysical machines, and puppets that, in staying true to the textual inspiration, can lead us to unending passageways and paradoxical discrepancies in spatial coherence. Goldfarb refers to Polish critic Jerzy Jarzębski, who "brilliantly reads the Schulzian chronotope as the fusion of 'dream time' or mythic time with labyrinth space."[71]

Part of the popularity of the Quays' film comes from its successful visual transformation of a text-based, inner-envisioned world into a visible world. *Street of Crocodile*'s vitalist urge is apparent not only in the transformation of inanimate materials into "living" ones, but also in a purification and condensation of the catalyst of Schulz's text and references into a cinematic expression of visual metaphor, rich tropes, and polysemy. Referring to Bachelard, Nelson describes the house as "perhaps the most familiar of all psychotopographic loci."[72] The cloistered interiors of the Quays' film bring to life the reclusive, psychological time-space of Schulz's world, uniting the sealed-off room of "Tailors' Dummies"—the

film's philosophical and metaphysical source—with the "polar regions or unexplored countries of which almost nothing is known."[73]

Cycles and recycling play important roles in Schulz's work, since they combine to form a central theme of his text, formally and in content. In the cinematic rewriting of *The Street of Crocodiles,* traces of Drohobycz's cinnamon shops—ancient layers of dust, deserted street corners, a malingering boy, objects constructed of the collective detritus that Schulz so brilliantly describes, louche seamstresses—are strewn as haptic reminders of a world lost and of the world described by the father in the three treatises of "Tailors' Dummies." Goldfarb:

> This piecing together of fragments of different mythologies is a standard mode of Schulzian myth making. The mythic origins of the elements are real. They have a textual history. Their combination, however, is "illogical." They could make sense only in the ephemeral logic of dreams or in the disjointed reasoning of a child's mind, concatenating arbitrary relations as causal links.[74]

The Quays also piece together fragments, using objects from the world around us that do not necessarily derive from life and immediate reality, but have a *textural,* material, and cultural history. I have stated that notions of language, structure, and perception that define the animated image and the special case of puppet animation are crucial to developing critical contexts to describe it. The language of dreams may be difficult to enunciate cinematically, but it does have a position in our experience. Jarvie's remarks on the differences and overlaps between fictional worlds and reality underpin this:

> Stories, day-dreams, dreams, drama vary considerably in the degree to which they contrast with reality; that they exist, that we have them, makes them part of the real world. Yet they have this special proto-filmic quality of being worlds nestled within the real world and hence useable to highlight its features, mark its differences.[75]

The proto-filmic quality is similar to Goldfarb's reading of Schulz's stories. Reflecting on relationships between preverbal thought, oneirics, and spectatorship can contribute to understanding the pleasure involved in watching the Quays' film and of critics' and spectators' engagement to articulate the

impressions the film evokes. *Street of Crocodiles'* meandering plot is underscored even more by its foregrounding of style and its transformations of Schulz's internal logic into film—an il-logic of dream texts frequently found in late impressionistic descriptive prose. Questioned about the status of the text in the film's development, the Quays said: "We never think about it; always, it's the way it works on the retina. We wouldn't bind ourselves to a text. At the very end of [*Street of Crocodiles*] there is a text, but it is an apology—it was Schulz's text."[76] Schulz's text is also Schulz's narrative literary formulation of a world.

Schulz's own words on the urge to address the reworking of myth are illuminating:

> Poetry happens when short-circuits of sense occur between words, a sudden regeneration of the primeval myths. Not one scrap of an idea of ours does not originate in myth, isn't transformed, mutilated, denatured mythology. The most fundamental function of the spirit is inventing fables, creating tales. . . . The building materials [that the search for human knowledge uses] were used once before; they come from forgotten, fragmented tales or "histories." Poetry recognizes these lost meanings, restores words to their places, connects them by the old semantics.[77]

The Quays' creation of tales uses physical building materials that have often been used once before and come from "forgotten, fragmented tales or 'histories.'" Like Benjamin's detritus brought together in a new "volatile relationship," they are sifted from histories of art, gathered during secondhand shop forages, materials frayed by age, alienated from their original purposes, and reconfigured to make new meanings. Their collaged book cover for their own copy of Schulz's book is also a collage of fragments (see Plate 7). They invest a poetry in their objects; indeed, they "demand that the décors act as poetic vessels and be foregrounded as much as the puppets themselves."[78] Goldfarb describes an analogous rummaging, both in terms of the original creative act (the Quays' film and Schulz's text) and in terms of how those who emulate them draw on what the artists distill from the plethora of imagery they gather:

> A good Polish flea market today is probably only a sparser version of what it was one hundred years ago—a bricolage of old swords, coins, knives, stamps, machine parts, books, embroidery, eyeglasses, foun-

tain pens, menorahs, handmade lace, china, microscopes, cameras, war medals, carved saints, beaded caftans, military hats, wedding dresses, caged birds, farm implements, postcards, tooled metal reproductions of the Black Madonna of Czestochowa, wooden shoes, fresh eggs, photographs, pocket watches, hand tools, drafting compasses, musical instruments, and fermented grain juice in old vodka bottles for the preparation of a sour soup called "zurek." Each of these things belongs to a rich semiotic system known to the initiates who buy and sell them. Those who write about Schulz are left to rummage through this exquisite garbage heap of symbols.[79]

This description of a Polish flea market not only describes the objects Schulz invokes in his stories; it could also be a props shopping list for *Street of Crocodiles,* and viewers intimate with the origins of the Quays' materials have access to the film's own semiotic system. But it is not simply the materials they collect and how they arrange them in the mise-en-scène. In their use of lighting, lenses, and camera, the Quays pay infinitely precise attention to the simplest things—a screw, a dandelion clock, a mottled piece of glass—which are transformed into a poetic epiphany. They explain how this is inspired by Schulz's writing: "We want animation to be like a mark on the margins, a grand apocryphal, in the same sense as Bruno Schulz's work. It is a defiance we picked up thanks to his work, which has pushed us to create something of which we are quite proud."[80] Interpreted by the Quay Brothers, the marginal and the uneventful are transported into the realms of visual poetry. Goldfarb highlights a similar process in Schulz's writing:

> Though the overall effect of Schulz's stories is fantastic, the specific details he uses tend to be scrupulously realistic descriptions of everyday life. When Schulz describes the angle of light on a particular street at a specific time on a certain day of the year, we can be fairly sure it is like that. This is the area where Schulz's architect's precision appears. It would be a cheaply gothic effect to heighten the fantastic quality of the story with words like "freakish." As such it would weaken Schulz's technique of raising the everyday, or . . . "flea-market reality," to the level of epic.[81]

Their precision rests in lingering on small gestures. Instead of taking a fleeting glimpse of an object, the camera often rests on a shop window display, a pane of

glass, a layer of dust that, because of the attention the camera gives it, becomes singular and endowed with a mythical attribute. The Quays: "For us, [Bruno Schulz] is one of those rare writers who demand a very deep private shade, not public sunlight. His writing is a prose texture—extremely dense, thick, and poetic."[82] They take on Schulz's cue in the lighting and décors, and the architectural labyrinth of the film assimilates and transfigures the text's descriptions.

The "Generatio Aequivoca"

One of the most astonishing passages in *The Street of Crocodiles* collection is Schulz's "Tailors' Dummies," which contains three subsections.[83] It seethes with concepts that come very close to definitions of vitalism. Nelson suggests it is in his *Cinnamon Shops* that Schulz presents "his main metaphysical proposition, which is deeply Platonic; that what we mistake for objective reality—that is, the empirical world of the senses—is always trembling on the point of disintegration."[84] Crucial to understanding why the Quays' film manages to express in images what Schulz's proposition entails is that our "mistake" that Nelson articulates can incite a sense of apprehension, and it is this apprehension that the Quays have managed to so skillfully create in their animated imagery: a haptic world of the senses that *is* crumbling, that *does* fall apart and disintegrate. But because this objective reality—the profilmic matter, objects and stuff—is animated, it *does not cease to be in the world as objects.*

Schulz himself helps to illuminate this, as he describes a young boy listening to his increasingly demented father speak. He is sitting in a sewing atelier with two seamstresses, the lamps smoking and the sewing machines running, unattended, because the women are still, transfixed:

> "The Demiurge," said my father, "has had no monopoly of creation, for creation is the privilege of all spirits. Matter has been given infinite fertility, inexhaustible vitality, and, at the same time, a seductive power of temptation which invites us to create as well. In the depth of matter, indistinct smiles are shaped, tensions build up, attempts at form appear. The whole of matter pulsates with infinite possibilities that send dull shivers through it. Waiting for the life-giving breath of the spirit, it is endlessly in motion. It entices us with a thousand sweet, soft, round shapes which it blindly dreams up within itself.

"Deprived of all initiative, indulgently acquiescent, pliable like a woman, submissive to every impulse, it is a territory outside any law, open to all kinds of charlatans and dilettanti, a domain of abuses and of dubious demiurgical manipulations. Matter is the most passive and most defenseless essence in cosmos. Anyone can mould it and shape it; it obeys everybody. All attempts at organizing matter are transient and temporary, easy to reverse and to dissolve. There is no evil in reducing life to other and newer forms. Homicide is not a sin. It is sometimes a necessary violence on resistant and ossified forms of existence which have ceased to be amusing. In the interest of an important and fascinating experiment, it can even become meritorious. Here is the starting point of a new apologia for sadism."

My father never tired of glorifying this extraordinary element—matter.[85]

The passage not only describes Schulz's particular understanding of the life of objects, it also suggests the effective transubstantiation that dead matter undergoes when it is animated. Referring to *Street of Crocodiles,* the Quays remark that they "grounded the film around [Schulz's] very specific treatment of matter, certain metaphysical notions of 'degraded life' (as found in "Treatises on Tailors' Dummies"), and his mythopoetic ascension of the everyday."[86] Schulz suggests that matter has a vitality in and of itself.

The conclusion of his "Treatises on Tailors' Dummies, or The Second Book of Genesis" includes a description of a "generatio equivoca" that offers a central trope for the present context—"a species of beings only half organic, a kind of psuedofauna and pseudoflora, the result of a fantastic fermentation of matter."[87] This text had substantial impact on the Quays' aesthetic and cinematic understanding of objects, and they refer to it in a 1986 text they released the same year that *Street of Crocodiles* was made: "We were naturally drawn by his sense of the marvellous, the fabulous, his 'apocryphal thirteenth month,' his, as he called it, 'generatio aequivoca.'"[88] The vitalist concepts implicit in Schulz's extended description of the generatio aequivoca—creatures that were "mobile, sensitive to stimuli and yet outside the pale of real life" of which "chemical analysis revealed in them traces neither of albumen nor of carbon compounds"[89]—are pivotal to understanding how and why the Quays' puppets take on certain attributes and appearances. If we take the term literally, in Latin *generatio aequivoca* translates as "self-reproduction" and is known as a form of

Aristotelian abiogenesis, which reflected on the possibility of spontaneous generation of living organisms from dead or inorganic matter. The Quays' treatment of this concept cinematically is what many critics call the "alchemy" of their works, which reconciles pre-Enlightenment, pre-positivist, and later theories of vision and illusion with vitalism. But they pursue an alternative philosopher's stone rather than gold: a version of "the elixir of life," a "quintessential spirit" that the alchemists considered "was apparently . . . identical to the philosopher's stone—to occur not only in plants and animals, but also in inorganic minerals."[90] And it is this third category, inorganic materials, that distinguishes vitalism from animism, stones from animals and plants.

In an essay offering an expanded reading of Schulz's particular cosmogony, Mikal Oklot attributes Jerzy Jarzębski with suggesting that "generatio aequivoca, a term denoting self-reproduction, comes to Schulz most likely from Arthur Schopenhauer, whose thought was critical in shaping the imagination of Russian and Polish writers."[91] Citing *The World as Will and Representation,* Oklot suggests that Schopenhauer regarded generatio aequivoca as "infinite eagerness, ease, and exuberance with which the will-to-live presses impetuously into existence."[92] In the remainder of this sentence, from chapter 28 titled "Characterisation of the Will-to-Live," Schopenhauer continues:

> Under millions of forms everywhere and at every moment by means of fertilization and germs, and indeed, where these are lacking, by means of generatio aequivoca, seizing every opportunity, greedily grasping for itself every material capable of life; and then again, lest us cast a glance at its awful alarm and wild rebellion, when in any individual phenomenon it is to pass out of existence, especially where this occurs with distinct consciousness.[93]

The engrossing vitalism inherent in this description of matter, of all matter, also without biological process as "grasping for itself every material capable of life," is remarkably resonant with Schulz's own description of the "fantastic fermentation of matter" he attributes to the generatio aequivoca in his writing and to the "infinite fertility, inexhaustible vitality" the father attributes to matter in the preceding passage. Ficowski suggests that Schulz had a theoretical view that "the limitations of human knowledge, our epistemological helplessness, decreases the distance between the power of knowledge and art."[94] In the Quays' films, this helplessness is transformed by reification of the concept into a haplessness of matter, in

the nonanthropomorphic puppets and machines that propose epistemological puzzles to the viewer. The chapter in Schopenhauer's book that contains the citation above begins thus: "Our second book ends with the question as to the aim and purpose of this will [will-to-live] that has proved to be the inner nature of all things in the world."[95] He then offers an alternate conceptual framework that is remarkably useful as a compelling analogy to describing the experience of animation film, especially as he avoids the often (and over-)used notion of the anima, the soul, as being what animation can effect in inanimate objects. This is because one of the most striking features of the Quays' puppets is that, in distinction to most anthropomorphized puppets, they *do not* perform a soul. Indeed, what is remarkable in many of them is that they lack individual character, often going through motions that don't necessarily imply that their "being" in the world is of any consequence. They exhibit rather a version of the vitalist will-to-live, the generatio aequivoca in the realm particular to a film.

Goldfarb suggests an approach to Schulz's texts, one that, if one thinks of cinema as a "dream screen," may also explain why this text can be interpreted cinematically:

> The logic of these "strange" stories becomes clearer if they are read like dreams. . . . Everyone is a "real-world expert," and few people are "dream-world experts"; hence, dreams are difficult to explain. They have an internal logic and make sense while they are happening, but seem to fall apart when we try to explain them on the basis of their plots.[96]

Street of Crocodiles presents a "problem" similar to Schulz's prose, in part because the film's images and objects are based on the short story's metaphysical events and characters' experiences. Puppet animation provides a suitable stylistic palette for visualizing these literary techniques, metaphors, and vitalist resonances that are indelibly and imaginatively linked to the objective, phenomenal reality that Nelson refers to earlier in what she termed Schulz's main metaphysical proposition. A fragment of cloth, a metal shard, a dried broccoli branch are transubstantiated into their vitalist, animated counterparts. The polysemy that Schulz's text presents is transformed cinematically into hyperimagery, using the basic animation device of single-frame shooting. During projection, these frames can express a compression and condensation equaling that of Schulz's creative play. The Quays make use of a defining feature of animation: absolute control over the

single frame and the resulting flow of images that present that which does not exist in the physical world as alive, i.e., the "bringing-to-life" of objects.

Returning to Schulz's text, and bearing in mind the concepts explored above, Goldfarb singles out a quality of Schulz's writing that, in the Quays' reworking of the text, is similar to what confronts their viewers:

> The meaning of such texts becomes a function of their intertextuality—their place among other texts. The failure of critics to recognize the interpretive demand of these works partially explains the scarcity of interpretive criticism on Schulz. This reconstructive activity is precisely what so many avoid when they stress that Schulz created "his own" strange mythology out of sheer genius. In fact, Schulz's prose is a confluence of mythic streams that could not be renarrativized as a straightforward allegory. Without specific textual criticism, Schulz's prose suffers the catastrophe of "those blind birds made of paper." The reader is left to search the skies and reassemble the flock.[97]

This echoes Deleuze's proposal that any work in a field is itself imbricated within other fields and underscores how comparative exploration of other fields of creative activity can enhance hermeneutic study. Schulz's text is often considered in proximities to Kafka and Walser, and the Quay Brothers' film locates the text in a tradition of cinematic image making. Some of the Quays' artistically sensitive and astute critics have already undertaken a reconstructive activity in their writings. The next chapters will piece together how the Quays transform the "blind birds made of paper" into one of the most intertextual and seminal films in animation and cinema history.

TRAVERSING

THE ESOPHAGUS

3.

closer look into recesses and corners of the Quay Brothers' studio beyond the glass cases and bookshelves reveals how it is brimming with paraphernalia and tools. Compasses, screwdrivers, files, bits and pieces of old metals, puppet armature parts, filigree wires, and pulleys are meticulously arranged in cupboards, shelves, and drawers and attest to the artisanal skills their films require. Much has been written about the alchemy of their films; the *process* of how they achieve this alchemy is rooted in the origins of the word, in transformation but less so than in a search for gold or a philosopher's stone through chemical process. It has more in common with a respectful and deeply curious attitude to vitalist potentials of the commonplace, the forgotten, the arcane, and—on first glance—the banal than with a methodological or systemized searching for materials appropriate to any one film.

Their research and studio process is more often than not rooted in an utterly tactile sensibility and in their notion of "the liberation of the mistake." An example of this emerged from an interest in anonymous architectures and a strong fascination for Hans Poelzig and the entire realm of the Baroque, in particular the German Asam brothers and the Zimmermann brothers. Holding

a postcard of the St. Johann-Nepomuk Church, also known as the Asamkirche (Asam Church) built in the mid-eighteenth century by Rococo architect and sculptor Egid Quirin Asam and his brother Cosmas Damian in Munich, they turned it upside down. What was an ornate, skyward-reaching ceiling vault transformed into a deep, concave space, walls lined with architectural oddities, paintings, plaster decoration, and other religious artifacts, the floor now a ceiling. This ornate grotto inspired the interior space and ethereal, liquid mood of Lisa Benjamenta's refuge, the subterranean realm in *Institute Benjamenta.* The kind of research the Quays undertake respects existing creative origins and identifying features while reinventing them in sets and visual compositions that result in their unmistakable cinematic style. The Quays regard themselves as "authentic trappers," be that in the gentle rummaging at a *marché au puce* in the boxes of detritus hidden beneath vendors' tables; not finding a sought-for book in a library, then discovering on the same shelf another volume secreting an unexpected wealth of images, diagrams, and ideas. In countries they have traveled to around the world, the archive, the used-book seller, the antiques shop, the library, each one with an idiosyncratic ordering and disordering, are the secreted and generative sources of ideas, materials, sounds, music, and figures that find their way into the Quay Brothers' more than thirty films to date.

Distinct from the mythic origins of their preferred authors' descriptions of matter, the objects, architecture, and other elements in the Quays' mise-en-scène have physical, tangible origins. They provide historical references: *objets trouveés,* faded fabrics showing the effects of age and wear, Duchamp-esque readymades, and bachelor machines—all are suggestive of the eras in which their literary sources set their tales. An example of this is Schulz's combing of history, which is mirrored by the Quays' excursions into the locations of these mythologies to gather the stuff, the forgotten materials from attics and museums; in immersions in the emotional capacity of music or in the 8 mm films they shot on their travels; and in the photographs, postcards, and old prints that once were contemporary to these authors and later function as silent witnesses to the atmosphere of many of their works. *Street of Crocodiles* gathers and reassembles fragments of materials from this lost history, transporting Schulz's literary descriptions into the locations that are the sets of the film.

Mapping the architecture, spaces, and objects that are the labyrinth of the Quay Brothers' films, and of *Street of Crocodiles* in particular, means investigating how the architectural constructions and materials create the spatialities particular to the film's world. Critics have described *Street of Crocodiles* as

labyrinthine. I will interpret this in four ways: first, because it takes cues from Schulz's metaphysical descriptions of space and time for its cinematic images (outlined in chapter 2); second, as a collaged, convoluted, and disconnected space littered with puppets and objects; third, to show how discrepancies of scale and miniatures contribute to the credibility of the realm; and finally, to suggest how it becomes labyrinthine in the concrete sense of negotiating a montaged spatial uncertainty. I then propose how the combination of these can incite an animated architectural uncanny.

Labyrinths

While the analysis of Schulz's text concentrated on stylistic features that resonate between the film and his writing, a further element that contributes to manipulations of space, such as are found in Schulz's writings, is one of time. *Street of Crocodiles'* meandering narrative takes us through a labyrinth of spaces that show faint regard for causality or continuity. Ficowski suggests that

> Schulzian time . . . inventively departs from conventional concep-
> tions. Past time returns and exists in the present, elements of dream
> coexist with reality and possess its same density in a fluid, changing
> chronology. Disparate elements of dream and consciousness weave a
> reality existing in an expanded time subject to man.[1]

In the film, shifts in time translate into spatial change. The past often resurfaces in the form of a space's revisitation, as in the two sequences—one a few minutes after the exposition and the second at the end of the film—that formally bracket the puppet's excursion into the mythic time-space of the film's zones, shops, and corridors. As the puppet touches a tangled string, it unravels; at the end of the film, back in the same space, it entangles itself again, a closure of sorts, tying up time's flow as the film's color bleaches to a mythopoetic monochrome. Goldfarb summarizes Schulz's literary methods that suggest a number of affinities with the Quays' visual style:

> Not only is Schulz's writing like a labyrinthine structure, but a laby-
> rinthine map of the city is like a text from the fragmented memory
> of childhood—a text that is labyrinthine in all dimensions (externally
> in its graphic appearance, internally in its logic, continuously on the

dimension of interpretation proceeding from external to internal, then recursively as we negotiate among nested interpretations somehow inside and outside the text, as we create our own interpretations).[2]

Goldfarb's analogy of the labyrinthine text as a fragmented memory of a map of a city is also a surprisingly accurate analogy for reading *Street of Crocodiles*—and the film suggestively begins with a shot of a map. The puzzle is intensified once we slip through the Wooden Esophagus, the passageway between the live action (black-and-white) and the animated (color) realms, and like Lewis Carroll's Alice falling down the hole or Cocteau's Orpheus stepping through the mirror, we enter the Quays' spatial and architectonic interpretation of Schulz's labyrinth.

This movement between realms translates into the Quays' film with attention to spatial and narrative transitions—for instance, in the opening Theater Stage and Wooden Esophagus sequences. In close-up, a small mechanical lens apparatus is perched on a densely drawn black-and-white map. A hand enters the frame and flips the lens down, magnifying a section of the stark graphic map detail that fills the frame. The camera pulls back to an old man who studies the map, then haltingly makes his way through an empty theater, doing preperformance checks. He counts the spotlights and walks up the short flight of stairs, stage left, to the proscenium and moves a lamp on the stage; music begins and he exits to the right of the stage. Up to this point in the film, the live-action images are black-and-white and spatial arrangements are conceptually clear as the camera follows the man and his movements through the room.

This spatial coherence is disrupted by a hard cut that presents a composition of objects, also in monochrome: four close-up still-life shots of a mesh form, a pulley, a scissors, and a bowl of screws shot with macro lenses separated by tracking transitions (two vertical, one diagonal). Because these objects and spaces are unintroduced and diegetically unconnected, the viewer is at a loss as to where they are relative to the previous shot. We then return to the live-action setting and the man enters the frame from the left, moves across the stage to a wooden prop resembling a pulpit or kinetoscope, and looks through the eyepiece at the top of it. Pale blue titles with the words "Prelude: The Wooden Esophagus" are superimposed over the scene. A cut is followed by a vertical pan into a color space with sectioned wood planes and metal apparatus. Cutting back to the actor in medium close-up, he pauses and then, laboring his tongue in his cheeks and mouth, coaxes forth a gob of spit. It drops from his wet, puckered lips and falls into the Wooden Esophagus. On a hard cut an animated simulacrum of the spit

appears, descending into the colored realm, this time shot to show more of the space and objects within. The moment it lands on a bloodied razor blade apparatus, this begins to churn. Interspersed with transitions, the camera pans down through levels of now animated metal objects, including pulleys and a sewing-machine-like apparatus shot in similar lighting and macro lens effects as the earlier shot of black-and-white objects.

A thin, moving string is guided, bloodied, and trailed in, and through these machines and the camera comes to rest on a puppet whose arm is fixed at the wrist in a street lamp, trapped by the same string that courses through the machines. The viewer's comprehension of the spatial labyrinth of these three distinct spaces—the live-action realm, the Wooden Esophagus's interior, and the puppet's surroundings—becomes clearer as we return to the live-action realm, where the old man's hand, in close-up, grasps a pair of scissors on the outside of the Wooden Esophagus. Inside, the puppet pulls at the string. The man's hand makes a cutting gesture and the camera cuts back to the puppet's realm and a close-up of its arm as scissor tips move in and snip the string. Pulleys spin out of control, the puppet's arm is cut loose, and it staggers as it is set free into the realm. These disconnected spaces are connected by the string that courses through all three of them, and it provides the connection that offers clues to disentangle the spatial labyrinth.

Spatial Collage

Film architecture, or what is generally understood as set design, represents a fictional space; it is not completely bound to physical laws, such as gravity or weight-bearing limitations. This puts it in a privileged position in relation to the lived-in spaces of built architecture. Juan Antonio Ramirez assigns the properties of cinematic set design to the following categories: it is illusory, fragmentary, flexible, and movable; it is nonorthogonal and demonstrates distorted size and proportions; it is quickly built and usually quickly dismantled or destroyed.[3] The same conditions apply to the Quays' puppet sets: the actions and movement of the puppets take place within an existing space that presents spatial dimensions and perspectival depth.[4] Set design in puppet animation has a lesser degree of controllability than other techniques of animation because, although a film is shot frame by frame using stop motion, the images are produced in front of the camera using a mise-en-scène similar to live-action studio productions. In *Street of Crocodiles,* the main formal set parameters are texture (materials), spatial

constructions (zones), and scale (miniatures). Yet puppet animation can subvert and expand upon Ramirez's definitions of live-action set design, since the artificiality inherent in film architecture can be exaggerated in puppet animation and does not have to exhibit an architectural logic. Analogous in some respects to live action, puppet set design can be tailored to create illogical architecture and highly artificial spaces. Keeping scale, camera angles, and lenses in mind, like live-action filmmakers, the Quays can "cheat" on architectural requirements, distort perspective, and, since they are building miniature sets, use materials that would otherwise not be feasible on a 1:1 scale. Planning a specific scene often requires combining architectonic fragments that do not have structural coherence, often to enable ease of camera movement.

The Quays' sets are constructed of a variety of materials, including mirrors, posters, fabrics, glass, wood, and metal. Characteristic is a preference for patina, rough edges, folds, and visually rich tactile surfaces—for *Street of Crocodiles* all in keeping with the inspiration from Schulz's descriptions of the alleys, shop windows, moods, and textures in his story. The Quays often use materials that have had a past use in the material world (a strip sample of thread colors that adorns the Tailor's Shop cabinets, screws, doll fragments, cloth), and they reappropriate this past use in the design and composition of the puppet or set constructions. This simultaneously provides a sense of recognition and effects a defamiliarization. The attention given to details—semiopaque films on glass surfaces or carefully sedimented layers of fine dust—creates an effect of both time suspended and time past. Reflecting on their first encounters with the puppet animation technique, the Quays remark that they "could control every aspect of the film[s] to an unvarying degree: literally object by object, limb by limb, frame by frame. You conceive, live, and animate at 1/24th of a second."[5] They develop and build their sets in an intimate tabletop working space where mostly just the two of them are engaged in developing ideas and trying them out: "The first thing you do is build the sets—you're really building your mise-en-scène when you've built the sets. It's important when you say, 'Are there going to be two windows? Is there going to be one window and two doors?'"[6] They have also been assisted with many of the technical challenges of their sets, puppets, and automata by master craftsman and technical virtuoso Ian Nicholas. A furniture restorer by trade, Nicholas has worked with the Quays on all their films since *Rehearsals for Extinct Anatomies,* creating many of the armatures, metaphysical machines, automata, and other devices in the films, including commercials.[7]

The *Street of Crocodiles* sets were built in fragments that were then interrelated and diegetically connected in the editing process. Bearing the Quays' interest in collage in mind, I will explain my interpretation of the collaged, convoluted, and disconnected littering of space in *Street of Crocodiles*. The Quays developed a concept of set design based on this principle, in part because it allowed them the possibility to randomly join architectural images with varying perspectives:

> Architecturally that was the first time that we'd really attempted something on that scale and tried to use space in a way to deliberately confuse. . . . We realized in making [*Street of*] *Crocodiles* that we would need a whole collage technique of putting building fronting onto backs, backs onto fronts, and to sides. It was the easiest way to actually execute that kind of confusion.[8]

As the script itself evolved during filming, the sets were fundamental to its further development. The Quays had to make their most serious decisions when building the set, and sets were often rebuilt or adjusted as they realized something else was needed: "What we thought was the major—the middle—zone had to be sort of central, although when we first built it, we hadn't designed it like that. . . . You realize the necessity as you arrive at that time."[9] As the production team was small, they were able to take this time to adjust the sets as they went along.

There are ten discernible main set fragments that either front onto the central set or are separate interiors, fragments that are also collaged in editing. The Theater Stage is the live-action scene at the film's outset that takes place in a real theater. This set location was extant and corresponded to human scale. The set includes a hallway with a door through which the man enters the theater, the main theater space with chairs in rows in front of a raised proscenium stage with steps on the side leading up to it. The Quays placed the Wooden Esophagus, a vertical construction with structural affinities with a kinetoscope, on the live-action stage. It has three distinct zones that are intrinsic to the shift from live action to animation. The Wooden Esophagus is the intermediary object and passage to the animated, metaphysical realm. The outside of it is seen in the live-action sequence, and the transition from the live-action set to the animated realm is instigated by a glob of spit that originates in the monochrome live-action realm. As the spit falls into the Wooden Esophagus, it is replaced by a similarly shaped animated object and the image changes to color in the same framing that the

live-action shooting ceases and the animation begins. The Wooden Esophagus's interior is a vertically oriented set with horizontal planes of blood-stained metal parts and razor blades, pulleys, and wooden walls. Cutting from the Wooden Esophagus, an Antechamber is introduced as a set fragment of a wall with a street lamp above a door. In crosscutting with the black-and-white exterior of the Wooden Esophagus, scissor tips that appear top right and snip the string holding the puppet's arm suggest that it is standing inside the Wooden Esophagus. The Quays also indicate the difference in scale between the hand using the scissors and the puppet inside the Wooden Esophagus, between the live-action and animated realms.

In *Street of Crocodiles* the main protagonist moves through and explores an architectural space. The film's experimental narrative is partially organized around the puppets' point-of-view structures and relies to some degree on the Kuleshov effect, as does much puppet animation.[10] Once we have left the Wooden Esophagus, we enter the rest of the main Antechamber area, which is a third fragmented set. The diegetic space is constructed in-camera out of separate sections; the doorway, a glass-roofed room, and a wall with a ladder, screen, and hanging gloves were separately built. The main Antechamber is also the point of entry into the Zone that is suggested by moving shadows and offscreen sound. This Zone is the main set that is built around a three-sided central area lined by shop windows, recesses, doors, and the entrance to the Street of Crocodiles, which is the fifth set. It is also the stage for some of the other puppets located in the shop windows surrounding the square. Toward the back of the square and contiguous with it, steps lead to a raised area: this Street of Crocodiles set extends into the distance and is fronted by a decorative entry portico that is embellished with a crocodile sculpture at the top. Buildings with windows lining the left side suggest tenements. The Quays explain how they came to conceptualize this labyrinth:

> [The puppet] is lost in this realm. And as Schulz said, it's the zone marked in white on the map that is ill-defined and can't be defined because they can't map it. That's what I think first drew us to "The Street of Crocodiles" in Schulz, the opening scene, when he talks about the Street of Crocodiles, a certain zone in our metropolis which can't be mapped because it is sort of false. It's a false zone, a forged zone.[11]

In this forged zone the puppet looks through a lit-up window in the Street of Crocodiles, and his point of view reveals a space that contains animated automata: the Metaphysical Museum set fragment is seen through an eyehole. Other than the outside wall that the puppet looks through, the space he sees (and we see) through the window is undefined, in part due to extreme play with focal planes. This set construction appears to be inspired by the peephole window of Marcel Duchamp's assemblage installation *Given: 1. The Waterfall, 2. The Illuminating Gas* (1946–66) that was gifted to the Philadelphia Museum of Art in 1969 (the year the Quays left Philadelphia).

The seventh set—the Hall of Mirrors that fronts onto the Zone—is defined by vertical planes of glass and reflective surfaces that enclose and mirror the diegetic space and also provide glimpses toward a suggestion of offscreen space. The walls and mirrors form rectangular spaces, including a room that is littered with objects: dissected watches, an architectural arrangement of bleached bones, glass cabinets. A significant part of the film takes place in the Tailor's Shop set, one of the shop fronts that the Schulz puppet enters from the Zone as he is lured in by the Tailor. It has two main spaces. The first main space is the entry to the main room of the Tailor's Shop, where the Automaton Waltz takes place and where the Schulz puppet is refitted with a porcelain head. The second main space (the ninth set fragment) is the Tailor's Back Room, which houses the Tailor's collection of erotic objects. At the end of the film, the puppets move through an arrangement of Passages (the tenth set fragment) and through the Hall of Mirrors, returning to the Tailor's Shop. This is also the penultimate scene, followed by a final scene in which Schulz is seen crouching in the Wooden Esophagus's Antechamber with a text passage superimposed above him. Besides the ten set fragments that are the puppets' diegesis, there are a number of mechanical apparatus shot mostly in close-up and medium close-up, similar to the ones in the Metaphysical Museum. These machines—pulleys with wires propelled into the distance, a bowl of metal parts, a rubber-band machine—were filmed in brief sequences in spaces that appear independent of the rest of the film's spaces and are intercut with them to suggest the vitalist life of machines and automata in the film. The interiors, as with most of the puppet animation films, seem to be airtight. It is hard to imagine that a gust of wind ever disturbed the accrued, sedimentary dust that glows softly in the bright light that infiltrates these spaces. These are akin to Bachelard's drawers, chests, and wardrobes, like a "lovingly fashioned casket [that] has interior perspectives that change constantly as the result of daydream. We open it and discover that it is a dwelling-place, that a

house is hidden in it."[12] Bachelard's unparalleled phenomenological exploration of spaces evoked in literature and poetry relates these to the creative imagination of memory and dream. Together with these interludes, the collaged set fragments interconnect to create the world of the film.

Miniature Worlds

The Quays' interpretation of Schulz's labyrinthine spaces takes place in a world that is in miniature scale. In "The Philosophy of Toys," Charles Baudelaire writes of the powerful nature of children's toys and of a toyshop asks the question, "Is not the whole of life to be found there in miniature, and in forms far more colourful, pristine and polished than the real thing?"[13] During screening, these miniatures appear in proportional relation to the space and architectures that present a world that is miniature no longer; rather, it is the world of the film. One profilmic aspect of scale is pragmatic: most sets are arranged so animators can work around them when manipulating puppets or other objects within the set (see Plate 8). They can be constructed in such a way that sections of a four-walled rectangular room can be moved away during close-ups or other shots. The scale of the spaces is proportionate to the puppets' own size. In *Street of Crocodiles* the Schulz puppet is approximately thirty centimeters in height; the rooms, alleys, and interiors were designed in accordance with its anthropomorphic proportions. (A puppet is seldom placed in a natural setting or an existing architecture built to regular human scale; if so, this emphasizes the difference between puppet and human proportions.) Puppets occupy a space constructed to accommodate their relative size. They walk through doorways, sit on chairs, look through windows, and sit at tables that have been built to scale.

We may become aware of the actual size of such an object being used in an unconventional way; there are sequences in *Street of Crocodiles* and other films that subvert proportional rules. The Quays occasionally include elements and tools of their own handwork: screwdrivers and hand scissors (like those we would find in a workshop drawer at home), tips of a scissors that looms over a puppet, a tiny scissors held by the Tailor. They also suggest the absent human hand that would use this tool and, in a fleeting moment, we become aware of the actual size of the sets, imagining the size of the hand that would hold the scissors, enormous in relation to the set. The diegetic appearance of the animator (see Figure 6) or the metonymy of scissors or tweezers is frequent enough to be considered a defamiliarizing function of the films. In the Metaphysical Museum ice cubes or dandelion

clocks that are placed in the frame call attention to the size of the human hand that picks them. Elsewhere we see these objects in the same frame as one of the puppets, breaking the illusion that the scale is equivalent to human proportions.

There are perceptual and experiential implications of the miniature for our cinematic experience of *Street of Crocodiles'* narrative. Camera framing and perspective allow us to experience the world on-screen as one we can understand, yet we know that these objects and spaces are much smaller than they appear to be. Susan Stewart has analyzed the ways in which everyday objects can be narrated to realize certain versions of the world: "That the world of things can open itself to reveal a secret life—indeed, to reveal a set of actions and hence a narrativity and history outside of the given field of perception—is a constant daydream that the miniature presents."[14] This echoes Schulz's microcosm, and part of the enchantment of the film has to do with animation of inanimate things and particularly with the miniature aspect of them.

Stewart refers to a passage in Charlotte Yonge's *History of Sir Thomas Thumb* (1855) that describes young Tom's first days in the world and how natural materials are transformed as miniatures:

> The miniature has the capacity to make its context remarkable; its fantastic qualities are related to what lies outside it in such a way as to transform the total context. Thistledown becomes mattress; acorn cup becomes cradle; the father's breath becomes a cyclone. Amid such transformations of scale, the exaggeration of the miniature must continually assert a principle of balance and equivalence, or the narrative will become grotesque.[15]

There are moments when the narrative of the Quays' film does become grotesque. Stewart proposes that "the hand [is] the measure for the miniature,"[16] and while this is self-reflexively evident when everyday objects like scissors are placed in the sets, the Quays do not strive for the principle of balance and equivalence Stewart mentions. Equivalence between nature, familiarity, and scale is constantly undermined, in that objects are foregrounded without explanation, without a contrived simile to a natural representation. Susan Sontag has suggested that there is a beautification of the grotesque, the common, and the ugly by virtue of being photographed.[17] The Quays' lingering shots extend this photographic beauty into a mythopoetic one: dandelion clocks are gossamer rainfall; pulleys become titans; dust, an adumbrating cloak (see Figure 10).

This is heightened by the images' haptic qualities. Examples of this are the Screw Dance's choreographed screws and the Metaphysical Museum scene's dandelion clocks and ice cubes (familiar from *This Unnameable Little Broom*). We see them through the small window, doing what it is that dandelion clocks and ice do: the seed filaments detach from the center to become a fluffy cloud, and the ice melts and reconfigures itself in reverse. There is no reason for these to appear in the film, no narrative motivation. We see them simply as a spectacle of the miniature, a performance that has the sole point of celebrating itself. Shot in close-up with macro lenses, their gestures become gargantuan and spectacular, although we can estimate their actual size by comparing them to screws, ice cubes, or dandelions we know in the phenomenal world.

Figure 10. A metaphysical machine from *Street of Crocodiles* (1986).

Stewart discusses transitions in written narrative from the inanimate to the animate: "In the depiction of the still life, attention is devoted to objects, but once the inanimate is animated, the parallel problem of description of action must be placed against the depiction of objects."[18] In the film, narrative is often interrupted by a scene or shot of one of the machines formally treated in such a way that it has the calming effect of watching a still life or exhibits an element of the spectacle. The difficulty of description of action versus object also arises in the scene with the trio of screws. Describing the screws themselves is relatively straightforward—composition, spatial relationships, textures and shapes—but once they begin to move, to unscrew themselves from surfaces in rhythmic movements that suggest complicity with the music, we begin to interpret the actions. The Quays describe how the screws in their film acquire a sense of presence:

> Cel animation showing a screw coming out of the ground would only be a screw coming out of the ground in two-dimensionality. The point is that it can't be a clean screw, either. The important thing is that you felt that it was buried there for centuries, and it's sort of become unmoored, like migration.[19]

These hiatuslike cameos are scattered throughout the film. They are rarely inanimate, and attempting to describe their actions leads either to a description of movement or to a psychologizing of them in relation to one of the figures. Marks proffers that haptic visuality—which is what these cameos generate—requires the viewer to work to constitute the image, "to bring it forth from latency. . . . In this mutually constitutive exchange I find the germ of an intersubjective eroticism."[20] This can explain in part the fascination the Quays' films hold for many viewers, as the filmmakers experiment with a visual erotics Marks defines as "one that offers its object to the viewer but only on the condition that its unknowability remain intact."[21] The need to describe action of the animated inanimate is thus replaced by a sensual lingering, a haptic eroticism, that remains spectacular.

Stewart proposes that "there are no miniatures in nature: the miniature is a cultural product, the product of an eye performing certain operations, manipulating, and attending in certain ways to the physical world."[22] In *Street of Crocodiles,* the Quays take this a step further by including cultural and aesthetic references through their use of materials, styles, and objects familiar to the viewer, and objects from nature or from everyday use (screws or scissors) emphasize the artificiality. A related visual trope is that of recycled and reiterated gestures, the empty movements that emphasize the nonhuman condition of automata: screws rotate aimlessly and the Tailor's Assistants' arms rotate in their arm sockets. A rubber band machine is either just that or it is a metaphor for the vitalist, soulless urge of the Street of Crocodiles, transformed into a repetitive-compulsive gesture by the camera movement, framing, and sound.

The miniature is perceptually close to our experience of the fantastic. Neither the miniature nor the fantastic exists in the natural world; each is co-created by the observer. The Quay Brothers seem to understand the fantastic as Tzvetan Todorov defines it: there is a moment of hesitation between a phenomenal and supersensible explanation, distinct from both the uncanny and the marvelous that have a natural explanation. The fantastic, however, is when the reader (or viewer) cannot decry whether a narrative phenomenon belongs to the genres of the marvelous or the uncanny, as the fantastic exists between these two categories.[23] Todorov's category of the fantastic is "that hesitation experienced by a person who knows only the laws of nature, confronting an apparently supernatural event."[24] This is the apprehension (a term I describe in more detail later in this chapter) I will suggest their films can evoke. The Quays are cautious in their use of the fantastic:

If you are thrown too much into the fantastic, so that you lose all handhold, then it defeats you. In a sense you create a fantastic world, like in the Gilgamesh film [*This Unnameable Little Broom*]. It is important to establish that [the puppet] has certain functions in that world, so that when further elements of the marvelous happen, you can move up to that plane, then back off, and then come back down.[25]

The fantastic is an aesthetic means to express a visual correlation for the permeable borders between reality and vitality, between natural physical laws and the increasingly seamless inclusion of fantasy in fictional realism. Watching the scenes described above, we oscillate between understanding that this space exists outside the cinematic experience—in constructed miniatures—and giving ourselves completely to the haptic experience of aestheticized, defamiliarized objects. A still or single-frame image can still be contextualized as a moment isolated from a continuum of living and moving through the world, whether cinematic or real. This is, of course, part of the reason the Quays can construct narrative that uses miniatures, but in their framing and convergences of scale within the frame, they appear believably proportional, are haptically experienced, and we engage with them emotionally as the animation reveals its secret "life." These indefinite spaces and the objects in them contribute to the otherness of the realm, a disjunctive no-space that creates a particular sensation of spatial uncertainty.

Spatial Uncertainty in *Street of Crocodiles*

A distinct feature of *Street of Crocodiles* is the singularity of its interiors. Yet if the film intends to establish a sense of an extended world beyond the diegetic space, offscreen, nondiegetic space must also be suggested as an extension of on-screen space to create a sense of continuity with what we see on-screen. Although the puppets' gazes seldom wander beyond the perspective of the film's sets, we can imagine an offscreen imaginary space that is based on the spaces the film has already presented. The space is even more contained because shots suggesting natural surroundings of the film's location (urban surrounding or countryside, sky) are extremely rare in this and almost all Quay films, or they are highly stylized, as in *The Comb, Ex Voto* (1989) and *In Absentia* (see Plate 15). When the puppet enters the Antechamber, we see the sky through the glass roof (and in the alley off the Zone); although there is an indication of sky and perspectival horizon, the film's realm seems hermetically sealed off from its surroundings, much

like Schulz's urban environmental descriptions. What kind of extended city or world surrounds and contains the spaces we visually experience? Are they similar to the ones in the frame? If not, can we imagine what they might be?

Burch defines six segments of offscreen space as the four borders of the frame, the space behind the camera (not geometrically defined), and the space behind the set or some object, and he divides these into two categories: imaginary and concrete.[26] In *Street of Crocodiles,* offscreen space on the whole remains imaginary. In the Dark Mutterings sequence (9:31–10:20), the puppet looks behind a wall into a dark space and perspective lines that would indicate it does actually have a finite containment disappear as the intensity of light reduces to complete darkness. The sound track's whispering voices and mechanical workings of pulleys that transport a string into the dark seem to originate from this deep space, cueing the puppet to look behind the wall. The void beyond remains obscure and undefined. The Quays describe motivations for the spatial and aural mood of this scene:

> What we wanted was that you felt that these strings were going someplace and being pulled by some force unknown, and you actually see the pulleys stop. But we found in the end that the string should be pulled by forces that even he [the puppet] should have no idea of. The puppet is trying to discover where the forces may go and where they emanate from. But also you don't know in the end whether it's the Tailor, because earlier you saw the Tailor winding the strings up, so, in a way, it's a malevolent repetition.[27]

There are a few scenes where an offscreen space suggested by a look or a gesture becomes what Burch calls "retrospectively concrete."[28] In the Hall of Mirrors we first see the puppet in close-up behind mottled glass. Over the course of these shots, the camera pulls back to medium and then medium-long to reveal the set that is constructed of glass and mirrors. The complexity of the Quays' construction of space and use of ellipses creates ambiguous space where the viewer cannot reconstruct where she is in the film. Most of the film's offscreen space is imaginary and evokes active engagement with a related tension that Burch describes as predictive:

> This off-screen space might conceivably remain imaginary if no wider shot, no shot taken from another angle, or no camera movement is

introduced revealing the person to whom an arm belongs, to whom an off-screen glance is directed, or the exact off-screen segment toward which an exiting character is headed.[29]

By not alleviating the expectation with a concrete space, the film undermines our sense of orientation. This is especially the case in the shots and scenes with the Metaphysical Machines. Except for the ones in the Zone's shop windows, the Hall of Mirrors, and the Metaphysical Museum, we are given no indication where they are in the film's spatiotemporal construction. Because such spaces are not located per se in the other sets or justified within the narrative, they have both a decorative effect and one that elicits intellectual uncertainty. (This will be discussed in more detail below in the context of an animated architectural uncanny.)

There is a third kind of out-of-field that is worth considering: the nondiegetic space in which a film set is built (see Plate 8). A recurring awareness during watching *Street of Crocodiles* (and perhaps any puppet animation film) that can momentarily break engagement with the film's fictional world is the knowledge that the set is small scale and positioned in the artists' studio. This is the kind of knowledge that we tend to suppress; otherwise, we are recurrently preoccupied with what its spatial relations are to the rest of the room: Where are the filmmakers standing? How is the set positioned? If more than one set is used in the film, where is it placed in relation to the one we see on-screen? *Street of Crocodiles* is a set of interiors, but in what relation do these interiors stand to off-screen space that is not part of the diegesis, of the cinematic realm we see? The Quays thus disrupt our expectations of the spatial relations of beside, through, in, and beyond. In the film, the space flows; it is unlimited and undefined, obeying its own logic; we are not given enough visual clues to imagine a rational extension of the real space offscreen outside the shooting setup. This disruption of expectations can elicit a number of viewer responses, and one I am particularly interested in is apprehension—an experience outside individual personal, historical, and aesthetic experience, perception, and cognition, caused by intellectual uncertainty, an uncertainty that has its origins in the uncanny.

The Animated Architectural Uncanny

The architectonic world of the Quays' puppet animation films undermines our rational and phenomenological experience of built architecture. The intrusion of cinematography into the dimensions of architectonic space effects a whole

series of essential aesthetic, phenomenological, and practical shifts. As Helmut Weihsmann notes:

> Cinematic architectural designs provide insights into fantasies of form and space, they can reveal what prima vista remains hidden to the observer or what remains hidden without the cinematic apparatus. . . . Film can be an instrument for reading architecture.[30]

French filmologist Anne Souriau identifies three functions of décors as affecting the reading of the (live-action) film set: decorative, which is pleasing; localizing, which provides information about the film's events; and a symbolic function that "permits [the film] to express what either cannot be said or is best left unsaid, thereby investing the film with ideas and feelings, with signification."[31] There is another aspect of our experience of architecture in the Quays' films that is particularly compelling. Taking into account Souriau's concept of symbolic set design as expressing feelings, animated techniques can effect in us a private, personal, and often incommunicable experience: that of the uncanny.

Victoria Nelson suggests that "it might be argued that the great Western critical voyage of discovery over the last century has been that of reinterpreting all phenomena of the universe within a secularised psychological framework."[32] One of these is Sigmund Freud's notion of the uncanny, one of many contributions he made toward secularization of human experience. Anthony Vidler reframes this in terms of architecture and space as what he calls the "architectural uncanny":

> Architecture has been intimately linked to the notion of the uncanny since the end of the eighteenth century. At one level, the house has provided a site for endless representations of haunting, doubling, dismembering, and other terrors of literature and art. At another level, the labyrinthine spaces of the modern city have been construed as the sources of modern anxiety, from revolution and epidemic to phobia and alienation.[33]

Synthesizing the individual features of set design and architectures, textures, puppets, and automata, a particular feature that runs through many of the Quays' films comes to the fore: an animated architectural uncanny, an attribute that has affinities with the uncertainty of *Street of Crocodiles'* labyrinthine structures.

This concept illuminates the Quays' merging of historical architectural references and the vitalist undercurrent imagery that texts from Walser, Schulz, and Kafka invoke. Because the film is a photochemical record of indexical reality, the uncanny relates as well to Susan Sontag's suggestion that "as photographs give people an imaginary possession of a past that is unreal, they also help people to take possession of a space in which they are insecure."[34] The disorientation that the Quays' fragmented, collaged sets evoke originates in an intellectual insecurity, a significant factor in the experience of the sense of the uncanny.

Freud's concept of the uncanny *(das Unheimliche)* derives from a set of German words—*Heimlichkeit* (secrecy), *heimlich* (secret), and *heimelig* (cozy, homey, homely), words defined in Daniel Sanders's *Wörterbuch* of 1860,[35] words that express both a sense of happy, secure domesticity and one of privacy. The bourgeois home *(das Heim)* had such a high value in the late-nineteenth century because it was threatened by the relentless engines, both mechanical and metaphorical, of industrial development. It became an ambivalent idea in a period of uprooted traditions that were ultimately put to question by Freud. Vidler notes that "Swabian and Swiss authors seemed especially susceptible to such notions,"[36] and they are central to the literary styles of Walser (a Swiss) as well as Kafka and Schulz. For *Street of Crocodiles,* the Quays were inspired by Eastern European villages and alleyways, imagery, and filmmaking—visual tropes that suggest a lost *Heimlichkeit* and *Heimat* (homeland) and carry the unfamiliar and the unknown with them, in part due to the isolation and alienation of these countries when the Communist regimes took power. Some of their later films foreground Swabian-related Bavarian ornaments, interiors, and typography to create a mood that is both familiar and sentimental, but also pervaded with a sense of dread that arises from particular associations to the stiff, self-imposed restrictions of the German *Bürgertum* (bourgeoisie).

In his reading of Freud's 1919 essay "Das Unheimliche" (translated into English in 1925 as "The Uncanny"),[37] Vidler addresses an essential idea pertaining to space that has compelling potential applications to the cinematic experience of puppet animation:

> The uncanny is not a property of the space itself nor can it be provoked by any spatial conformation; it is, in its aesthetic dimension, a representation of a mental state of projection that precisely elides the boundaries of the real and the unreal in order to provoke a disturbing ambiguity, a slippage between waking and dreaming.[38]

This mental state is articulated as experience in the worlds evoked in Schulz's and Kafka's writing about the life of objects, and it is represented in the Quays' film by the Schulz puppet's slippage between the Zone (dreaming) and the Antechamber (waking). While Freud aims to establish a set of general effects, I am particularly interested in one of his notions: that one factor in the production of the feeling of uncanniness is intellectual uncertainty.

It should be clear by now that I assume the spectator is actively involved in a variety of ways that contribute to her particular understanding of the film. Bordwell suggests that "comprehension is concerned with apparent, manifest, or direct meanings, while interpretation is concerned with revealing hidden, nonobvious meanings."[39] The hermeneutic engagement with the Quay Brothers' complex works triggers a reaction related to the uncanny that precedes interpretation and contributes to understanding their films: apprehension.[40] Apprehension is the cognitive condition of understanding; it means grasping something with the intellect, but it can also mean a grasping without affirmation of that intellection and an anticipation that what may come may not be what is expected. Apprehended knowledge can be firsthand and sensory, as in the case of children, when they apprehend that a flame can burn and cause pain. It can also be knowledge that comes from others—for instance, abstract concepts that conflict with our direct sensory, or phenomenal, apprehension. The Quays' films contain many unexpected visual and aural tropes and often use a montage dialectic of disorientation. Apprehension occurs at the moment that the viewer experiences the laws of their film's world, laws that exceed our own phenomenal experiences of reality, that cannot be explained by the material/mechanical origins of what we see, and this is the moment when interpretation can begin. Mark Bartlett suggests that

> apprehension means that comprehension can never be complete, that interpretation can never account for everything in a phenomenological experience. It is valorized in that knowledge in any sense is always incomplete, always partial, which is another justification for microanalysis and a turn away from grand unified theories.[41]

The concept of apprehension I am using—a grasping without affirmation of intellection and an anticipation that what may come may not be what is expected—underpins my analysis of the Quays' films and of the spectator's experiences of defamiliarization and alienation and their psychological/emotional effects. In

other words, the sense of the uncanny in *Street of Crocodiles* is intimately bound to one's own perception and cognition of the world that informs the experience of the film's world.

Vidler has located a spatial and architectural uncanny, specifically in reference to "architectural speculation on the peculiarly unstable nature of 'house and home,' to more general questions of social and individual estrangement, alienation, exile, and homelessness."[42] He points out that the uncanny has been linked to architecture since the end of the eighteenth century, well before publication of Freud's seminal text. Vidler traces the spatial uncanny that he describes as developing "out of the aesthetic of the sublime to its full exploitation in the numerous 'haunted houses' of the Romantic period imagined by Victor Hugo, Thomas De Quincey, Charles Nodier, and Herman Melville."[43] This list of authors, who aimed to flee their contemporary realities, can be expanded to include Kafka and Schulz, both of whom can be regarded as a variety of late Romantic authors. Haunted houses were prominent in early—silent—animation films, and the "trick" technique of single-frame shooting brought houses to life, as did Georges Méliès's enchanted trick films, James Stuart Blackton's *The Haunted Hotel* (1907), and many of Charles Bowers's films. This trope continues to be a recurring theme in animation.[44] The house is often dismembered, and it often visually develops in parallel with the main character's slow shift to madness. Staying close to Freud's own discussion of E. T. A. Hoffmann, Vidler discusses Hoffmann's short story "The Sandman":

> It is in no way accidental that Hoffmann's almost systematic exploration of the relations between the homely and the unhomely, the familiar and the strange, extended to an equally subtle examination of the role of architecture in staging the sensation and in acting as an instrument for its narrative and spatial manifestations. Hoffmann was himself an amateur architect, stage set designer, and "collector" of strange houses.[45]

The Quays made a dance film based on Hoffmann (which is discussed in chapter 7), and other filmmakers have interpreted Hoffmann's short story. Paul Berry's puppet animation *The Sandman* (1991) draws directly on his explorations of how staging space can create an uncanny sense. Extremes of geometric abstraction and exaggerated human behavior and movement create a fantasy world between waking and dreaming, in which inner sensations become an active part of the

protagonist's outer, experienced world. Vidler describes Hoffmann's synthesized inner and outer worlds:

> Hoffmann, despite his accentuated irony, found in architecture the tangible sign of a musical harmony unattainable in sound. He also "designed" with meticulous care the settings of his stories, delineating spaces that, sympathetically as it were, resonated to the psychological dimensions of his characters, not simply the illustrations of primitive Gothic terror but the constructed equivalents of the psychological uncanny in architecture.[46]

Schulz's tale and his descriptions of his stories' settings and objects bear comparison with Vidler's description of Hoffmann's texts. His account of Hoffmann's attention to architectural subtleties rings true for Schulz's evocation of spaces that are in close psychological proximity to his characters. Even in the short story upon which *Street of Crocodiles* is based, Schulz creates a mood in keeping with the sense of loss and longing for another, more *heimelig* (cozy) environment. Although the film makes limited direct references to the written text, there are scenes and settings that are direct representations of architecture described in the story. The following passage from *The Street of Crocodiles* could almost be a reverse ekphrasis, a literary description of the Quays' Zone set:

> One could see there cheap jerry-built houses with grotesque façades, covered with a monstrous stucco of cracked plaster. The old, shaky suburban houses had large hastily constructed portals grafted onto them which only on close inspection revealed themselves as miserable imitations of metropolitan splendour. Dull, dirty, and faulty glass panes in which dark pictures of the street were wavily reflected, the badly planed wood of the doors, the gray atmosphere of those sterile interiors where the high shelves were cracked and the crumbling walls covered with cobwebs and thick dust, gave these shops the stigma of some wild Klondike.[47]

The uncanny ambiguity between waking and dreaming especially evident in *The Comb, Rehearsals for Extinct Anatomies, Nocturna Artificialia,* and *Street of Crocodiles* can be interpreted as cinematic representations of mental states; the "slippage between waking and dreaming" takes place on the screen. This was a favored

topos of the surrealists, although it is generally accepted that the Surrealists gave no indication of being beholden to Freud's concept. Hal Foster renegotiates a link between Surrealist principles and the uncanny. As it expands Vidler's discussion and my argument, I would like to linger briefly on one discourse with which Foster engages.

There is an expression of the architectural uncanny in the film that relates to animation's use of what Foster calls the "prized emblems in surrealism: romantic ruins . . . evocative of the space of the unconscious . . . and modern mannequins, with the status of both intimate and alien."[48] Foster goes on to describe the uncanny aspect of these two tropes: "In short, in both images the animate is confused with the inanimate, a confusion that is uncanny precisely because it evokes the conservatism of the drives, the immanence of death in life."[49] This is also evident in the literature discussed in chapter 2 and is indeed one of the defining features of those authors' writing: the animistic bringing to life of inanimate objects. *Street of Crocodiles* makes heavy use of these two types of images and features spaces full of ruinous passages and references to "dead" architecture, rooms, townscapes, and streets. And, as we will see in chapter 4, the second trope prevails in doll-headed puppets with protruding armatures, bolts, wires, or actual screws that have a subterranean life of their own.

By incorporating automata in puppet and object design and "romantic ruins" in their sets, the Quays create an especial capacity to suggest the uncanny. According to Freud, "this uncanny is nothing new or alien, but something which is familiar and old-established in the mind and which has become alienated only through the process of repression . . . something which ought to have remained hidden but has come to light."[50] The Quays' eerie use of familiar objects in a collaged and montaged spatial uncertainty and the illusion created by the cinematic apparatus bring this "something" to light twofold: the bringing to life of inanimate objects on the one hand, and the cinema's capacity to allow us to experience what we logically know is impossible but secretly wish is not. The fundamental principle of all puppet animation films—the animation of the inanimate—goes against logic in terms of our experience of the phenomenal world.

The uncanny, intellectual uncertainty, and apprehension also incite what Freud calls an animistic wish for omnipotence, which "relates to the unrestricted narcissism of an [animistic] stage of development, which [strives] to fend off the manifest prohibitions of reality."[51] For the viewer of the Quays' films, the "manifest prohibitions of reality" are circumvented in the experience of a pleasure that Michael O'Pray describes:

the idea of a certain pleasure achieved by animation (not all of course) wherein we identify with its virtuosity. . . . It is not simply a characteristic of the animation but somehow is an integral part of how it affects us. In this virtuosity where form and content reach a perfection, there is the deepest pleasure because we are confronted with a control and importantly, the very fantasy of that control in the animated figures. . . . Our desire to will something without in fact acting upon it is acted out in animation itself through the virtuoso use of forms.[52]

While O'Pray is discussing drawn animation, the "desire to will something" is a desire that Schulz possessed and gained pleasure from through his writing, and while we know the puppets and objects in *Street of Crocodiles* cannot be experienced as real, we gain an omnipotence-related pleasure from their animate behaviors. Freud suggests that "as soon as something *actually happens* in our lives which seems to confirm the old, discarded beliefs we get a feeling of the uncanny . . . the whole thing is purely an affair of 'reality-testing,' a question of the material reality of the phenomena."[53] Freud concludes that "an uncanny experience occurs either when infantile complexes which have been repressed are once more revived by some impression, or when primitive beliefs which have been surmounted seem once more to be confirmed."[54] The revival of a sense of omnipotence helps the viewer to escape the unsettling experiences of intellectual uncertainty and its related apprehension while retaining the pleasurable ones. Thus, the animated architectural uncanny is not only confirmation of the animistic wish for omnipotence, which we could regard as desire in Schopenhauer's terms of the will-to-live, but also a return of the repressed belief that the dead can be resurrected (screws frolic, automata live). Nelson suggests that "consuming art forms of the fantastic is only one way that we as nonbelievers allow ourselves, unconsciously, to believe."[55] It may not be overstating that the fantastic elements in the Quays' film (and, indeed, in many puppet animation films) can contribute to fending off the "manifest prohibitions of reality," redeeming the lost state of belief in contemporary secular experience.

The Quays' engagement with spatial themes of inside/outside and imagined/experienced mirror Schulz's continual negotiation between real and metaphysical worlds. They transform the objects and materials they work with into imagery that expresses both real and imagined experiences of space, imagery that is co-created by the viewer. Atkinson has suggestively described the Quays'

narratives as "parabolic."[56] Whether labyrinths, zones, or maps, what predominates in these two artistic works, text and film, is a preoccupation with differences between metaphysical description and the phenomenal world, and with dream and disorientation. The collaged set fragments and the ones the Quays suggest offscreen, and the way they are constructed in editing, create the architectural labyrinth of *Street of Crocodiles*. This combination, which evokes a sense of the uncanny (and apprehension), locates their works in an anachronistic Sturm und Drang (storm and stress, the German precursor of English Romanticism), yet it is not pure. It is tainted by surrealist gestures, an aesthetic of erotic psychopathology, and the ruddy, bloody wonders and machineries of medieval occult and prepositivist science, which recall Zielinski's "an-archeology" of technological vision described in the Introduction. Manifest throughout is a sustained engagement with metaphysical concepts, using puppet animation to transcend the physical and corporeal nature of the materials they use. The Quays describe their spatial conceptualizations:

> In the puppet films, we came to terms with conceiving of space:
> whether it was to be stylized (the great privilege of animation)
> or realistic, a metaphysical space or a fantastic, nongeographical
> space, a mental configuration. . . . Whatever form the space took,
> it was always firstly a poetic vessel through which the fiction
> would course.[57]

Besides being referred to as surrealists with regard to their early films, the Quays and their works can be placed in contexts of architectural postmodernism and deconstruction. The Passage de L'Opera in Paris, demolished to make way for nineteenth-century city planning, is an image that inspired some of *Street of Crocodiles'* set design,[58] and it is also one of the images Breton described in his examples of romantic ruins. A viewer's response to an Internet review published online in 2002 also makes a distinction between the general use of surreal and Breton's definition of the term:

> Seeing *Street of Crocodiles* and some of the Quays' other short films
> some years ago was one of those experiences that changed me forever,
> and I continue to wait impatiently for each new film. They say here
> that they are tired of the term "surreal," which is indeed overused, but
> it has always seemed to me that they, more than anyone else work-

ing today, realize Breton's definitions of surrealism, and particularly his notion of "convulsive beauty." If their work is not "explosante-fixe, erotique-voilee, and magique-circonstancielle," what is?[59]

The Quays' sets and puppets are often included in displays at festivals. Encouraged and supported by Edwin Carels, in 2007 they developed the *Dormitorium* exhibition and constructed a collection of *Wunderkammer,* eighteen cases of their meticulously crafted sets and stage designs.[60] What fascinates is not simply the detail and the miniature scale; the *performance* of these sets in the cases also pulls the observer in. Bending over to look into the nonperspectival depth of a set from *The PianoTuner of EarthQuakes* or peering through one of the convex glass windows, the distorted vision of a set fragment becomes cinematic, similar to the macro lenses and focus pulls the Quays use in their films. In the noncinematic stillness, puppets and objects no longer dominate and define the space. The sets' materials are the stars here: fabrics and cultivated dust *(Street of Crocodiles),* nurtured patinas on metal and wood *(The PianoTuner of EarthQuakes)* (see Plate 20), mottled and textured surfaces *(This Unnameable Little Broom)* (see Plate 4), starry iron filing "fur" (see Plate 9), air-layered paper sculpture *(The Calligrapher)* (see Plate 15). The opportunity to linger over exquisite detailing that can go undiscovered in a film's crepuscular lighting and time-based projection is one of the exhibition's attractions. Although they provide audiences the opportunity to see the relation between the screen world and the mechanical and technical investment required for puppet animation, for the Quays, these displays are not representative of the films:

> They are in no way meant to be seen as finished objects when seen in isolation out of the natural context of the very films themselves. They lack entirely the further additional multiple potentials of sound, music, lighting, the choreography of rhythm and movement of puppets or objects through framing; and lastly, the interpretative mise-en-scène applied to all these. Retroactively, they are a reminder of the static imitation of the film's otherwise natural evanescent flux.[61]

The sets are the environment for the films' "actors"—the evanescent flux of the puppets, vitalist automata, and metaphysical machines.

PUPPETS AND

METAPHYSICAL MACHINES

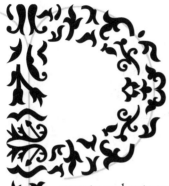

uppets and automata have transfixed audiences for centuries and hold a prominent position in artistic and critical discourses around cultures, human behavior, and the imaginary world. They continue to have a huge range of use within contemporary arts, performance, and film. Until the cinema developed as a reproducible medium, it was mainly in puppet theaters, public exhibitions, and private salons that audiences experienced these empty vessels often modeled on human likeness. They were also prevalent in the post-Enlightenment period, coinciding with German Sturm und Drang (storm and stress) and the Romanticism that followed, a period during which a number of significant philosophical treatises and doctrines reacting against rationalism and empiricism were written. In literature, authors including Ludwig Tieck and E. T. A. Hoffmann describe the world of these stand-ins for human behavior. Literary works and treatises, such as Heinrich von Kleist's "On the Marionette Theater" (and later, Schulz's "Tailors' Dummies"),[1] reacted to these discourses, and Richard Weihe has written about how Georg Büchner also formulated thoughts on the marionette as a metaphor for the relationship between the individual and society.[2] All include thoughts on the automaton's maker and his (rarely her) relationship with it. While many of these uses of and concepts for puppets are valuable, I am interested in how the fact of their presence in the phenomenal and cinematic worlds implies a different viewer experience. The Quays' automata and puppets act as intermediaries between

the filmmakers' tabletop world and the world they evoke on-screen; they are, as the creators, embodied in their puppets. The main issues I concentrate on in this chapter relate explicitly to the Quays' puppets: the role of the animator in creating movement and its overlaps with and distinction from puppet theater; a taxonomy of the Quays' puppets and their contextualization within a specific corpus of puppet animation; specific phenomena that enable the viewer's engagement with these constructions of inanimate matter; and finally, how the Quays' juxtaposed puppet constructions engender the viewer's dislocutory, co-creational participation.

The Quays' studio is a tactile atmosphere populated by strange and exquisite objects. Puppets they have built and used in their films are perched on books or jumbled together in dusty piles in glass display cabinets. A cymbals-holding monkey windup toy that could fit in a hand lies in close proximity to a dominatrix doll with a boldly painted face and naked breasts; the Alice puppet from two *Stille Nacht* films is on tiptoe, immobile. Suspended by strings or collecting their own private dust on shelves, they seem to lie waiting for their opportunity to slip into one of the films. Imaginative commodification of fragments and objects is part of the Quays' charm as artists, and their puppets and objects alter the experience of materials in two ways. The obvious one is their use of the puppet animation technique, which endows nonorganic and organic matter with the illusion of movement. The other, more subtle way, both elatory and disturbing and shifted into the realm of poetry, is the synesthetic effect of music, movement, and textures. Images of dust-cloaked objects pulled out of sleep, induced or accompanied by unusual sounds, are recurring tropes and form a dominant aesthetic element of the Quays' animation.

The Quay Brothers have made dozens of puppets themselves or with assistants. Many of their puppets seem to share unmistakably Quay-ish qualities; others seem to drift away from what we come to expect from one of their characters. In their own words: "Puppet films by their very nature are extremely artificial constructions, even more so depending at what level of 'enchantment' one would wish for them in relation to the subject, and, above all, [depending on] the conceptual mise-en-scène applied."[3] The technical roles vary from film to film, and each of the filmmakers ultimately does everything, from lighting and set design to shooting and animating the materials in front of the camera; these roles are usually accredited to both of them in the films. While they both build puppets, the puppets are treated differently: "Whoever builds the puppet animates it, as he has come to terms with its possible life beyond deadness and

has a vision of how it moves and the vision it might represent for him."[4] The move from collage to puppet animation in the late 1970s also meant a shift in the Quays' interest in other artistic concepts and production: "Puppets always held a strange mystique for us—the power of the mask, its 'otherness,' the fact that you had to 'read' them."[5] The new dimension of architectural space meant they had to find a way to express their graphic style in a new set of parameters. Without training in puppet design, they had been daunted by the complexities of animating puppets in *Nocturna Artificialia*. The main figure was designed using a standard small-scale jointed wooden model that is used by artists to understand how the human body moves. Although the figure was the scale they wanted to work with, it was impossible to animate because its armature was not stiff or sensitive enough to be able to maintain the delicate incremental movements that single-frame shooting requires. Dissatisfied with the experience, they took recourse in using *objets trouvés*. In *Languages of Art,* Nelson Goodman suggests that "in representation, the artist must make use of old habits when he wants to elicit novel objects and connections."[6] Their long-standing custom of regular early morning visits to flea and antiques markets in London and abroad provided the Quays with unusual and bizarre objects that could be used as they were or transformed into novel hybrid forms.

The Dancing Demiurge

Puppets are embodiments of what Nelson describes as the "ideal of Renaissance Hermeticism and Neoplatonism propounded most famously by the natural philosopher and heretic Giordano Bruno: the divinization of the human."[7] In a kindred spirit, centuries later another author speculated on the nature of the puppet, exploring the distinction between human and puppet performances in search of which of these could be considered closer to perfection. A contemporary of Schopenhauer, Heinrich von Kleist was a German author responsible for some of the first attacks on rationalism and the Enlightenment; his plays and short stories with extreme characters explore his despairing view of the failure of reason. Nelson suggests Kleist was a "frustrated theurge," and it is tempting to speculate that had he lived to experience the invention of animated cinema, this frustration may have been soothed.[8] His 1810 philosophical conversational essay "On the Marionette Theater" offers an insightful and tantalizing set of literary and philosophical proposals and paradoxes about the marionette that are particularly relevant for animation, and markedly so for the Quays' work with puppets.[9]

In the text, an unnamed figure, in conversation with Mr C., a dancer at the opera, ponders the qualities of grace in the movement of puppets and the factor of human volition:

> I asked him if he thought the operator who controls these puppets should himself be a dancer or at least have some idea of beauty in the dance. He replied that if a job is technically easy it doesn't follow that it can be done entirely without sensitivity. . . . But, seen from another point of view, this line could be something very mysterious. It is nothing other than the path taken by the soul of the dancer. He doubted if this could be found unless the operator can transpose himself into the centre of gravity of the marionette. In other words, the operator dances.[10]

Animated puppets, as actor-objects, have no character, indeed no life of their own, without the animator's involvement. An issue of central importance to understanding the experience of the Quays' constructions is clarification of the on-screen *status* of these animated objects and how we relate to them. We see a moving image, but we know that the objects we see appear alive through pure artifice. A partial answer is, of course, Mitry's statement that "one might say that *any object presented in moving images gains a meaning* (a collection of significations) *it does not have 'in reality,' that is, as a real presence.*"[11] But we also know that in contrast to live-action figures, puppets do not exist except as inanimate objects beyond their animation on-screen. The spectator may oscillate between this awareness and a sublimation of it that allows her to perceive animated objects as living. The animator as puppet operator not only dances; he or she is able to give the puppets a semblance of Kleist's soul via the vitalism implicit in their animation. In an essay relating animation film to literary examples of the automaton and marionette (Kleist and Hoffmann), Weihe distills the essence of this distinction:

> First, it seems obvious that in Kleist's set-up we can replace the "machinist" by the "animator" of an animation film, while the marionette is equivalent to the animated figure. But what about the *strings* of the marionette? For the puppeteer they are the technical device by which he controls the marionette's movements; in puppet animation these "strings" are invisible, indeed, non-existent. Their function is replaced by the technique of frame-by-frame animation.[12]

In puppet animation, the marionette's dance is a complex process of usually between twelve and twenty-four subtle changes of the puppet's position per second. Whether the bouncing or oscillating balls in *Rehearsals for Extinct Anatomies* or *Stille Nacht II* (1992), the screws twirling and rotating in dust in *Street of Crocodiles,* or the Gilgamesh puppet cycling across the floor, the puppets' movements are planned and executed with exacting calculations. The puppets' dance on-screen is the result of careful manipulation in front of the camera over a period of time that is exponential in comparison to the brief moments we see the puppet on-screen.

Kleist's fictional acquaintance describes two results of the marionette's movements. The first is that the puppet is not guilty of affectation, which he regards as an advantage. The second is weightlessness, which is less pertinent here, as Kleist is discussing nonanimated handheld marionettes:

> For affectation is seen, as you know, when the soul, or moving force, appears at some point other than the centre of gravity of the movement. Because the operator controls with his wire or thread only this centre, the attached limbs are just what they should be . . . lifeless, pure pendulums, governed only by the law of gravity.[13]

The Quays' puppets (or some other puppet animation, for that matter), while lifeless, do not appear to be so and they need not be governed by laws of gravity. The discussion continues and the acquaintance declares that "where grace is concerned, it is impossible for man to come anywhere near a puppet. Only a god can equal inanimate matter in this respect. This is the point where the two ends of the circular world meet."[14] In terms of puppet animation and vitalism, we can interpret this grace as an expression of Schopenhauer's revision of Kant's "the thing as such" *(das Ding an sich)* in that the material/mechanical qualities are enhanced by an apparent will endowed by puppet animation's animistic properties, a will that is vitalist in essence. The two ends of the circular world are vitalist at the one end, phenomenal at the other. The essay ends with Kleist unconvinced, the acquaintance declaring that "grace itself returns when knowledge has as it were gone through an infinity. Grace appears most purely in that human form which either has no consciousness or an infinite consciousness. That is, in the puppet or in the god."[15] In puppet animation, these two qualities merge: the lay figure, the puppet—through the hand of the animator and the technical apparatus of animation filmmaking—is endowed with grace.

Concepts in Kleist's essay can productively be brought to bear on intrinsic qualities of puppet animation's animation of inanimate forms. Using the example of Charlie Chaplin, Mitry also makes an invaluable distinction between dance and other music-driven movements that resonates with Kleist's concept of grace:[16] "When a natural movement is subjected to a predetermined rhythm, it becomes to some extent 'mechanised,'" and when the figure's "control appears to be the effect of free choice . . . the rhythms of gesture become the expression of an 'internal' movement. . . . That is why dance is never ridiculous, whereas an involuntary 'mechanised' gesture is always grotesque."[17] Creating a brilliant bridge between "dance, the 'pure act of metamorphosis,'" and animation, Mitry suggests movement choreographed to music in animation "is no longer a matter of free will but of blind submission—or which inanimate objects are better suited for the fact that their very inertia means that they are liable to all and any movement without inviting humiliation or ridicule."[18] In an analogy, the animator is like a neoplatonic "god" that can circumvent the mechanistic-materialistic limitations of materials to give them properties of Schulz's extraordinary element of matter. In doing so, by distancing human volition by at least one level, since the animator must "act" through the puppet, the animator summons forth a sense of grace while concurrently investing the puppet with an appearance of consciousness. This inherent paradox is the animistic vitalism of the animated figures: they do not need a physiochemical state in order to live.

Bordwell and Thompson, referring to the control of a figure's behavior in the mise-en-scène, draw attention to the fact that

> the word "figures" covers a wide range of possibilities, since the figure may represent a person but could also be an animal (Lassie, the donkey Balthasar, Donald Duck), a robot (R2D2 and C3P0 in the *Star Wars* series), an object (as in *Ballet mécanique*'s choreography of bottles, straw hats, and kitchen utensils), or even a pure shape (as in *Ballet mécanique*'s circles and triangles).[19]

Figure, of course, also refers to the protagonists in literary texts like Schulz's or Walser's, be they human or inanimate objects. The similarities between characterization in literature and the literary origins of the Quays' films are pertinent when reflecting on the specific cinematic qualities they achieve. The written text relies on the reader's ability to make her own inner picture of the characters described in texts. In photochemical film, the puppets may be photoindexical representa-

tions of real objects, but these actor-objects have no character, indeed no life of their own, without the animator's involvement. Mitry describes the reader's powers of imagination in the following way:

> But whatever [the author] may do to try to lose his own personality from his work, the author is always evident in his characters. However true and lifelike their psychology, it is nevertheless a subjective creation, since analysis, in literature, is merely the author's opinion of his characters, his detachment as he considers them, judging them by absolute criteria which he himself establishes. It only becomes *genuine* psychological analysis when the subject is the author himself, observing himself, studying himself, and telling his own story. . . .
>
> The cinema, on the other hand, presents only actions. Though the characters are the creation of the filmmaker, at least they are there, present and active, "in the flesh." Dissociated from creative imagination, they seem to have an independent, exclusive existence which is objective and no longer merely conceptual. However basic their psychology, it is always "located." The characters are drawn according to circumstance and their development always depends on an effectively "experienced" reality. They are human beings in the world; they act and are acted upon.[20]

With some exceptions *(The Comb,* the artists' documentaries, *Street of Crocodiles,* and *In Absentia)*, none of the Quays' shorts have an actor who has an independent, extrafilmic, or nonfilmic existence. Mitry's distinction of characters cannot account for the animated puppet that cannot be "dissociated from the creative imagination"; in fact, it embodies exactly this, in that its "existence" is defined entirely by the conceptual process of its construction and animation. This is further strengthened by Arnheim's proposal that the author "is not tied to the physical concreteness of a given setting. . . . He does not have to worry whether the combinations he creates are possible or even imaginable in the physical world."[21] What we see is the character of the animator transmuted through the materials and the way the puppet is made to move in the cinematic realm. Puppets also "act and are acted upon," yet the animator determines all actions. Without human intervention, puppets remain an inanimate representation. They can be endowed with anthropomorphic qualities and certain character traits through posture, body proportions, facial expression, gesture, clothing, and props. This is equivalent to

the descriptive element of characterization in writing. Yet the puppet does not act until it has been manipulated by the animator's hand, given her signature, shot in single-frame method, and projected. Each figure is the result of stylistic and aesthetic decisions made during construction and later while animating its gestures and actions. Animation character creation bears comparison to writing in that, in Mitry's definition, the subject is the author him (or her)self. The Quays are, indeed, "evident in [their] characters." This also recalls their comment above that whoever builds the puppet animates it, because it is the builder's own vision of how it moves. In this way, puppet animation presents more than what Mitry calls "actions"; it presents a highly subjective and minutely controlled extension of the live, in-the-flesh animator and his or her creative process.

A character's psychology, which Mitry somewhat nebulously describes as "located," raises a further issue that is problematic when describing a puppet. If Mitry means that it is located in the living being who is taking on the role of the character, then where is the psychology of a puppet—its motivation, attitudes, and reasons for actions—located? The obvious answer is that it is the animator who determines the psychology since the animator determines all actions. The personality and psychology of the animator is transmuted into each character, "ascribing to it his thoughts or emotions." For now it suffices to say that its psychology is read by the audience using codes of style, behavior, gesture, and sound. It is also, to a great degree, constructed out of the often anthropomorphic qualities of the puppet's appearance.

Writing in 1963, Mitry refers minimally to animation films in his aesthetic and psychological analysis of cinema, and it is interesting to speculate how he would have expanded on some of the pertinent and insightful queries he raised. It is telling that he places terms like "in the flesh" or "experienced" reality in quotation marks. A phenomenological treatment of the issues he raises—as I am attempting in this book—can effectively remove the tentative quotation marks he inserts. His description of animation as a genre of cinema—one that is also assumed by many others writing about the form—needs correction and expansion. Its alienated forms, its expressive fantasies, its formal, aesthetic, and phenomenal distinctions from live-action film, and its variety in technique and materials are but a few of the factors that make it distinct from other kinds of cinema. Its technique and production processes enable creative filmmakers like the Quay Brothers to express and allow us to experience unique forms, realms, and concepts not possible in (nondigital) cinema. Peter Wollen raises a similar issue, i.e., the discrepancy between text (script) and performance (film):

The distinction between composition and performance is vital to aesthetics. The score, or text, is constant and durable; the performance is occasional and transient. The score is unique, integrally itself; the performance is a particular among a number of variants.[22]

In puppet animation film these variants are not as free form and unreliable as in live action, nor are they as constant and durable as in 2-D animation. The characters in puppet animation can be constructed and animated exactly as the animator intends, depending, of course, on the skills of the puppetmaker and on who is animating the puppets. Wollen suggests further that "the distinctive marks of a performance, like those of somebody's accent or tone of voice, are facultative variants."[23] Voice-over is another way of endowing character (feature-length animation increasingly uses well-known actors' voices); it is relevant that the Quays' puppets, however, are mute. Stewart suggests that "the automaton repeats and thereby displaces the position of its author."[24] While the Quays "author" their puppets, their emotions and thoughts are a transmutation of each filmmaker's own, and the performance is created by the technical means of animation. This elides wonderfully with Kleist's notion that the path to the marionette's soul is created through the dance of the puppeteer.

The Quays' puppets, objects, and machines follow a lateral hierarchy of performance. The main puppets develop the loose narrative and interact, and the objects' performances are often interludes that rarely interact with the main anthropomorphic figures. The objects contribute to the apprehensive mood of the film, suggesting the undercurrent, vitalist realm in *Rehearsals for Extinct Anatomies, Street of Crocodiles, In Absentia,* or the *Stille Nacht* films. And throughout the films, screws dance, metal fur gyrates, balls oscillate, and watches pirouette as the camera reveals the films' hidden recesses and corners. Compared to these metaphysical machines, the sculptural human simulacra puppets divulge little sense of emotion, retaining a single facial expression throughout a film. The static facial expression of these puppets can create a dislocutory apprehension as the puppets' emotional registers are not communicated facially. Movements are limited (and assisted) by armatures, the curve of a hand or the fixity of a gaze remains the same in each scene, regardless of the action. While similar static forms are often used in puppet animation, the Quays' puppet performances have more affinities with Antonin Artaud's concept of hieroglyphic theater (that was his aesthetic response to experiencing Balinese theater): a "metaphysics of gesture," in which narratives are

told through "states of mind, which are themselves ossified and reduced to gestures—to structures."[25] He suggests "a kind of terror grips us as we contemplate these mechanised beings, whose joys and sorrows do not really seem to belong to them but rather to established rites that were dictated by higher intelligence."[26] Artaud's express interest in metaphysics leads us easily to vitalism, and the terror he experiences softens in the Quay Brothers' works and the vitalist state of the puppets to a form of pleasurable apprehension for the viewer. By guiding the viewer emotionally (mainly via the sound track), it also means the anthropomorphic puppets do not dominate the composition, i.e., the sets and other objects aren't necessarily only in the service of the main figures. The intentional display of the puppets' physical construction is also a stylistic decision: visible armatures, body parts identifiable as those of porcelain dolls, collage, or bric-a-brac assortments of diverse materials; a Dalí-esque skirt of boxes instead of hips and legs for the Tailor's Assistants in *Street of Crocodiles*. They are a manifestation of the second of Hal Foster's prized emblems in surrealism: "modern mannequins, with the status of both intimate and alien."[27] Intimate, because of the pretty dolls' heads and body parts; alien, because of the contradiction between the gynomorphic torso and the nonhuman objecthood of the wooden cratelike bottom half of the construction.

Andre Habib posed Kleist's question to the Quays, asking them if they believed that a puppet can have more grace than a dancer. Their response is another conceptualization of Kleist's argument, one that reflects on animation and possibly on experiences gained in the dance films they had made in the years previous to the interview:

> Certainly not. It's of a different kind. I don't think you can ever compete with the human body, the way a dancer can. But I think a puppet can achieve other things, on a more symbolic level. You would never make your puppets work the way a dancer can and we wouldn't begin to attempt it. It's a sort of empty virtuosity, even to begin. It's important to watch what a dancer can do.[28]

Atkinson aptly summarizes an analogous relationship between dance, animation, and puppets: "As wholes, Quay films are carefully considered answers to the question of how many angels can dance on the head of a pin—and we realize the question is fruitless: It doesn't matter. What matters is the dance itself."[29] Animation is the dancing genie in the bottle.

Matter, Insecticity, Flesh: A Typology

The combination of a particular style of puppet animation and the influence of nonanimated cinema contextualizes the stylistic wealth of the Quays' puppets. Their puppet animation films are part of a contemporary continuation of what constitutes a canon that includes Georges Méliès, Władysław Starewicz, George Pal, the Gebrüder Diehl, Joanna Woodward, Jan Švankmajer, and Kihachiro Kawamoto. European animators dominate their list of influences, but the Quays also mention Charles Bowers's films, and visual echoes of his marvelous contraptions appear in many a Quay film. The Quays' puppets bear the most relation to those of Starewicz, Švankmajer, and Bowers that use insects, plants, found materials, and other objects of the tangible world. The Quays' puppets are distinct from conventional dimensional animation films that use plasticine or latex puppets; the figures are made of armature-based hard materials and have fixed facial expressions and body forms. Softer materials are malleable, and alterations in facial expressions, body movements, and shape are often carried out on the puppet in front of the camera or by utilizing exchangeable facial features, such as lips, eyes, eyebrows.

Street of Crocodiles features a mix of puppet styles: the Schulz puppet (the main figure), the Boy, and the Tailor are constructed analogous to the human figure. The three Tailor's Assistants are composites of female torsos mounted on boxes with drawers and wheels that propel them. The Boy, the Tailor, and his Assistants have similar ceramic heads, unlike the Schulz puppet, whose head is made of plaster. This sets him apart from the world of the other puppets, and perhaps is an indication that he is in a dreamworld. All of these puppets are armature-based. Other gyno- and anthropomorphic puppets include a female doll with a naked rubber torso and cloth legs, a monkey with cymbals (an old windup toy), and a wooden puppet (which makes a repeated physical gesture of vomiting) with a movable mouth that suggests it may have been used by a ventriloquist. These three puppets, originally dolls or toys, have a historical and cultural palimpsest of materials. An anthropomorphic figure constructed of glass pieces and lightbulbs arranged on an armature stands out somewhat stylistically from the other puppets. Besides the anthropomorphic puppets, the film features a collection of objects, machines, and unusual constructions—the metaphysical machines that often introduce a hiatus in the narrative. These include a variety of screws, a rubber band machine, pulleys, mechanical devices, and a pocket watch. All of these are animated in the film. The sets also contain other nonanimated

objects that embellish the mood, such as a meticulously arranged pile of bleached bones, a stack of boxes in a window, and the elaborate interiors of the Tailor's shop that visualize the spaces Schulz describes: "the storerooms, which could be seen through the open door, were stacked high with boxes and crates—an enormous filing cabinet rising to the attic to disintegrate into the geometry of emptiness, into the timbers of a void."[30]

The animated figures in most of the Quays' animated shorts are made of cloth, plaster, glass eyes, bits and pieces of found materials, metal, and wood. For the Quays, their process varies: "Puppets sometimes are built first. Usually they are built after the sets, because you know the tonal range and texture of the set."[31] The main figure in *Street of Crocodiles,* perhaps a simulacrum of Schulz himself, is a gaunt construction of the Quays' preferred materials: its head is roughly crafted of ravaged plaster, with luminous, liquid glass eyes; a tailcoat hangs on its graceful, haggard frame; and its thin, delicate hands are so expressive that each hapless gesture they make is poignant. In some films—for instance, *Street of Crocodiles,* the *Stille Nacht* shorts, *The Comb*—the construction of these fragments is an intended human or anthropomorphic simulacrum because of the design, gestures, and personality the Quays decide to give the puppets. In other puppets, like the one-eyed wire-and-plaster homunculus of *Rehearsals for Extinct Anatomies* and the insectlike creature from *In Absentia,* other unsettling attributes dominate. Although the materials of their construction can indicate their origin, i.e., the puppets' heads are ceramic and were originally used to make dolls, each puppet is built exactly according to the Quays' specifications. On a suggestion that their puppets can have a propensity to appear too human, the Quays commented: "You have to be careful. We found the Tailor's head in the markets and in a sense you realize you have to build a body that would fit it."[32] The choice of materials also has consequences for the film's mood. The Quays:

> If you create the density of the world that you're out to create, the audience will make that leap and be won by the fiction. If it senses that the puppet is just a little ragamuffin and thinks, "Aha, you use little bits of mop for the hair," then you've lost. It is as if, right away, the fiction—orders of power—abducts so powerfully. And even then, if [the camera goes] in close up, I think you wouldn't know if you looked at one of our puppets—you really believe that it's come from some other realm, that it hasn't been made.[33]

These levels of enchantment are achieved by a unique typology of puppet design. Besides the anthropomorphic puppets, automata, and simulacra, the Quays have consistently used what I call insecticity in their films, where insectlike figures feature prominently. These disturbing anomalies are a distinct type of figure in *Rehearsals for Extinct Anatomies, Nocturna Artificialia,* and *The Comb* that resurfaces in altered form in *In Absentia* and *The PianoTuner of EarthQuakes.* Sometimes winged, usually sinister, and in some instances the source of conflict or a turning point in any of these films, insectlike puppets embody a darker side of the psyche but also provide an aestheticized rendering of entomological beauty. Using insect-inspired puppets is an unusual method to bring elements of the natural world into the animated realm that have an organic, living reference (unlike many of the other objects). Because insects are so thoroughly nonhuman, they have had a strong, symbolic use in some so-called primitive, animistic cultures for ethnoentomology, a branch of cultural entomology.

Władysław Starewicz, whose insect *feéries* transformed silent slapstick narrative into an enchantment, is one of the Quays' favorite filmmakers, and the influence of his films on the Quays' works is easily understood. Although Starewicz's insect fantasies date from early cinema, their visual impact can be easily programmed together with contemporary animation. Unlike most films from the first decade of the twentieth century, who quality is archaic, Starewicz's films seem timeless in their effect and quality. This is in part due to an animistic aspect of his work that transforms stylized stag beetle, grasshopper, and other insect body parts into bizarre animated puppets in a fantasy world rooted in human commodities and traditions. Starewicz's films are narrative (*The Dragonfly and the Ant,* 1913), often comedies (*The Cameraman's Revenge,* 1912), yet some, like *The Insect's Christmas* (1913) or *Winter Carousel* (1958), are slightly disturbing films and are more informed by an animistic feel. Atkinson suggests that one of the enduring qualities of his work is the fact that his creatures are "only barely anthropomorphised. . . . No matter how lighthearted the scenarios, his films play like ghoulish pantomimes for entomophobes."[34] While some of the Quays' insectlike puppets engage in human behaviors, there is far less parody because there is far less anthropocentric narrative than in Starewicz's films.

The Quays have created their own, unique entomological bestiary, and insecticity is a persistent visual trope that runs throughout their opus. In the early films, the battling brothers in *Ein Brudermord* are two scorpionlike puppets that battle to the end (see Figure 5). In later films insect-inspired figures often act as the motor that drives a conflict. In *The Cabinet of Jan Švankmajer,* the pupil

hesitates as he is required to put his hand in a box containing an unseen, fur-embellished spider, and even the bullet projectile in *Stille Nacht III* (1993) has the instinctual determination of a winged insect. There is something coldly eerie about these puppets; they have another life besides the one invested in them with animation and it is distinct from vitalism. It is the secret life of insects, instinctive, an aggressive drive to survive, conquer, and dominate. When asked by Roberto Aita about the nightmarish quality of their films, the Quays proposed an analogy between the world of insects and the world of *In Absentia:*

> We really believe that with animation one can create an alternate universe, and what we want to achieve with our films is an "objective" alternate universe, not a dream or a nightmare but an autonomous and self-sufficient world, with its particular laws and lucidity. A little like when we observe the world of insects, and we wonder where the logic of their actions comes from. They can not talk to us to explain what they are doing; it is a bizarre miracle. So, watching one of our films is like observing the insect world. The same type of logic is found in the ballet, where there is no dialogue and everything is based on the language of gestures, the music, the lighting, and the sound.[35]

The "objective alternate universe" in *In Absentia* is the colored world of an insect-like creature. Instead of using insectlike puppets to illustrate familiar aspects of human behavior, the Quays draw the viewer into a world that provides few comforting familiarities. The "autonomous and self-sufficient world" is isolated; time and rhythm are suspended and replaced by the fascination of the puppets' bodies, textures, and scurried, instinctually autistic actions. This instinct is enhanced with what appears to be a primordial animistic intellect driven with consciousness and intent. Simultaneously brittle and armored, the Quays' puppets are well suited to the stiff armatures they are built on; angular and darting movements and unexpected gestures contribute to the unease of watching them. Traces of these insects find their way into the commercials. In a commercial for Fox Sports Television, the animated stag beetle puppets play hockey. Instead of unsettling the audience, these puppets act out a Starewicz-like slapstick (pun intended), pirouetting and aiming puck passes at each other. Together with the other organic materials they use—brittle insect husks, dried star anise, thorny rose stems, fluffy dandelion clocks—a theme reveals itself: artificial constructions that add animistic qualities to materials from the natural world.

Other kinds of organic matter feature as well: an enduring image that most viewers of *Street of Crocodiles* readily recall (that still evokes gasps in the cinema) is in the scene where the Tailor seems to conjure a slab of liver on a table.[36] He smoothes tissue paper over its wet surface, and rows of pins, like marching soldiers, proceed to insert themselves into the paper and flesh. The Quays describe how this scene was conceptualized:

> We always thought it should be a megalomaniac tailor who senses that, after the Second World War, when the powers that be have divided up the borders and restitched the seams, as it were, just shifts them—that's the scar. And so he sort of strokes the seam of the scar tissue, but you're basically showing that the country's a piece of meat, which can be carved up like this. It's the same thing metaphorically: he had a client on the left who he was going to dress, dress as meat, so there were two fittings. You can map out a country or you can map out a man . . . they're [both] meat.[37]

As it makes a fairly clear allusion to the political history of Poland, this is an unusual scene in the Quays' otherwise relatively nonideological oeuvre. In *The Cabinet of Jan Švankmajer,* a drop of blood on a tissue sets the clockwork of the Švankmajer puppet in motion (see Figure 6); in *Stille Nacht III* an egg leaks blood; and in *The Comb* two hands force a ladder through a reclining puppet's torso, rupturing glistening, wet, bloody flesh. Real organs and flesh in animation have been used by other filmmakers, none perhaps more sanguinely than Švankmajer. Fresh or in various stages of decomposition, they draw attention to the power and paradox of animating body parts. With their direct relation to our own physical, embodied experience, these sanguine animated chunks have a jarring effect on us. The slab of liver, the smooth kidney, are not animated; they do not come to life. In spite of the undeniable, visible truth of their obvious deadness butchered from the body of an animal, the deadness of the material is enchanted via the animation around them.

Cut out of interdependence shared with the absent body, and placed in a mise-en-scène and animated, these sequestered organs take on new meaning. Torben Grodal suggests that "representations that focus on the relative autonomy of interior parts of the body are often experienced as particularly nonhuman."[38] This can explain how the aversion or alienation we experience in these scenes can give way to curiosity or pleasure. A good example of this is Švankmajer's

claustrophobic *Light, Darkness, Light* (1989), one of a number of his films with pieces of meat, tongues, and intestines (*Food,* 1992; *Meat Love,* 1989; *Dimensions of a Dialogue,* 1982; *The Death of Stalinism in Bohemia,* 1990). In the first few scenes the film seems quite predictable because of its use of clay metamorphosis popular in conventional films, but the introduction of real, bloodied organs belies Švankmajer's disquieting intent. A collection of clay body parts hears a knock on the door, which opens and a glistening, severed tongue enters the room. It initiates a human assemblage of glistening eyeballs and dismembered body parts that, upon completion, becomes a human mockery too big for the room; the final claustrophobic scene insinuates many possible conclusions. In Švankmajer's films the body is used and reproduced as a mechanism embedded in an ideological critique: his films transport both an ideology and a sense of surrealist revolt, inasmuch that surrealism questions the taken-for-granted bourgeoisie aspects of oppressive society.[39] In his works, he plays out submerged political and social discourses through the devices of metaphor and symbolism. The pieces of flesh are usurped and alienated from their original function, from a body that once was alive and then put on display. They express ideological and cultural relations in their interactions that result from the animator's intentions and use of metaphor.

The Quays' use of flesh is more specifically erotopathological and aesthetic. The kidneys and liver that appear in *Street of Crocodiles* are integrated into the compositional finesse of the sets and the puppets interact, stroking them with smooth, sensual caresses. The Quays also use these pieces of flesh as an element of poetic and stylistic interpretation of Schulz's text. They are stand-ins for that hapless matter so enamored by the rambling father in "Tailor's Dummies": "Matter is the most passive and most defenseless essence in cosmos. . . . Homicide is not a sin."[40] In the scene with the Tailor's Assistants, kidneys, placed at the bottom of an anatomical illustration of a vertical penis, are erotically stroked while deeply embedded sharp pins extract and erect themselves (see Plate 10). The liver is pierced by pins as well, and violence is done to a meaty pocket watch: in the Watch Death sequence (5:11–5:38), an assaulting gang of marauding nails and screws unscrews itself from the tabletop and forcefully penetrates the glass watch face, and in a rare sound effect that actually matches what we see, we hear breaking glass. The watch face cover flips up and the pocket watch pivots to reveal its back metal cover, which opens to reveal a bright red, flesh-filled interior, like a skinned animal (see Plate 13). Glistening, it quivers as the gang's murderous trajectory pierces through and they emerge from the flesh to return to the tabletop and roll off-camera, like thugs into darkness. Raw flesh adds an additional layer of

unease to the other kinds of matter in these disturbingly beautiful, sexually patho-
logical rituals of the realm.

Empathy, Texture, and the Grotesque

The puppets in the Quays' films are artificially constructed, defamiliarized repre-
sentations. Why do we engage with them? How do they move and engage us?
Nelson Goodman's remarks on representation address emotional engagement
with figures: "A notable difference is that since, strictly speaking, only sentient
beings and events can be sad, a picture is only figuratively sad."[41] This becomes
more complicated if the word "picture" is substituted with "puppet." Since a pup-
pet is neither a sentient being nor a painting, how can it evoke emotions such as
sadness? The animated puppet exists, but it is not alive; it is what Goodman calls
a "man-representation," but is a puppet without denotation?[42] This is where the
tangibility of the puppet and the Quays' design and manipulation of it become
indispensable elements in our understanding of what it represents. It is a con-
struction of "in-the-world" materials that are assembled to be a "man-representa-
tion." It is also a representation imbued with an animistic force—on the one hand
through the cinematic illusion of the animation technique, and on the other by
the emotionally underpinned movements and gestures that the Quays add incre-
mentally while filming, which, in screening, suggest a form of sentience.

Many film studies investigations in this area of spectatorship are
premised on a cognitive and cultural understanding of what we see (Bordwell,
Grodal, Carroll). Since many of the worlds that animation conjures technically
can have little to do with the tangible world, the viewer must be able to develop
different schemata from those she constructs for live-action film, which is more
or less photorepresentational (digital animation and compositing have, of course,
changed this dramatically). Although rooted in an understanding of the world we
live in, the mental processes that animation stimulates and activates have much
more to do with a set of experiences and schemata located in the imagination,
the locus of most artistic production. Any relatedness to physical phenomena
must necessarily come through an association, a mental model, or some kind
of sensible equivalent in the phenomenal world. It can also be based on previ-
ous experience with similar visual still and moving-image work; we can learn to
read these worlds the more we are exposed to them. In contrast to the drawn or
painted representational worlds of pure animation, the universe, realm, or world
particular to the Quays' films is determined by their formal techniques and style

applied to objects that occupy space in time. In this way their reception is related to an overlap of our experience of fabrics, objects, materials, and spaces in the phenomenal world with the world the films present.

A further insight into the viewer's engagement that relates to Mitry's earlier proposals on figures is found in Christine N. Brinckmann's exploration of empathy and anthropomorphic "endowing of soul" to abstract forms in the Absolute films of Walter Ruttmann and Viking Eggeling. Describing how movement creates alliances and choreographies between the figures, she then queries the audience's engagement: "In light of such cinematic processes the temptation is there, both to identify the moving forms and to animate them with characteristics and intentions."[43] I suggest that, besides the emotions elicited by the puppets modeled on human form, we feel a sense of empathy for and identification with a variety of the Quays' more abstract constructions, from the pas de trois of spiraling screws to the violently pierced, bloody pocket watch. Ed Tan's writing on comics and film is generally helpful when trying to define what evokes an emotional response in animated figures.[44] In terms of abstraction, it gets more interesting when Tan describes two versions of aesthetic fascination in film: fictional emotion, which is stimulated in the fictional events in the diegesis; and artifact emotion, which originates in an admiration for the film's construction and its formal parameters. These are usually deemed to be secondary, but for nonconventional animation film and figures I suggest that with the Quays' films, artifact emotion can be the primary emotional stimuli. Tan remarks that the emotions allow us to access subjectivity of individual figures and suggests that typical artifact emotions are enjoyment, astonishment, and admiration.[45] This reaction is remarkably similar to a state of enchantment that I describe in more detail below, a feeling that implies emotional response, and both artifact emotion and enchantment are bound up with the discovery and understanding of events and figures we will not experience in the phenomenal world.

Bearing Brinckmann's and Tan's comments in mind, I would challenge Grodal's cognition-based discussion of spectators' difficulty in engaging with nonanthropomorphic figures:

> When watching a visual representation of phenomena without any centering anthropomorphic actants, we often "lose interest" owing to lack of emotional motivation or the cognitive analysis of the perceived, a fact which many makers of experimental films have discovered when presenting their films to a mass audience.[46]

Rehearsals for Extinct Anatomies, the *Stille Nacht* films, and many lengthier scenes in *Street of Crocodiles, The Comb,* and *In Absentia* do not have anthropomorphic actants. We comprehend the objects as what they are—a screw, a Ping-Pong ball, a pulley, a rubber band machine—but also experience the sense of enchantment and emotional, sensual presence with which animation endows them. The combined effects of empathy, artifact emotion, and apprehension that I've proposed offer a solution to understanding why Grodal's claim does not hold for the Quays' films that do without what he suggests are necessary centering figures, as indeed do films from a good many other animation and experimental filmmakers.

Nelson suggests that, as a writer, Schulz belongs to "the category of European high-art grotesque."[47] Many of the Quays' puppets are grotesque in the sense Nelson defines it—as a surrealist grotesque: "the juxtaposition of incongruous elements [that has a] crucial aesthetic goal: that of collapsing the boundaries between subject and object, representing interior human feelings as exteriorized objects in the environment."[48] They combine humanlike body parts and armatures with materials and fragments of other objects and juxtapose incongruous elements. (I will return to this later.) The viewer alters her understanding of these elements to be able to understand them. Grodal has some interesting thoughts on this process:

> It is important to emphasize that cognitive identification (and empathy) are normally established at a very general level. In films about animals or in animated cartoons we can identify with animals; that is, we reconstruct their wishes, plans, and needs; but we do not mentally construct special "quadruped," "winged," "finned" or "beaked" mental models except in very special situations where the context demands the rudiments of such models in order to make a situation comprehensible. It is easy to make such identifications with beings very different from ourselves, because the specific motor realization of mental models normally takes place at a non-conscious level of the brain.[49]

He suggests that the viewer is engaged in different levels of specification and that character identification is developed by what he calls "texture" and narrative that enhance these learning models: "The salience and activation-power of fictions may be enhanced if the 'texture' of protagonists has a close match to that of the particular viewer."[50] (This could explain the attraction of adults to a wide range of cartoon animation that uses the Kindchen schema in character design.)[51] Grodal's

use of texture refers to sociohistorical, class-culture, or gender-specific mental models. We can also understand texture in a literal sense: the materials from which animated figures are constructed as sculptural objects are often composed of materials that are not what we would expect a human being to be made of, but the bits and pieces are familiar to us from our own forays in flea markets or stowed-away boxes in the attic. And the objects often embody something else. In the Tailor's back room in *Street of Crocodiles* there is a glove on the wall containing long strands of looped hair that partly protrude out of it. I asked the Quays whether the glove was a reference to themselves: "No, to Krafft-Ebing [laughter]. It was the rear room [of Schulz's story]. It was all about the fetishisms, you know, and everything that Schulz's more suppressed *louche* side would conjure up."[52] A viewer familiar with the context of von Krafft-Ebing will be rewarded in these moments, if their textural mind-set is aware of the reference.[53]

Thus, texture can also explain why audiences are drawn to the Quays' puppets: the actual textures of these figures. Grodal proposes that "we only have a very general awareness of our body. We do not have constant mental representations of our toes, ears, breast(s) or other specific body parts: they only attract attention on special occasions."[54] Unfortunately, Grodal doesn't elaborate on what these special occasions might be. I would suggest that the Quays' puppet animation can be such a special occasion. Although the Quays invest their puppets with humanlike qualities in many films, the textures of body parts, their surfaces, and fixity of materials constantly draw our attention to their difference from our own flexible, mortally fleshed bodies. Grodal investigates how we understand what he calls "humanness," a term that sometimes appears in single quotation marks and sometimes not. He does remark that divining the essence of humanness is a recurrent theme in ambitious films (and, I'd suggest, in monster and automata-centered B-films), that it is deeply philosophical and often used in a negative way when this attribute is lacking.[55] The determination of this arises from

> contrasts and differences to other living beings, as when humanness is determined by delimiting it in relation to a beastly otherness that has its own *raison d'être,* but the determination is often subtractive: the essential human features are implied by describing certain human-like but "non-human" actants, who retain some features comparable to those of humans but who still lack some "essential" human features.[56]

The otherness in *Street of Crocodiles* has less to do with beastliness than with a raison d'être that is motivated by Schulz's descriptions of matter and with vitalist qualities of animated automata.

Many of the Quays' anthropomorphic puppets have sweet faces (the porcelain dolls' heads were, after all, originally made to appeal to children and women) that have a strong appeal in moments of confusion or emotion. For instance, in two scenes in *Street of Crocodiles* shot in close-up, the Boy sees the dominatrix-tinged female torso, and the Tailor's Assistants are shocked by a screw. Grodal suggests that "massive viewer-interest indicates that the phenomenon of 'humanness' has very strong cognitive and affective appeal."[57] But he also points out that "non-humanness often comes in two variants: the negative variant, in which it is connected with the subhuman, and that in which the non-human features are connected with the superhuman, whether evaluated as positive, negative, or complex."[58] The Quays' grotesque puppets—combinations of objects and human attributes—are in the second category.

The appeal and affective experience of watching these puppets can be approached through Jane Bennett's philosophical proposition to offer an alternative to what she terms the "disenchantment tale" of modernity and contemporary life—"a place of dearth and alienation and of control."[59] Bennett proposes an alternate tale, one that is highly pertinent when thinking about the Quays' puppets described here—filled with what she calls "sites of enchantment" that include

> the discovery of sophisticated modes of communication among non-humans, the strange agency of physical systems at far-from-equilibrium states, and the animation of objects by video technologies and animation whose effects are not fully captured by the idea of "commodity fetishism."[60]

In the animistic world of the Quays' films, their composite puppets, automata, and metaphysical machines perform nonhuman communication without linguistic structures, and their musically choreographed motions and gestures incite empathy, artifact emotion, and enchantment that is distinct from such emotions elicited by anthropomorphic or human forms. The Quays say that "the crucial thing about automata is their enchantment. They can be extremely sophisticated but at the same time very basic in terms of what they can do."[61] In the Introduction to her book, Bennett outlines a phenomenology of enchantment:

Enchantment includes, then, a condition of exhilaration or acute sensory activity. To be simultaneously transfixed in wonder and transported by sense, to be both caught up and carried away— enchantment is marked by this odd combination of somatic effects.[62]

In the Quays' films, two of these effects are intellectual uncertainty and apprehension, which exhilarate us physically as we are barraged by the combination of exquisite haptic objects, elegant and choreographed gestures, and a sound track that transports us into highly emotional realms. Bennett continues:

> The mood I'm calling enchantment involves, in the first instance, a surprise encounter, a meeting with something that you did not expect and are not fully prepared to engage. Contained within this surprise state are (1) a pleasurable feeling of being charmed by the novel and as yet unprocessed encounter and (2) a more *unheimlich* (uncanny) feeling of being disrupted or torn out of one's default sensory-psychic-intellectual disposition. The overall effect of enchantment is a mood of fullness, plenitude, or liveliness, a sense of having had one's nerves or circulation or concentration powers tuned up or recharged—a shot in the arm, a fleeting return to childlike excitement about life.[63]

In the encounter with animistic and vitalist imagery we are continually oscillating between this enchantment and an awareness of the material fact of these inanimate materials. Watching the Quays' vitalist worlds, the viewer oscillates between the knowing of the illusion and the pre-knowledge state of apprehension. Monica Greco suggests that "once it is understood performatively, as resistance and excess with respect to the remit of positive knowledge, vitalism therefore appears valid—not in the sense of a valid representation of life, but in the sense of a valid *representative* . . . to erase the contradiction that vitalism provides, to dismiss it as a weakness of thought, is to silence life, and to become ignorant of ignorance."[64] The Quays' film can evoke Bennett's surprise state, in that it is a novel encounter and its worlds can disrupt the sensory-psychic-intellectual disposition: this is the moment of apprehension that often occurs when watching the Quays' puppets. (Bennett's concepts are also helpful to disassociate the emotions that animation evokes in spectators from a common misconception that they are childish or regressive.)

The Quays' noncompossible portmanteau puppets (explained in more detail in the following section) share properties with what Bennett describes as metamorphing creatures in film and literature—a deliberate bug, an aerial goat, an organless body—that are interspecies and intraspecies crossings in a state of becoming.[65] This is also the category of winged, finned, or beaked mental models Grodal described earlier. Bennett then describes what is responsible for their having the power to enchant:

> Their magic resides in their mobility, that is, in their capacity to travel, fly, or transform themselves. . . . Metamorphing creatures enact the very possibility of change; their presence carries with it the traces of dangerous but also exciting and exhilarating migrations.[66]

This magic is inherent in animation's principles of illusory movement of otherwise static and lifeless forms. Doubtless the initial pleasure a spectator feels is an aesthetic one. Collage style, carefully composed images, a wealth of shapes, textures, materials both archaic and postmodern, are arranged in curious and elliptic narrative structures and underlaid with haunting music and soundscapes that can simultaneously alienate and charm. By feeling empathy with animated forms and figures, spectators can experience an Otherness and, perhaps, joy and enchantment, which, in turn, can relieve the sense of dearth, isolation, and alienation that the disenchantment tale of information culture propagates. The feeling of enchantment is a phenomenological experience that contributes to the pleasure of watching the Quays' works.

Automata and Portmanteau Puppets

Automata are abundant in the Quays' films. An automaton concept was constitutive in the script for their second feature-length film and it is especially prominent in films made after *Street of Crocodiles*. The Quays emphasize this: "Technically, *Street of Crocodiles* is a kind of vast automaton notion. In fact, in a sense, the character cuts himself free, doesn't he? In fact, that's the conceit—to say that a real automaton would still be tied to those strings."[67] They appear to be autonomous characters independent of the hands that crafted them, but there is an intrinsic difference: artifacts, but alive; objects, but apparently sentient (on-screen). Recalling the earlier discussion of Kleist's marionette, the apparently independent movement of an animated puppet's actions and

its "experiences" makes it a different kind of automaton than the hapless ones described in literature or actors in the role of an automaton. A puppet can appear to see, respond, gesture, act, and understand, yet outside of the film frame a puppet is simply a puppet.

In *The Architectural Uncanny*, Vidler also develops concepts about contemporary architectural design around the body: "Freud's analysis of the uncanny effects of dismembered bodies is especially redolent for the interpretation of architectural fragmentation that rejects the traditional embodiment of anthropomorphic projection in built form."[68] Vidler goes on to describe the criteria: in pieces, fragmented, torn apart, and mutilated or having infinitely ambiguous and extensive interiors and exteriors.[69] Sculptures, paintings, puppets, and photographs of such bodies were prevalent in twentieth-century art (e.g., Hans Bellmer, Georg Grosz, Umbo, Raoul Haussmann, Hannah Höch, and Cindy Sherman). In 1999, the exhibition "Puppen Körper Automaten: Phantasmen der Moderne" (Puppets, Bodies Automata: Phantasms of the Modern) opened in Düsseldorf, a remarkable and comprehensive historical collection of artworks, cocurated by Pia Müller-Tamm and Katharina Sykora. Müller-Tamm describes the attraction these objects can have:

> These exemplary artefacts have—already before their entry into the artistic work—an ambivalent character: They represent on the one hand that made by humans, for a second-hand nature, for the constructed and controlled, for the mechanically functioning, instrumental, servile, for objects and things. On the other, they offer a vivification through the user's or viewer's fantasy, and then reveal a magical, frightening, unsettling, irritating and alienating effect.[70]

This becomes exceptionally uncanny in the Quays' set design and puppet construction. They are referential, fragmentary, incoherent, and deracinated from existing architectural constructions and spaces, as the puppets can diverge from anthropomorphic human proportions and appearance. The characteristics listed above are reinterpreted in Vidler's description of the reinscription of the body in architecture and transformed again in the uncanny body that figures prominently in the Quays' puppet and set designs. The uncanny effect in *Street of Crocodiles* is provoked to a great degree by the use of historically specific, extant inanimate materials—plaster, wood, old fabrics, rusting metal, wire constructions—which create apprehension via an ambivalence of knowledge between this and the

pathetic (empathetic) fallacy of anthropomorphization, in the moment when these materials are reified and attributed with senses, feelings, and cognizance. The traces and residues that permeate *Street of Crocodiles* are redundant materials: salvaged windowpanes, threadbare fabrics, and antiquated mechanical apparatus—a bricolage of bits and pieces that collects the remnants of a locus that no longer exists, a romantic ruin. Although the architectural elements of the sets seem to suggest containment and coherence, it is in the very fact that fragments are usurped from an origin that is no longer there that provokes an apprehensive oscillation between their temporal and spatial dislocation and the hermetic "completeness" of the set.

The Quays' puppets function as doubles, as fetish objects, and they also raise queries that recall theories of the double, of simulacra and automata, all of which figure in the authors discussed previously, and vitalism and animism are at play. Jonathan Romney suggests: "The Quays do not so much animate dead matter, as dramatise the deadness of matter. Quay puppets are not alive but undead; they don't have lives, they have after lives."[71] Robyn Ferrell suggests:

> Objects and graphics function as narcissistic "doubles" as a protection against death: But doubling generally is uncanny because of a kind of primitive thinking, now surmounted but not eradicated, [Freud] says. The splitting into two (e.g., the invention of a soul) was a narcissistic protection against death. But, following its repression, the double returns as a "harbinger" of death.[72]

In puppet animation film, the double returns as harbinger of death on two levels: as an object constructed of lifeless materials and as an animated "double," and thus it is doubly uncanny. The homunculus's twitching eye in *Rehearsals for Extinct Anatomies,* the Alice doll's telescoping ankles in the *Stille Nacht* films, the insectlike, compulsive gestures of pulsing, pumping apparatus—the Quays' uncanny images of lives and afterlives evoke an apprehensive pleasure at seeing the impossible. There are many instances of this: blood-smeared razor blades and bloodied, flesh-filled pocket watches; rusty screws that free themselves of their holdings and roll away offscreen to reappear and re-imbed themselves in a floorboard; a beam of light that shines on a lightbulb figure that instigates its movement as it begins to furiously polish an object made of the same materials as itself. Jean Baudrillard suggests the automaton "is an interrogation upon nature, the mystery of the existence or non-existence of the soul, the dilemma of appearance

and being."[73] In many of the Quays' films, fragile objects and aimless figures carry out pointless tasks. These vitalist loci punctuate the world of the films, populated by bizarre, sometimes endearing, sometimes erotically charged objects. We are puzzled by their repetitive purposefulness: it is a purpose without a point. The conundrum of their fantastic construction of lifeless objects is partially resolved by movements that suggest a vitalist appurtenance of being.

There may be a deep satisfaction in seeing objects and puppets that are assembled in such a way as to suggest that they bear resemblance with living or moving things. The Quays describe some of the themes at work in their films in this way:

> You're dealing with darker forces and darker elements, if something goes pathological it sort of deroutes and goes beneath and more subterranean, it could be sexual, it could be psychotic, it could be anything, but I think we tend to leave it a bit more vague. In general the pathological scores at a very deep level, it can be very true, it can be very real. Also, nature deroutes and creates strange, as it were, pathologies, but it's aberration in a way, and you're talking about the aberrational, but at a more symbolic level.[74]

These deroutings cause a pleasurable apprehension that is not specific to anthropomorphic puppets. The writhing layers of iron filings that cover surfaces in *Stille Nacht I: Dramolet* can evoke this, as can a hand sensually stroking a moist kidney or caressing a slab of liver *(Street of Crocodiles),* as can the dancing or twitching finger in *The Comb.* There are more deroutments: the homunculus rubbing the mole on its head in *Rehearsals for Extinct Anatomies* or, at the end of *Street of Crocodiles,* the graceful Tailor's Assistants beginning a repetitive, hapless rotation of their arms, armatures exposing material intimacies of the shoulders' stuffing and sharp metal parts.[75] The small events of these theaters infect the actions of the gynomorphic figures. They too are machines, automata, not only at the beck and call of the crafty Tailor but answering to some deeper sublime or animistic power that suggests they are trapped in their forms, bric-a-brac constructions of cloth, metal, and porcelain. But it is the music that suggests this, a sweet, poignant pleading violin that pulls us in deeper to engage on the emotional level of the music. This is one of the few moments in the film when the puppets seem to be part of a community, lost souls in the deteriorating memory of Schulz's magic and forgotten world.

Bricolage and its close relative, assemblage, perhaps best exemplified by the works of Kurt Schwitters, Cornell's boxes, and Duchamp's readymades, figure abundantly throughout the Quays' filmmaking. The Quays' acumen to construct isolated bits and pieces into unusual objects and, indeed, sculptural artworks contributes to creating analogies between natural materials and an idiosyncratic perception of the world. The haptic qualities, the textures, forms, and sensual intensity makes many of their works unique. Animation then imbues their materials with a vitalist urge akin to the descriptive writings of the authors, reifying and detailing the minutiae of everyday life as objects engaging in small, epiphanic events. In contrast to most puppetmakers, the Quays have a tendency to intentionally expose what lies beneath the surface: "When we do that, it's also because you know you want them at that point—that they are puppets, but you go beyond that; then you can reveal that they *are* puppets."[76] This self-reflexive gesture also enhances the automaton-like quality. While this incites a momentary break in the fictional world, it corresponds to Schulz's world, in which

> demiurge, that great master and artist, made matter invisible, made it disappear under the surface of life. We, on the contrary, love its creaking, its resistance, its clumsiness. We like to see behind each gesture, behind each move, its inertia, its heavy effort, its bearlike awkwardness.[77]

The Quays' predilection for rootless, abandoned materials continues traditions of Duchamp's bachelor machines and readymades and Surrealism's exquisite corpses. Their use of dead matter that mocks human form and foregrounds the material's autonomy is intertwined in the challenge to animate and sensualize deadness. Conjuring this world means exposing matter's "bear-like awkwardness"—transmuting Schulz's generatio aequivoca, his literary automata, into silently performing materials manipulated and animated by the hands of their makers. A sentience, an appurtenance of life, is evoked by the puppet's physical manipulation between frames. Again we can take a cue from Schulz's "Treatise on Tailor's Dummies":

> "Can you understand" asked my father, "the deep meaning of that weakness, that passion for colored tissue, for papier-mâché, for distemper, for oakum and sawdust? This is," he continued with a pained

smile, "the proof of our love for matter as such, for its fluffiness or porosity, for its unique mystical consistency."[78]

In *Street of Crocodiles,* stodgy, thick dust becomes a revelation when the camera rests upon it, or sand comes to life, flitting and pulsing, sand beetles struggling beneath its surface on their backs with legs kicking, creating exquisite jumpy pools of insect-life struggle (one of three shots filmed close to real time). In an uncanny reversal of disconcerting density, there is an understanding of what it is to be trapped in a sawdust-and-cloth physicality and to be privy to its sinister and sensual potential.

In chapter 2 I described the usefulness of Joyce's portmanteau words with reference to Fritz Senn's interpretation of dislocution. I now want to bring this to bear on the manner in which the Quays construct their puppets, but I will use specific concepts of cinematic metaphor to transcribe dislocution into the contexts of the Quays' puppet animation. The pronounced artifice of their mise-en-scène relaxes expectations of a live-action cinematic equivalent of human life form, and metaphor is one way to approach the Otherness of the objects. The Tailor's Assistants in *Street of Crocodiles* are a good example of this: the dolls' heads were found in London's Covent Garden market, the torsos constructed around a metal armature, the lower part of them a box-formed wooden skirt on concealed wheels. In a thorough analysis of cinematic metaphor, Trevor Whittock describes related forms found in cinema, including epiphor, juxtaposition, metonymy, synechdoche, objective correlative, distortion, rule disruption, and chiming.[79] An important point is brought up by Whittock regarding the relations between various tropes or metaphorical devices:

> They function in relation to one another and to other elements
> in the work, which brings me to a fundamental point. In art,
> figurative meanings coalesce to form new constellations; patterns
> amalgamate to create larger structures; constituent parts are ever-
> combining into significant wholes. Metaphor is not only an element
> in this process: The very process itself is one of metaphorical
> *transformations.*[80]

These parts, which I will describe in more detail later, are the root of the sensation of apprehension. The viewer's co-creational, dislocutional development of increasingly coherent patterns—in the narrative, metonymy, the mise-en-scène,

the undercurrent life of the realm—prevails as intellectual apprehension gives way to a pleasure of emotional comprehension. Thus understood, cinematic metaphors are part of the greater *process* of transformation, a process driven by the reader's own powers of imagination, which the author feeds with certain related tropes. I suggested that the viewer of the Quays' films, like a reader of *Ulysses* or *Finnegans Wake,* is forced to participate in the creation of the new meanings. Besides stylistic and linguistic innovation and the move inward to the protagonist's mind, in Joyce's later works the portmanteau word, another form of metaphor, takes on the status of a character; in analogy, puppets like the Tailor's Assistants are sculptural portmanteaus.

At this point it is relevant to recall that at the time of making *Street of Crocodiles,* the Quays were frequently referred to by their critics as surrealists. Robert Short suggests the Surrealists were more concerned with technique and style and that they "propose analogical thinking which can permit the reclassification of experience in an emotional and intuitive way. They claim that the poetic analogy has the power to reveal the principle of identity between the human mind and the exterior universe."[81] In Schulz's writings, this principle of identity is created by merging imagination and vitalist descriptions of the palpable world. The Quays transform Schulz's story into poetic analogies via imagery and sound using materials that stand comparison with ones that Robert Short attributes to surrealist concepts: "The poetic or plastic image, especially when it brings together a pair of elements which reason would regard as having nothing in common, often generates a mysterious luminosity and appears to be inexplicably appropriate, even inevitable."[82] This notion of pairs of elements applies to some of what I call portmanteau puppets that populate the Quays' films. These are composite figures made of disparate materials that notionally have nothing in common, but which, in their specific combinations, create a unique type of cinematic metaphor. This invites the viewer's analogical, co-creative complicity and is also partly responsible for inducing the pleasure of apprehension, which is located between the intellectual certainty of the real world and the counterpart intellectual uncertainty of the Quays' cosmogony.

Noël Carroll's "A Note on Film Metaphor" informs my concept of portmanteau puppets with a convincing set of proposals. Referring to a range of examples, from Fritz Lang's *Metropolis* (1927) to Popeye cartoons, Carroll explains that homospatiality (elements copresenting in the same figure) is a prerequisite for such visual metaphors, as it "provides the means to link disparate categories in visual metaphors in ways that are functionally equivalent to the ways that

disparate categories are linked grammatically in verbal metaphors."[83] Linking disparate categories in the same figure and image includes using materials from widely differing origins and materials. Examples of homospatiality in the Quays' puppets are the hand with a cuff of stringed beads with a key protruding from the back of the wrist *(Stille Nacht III)*, *Rehearsal*'s wire-and-plaster homunculus, and the Tailor's Assistants: the category of human and mechanical are combined in a single figure (see Plate 11). Another extremely apposite property Carroll elaborates on is "physical noncompossibility," something that "is not physically compossible with the universe as we know it that muscles be anvils, that people be cassette recorders or that spies be foxes."[84] Carroll discusses drawn animation, but his concepts also work for puppet animation that animates objects from the phenomenal, physical world, disparate elements that can be fused together in composite figures.

I will briefly revisit the portmanteau word, a linguistic blend of two or more lexemes from words that create a new single word and in their combination create a new meaning that alludes to the original words. In chapter 2, I explained how this new meaning is created by the reader's engaging in disjunctive synthesis, and examples of Joyce's portmanteau words were all adjectives or pronouns. In the "Cyclops" chapter of *Ulysses,* Joyce lists the names of the Delegation of the Friends of the Emerald Isle, including Commendatore Bacibaci Beninobenone; Borus Hupinkoff; Grandjoker Vladinmire Pokethankertscheff; Hi Hung Chang; and Nationalgymnasiummuseumsanatoriumsordinaryprivatdozentgeneralhistoryspecialprofessordoctor Kriegfried Uberallgemein (12: 556–69).[85] These linguistically bound names create a homogeneous identity (and are especially witty when spoken aloud). I will interpretatively elaborate on the last two names of the last name. The play with German words *Krieg* (war), *Friede* (peace), and Siegfried (a Teutonic dragon-slaying hero from the third of four operas in Richard Wagner's *Ring of the Nibelungen,* based on an epic poem) creates a bellicose Kriegfried. Paired with the last name, a combination of *Überall* (all over, pervasive) and *gemein* (beastly, cruel) and *allgemein* (universal, common) elicits a figure whose name has multiple meanings and attributes. Carroll elaborates that homospatiality and noncompossibility can suggest identity "when they are visually incorporated or amalgamated into one spatially bounded homogeneous identity."[86] The combined parts of some puppets in the Quays' films, analogous to Joyce's portmanteau names that are bounded and create an identity, result in an identity of the puppet, one that is complicit with Schulz's concept of the generatio aequivoca. Many a Quay portmanteau puppet—the Enkidou puppet of feath-

ers, cloth, and bones, the Tailor's Assistants' torsos on wheeled wooden boxes, a watch lined with flesh, and, indeed, many a puppet in other filmmakers' work—is noncompossible. While made of materials from the phenomenal world, they cannot exist as living entities in the real world. Deleuze and Guattari propose

> there is no such thing as either man or nature now, only a process that produces the one within the other and couples the machines together. Producing-machines, desiring-machines everywhere, schizophrenic machines, all of species life: the self and the non-self, outside and inside, no longer have any meaning whatsoever.[87]

The Quay Brothers' disjunctive poetics is evident in the combination of merging noncompossible elements in puppet construction and creating credible entities with some semblance of life—"species life" is a translation of *la vie générique* (the original French term in *L'Anti-Oedipe*) and the generatio aequivoca—through the recording of the process via animation.

Carroll names eleven prerequisites for a film metaphor that includes ones that must be in place for the spectator to engage with the kind of noncompossible film metaphor I am proposing for the Quays' puppets. Three of these are particularly relevant for my discussion here: that the filmmaker be aware that the image presented is of something physically noncompossible; that the spectator believes that what is represented is intended to be physically noncompossible; and that the filmmaker intends the presentation of noncompossible elements in a homospatially unified array that invites the viewer to explore how these categories illuminate each other so that they have heuristic value.[88] Because the composite objects are of inanimate matter and animated, the Quays are aware of presenting a noncompossible image, and for the same reason, the spectator also realizes and accepts the second condition that the images are physically noncompossible, but via disjunctive synthesis they become credible "compossible entities in what might be called the world of the fiction or the world intended by the narrator."[89] The world intended by Schulz is a vitalist one, and the Quays' animation transposes these literary metaphors into cinematic ones that the viewer is complicit in co-creating as viable, believeable entities in the film's fiction. This is the dislocutory act performed that transforms the assemblage of disparate categories—in the *Rehearsals* puppet (see Figure 14), tangled metal wire, a glass eye, plaster skull—into an inhabitant of the film's vitalist realm, shared with other metaphysical machines. As for the third condition, that of the filmmaker's intent, the Quays

make a relevant statement about certain freedoms that come with using anonymous objects: "You accept their very physicalities palpably as objectified dream or as music, and it's at this point that you can convey compound zones, darker ranges, deeper possibilities, as well as perpetuate other narratives, other secret liberties."[90] These "compound zones" are the Quays' invitation to the spectator to explore the historical and aesthetic referents of the materials that perpetuate other narratives. These three terms—visual metaphor, homospatiality, and physical noncompossibility—are requisite to the spectator's acceptance and understanding of the actants in the Quays' cinematic worlds as portmanteau puppets.

Carroll suggests that "metaphors interanimate the relations between classes or categories."[91] The Quays' noncompossible puppets literally interanimate between categories of literature, sculpture, commodities, and cinema, between philosophical and perceptual categories of phenomenal, vitalist, and animistic worlds. The spectator's disjunctive synthetic experience of the aesthetics, actions, and effects of the typology of figures this chapter has described and interpreted are inseparable from the physical spaces they are filmed in. The next chapter therefore takes cause with how this cinematic labyrinth is constructed, mediated, and negotiated by the camera, the puppets, and the viewer.

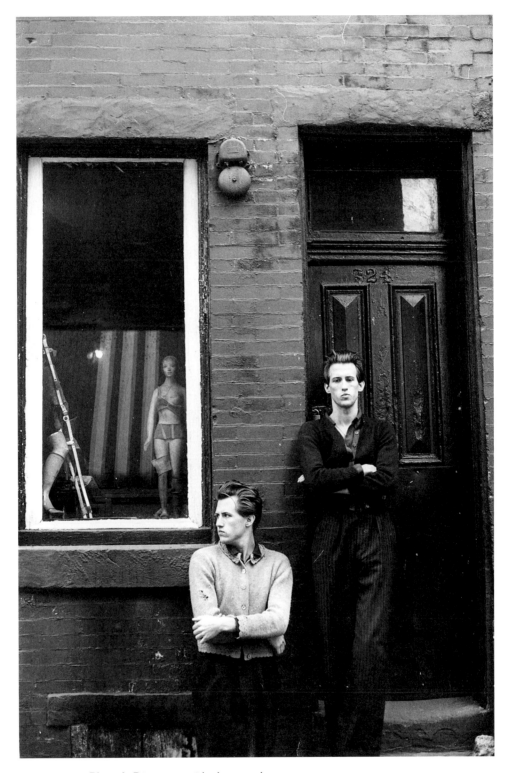

Plate 1. Diary page with photograph
of the Quays (Stephen left, Timothy
right) in Philadelphia in front of a pros-
thesis shop, circa 1973. Copyright and
courtesy of the Quay Brothers.

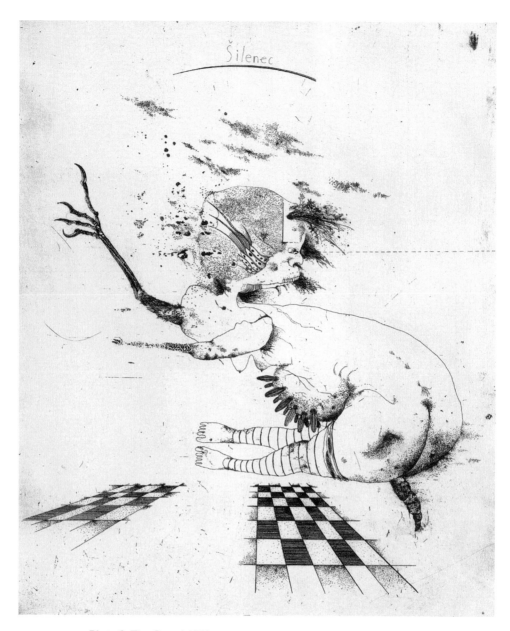

Plate 2. The Quays' 1971 engraving
"antidote" to the Janáček opera *The
Excursions of Mr. Brouček to the Moon
and to the 15th Century (Výlet pana
Broučka do Měsíce/Výlet pana Broučka
do XV. století)* (1920), an opera about a
voyage to the moon with science-
fiction elements. Copyright and cour-
tesy of the Quay Brothers.

Plate 3. *Serenato in Vano*, etching made in 1971 while at the RCA. The Quays call it "a response of recommendation for obsolete instruments" for the homonymous composition by Danish composer Carl Nielsen. Copyright and courtesy of the Quay Brothers.

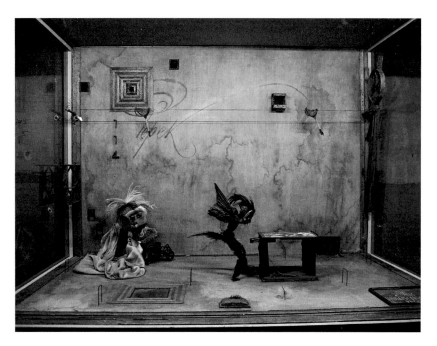

Plate 4. Original décor of *This Unnameable Little Broom.*
Copyright and courtesy of the Quay Brothers.

Plate 5. One of the spaces of apprehension in *Street of Crocodiles* (1986).
Courtesy of the Museum of Design Zurich and copyright the Quay Brothers
and BFI.

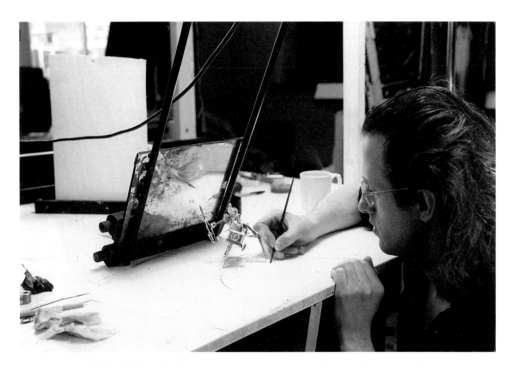

Plate 6. Timothy Quay creating the animated calligraphy during shooting of *Rehearsals for Extinct Anatomies* (1987). Copyright and courtesy of the Quay Brothers.

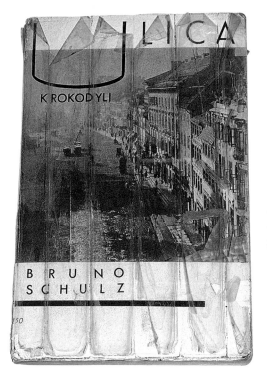

Plate 7. The Quays' own revamped copy of Bruno Schulz's *Ulica Krokodyli*. Courtesy of the Museum of Design Zurich and copyright the Quay Brothers.

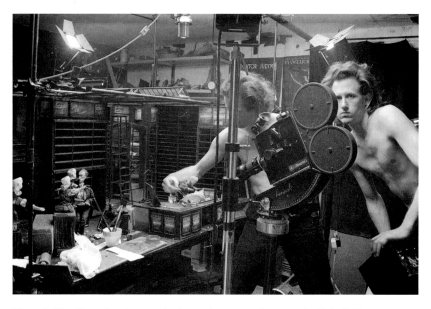

Plate 8. The Quay Brothers in the heat of summer shooting the Tailor's Shop sequence for *Street of Crocodiles*, circa 1985. Copyright and courtesy of the Quay Brothers.

Plate 9. Décor from *Stille Nacht 1* as it was displayed in the "Dormitorium" exhibition. Copyright and courtesy of Mark Bartlett.

Plate 10. A Tailor's Assistant caressing one of the erotic objects in the
Tailor's back room. In the film, the pins extrude from the kidney as it is stroked.

Plate 11. Two of the noncompossible puppets in *Street of Crocodiles.*
One arches its back, responding in mock ecstasy to seeing a screw in the
Schulz puppet's striped box.

Plate 12. A still of one of the many deep focus pulls in *Street of Crocodiles* that shows the remarkable depth of field achieved.

Plate 13. Screws on a bloody rampage: a still from *Street of Crocodiles*.

Plate 14. An elaborate machine for breaking rubber bands from *Street of Crocodiles*. The apparatus rises up to place a rubber band between the two horizontally moving arms.

(opposite) Plate 15. Publicity poster with décor designs for film, opera, and theater. *Upper left: Ex Voto* (1989) for MTV. *Upper right:* Model décor for *Le Bourgeois Gentilhomme* of Molière for the National Theatre London. *Second left: The Calligrapher* (1991). *Second right: Mazeppa,* opera by Tchaikovsky for Bregenz/Nederlands Opera, director Richard Jones. *Third left: Love for Three Oranges,* opera by Prokofiev for Opera North/English National Opera, director Richard Jones. *Third right: De Artificiali Perspectiva, or Anamorphosis* (1991). *Bottom left: Long Way Down (Look What the Cat Drug In),* 1993 music video for Michael Penn. *Bottom right: The Comb [From the Museums of Sleep]* (1990). Copyright and courtesy of the Quay Brothers.

Atelier Koninck QBFZ
SUFFOLK HOUSE
8 TOULMIN STREET, LONDON SE1 1PP
TEL. 071. 378 86 38

QUAY DECORS BROTHERS
ADVERTISING. THEATRE. PUPPETS. OPERA

Plate 16. A still from one of the "exterior" landscapes of *In Absentia* (2000). The panels and rays of light are animated in the film, changing in intensity, shape, and perspective.

Plate 17. The Librarian explores artifacts in *The Phantom Museum: Random Forays into Sir Henry Wellcome's Medical Collection* (2002). The anatomical illustration was also seen in the Tailor's back room in *Street of Crocodiles*.

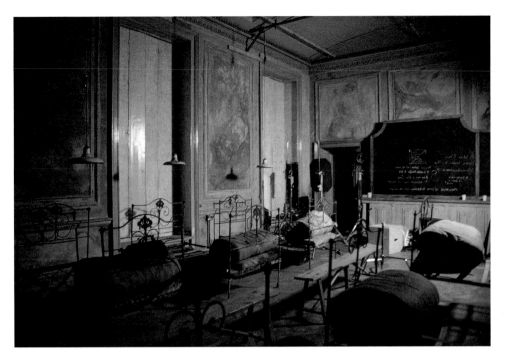

Plate 18. The actual colors not registered on the monochrome film of the students' dormitory set during filming at the Hampton Court, London, shoot in 1994. Photograph copyright of the author.

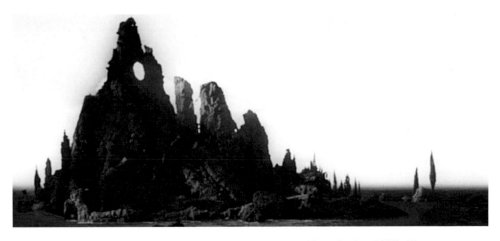

Plate 19. A landscape shot of *The Piano Tuner of EarthQuakes* (2005). The miniature set design for Droz's island and villa was inspired by Swiss symbolist painter Arnold Böcklin's *Insel der Toten* (The Isle of the Dead) series (1880–86).

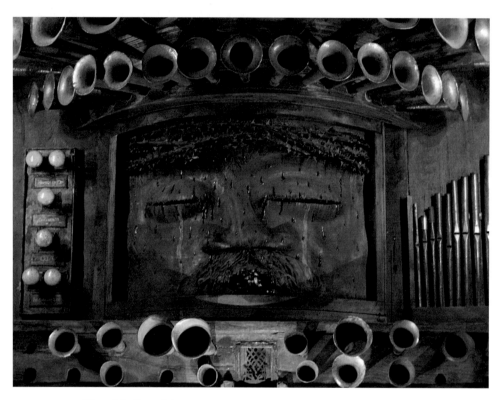

Plate 20. One of the seven automata in *The Piano Tuner of EarthQuakes* on display in the touring "Dormitorium" exhibition of the Quay Brothers' stage and set designs. Courtesy of Mark Bartlett.

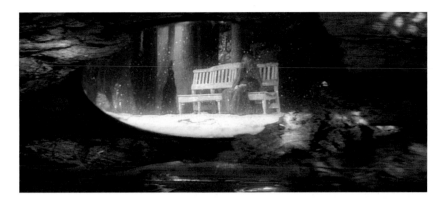

Plate 21. Malvina captured in a glass snowball realm in the sixth automaton of *The PianoTuner of EarthQuakes*.

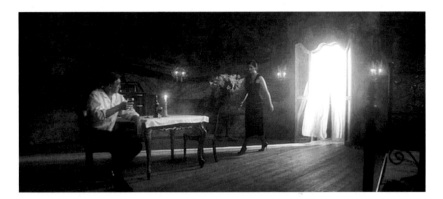

Plate 22. A painterly interior shot from *The PianoTuner of EarthQuakes* with Droz (Gottfried John) and Assumpta (Assumpta Serna).

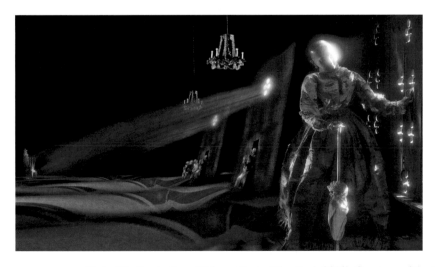

Plate 23. Production still from *Maska* (*The Mask*, 2010). Courtesy of the Quay Brothers and Semafor Studios.

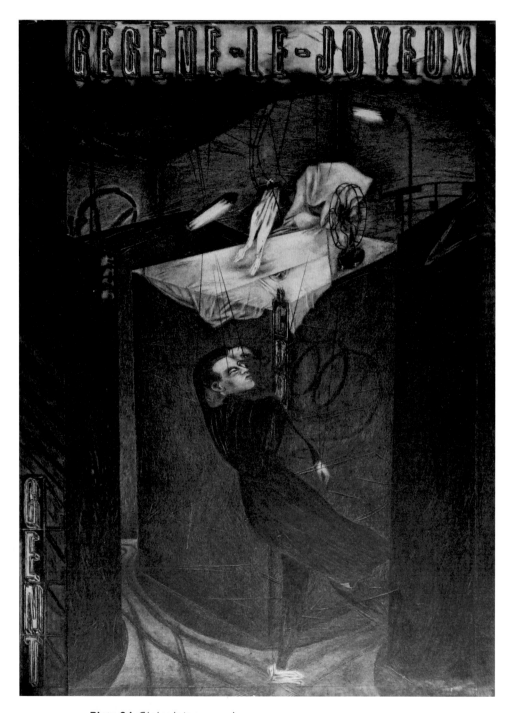

Plate 24. *Gégéne-le-joyeux,* made
around the time the Quays discovered
Robert Walser and began reading
Bruno Schulz, the drawing was a "direct
precursor to the Schulz puppet for
Street of Crocodiles." Copyright and
courtesy of the Quay Brothers.

NEGOTIATING THE LABYRINTH

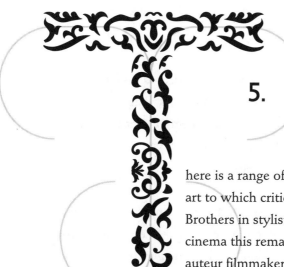

5.

here is a range of influences throughout the history of art to which critics and curators refer to bring the Quay Brothers in stylistic proximity with other artists. But in cinema this remains a small group of experimental and auteur filmmakers. Cineastes whom the Quays mention as having had a particular influence on them are Aleksandr Dovzhenko, Robert Bresson, Theodor Dreyer, Georges Franju, Charles Bokanowski, Andrei Tarkovsky, Aleksandr Sokurov, and others. All of these filmmakers are noted for their unusual poetics of lighting, mise-en-scène, and camera. The influences of impressionist cinema and especially surrealism are evident in some of the early films—*Nocturna Artificialia, The Cabinet of Jan Švankmajer,* and *Street of Crocodiles*—and they qualify as recent works in this tradition. The diagonally striped box the puppet holds in *Street of Crocodiles* was a small homage, a nod, to Luis Buñuel's *Un chien andalou* (1929), a film that stimulated some incisive thoughts in the Quays early on:

> [*Un chien andalou*] is one of the most powerful films we ever saw, and it's a short film, which proves you didn't need to do a feature film to astonish. It has a violent lyricism and the poetic images were wild, really attractive. It's just a layer; it's as much as you read anyone's work, it adds to the density of the material, and it's not important to

know, not at all. [The puppet] just has a box around his waist with a screw hanging out. It's better than a Gucci bag.[1]

Yet they are not completely at ease with the surrealist attribute, as is clear from a 1996 interview: "Of course we are familiar with surrealism, we know its history and its place, but the term can too often be used in a cavalier way, without acknowledgment of its real meaning. . . . When it's used cautiously and intelligently it can be a very descriptive term, but we're weary of its over-use."[2] In their later films the emulation surrealism seems to have initially provoked in the Quays is less mannerist and references are increasingly literary and musical. The Quays explain what interests them aesthetically:

> Our animation draws heavily on a very sophisticated visual language—a certain quality of lighting and décor, of stylized movement—which has a lot to do with Expressionism. But at the same time one could talk [of Buster] Keaton, or early Swedish or Danish cinema, all of which are crucial for us.[3]

Their works have also been compared to those of other contemporary filmmakers, including Canadian director Guy Maddin, noted for his use of filters, monochrome film stock, and silent film stylistics. Viewers familiar with the films will recognize the three directors' own knowledge and implementation of these techniques, and it can also explain the cinephile nature of their engaged audiences.

But these similarities rest within the works, evident in their response to Ryan Deussing, who suggested aesthetic similarities between Maddin's *Careful* (1992) and *Institute Benjamenta*. The Quays: "The relation to *Careful* is purely fortuitous. We had never seen the film when we got started shooting, and [Maddin] had never read [Walser's] book. Somehow we do share the same iconography."[4] The comparison and the shared iconographies originate in part in Maddin's fascination with the histories of silent cinema. His use of intertitles, scratching pristine film stock to make it appear old and worn, and his fantastic mise-en-scène and unusual narratives places him in the same continuum of filmmakers as the Quays. Maddin's characters in *Careful,* for instance, are distant and stilted, unemotional, much like puppets themselves. The era of filmmaking the Quays mostly align themselves with is telling and reveals much of their own cinephile natures: "The whole history."[5] They are regulars in the art house cinemas and have combed many histories of filmmaking; fine filaments find their way into their films.

In interviews, the Quays readily cite animation filmmakers who use techniques other than puppet animation as influences on their own works, including Walerian Borowczyk (who had a much stronger impact on the Quays than is usually reported), Jan Lenica, Jerzy Kucia, and Alexandre Alexeïeff (who made most of his French films with Claire Parker). These animators have certain formal and aesthetic affinities with the Quays in terms of creating moods using special lighting, camera styles, or source materials. Borowczyk's earlier drawn animation films have anti-narrative structures and his graphic designs appealed to the Quays' illustration interests. Kucia's films are often black-and-white, and he is highly conscious of the enormous range of moods light affords, experimenting with lighting and movement, as in *Refleksy/Reflections* (1979) and *Przez Pole/Across the Field* (1992). His somber use of chiaroscuro, to the point sometimes that the image is almost entirely black for long sequences, is akin to the effects that Alexeïeff and Parker achieved with the pin screen technique in *Une Nuit sur la Mont Chauve/Night on Bald Mountain* (1933). They used side lighting to create minute gradations in the shadows thrown by varying protrusion of pins out of his pin board. Almost all of these artists originated from Eastern Europe and Russia, an influential locus the Quays acknowledge: "We're much more indebted to Russian and Polish animation from the turn of the [twentieth] century . . . we know that work very well. It's just that most other people don't."[6]

As with these filmmakers' works, the Quays' poetic syntax requires viewers to participate in the relationship between sound and image and to invest in schemata building if they are to find some sort of narrative or plot within the visual framework composed around the musical score (that will be explored in chapter 6). This is also apparent in a 1994 description of their working method: "We improvise enormously under the camera, and when we get [developed film] back, we know if things are working, and if it's not working we scrub the scene and we'll rethink it, but it's always a very organic process."[7] While belonging to a particular community of experimental filmmakers, there is much that also makes the Quays distinct from a general classification as animation filmmakers within a puppet animation tradition. A complex stylistic methodology persists throughout their work, one that is apparent in both their live-action and animation filmmaking.

Violating Space: Montage and Disorientation

Many of the Quays' cinematic shorts deliberately construct a spatial logic of *direct connections between discontinuous spaces,* creating a distinctly unique cinematic realm.

The previous chapters "Traversing the Esophagus" and "Puppets and Metaphysical Machines" proposed aesthetic and literary contexts for and described aesthetic features of the Quays' sets and puppets. The rest of this chapter explores four distinctly cinematic formal and stylistic technical parameters and devices of their work that set these features in motion—montage, lighting, lenses, camera techniques—which, to contradict Max Ernst, are indeed "la colle qui fait la collage."[8] As many later variations on these techniques originated in *Street of Crocodiles,* it will provide the main examples of their cinematic poetics.

Compared to drawn or painted planar (paper and cel) animation, puppet animation has differing modes of production, mise-en-scène, and camera techniques that have much more affinity with live-action filmmaking and expand the puppet animation filmmaker's palette with visual, spatial, and temporal features. The profilmic moment of shooting constitutes the inherent difference, and this distinction forms a significant part of my analysis. Only in single-frame animation (including animated sequences in a live-action film) does the quality of movement of the artifact *itself* come into play.[9] The Quays employ almost all the other arts in their puppet animation films: sculpture, architecture, graphics, painting, and the time-bound arts of dance, music, and literature. Static arts thus are freed of their immobility (and phenomenological inanimateness) through the technique.

Many microanalyses in film studies use a shot-to-shot protocol method as a basis for analysis. The systemized tabling of parametric information does provide an overview and does allow us to reconstruct the film in its final form. This information can explicate the technical process of filmmaking but not the countless decisions and "mistakes" that the Quays themselves account as crucial to the finished film. It brings with it the danger of assuming that the Quays proceeded with a linear, causal scenario for *Street of Crocodiles* and other films, which they pointedly declare they did not,[10] nor do they make use of the many conventions that define more mainstream animation shorts. What can be divined from this material is a sense of their preferences and style in cinematic parameters, such as a tendency to use chiaroscuro lighting or a rapid editing frequency. This kind of analysis is, in an extended sense, analogous to an autopsy, whereby the innards—the materials and structures and their organization—are revealed, but the creative impulse remains elusive.

I now tease out a montage system that transforms the Quays' sets and spaces into an intentional disorientation, a visual language of Joycean "dislocution" that creates unconventional worlds populated by their puppets and

metaphysical machines. Colleen Lamos regards Joyce's dislocutions as failures and suggests that "[Fritz] Senn argues that such failures are 'intrinsic' to the pro-grammed 'malfunction' of the work. In his view, Ulysses both thematizes and performs the movement of erring."[11] While I do not want to suggest that the Quays' films malfunction, I adapt this concept of programmed malfunction, as it indicates the intentionality on the Quays' part to create a pleasurable confusion, a confusion that engages the viewer to be receptive to the other laws of the film's realm. The organization of shots further enhances the complexity of the sets and the noncompossible forms within the images—the puppets and set fragments that are "imaginary, improbable or dispossessed of their real former functions."[12] The Quays' metaphysical machines and portmanteau puppets are already isolated metaphors in both the single frame and the mise-en-scène; and their juxtaposition with other shots creates an intellectual challenge that originates in redressing our conceived notions of continuity, spatial coherence, and narrative.

Familiar concepts of montage are not easily applied to most animated films because of their inherent differences from live-action films. Editing and montage of live-action films are, in the primary definition, attempts, post hoc, to refine the narrative coherence and continuity of a film and to remove unwanted or irrelevant material. Two-dimensional animation can take great liberties with these systems, and for most conventional forms of animated film these problems are avoided during production planning in storyboarding and design before the film is shot frame by frame. Even in some of the most abstract films, animation can provide spatial and temporal cues to create a coherent sense of psychological space, even if that space has a completely unfamiliar set of rules. In puppet ani-mation, however, rules of space are more rigid, since the space we see is three-dimensional and extant and has more correspondences with our own perception, expectation, and experience of space. Because puppet animation is a photo-graphic representation of objects in space, and because this is not abstracted (dis-tinct from two-dimensional animation, usually a graphic or painterly representa-tion of space and materials), it shares some formal features with live-action film. Karel Reisz describes a montage sequence as "the quick impressionistic sequence of disconnected images, usually linked by dissolves, superimpositions or wipes, and used to convey the passage of time, changes of place, or any other scenes of transition."[13] Conventional use of the montage sequence is "a convenient way of presenting a series of facts which are necessary to the story but have little emotional significance . . . which would be cumbersome to show in full or which, though essential to the story, do not merit detailed treatment."[14] The Quays'

montage disrupts this by presenting a series of enigmas that, taken singly, have little emotional significance but in their combination suggest the vitalist urge of the films' location.

Montage is divisible into different formal categories: actual physical assemblage of film material; planning of shots; the organization within the shots; the audio element and its composition in relation to the images, to itself, or to other nonmusical tonal elements; and last, the relations between these different elements. A general distinction can be made between two basic forms of montage; narrative montage, similar to North American continuity cutting, and expressive montage, associated with the Russian formalists and roughly divisible into the theories of Vselovod Pudovkin (the principle of film construction, or linkage) and Sergei Eisenstein. Beyond the physical cutting and editing of film stock, James Monaco's basic definition of montage offers further variations: (1) the dialectical process of creating a new meaning out of the original two meanings of directly connected shots, and (2) the montage sequence, in which a number of short shots are combined to present a great deal of information in a relatively short time.[15]

These definitions include constructivist montage concepts as well as Eisenstein's theories of montage of attractions and intellectual montage, which are more useful for my purposes because they offer alternatives to the linearity of narrative construction. Reisz describes the distinction for Eisenstein between narrative and storytelling: "Eisenstein's aim in thus breaking away from the narrative editing methods of his predecessors was to extend the power of the film medium beyond simple storytelling. 'While the conventional film directs *emotions*,' he wrote, '[intellectual montage] suggests an opportunity to direct the whole *thought process* as well.'"[16] As the Quays' films are not structured using clear narrative form or causal linking, directing the thought process is a way to support the viewer's heuristic engagement. The sequence analyses of *Street of Crocodiles* I undertake are indicative and exemplary for a system that is adapted and used in their other films. They reveal that the Quays' challenge to viewers to orient themselves in the film's disjunctive yet conjoined spaces is to a degree intentional; they partially wanted that "the geographies be rather blurred and indefinite—and at the same time they are so concrete."[17] One is often lost in the labyrinths their films construct, and the sense of disorientation intensifies during extended montage sequences. While the Quays do make use of some structures and narrative editing conventions of fictional realism, on closer scrutiny it becomes apparent how intricate their film grammar is within the contexts of cinematic montage. This montage is created by a typology of dialectical pairs constructed with mise-

en-scène, editing, and montage techniques specific to the Quays' style of experimental narrative strategies:

1. Continuity and spatial connectedness—discontinuity and disconnectedness;
2. Progressive and retroactive shooting;
3. Point-of-view structures and orientation—unmotivated montage, point of view and disorientation.

These are complicit in a mix of conventional and nonconventional editing techniques. Yet the Quays' originality lies in specific technical and montage techniques that construct their poetics of a dislocutory spatial logic of *direct connections between discontinuous spaces.*

Street of Crocodiles is set of short and long montage sequences that visually interpret descriptive moments from Schulz's text interspersed with scenes of narrative continuity that are usually centered on interaction between puppets. The viewer is taken on a trajectory through many of the streets, corners, hidden rooms, and "theaters" that are constructed using point of view and montage to create the world of the film. The Quays elaborate on how they construct space in two ways: on the one hand, by using classic continuity principles, and on the other, by undermining these, in other words, via a dialectics of continuity and spatial connectedness, discontinuity, and disconnectedness:

> In order to violate space you have to know how to maintain space. In a way it is judiciously playing between the two extremes—how much information and what to give, and then deny. Continuity can maintain space and also can rupture space. If a puppet turns and looks, you then pan to reveal that his space is connected to what he is looking at; that maintains the space. If you do a cutaway shot, and he looks at another space, you're securing space. We try to maintain space by looks; we always deal with the person looking.[18]

This ability to violate space comes from their understanding of how to use montage to undermine spatial logic of securing space, and the rupturing of space occurs in discontinuous editing, retroactive shooting, and unmotivated montage. The Quays began exploring these restrictions very early in their filmmaking: "When we did *This Unnameable Little Broom,* we built just one little set, but in this

sense it gave us the greatest freedom because we violated the space the most by creating a black void around it."[19]

Street of Crocodiles has scenes that use a dialectic of progressive and retroactive shooting, whereby the latter reverses expository conventions of narrative continuity editing. The Quays call the montage technique they use to incite a sense of recognition or previous knowledge "retroactive cutting." This creates disorienting effects that cue the viewer to understand how the conventional use of continuity is transgressed. It reverses the convention of commencing with a long shot followed by a close-up that explains by initially providing more information, then shifts to emphasize an element within that shot: "You see something that would only be revealed later. The cut, as it comes up, makes you think, 'That doesn't help.' So we like to go the opposite way, do the close-up, where you feel disorganized, so you come back and see an arm."[20] The arm, in this case, is the scene where the Schulz puppet touches the tangled filament. While the live-action exposition does partially adhere to conventions of the establishing shot of camera angle, eye-line matches, and varying shot size, retroactive cutting is also used, beginning with close-ups of a picture and the actor's face and progressing to a long shot of the entire room. In 4:40–5:02, retroactive cutting begins with an extreme close-up showing screws unscrewing themselves from a floor (see Plate 12). Extreme shallow focus leaves front and back of the horizontal plane out of focus as other screws enter frame left and roll offscreen right. This is followed by a hard cut to a long shot of the Zone, the monkey with cymbals in a window display flanked by two other shop windows, and the screws, now much smaller, rolling into the set from left of frame. This retroactive cutting commences in an ambiguous space that is then revealed to be the Zone. This principle is also used in one of the film's two live-action shots in the animated realm, the other being sand beetles struggling on their backs in sand. A close-up of a puppet's hand caressing its own breast (all the more uncanny as one of the Quays' hands is out of frame directionally pushing the rubber arm) pulls back to reveal the puppet's malevolent, carnivalesque face. Similarly, the animated realm within the Wooden Esophagus is introduced in a close-up not balanced by a long shot or another form of spatial orientation until the third entry of the camera into the realm. This part-to-whole metonymic strategy is disorienting and creates an apprehensive emotional mood. Combined with changes in depth of focus, reversed from deep to shallow focus, the objects within the realm control the viewer's perception of them. But because such montage sequences are not preceded by a point-of-view shot of a subject, this disorientation is not attributed to anything or anyone within the diegesis.

The Quays discovered another innovative use of reverse shooting to express the transitional properties of Schulz's world of matter. The last sequence of the film is composed of relatively long shots, beginning with a hard cut after two fast pans that transport us out of the Schulz puppet's subjective realm. The puppet's entry to and exit from the realm of the Street of Crocodiles both take place in the spaces introduced at the beginning of the film where we first see the puppet in the Wooden Esophagus Antechamber. The film is bracketed by these two sequences where he touches a tangled filament that, in the first sequence (2:49–3:00), unravels and in the second (18:45–18:54) becomes entangled again. These sequences are vital to understanding how the Quays conceptualized the Zone:

> We were trying there for something that Schulz had mentioned when he talked about those moments in time. It was the idea that when the puppet puts his hand on the cord, on the strings, and halts time, in a way he brings everything to a halt in the zone. It is something we never brought off, because what we really wanted was that it would go in reverse and time would flow back the other way, things would go back to their state prior to their decay and to their extinction. So we were trying to send everything flowing in the other direction.[21]

A successful instance of this "other direction" is the Metaphysical Museum montage sequence with scenes shot in reverse (8.59–11:42): a puddle of water grows into an ice cube and a dandelion clock reassembles itself, both returning to their states "prior to decay," creating scenes that express the laws of Schulz's world (and challenging the second law of thermodynamics and entropy). And in the final scene, the sense of closure and return to a space familiar from the beginning of the film is unsettled by a colored cloth around the puppet's neck, which was draped around him in a previous scene in the Tailor's back room. It erases the demarcations between hallucination, dream, and reality, mapping the labyrinth of the puppet's (and Schulz's) dreamworld. The colored animated world then fades to monochrome as the puppet freezes, looking up, and the blended-in text postscript to the film appears (Schulz's description of the dereliction of the *Street of Crocodiles* accompanied by a Polish voice-over).

Street of Crocodiles' systemized visual dislocution is a working method that uses montage sequences to express ordering of space and location of objects within the realm. These are created using a dialectics of point-of-view structures and orientation and unmotivated montage point-of-view and

disorientation. If we recall the collage concept the Quays used in their set design, part of the aim was to develop a confusion—"and that confusion we immediately felt was a pleasure, and that in order to be lost, you had to make it confusing."[22] The pleasure of this confusion is the sense of apprehension, of seeing what one does not yet fully apprehend, and the anticipation of discovery and comprehension. Using what I call unmotivated montage, this "lostness" is created by the Quays' arrangement of montage sequences that bundle disconnected objects in a shared, yet nonconnected space without invoking a passage of time, change of place, or transition. Examples of this are the Metaphysical Museum sequence and thereafter when the Schulz puppet is suddenly located in the Hall of Mirrors (11:58–13:00). It is not clear how these spaces are related, nor how the puppet moves between them, or who (or what) is doing the looking. In a dialectic to Reisz's description of the motivation for a montage sequence, it is exactly the elements of little emotional significance—the machines, the dust—that are cardinal in these sequences. In the lingering close-ups, they become (anti-)heroic, even gargantuan.

The point of view in *Street of Crocodiles* is often that of the camera itself, which the Quays tellingly call "the third puppet."[23] It is the point of view of the watchful presence of the vitalist undercurrent. But another point of view is implicit. The camera's point of view is always also that of the director, but in a directly active sense, since the animator not only determines formal parameters but also controls the between-frame adjustments of the puppets that result in movement, character, and "acting." This is another example of Mitry's discussion of a character's located psychology and my assertion that, unlike an actor, a puppet can neither be disassociated from creative imagination nor have a fully independent existence. Regardless of how much control a director will try to have over an actor's movements, actors are much more the possessors of a point of view; but puppets' actions and gaze structures are entirely created and determined by the animator. When a puppet looks offscreen or there is a match cut to what it is looking at, this calls attention to a much greater degree to the intention (and the actual action of moving the puppet) of the person animating the figure. This kind of point of view is much more mediated than in live action, because whether we have an omniscient or subjective point of view, we can be constantly aware of the animator's creation of the world we see.

A number of shots that use unmotivated montage seem to have neither a subjective nor an objective point of view, another grammatical element particular to the Quays. Burch offers a cue: "Still other possibilities can

result from the non-resolution of . . . open matches, films that would have this very ambiguity as their basis, films in which the viewer's sense of 'real' space would be constantly subverted, films in which he could never orient himself."[24] Most of the shots of the metaphysical machines are deliberately unresolved or are unmotivated by conventional point-of-view structures, and I propose this unmotivated third point of view is that of the vitalist, metaphysical machines. An instance of this is in the Watch Death montage sequence in which screws and nails pierce and crack a flesh-filled pocket watch. The sequence is preceded by a shot of the monkey clanging his cymbals; we haven't seen the watch before, and we don't see it again. Exceptions to this are in the sequences where there are eye-line matches with the Schulz puppet—for instance, when he is looking around at the shop windows in the Zone. Almost all the shots and scenes where he appears are constructed by his point of view, negotiating windows and passages or watching through a small window—another of the mysterious Bachelardian drawers, openings, and holes in the wall that inform the architecture of many a Quay film. But many other sequences don't provide this orientation and leave an ambiguity of point of view that creates curiosity, emotional tension, and apprehension in the viewer. In another example, the Wooden Esophagus Antechamber space is undermined by violating point-of-view systems (3:36–3:48). In the Antechamber, the Schulz puppet hears footsteps, looks up through the roof, and through his point of view we see the Boy running on a diagonal plane above him, which seems to be a reflection of him running on the ground. The physical illogic of this scene confuses the viewer because the point of view is suddenly from above and mismatched on a cut from the Schulz puppet's direction of looking. Burch suggests that "'mismatches' in screen direction are a valid technique only when the accompanying sense of disorientation results in a perceptible structure."[25] This scene doesn't result in an immediate perceptible spatial organization, yet the angular set design and angled point of view help the viewer understand that this realm obeys different laws than the extant world. On the suggestion that disorientation is an aim in the films' spatial constructions, the Quays respond:

> Oh yes, intensely. But it's not daunting. It is a provocation, and you align yourself with that rather than "I'm not going in here . . ." But it really is true about the whole idea of the pleasure in disorientation. Some people have pleasure in disorientation, others intensely think: "Why are you doing this to me? You have no right to."[26]

They easily justify giving this kind of uncertainty to their audiences, pointing out the difference between this and guided cinematic forms of suspense that follow Hollywood conventions, mentioning the films of Alfred Hitchcock and Howard Hawks, "where [the audience] know they're going to get something. This is a different kind [of suspense]. This allows them to be *really* lost, to join in with being lost without being lost."[27] This contradiction, of being lost without being lost, is a prominent dialectic in their montage system.

This lostness is apparent in the long, dense, and associative Metaphysical Museum montage sequence. Following a short sequence of hard cuts that confirm the Schulz puppet in a new diegetic space, a fade-in to an image is immediately followed by a fade-out. This cuts to a framed close-up shot of the puppet identical to two later shots suggesting, in conventional terms, a flashback, dream, or memory and functioning as a transition to the following sequence. Objects and mise-en-scène elements that have been scattered throughout the film are brought into a shared context here. The puppet is drawn to the flickering light of a small, dust-encrusted window. Through a small opening, images of

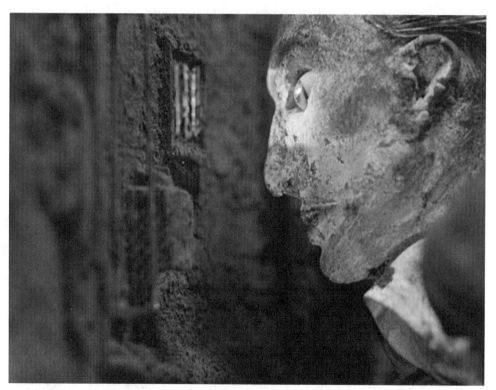

Figure 11. The Schulz puppet glimpsing a series of minor epiphanies: the Schulzian "ascension of the everyday."

pulleys, wires, ice cubes, and dandelion clocks keep the puppet's gaze imprisoned. He appears three times in extreme close-up in a point-of-view shot of the side of his face as he looks through the window, shot from a camera position outside the theater of objects (see Figure 11). This is different from the shot-countershot between his gaze and the objects' location. This montage sequence is composed mainly of fades and fast pans, enhanced with a technical, self-reflexive animation "subtext" (water forming into an ice cube, dessicated dandelion clocks reassembling themselves to gossamer globes). All hard cuts involve our seeing the puppet and the objects from his point of view; fades and fast-pan shifts are assigned to the objects that we assume are in his field of sight. Yet repetitions, eye-line matches, and crosscutting of previous images with new images and with close-ups of the puppet suggest a new set of relations that is extremely difficult to disentangle in the short time period in which they are projected. For instance, there is a long shot of the Schulz puppet seen through an opening: is he watching himself? These seem to be examples of what the Quays propose, that "there could also be analogic spaces, created in the editing process, or abstract spaces, created by massive close-ups and deficient depths of focus—by violations of scale."[28] Some transitions are eye-line matches from the puppet's point of view through the peephole, and other transitions are in spaces that we have seen before; and as the spatial relations of the Zone in which the puppet is standing have been explained, they would be impossible for his eye to see from his position. These "analogic spaces" are also created in other sequences sharing similar montage and camera techniques (2:11–2:29, 6:45–7:00, 9:37–9:57). All seem to be representing subjective states of mind, or, perhaps more so, they represent the "laws" of the film's world. The Quays' enigmatic films leave viewers with multiple choices: the co-creational opportunities offered in their cinematic equivalents to Joyce's literary dislocutions, and differing degrees of lostness and disorientation, with accompanying degrees of pleasurable apprehension and eventual comprehension. It is possible to simply enjoy the flow of images, or to try to find meaning or a schemata that works to fill in what seem to be narrative ellipses—in other words, to try to understand the Quays' own dense form of intellectual montage based on intuition and displacement, itself enabled by the mechanics of cinematic illusion.

Epiphanies of Light

If we can isolate one device of the Quays' films that has consistently developed throughout their later work, it must be the animation of light. Throughout *Street*

of Crocodiles, objects and spaces are revealed and occluded, they bloom and expire, in the light and shadows that shift and change intensities. Chiaroscuro lighting, mirrors, and reflections develop a spatial organization, and sometimes disorientation, contributing significantly to the mood of the film. It is light that seems to be the strongest transformation of graphic concepts in this and other films—the chiaroscuro that is one of their trademark devices. Light, both animated and used as a technical parameter, reveals the objects, guides us through the passages, and in some instances brings the objects to life. Intensities and qualities of light in the films vary, determined by choices and treatment of film stock (black-and-white or color), of lenses and filters, of materials and colors in set design, and of reflecting glass and mirrors that contribute to lighting effects. In the context of an interview query relating to his love of taxonomy and classification, Deleuze discusses his own particular engagement with this formal element of cinema that addresses its enormous range of possibilities:

> For example, I'm attempting a classification of light in cinema. Here is light as an impassive milieu whose composition creates white, a kind of Newtonian light that you find in American cinema and maybe in another way in Antonioni. There is the light of Goethe [*la lumière goethéenne*], which acts as an indivisible force that clashes with shadows and draws things out of it. . . . Yet another light stands out for its encounter with white, rather than shadows, this time a white of principal opacity (that's another quality of Goethe that occurs in the films of von Sternberg). There is also a light that doesn't stand out for its composition or its kind of encounter but because of its alternation, by its production of lunar figures (this is the light of the prewar French school, notably Epstein and Grémillon, perhaps Rivette today . . .). This list shouldn't stop here because it's always possible to create new events of light.[29]

Street of Crocodiles not only displays an astonishing play with light and shadow; in some shots and scenes, light also becomes an actant, its animated activity instigated by the Quays' manipulations and stop-motion filming of it. It flickers, travels across a wall, is reflected from a mirror; it pushes its way through mottled glass, manipulated in ways impossible to achieve in live-action filmmaking. The Quays create "new events of light"; explorations in *Street of Crocodiles* anticipate innovations in the *Stille Nacht* shorts, *Institute Benjamenta,* and *In Absentia.*

While lighting design varies from film to film, an indicative typology of specific lighting effects and manipulations includes chiaroscuro, multiplication of light, and animated light. None is exclusive to any one film: for instance, the two distinct sets in *Rehearsals for Extinct Anatomies* are formally and aesthetically defined by extremes of light. One set is a room with a somber mood and muted colors, while the other is saturated with high-key lighting that makes use of bright fill-light floods in a mainly white enclosed space. This second type of lighting is rather uncommon in the Quays' films, and it has been used mainly for artist documentaries, for *De Artificiali Perspectiva, or Anamorphosis*, and for some scenes in the live-action features. It matures to a full-fledged protagonist in *In Absentia*. Lighting effects in many of the later films are familiar from *Nocturna Artificialia*'s lighting design, in that they are heavily reliant on the use of low-key and chiaroscuro lighting and carefully placed key lights that reveal or dim our view of objects and that connect or isolate the film's architectural spaces. As well, the positioning of objects and puppets behind windows and in glass cases heightens the hermetic mood of a number of scenes. The light rarely intrudes enough for us to really see what is behind these windows, more often than not enhanced with a mottled surface of dust and grime. Colors appear darkened, muted, and the passageways, interiors, and even forest settings are usually lit with a single key light and additional subdued lighting that reduces shadows. This creates a diversity of chiaroscuro that is a distinct type in their lighting typology. In *Street of Crocodiles* these range from a moody, half-visible background with the pulleys and wires that travel into darkness, to the underlit monkey in the smeared shop window that becomes discernible only when it claps its cymbals, to the cheerful scene with a puppet made of lightbulbs and glass that takes advantage of reflective surfaces to enhance and multiply light sources. The Watch Death scene is one of the few scenes that uses close to high-key lighting.

Lighting has a narrative function not only in terms of revealing what we see, but especially in determining when we see it. When asked to what degree they intend to obscure vision, the Quays offer a response that is indicative of the essential role lighting plays in their work: "[It is about] multiplying [light] and frustrating a rationality. The rational mind would probably try to find a way out of a situation like that, and others would say, 'I like it like that, I like being confused, I like the pleasure of being confused.'"[30] The earlier discussion of montage confirms that the confusion they create using lighting is part of an aesthetic program of disorientation. As a type of light, the multiplication of light is often created using lighting and reflections. It is most prominent in the display cases for

the metaphysical machines, windows in the Zone that contain the musty world of the monkey with cymbals, the stack of boxes, the vomiting puppet, and the rubber band machine. It is also used in both the window into the Metaphysical Museum sequence with dandelions and ice cubes and the sequence in which the Schulz puppet finds himself in the Hall of Mirrors. Reflections play with our expectations of offscreen space and depth of field, and glass panes positioned throughout the sets have a double function of transparency and reflection. The Quays use light redirected by mirrors as a principal spatial structuring component to disorient: "[In *Street of Crocodiles*] you don't know if you are seeing through it or if you are seeing behind you, in the rear view mirror or something. It's like looking back in infinity. It's a hall of mirrors."[31] Two scenes in which the Boy uses a hand mirror to reflect light were based on one of the Quay Brothers' 8 mm "diaries." They had filmed a youth in Wrocław who was playing with a mirror and its reflection. This inspired the Imp and Mirror scene (6:03–6:32). The Boy holds a small mirror that catches a beam of light from the Lightbulb puppet. Shifting its position at different angles, he sends an unruly flash of light to various corners of the Zone. He aims it at a screw on the floorboards and the light "animates" it to jump in the air. Cut to a murky window: the light flashes across it, permeating only slightly into the darkness behind, revealing the monkey puppet. The light causes it to jerk into play, banging its cymbals so fast they blur. In the second scene with the Boy that uses this reflected beam (7:22–7:56), it settles on a window and reflects onto the Schulz puppet's face. The Quays intended him to see "the light ricocheting and then heads off in that direction, as though in pursuit of this epiphany of light."[32]

There were other discoveries of light. While the Quays were building puppets for *Street of Crocodiles,* the light above the worktop shone through the Tailor's Assistants' semi-opaque porcelain heads. The unexpected top-lighting effect led the Quays to experiment with cotton wool, filling the empty heads with it to create a diffuse light when lit from above, making the whiteness of the porcelain and the empty eye sockets glow.[33] According to the Quays, the work with lighting and reflections required especial care during shooting (see Plate 8):

> In *Crocodiles* there was so much glass on the set that you constantly had to duck, to get out of frame because of our reflections. There is that one scene where [a Tailor's Assistant] is stroking the glove, where you see [a movement] in the glass, and one of us forgot to duck. And we were bare-chested too, and it was really light. Usually

we wear black, but it was such a stinking hot day, you just see this sort of boiling effect.[34]

Reverse-animation techniques were also useful in controlling light in very small detail. When filming a puppet that moves into a beam of light, they found it impossible that the light would convincingly reflect from the eye; they resolved this by starting shooting with the puppet in the light and animating the scene backward: "We are always thinking in reverse how to animate [the Schulz puppet]. We realized very quickly that we had to animate in reverse to hit the light."[35]

Discussing *Institute Benjamenta* in an interview, the Quays said, "To every space is allied its own quality of light, and this too should be a poetic conception. Light creates the essential *Stimmung* [mood], the metaphysical climate, those 'thicknesses' in the space itself."[36] Quite by accident, while shooting the animated sequences for the first feature, the Quays discovered another element of their light typology that became a salient poetic concept for later films. Sitting in the studio, with one of the miniature sets there by chance, they became aware of sunlight entering the space: "It was the epiphany of light—God said, here's your moment. The first time we took the [single frame] trigger and counted one thousand, two thousand, three thousand, then the next day every five seconds, then every seven. In the end we just chose the take we felt was most liquid."[37] Shooting over three days, they had to work with the sun's trajectory that came in at the

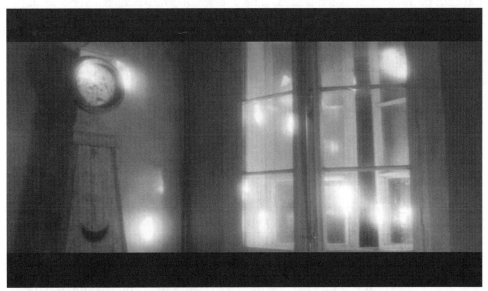

Figure 12. A still from *In Absentia* (2000) showing the film's dramatic chiaroscuro of animated light reflecting off walls and glass panes.

end of the day as it passed through a gap between two buildings, traversed the floor, and climbed the walls. The Quays applied the aspect of control that animation allows over something intangible and, even at molecular levels, incorporeal: elusive, stray, energy-laden beams of light. Animated sunlight also inspired lighting in the feature's live-action sequences. Nichols Goodeve comments on *Institute Benjamenta*'s stunning light design that is especially prominent in Lisa's sanctuary:

> For Lisa, the Institute's instructress, the building is a realm of light. Light swells, advances, becomes like liquid myrrh, glows and invades her. At other times it may be a trapped, fetid, dead light, or an annihilating, corrosive light. What happens in the shadow, in the gray regions, also interests us—all that is elusive and fugitive, all that can only be said in those beautiful half-tones, or in whispers, in deep shade.[38]

The discovery the Quays made to animate sunlight was to have a significant formal impact on *In Absentia,* remarkable for its subtly innovative use of animated light—streams of it, shafts, beams, bright spots, liquid incandescence that moves through the puppet and full-scale sets, taking advantage of every opportunity to reflect off the many sheets and panes of glass (see Figure 12). In the animated dream sequences, it is shattering, blinding, unpredictable. In the live-action realm, it bathes the actress and spaces in a dim glow, occasionally increasing to the strength of the animated sequences. (The live-action sequences could not take advantage of the slow shooting speed that enabled the sunlight to "burn" into the film stock.) The animation allowed it to be mapped and controlled, directed across the objects and surfaces in the sets. The Quays had long been interested in light and reflections, and during production of *In Absentia* they experienced another epiphany, one that strengthened the discovery they made of animating sunlight while shooting the first feature. They described some concepts and techniques of light for the film:

> Stockhausen's music felt as if it was saturated in electricity, and consequently we decided to give the film a very particular type of lighting, almost divine. This way we shot almost all of the scenes with natural sunlight coming from the window in our studio, then utilizing mirrors and reflecting panels to sculpt the light according to the exigency of each scene. Being dependent on natural lighting tied us to meteorological conditions, hence we exploited the light quality which

entered our studio from time to time to realize an animated sequence. Additionally we simulated the lighting phenomenon of the so-called "heat lamp," which was in frequent use in many regions, to represent the mental landscape of the suffering protagonist.[39]

Again the fortuitous method the Quays tend to prefer became a well-organized obsession with capturing sunlight at every possible moment, even sleeping in the studio to catch the early light. It wasn't unencumbered sunlight that interested them:

> It was the days that we thought were too cloudy which worked the best. The clouds made the light dance. Some of the patterns were mad. A lighting cameraman never could have created anything like that. What nature gives is an invitation.[40]

Taking on this invitation resulted in one of the most striking pieces of manipulated moving-image cinema. With *In Absentia* and other films, the Quays have contributed "new events of light" to Deleuze's taxonomy. The combination of chiaroscuro lighting, multiplications of light, and animated sunlight is an enduring poetic strategy in later films.

Lenses and Depth of Field

Unlike the flat surfaces of 2-D techniques that in most cases must imitate lens and lighting effects in the actual drawings, puppet animation can make use of the manifold possibilities of different camera lenses and lighting setups to alter the image. The Quay Brothers play with depth of field, perspective, soft focus, and lenses. In particular, their use of wide-angle and macro lenses makes objects appear farther apart or distorted at edges, and distances between foreground and background planes appear greater.[41] In a discussion of Stan Brakhage's concept of the "untutored eye," William Wees expounds on camera lenses:

> In fact, all parts of the camera, as well as the film that runs through it, are built-in averaging devices. Because they are made to serve the statistically average "normal eye" of optical physics, they are likely to be congenitally blind to much of what the "untutored eye" sees—unless their averaging effects can be cancelled.[42]

The "eyes" with which the Quays provide us take advantage of the "untutored eye"—through a vitalist, animistic, even Schulzian filter—and also offer an opportunity to perceive objects and spaces much differently than our own eyes would allow. Focus pull is an in-camera transition that changes depth of field and can also be used as a montage element to confuse or define spatial coherence. It is mainly used by the Quays in point-of-view shots, occasionally as a spatial transition (see Figure 11). The Quays' use of and shifts in focal planes undermine the averaging effects of conventional lens usage; it is one of the identifying devices in almost all of their films, especially *Street of Crocodiles, Rehearsals for Extinct Anatomies,* the *Stille Nacht* films, *The Comb,* and *In Absentia.* These are compositionally motivated and activate the spectator to pay attention to spatial cues that the shifts in focal planes suggest. In her fascinating treatise on the olfactory/haptic qualities of *Institute Benjamenta,* Laura Marks comments on the Quays' short films:

> Their animations work with small-scale models populated by small objects. Focal length and lens choice create a sense of space in which the most interesting events do not occur in human scale. The camera moves delicately among these tiny theaters, creating a point of view that seems to belong to one of the objects or something even smaller and more ambient—the point of view of dust, or of the air.[43]

In *Street of Crocodiles* the focal plane shifts constantly, both guiding our attention and creating a sense of relationships between the objects (ice cubes, dandelion clocks). Discussing what she terms "the anthropomorphic camera," Christine N. Brinckmann describes differences between the cinematic image and natural perception in terms of focus:

> The unfocused filmic foreground can indeed be used for subjectification, as an indication that a fictional person sees an object beyond this zone. . . . Precisely the aberration from the usual composition of focused fore- and mid-ground serves here as a signal to perceive the image as anthropomorphic. It is more extreme when the focus is shifted during a shot.[44]

Multiple focus pulls made during single-frame shooting result in shots that invite the viewer to see what the Schulz puppet sees. These are anthropomorphic images, yet there is also a sense that another point of view is implied. The film's

black-and-white exposition, intercut with a monochrome shot of wire mesh objects, dust, pulleys, and a bowl filled with rusty screws, suggests "the third puppet," the camera. Such shots foreshadow the animated world to come; they are our induction to the realm of Schulz's world. Marks proposes that "haptic looking tends to rest on the surface of its object rather than to plunge into depth, not to distinguish form so much as to discern texture. It is a labile, plastic sort of look, more inclined to move than focus."[45] Because of the use of macro lenses and the camera's slow shift between focal planes, in these and many other shots in the film our gaze lingers on these surfaces; the Quays lead our gaze as we caress this exquisite composition of poetic detritus with our eyes.

These kinds of shots and scenes have a significant function in our experience of the film's textures and objects and are also interruptive moments in its elliptical narrative. Costa suggests that "their constant focus-games, these apparently chance camera movements that come to a halt and highlight absences or fragments or a seemingly irrelevant *picture space,* involve the spectator in combat, but they irrevocably condemn him to defeat."[46] Using lenses to exaggerate the textures and emphasize tactile surfaces of objects from the physical world is utterly intentional and foregrounds the artistic motivation in the Quays' cinematic work. Marks suggests that "haptic images do not invite identification with a figure so much as they encourage a bodily relationship between the viewer and the image."[47] We engage physically, sometimes synesthetically, with these fantastic images; we feel and smell the dust, taste the acrid rusting metal, all of which are emotionally charged and sensualized by the complicit music. The use of focus pull in *Street of Crocodiles* is employed in a number of ways. It can affect an in-camera transition (such as at 1:37–1:46, 5:03–5:10, and 10:27–10:29) and change depth of field. It is also a montage element within the frame to undermine or define spatial coherence, mainly in point-of-view shots, and it is rarely used as a spatial transition. The focus pull is a dynamic use of shallow focus effects in the film that express the Quays' preferred use of macro lenses for close-ups, another defamiliarizing device used in the film. The extreme close-up draws our attention to the material reality of the textures and materials, and hence has a realistic motivation (see Plates 12 and 13 and Figures 8 and 9). The defamiliarizing effect here is the extremely close visual confrontation with these materials, so much so that they take on monolithic, occasionally grotesque characteristics. The camera's lingering on objects with these attributes discreetly upsets the balance between nature, familiarity, and scale, in that objects are foregrounded without explanation, without a contrived simile to a natural representation.

Navigating the Realm: Frame, Shot, Camera, and Transitions

The Quays have a logbook from *Street of Crocodiles* that describes, in notes, draw-
ings, and sketches made during filming, the process for each shot in the film: how
they animated sequences, used lenses and F-stops, set up lighting, calculated
calibration, and other technical information (see Figure 13). Interesting is the fact
that the data is recorded in the *process* of filming, as a technical record of what
the Quays do as they go along. Regarding the traditional concept of storyboard or
scenario, they state that "at most we have only a limited musical sense of its tra-
jectory, and we tend to be permanently open to vast uncertainties, mistakes, diso-
rientations as though lying in wait to trap the slight-
est fugitive encounter."[48] *Street of Crocodiles'* length of

20:30 is the result of shooting approximately 29,500
frames, almost all of which were shot in single-frame
except the live-action exposition and a few other
brief shots. In film production a shot is defined as
"one or more exposed frames in a series on a continu-
ous length of film stock."[49] In live-action film, the
concept of a shot being a single frame is extremely
rare, while it occurs more in experimental and struc-
tural film.[50] Film analysis often uses single frames
of shots to illustrate descriptions of a longer shot:
Robert Stam, et al., state that the shot itself can pro-
vide "an inordinate amount of information—a fact which becomes obvious in any
attempt, as in a shot-by-shot analysis, to register in words the semantic wealth of
even a single, relatively straightforward cinematic image."[51] The Quays remark on
the particular attention each frame can be given in single-frame shooting:

Figure 13. A page from
the Quay Brothers'
shooting logbook for
Street of Crocodiles
showing top-view
camera and lighting
setups for the shot
of the razor-blade
apparatus as the spit
falls into the Wooden
Esophagus. Courtesy of
the Museum of Design
Zurich and copyright
the Quay Brothers.

> In a way [editing in animation] is even more crucial. Because you
> animate every single frame, you also respect every single frame. A
> camera man shooting just shoots material, tons of it, and then it
> comes to the editor, and he starts putting it together. But when you
> know you're shooting your own material and cutting your own mate-
> rial, you can see the 1/24th of a second.[52]

The significance of every single frame exposes the intricacies of the animated shot.
The shot takes on multiple meanings when discussing animation, if the end of

LIGHTING SET UPS

1(A)

overhead Bars

2 wirescrims
Flooded
43" high
aimed its

N°L

Gate in

14t

Gate

50"Max
height

N°
4
33" high
Aimed high
at rear wall
1 thin white scrim

N7

Gate 2

6

Overhead Bars

2 wire scrims
Fully flooded
63½" high

TRIPOD
51" high
Lens 32" from
outlet/spit device

1(EE)

Overhead
Lighting bounced
bof

Flooded
Aimed at
spit boy

5

Gate N°1

1

Flooded
No scrim

Aimed at far right wall

Gate N° 2

2

Flooded
metal scrim

Aimed far left wall

OVERHEAD BAR

No scrim
Aimed at lower
right of pit

4

Scrimed by 1 metal
aimed at upper
right part of pit

3
bounced off
ceiling

Flooded
No scrims

C
24mm

6
bounced off
ceiling board

Flooded
no scrims

the shot is defined by stopping the camera from shooting continuous frames. In animation, this happens with every frame shot. It is, of course, possible to identify shots and sequences separated via live-action transition conventions, such as fades, dissolves, wipes, and hard cuts. Single-frame shooting can emulate live action; although shot using single frames, the shots and scenes in the projected film seem to be shot in real time (albeit the time of the film's specific world). A sequence of individual frames (shots) can be followed by a transition that separates them from the next shot or sequence of single-frame images. The cumulative shots then appear as a continuous shot if the image composition, movement, and sound track have a coherent, spatiotemporal flow.

The Quays' description of creating a shot makes it clear that animation single-frame shooting can work with similar conventions as live action, but within much tighter temporal durations:

> You know that when you set up a shot that there's a beginning, a middle, and an end. I don't think we say, "This is going to be precisely thirty frames." We'll say, "It only has to be around thirty frames," but once the animation starts, it might drift to forty, fifty frames. You have to take into consideration that if the puppet might suddenly go like this [gestures], and then he pauses and looks, this might be a twenty-frame hold or a thirty-frame hold, and then he continues to look, and then you're up to fifty frames. You might cut it back to thirty frames, but you have to overshoot a little. You never know. You can cut where just two frames make all the difference.[53]

These subtle adjustments of shot length describe one to two seconds of film and show the amount of control and nuance that is possible in single-frame shooting. It is also important to bear in mind that the Quays aren't filming movement, but exposing single-frame still images. The grace, timing, and character of their puppets lies in "seeing 1/24th of a second" and knowing how to make minute adjustments between frames that result in the graceful, choreographed movements of their puppets. The Quays make use of most shot sizes; the objects are shot in proportions and spatial relations that emulate a live-action realm, mainly structured by arrangements of long, medium, and close-up shots (most close-ups and extreme close-ups being reserved for the animated realm) and connected by hard-cut transitions—with some exceptional exceptions, as we will see. Shot size can also function as a kind of pre-editing in the camera, setting up proportional and spatial

relations between figures, objects, and sets. Shot separation is then clearly marked by shifts in time and location, by actions and movement, and by a causal chain of events requiring identifiable markers of recognition for audiences. Separation between individual shots can be determined by conventional transitions: hard cuts and in-camera dissolves, fade-outs, fade-ins, wipes, and fade-to-black. *Street of Crocodiles* has 225 discernible shots separated by transitions, and over the length of the film (1,230 seconds) there is a transition on average every 5.5 seconds.

The coordination of shot length, shot size, and transition is especially evident in the first minutes of the film. The live-action exposition in the Theater is edited with hard cuts between close-up to medium and long shots that introduce and explicate the diegetic space of the scene. This sequence is interrupted by two separate short shots of objects in extreme close-up, and crosscutting between these and the live-action set anticipates the transition from live-action to the animation technique. First the camera descends into the Wooden Esophagus, and then a hard cut takes us back to the live action and a close-up of the actor letting a luminous gob of spit drop into the Wooden Esophagus. On a hard cut, we enter the animated realm, following an animated simulacrum of the original spit, which sets in motion the machinery within the world of the Wooden Esophagus, all shot in close-up. The interplay between outer (live action) and inner (animated) realms is insinuated by dense crosscutting between man and puppet. The link to the outer world is severed by the diegetic snip of a scissors that frees the puppet. A hard cut followed by a fade-in takes us to an unfamiliar location with an unspecified point of view from above of expressionistic diagonal roof elements and oversized scissors, followed by two fast pans. After this interruption of continuous space, the Quays then proceed to reveal the animated realm with a fairly long sequence of eye-line matches and crosscutting. This establishes spatial relations and the causality of the puppet's actions in the diegesis as he negotiates the Antechamber, touches the knot that unravels and sets the realm in motion, passes under the screen, and enters the Zone. The complex editing in these two montage sequences is composed of hard cuts that establish a certain spatial continuity between the shots and scenes. They are characteristic for other sequences throughout the film, and they also suggest relations between puppets, objects, and spaces. The high shot frequency in the Quays' montage sequences contributes to creation and rupturing of space that will be discussed below.

Since animation is shot frame by frame, it is obvious that the camera must remain in a static position to avert its movement between individual frames

that would result in a blurred or trembling image. Yet camera movement *during* shooting can change composition, effect transitions between different settings, follow actions, suggest varying points of view, and so forth. In a subsection of *The Language of New Media* titled "The Poetics of Navigation," Lev Manovich discusses how a number of films, including *Street of Crocodiles,* diverge from cinema's camera grammar and have their own systems:

> In *The Street of Crocodiles*, the camera suddenly takes off, rapidly moving in a straight line parallel to an image plane, as though mounted on some robotic arm, and just as suddenly stops to frame a new corner of the space. The logic of these movements is clearly non-human; this is the vision of some alien creature.[54]

Manovich is describing single-frame shooting with a moving camera that allows other freedoms in creating transitions, and such camera movements must be painstakingly synchronized with movement that is animated within the frame. The Quays' shooting methods are highly unusual in animation: they use calibrated tracking shots, animated pans, and what appears to be a moving camera—principal innovative techniques that appear in almost all their films.

The experience Manovich describes is an in-camera effect, an innovative transition that I call a "fast track" and the Quays call a "whip." They have used it consistently since its first appearance in the opening shot of *Nocturna Artificialia* and it is used more than forty times in *Street of Crocodiles.* The fast track has different dialectical functions in the film's montage but technically it is *the result of camera movement between single-frame shooting.* The calibration of camera movement between individual shots is increased, producing a different effect than a live swish pan or simple accelerated dolly or tracking. The Quays propose that "whips connect a space; they don't or shouldn't disorient. They just get you there a bit more urgently."[55] While the fast track connects spaces, in most instances in their films it actually does have a disorienting effect while getting us there "a bit more urgently." This urgency is one of the film's devices that needs to be understood in terms of intent. Original visual points of reference, blurred during the whip transition, are usually completely different once the camera comes to rest, insinuating a psychological shift as well, one that creates ambiguous, subjective point-of-view structures. This movement, originating from the nonhuman logic Manovich mentions, could also be comprehended as the point of view of one of the metaphysical machines.

The fast track is used in two variations. The fast-track cut effects a subsequent shift to a new diegetic space that is created by the hard cut, and this is similar to live-action conventions. When projected, the fast-track cut creates a disorienting, convulsive camera movement that has a unique aesthetic and haptic quality: this is the dialectic of direct connections between discontinuous spaces. While the camera is being calibrated and shifted upward (e.g., 1:07–1:19), there is an indiscernible hard cut during this movement. When the Schulz puppet is in the glass-roofed set, a similar effect happens (3:36) when the camera comes to rest on an image of the Boy running, whom we see upside down. The framed space is completely different from that at the outset of the fast-track cut. Because the fast track shot renders the continuous shot as fragmented and spatially disjunctive, the viewer must creatively infer the spatial organization between the two shots. The defamiliarizing effect is compositionally motivated and melds two phenomenally independent spaces into a continuous perceptual flow. Thus, the fast-track cut, because it is not the result of a perceivable cut, is neither a pan nor a clear transition. As the visual result is not a convention of live-action film, it self-reflexively draws the viewer's attention to how animation's formal and technical means expand those of live-action cinema. In most cases, the fast-track cut functions to disorient spatially, because although there is not a discernible cut, the spatial order and reference has changed after the camera comes to rest. The lack of a full break in image (a hard cut or a fragmented set would be necessary to move between two spatially distinct spaces without shooting the temporal and spatial transition between them) results in a spatial, but not temporal, connection between the initial image and the final one. The lack of temporally "correct" continuous space creates a disconnected, yet strangely coherent realm.

The second calibrated in-camera montage technique the Quays developed is the fast-track shift. In the fast-track shift the spatial move between two distinct sets *during* camera movement is not interrupted by a cut, again creating direct connections between discontinuous spaces. However, it is temporally condensed by the calibration and the possibility in single-frame shooting to "leave out" frames. The 1/24th of a second each of these frames would record in live-action shooting as an equivalent temporal passage of time during the camera's movement becomes an accelerated jump cut. This unnatural speed of movement is distinctive from more familiar, invisible camera movements that construct the fictional, spatial reality of the realm. The fast-track shift is mainly used in a visually established and continuous diegetic space and functions to establish different types of transition both between the live-action and animated realm (with the

Wooden Esophagus as passage between them) and in the animated realm. The lack of a full break between the two image spaces results in a visual elision that merges the initial location and the final one. This singular montage technique is not a live-action convention and possible only with animation single-frame shooting. In *Street of Crocodiles,* the fast-track shift is very quick and usually takes place over no more than a few individually shot and minutely calculated calibrated frames. The Quays: "Mathematically, especially dealing with tracking shots, you're dealing with time and mathematics, with speed and mathematics."[56] Their refinement of this technique contributes to the fluidity of space in some films, simultaneously drawing attention to its fabrication. The semi-flicker effect and fast movement is a film grammar that cues the spectator to concentrate on planes of focus. It becomes almost physically impossible to visually locate and focus on an object that passes through the frame during the fast-pan shift in order to implicate it (as it seems to suggest it should be) in the rest of the images. This deliberate method of avoiding continuous space and of changing focal point in the fast track is one element of a cinematic grammar that helps their works achieve their cinematic power.

Another variation of calibration and tracking during shooting is also used within a shot where the camera does not move on the Cartesian Y- or Z-axis but on the X-axis, on a flat plane toward an object (coordinate "O") in the frame. This creates a change in the shot size during the camera's calibrated movement toward the object in the set. In *The Cabinet of Jan Švankmajer,* this effect is used with an Arcimboldo portrait. In the same "shot" (of more than thirty-six frames) it takes us from a long shot of the room to a medium close-up of the portrait. During calibrated movements forward, the shot size changes as the camera approaches the portrait. In this jump-cut effect the individual images are blurry and appear to have multiples of the portrait on a single frame: this suggests that the shots were longer exposures and that perhaps the camera moved during the single exposure. Once the camera has made its approach, it pans down toward the top of a table as the Švankmajer puppet appears out of thin air during the pan (having been placed in the set between single-frame shots). The effect in projection—an animated zoom—is indeed one of "getting us there more urgently" and it does so in a staggered approach that has affinities with a jump cut but is a special effect of animation. As all objects in the frame are not animated, a continuous zoom or tracking shot would have been possible, but the effect would have been an abrupt aesthetic shift from the otherwise animated film. Costa: "What makes the Quays' films such a unique experience is not so much the animation of their

characters, but the animation of this choreographic camera that subverts the conventional direction of the spectator's gaze, generating a formal tension without obvious referents."[57] This is further enhanced by the Quays' use of macro lenses that provide virtually no depth of field.

Filming *Rehearsals for Extinct Anatomies,* the Quays discovered a new animated effect that would be used in the *Stille Nacht* films. Using a Ping-Pong ball attached to a string and a camera set on a pixilation speed of six frames a second, they hit the ball and turned on the camera:

> It creates the most mellifluous effect, and you get it straight through an arc. Mathematically, it was sheer luck the ball moved back and forth in some kind of pattern. We did tests later and we couldn't do it. It's an optical effect. Serendipity. It was so beautiful and amazing as it was in sync with the music. It was luck.[58]

Many other objects were given similar treatment: the quill-holding hand at the beginning of the film, the kidney-shaped heart of another, balls and wires. Some of these effects are based on movements around a central axis: the eyeball of one puppet was animated as it spun around an invisible wire inserted in the center of its head, a ventilating fan turning on its axis. Another effect was used with a ball bouncing up stairs that, swung between two points, was shot at a frequency so that it was captured at the end of each arc: one ball became two and appeared to be almost static. At some points in the film, an object is moved from side to side and the shot frequency doubles its appearance within the frame, as is the case with the wire homunculus and the kidney-shaped heart.

Keith Griffiths regards *Street of Crocodiles* as "one of the first 'trick films,' if you like, which was shot exactly like live action. . . . The whole thing is constructed in conventional live-action film form."[59] Yet while drawing on live-action conventions, formally, most of their films break with most classical cinematic editing conventions, such as establishing shots and intermediate shots, the trio master shot, close-up and reaction shot. The Quays' films have a singular montage technique distinct from live-action and 2-D animation. They exploit technical properties of animation to expand the film language of formal live-action techniques of lighting, lenses, shot transitions, and montage. The Quays' later works continue to refine *Street of Crocodiles'* parametric typologies of violating space, epiphanies of light, lenses (extreme close-ups, heavy use of macro lenses, and depth of field) and frame, shot, camera, and transitions (calibrated

tracking shots, a choreographed camera, high shot frequencies, and variances in single-frame shooting speeds). Responding to the suggestion that their filming is like live action, the Quays propose their work in film

> has more to do with creating a kind of liquid space articulated by very precise mise-en-scène: in short, a choreography of rhythms, ratios, gestures, and counterpoints . . . and it's this fluidity of space via these décors (and the montage!) that they defy their artificiality because you sense they are instantly assured of their "Otherness."[60]

Their systematic exploration of cinematic parameters and montage dialectics reveals how carefully constructed the spaces are that enable a particular deconstruction of space that creates the Otherness, the temporal and spatial world of *Street of Crocodiles* and other films. Their statement also underpins the musical aesthetics at work, the invisible but inseparable partner in the choreography of light, lenses, camera, and rhythms, our final parameter: sound. In a discussion about Eisenstein's dialectic and polyphonic montage, the Quays described their approach to this process:

> You should create a new form, an idea that moves onward, and every cut should propel that or accelerate it. . . . If you want to orchestrate five scenes, that's going to demand an even finer notion of what cutting can give you and at the same time making it clear. They are musical scenes, and Eisenstein knew music really well.[61]

In a context of the differences between verbal, graphic, and pictorial surrealist endeavors, Matthews points out the visual image's lack of structural unification (in contrast to the grammatical structuring of verbal *cadavre exquises*): "When we face a pictorial *cadavre exquis,* our reaction to what constituent parts of the drawing have to show is very likely to be influenced by our impression of how presentation is made."[62] Analogous to the concept of *cadavres exquis* in the creation and ordering, or choreography, of these images or shots, we now turn to music, sound, and noise, which complete the interworking of the mise-en-scène with a minutely planned composition and arrangement of sound that ultimately performs the emotional experience of the films.

THE SECRET

SCENARIO OF SOUNDSCAPES

6.

usic permeates the Quay Brothers' studio. The rafters and corners are imbued with compositions from Eastern European composers, madrigals, violin sonatas, avant-garde instrumentals, more contemporary minimalist jazz, and shortwave recordings from distant lands. There is so much music, in fact, that the small lavatory functions as a "musithek," the walls lined with hundreds of music tapes whose replaced covers are embellished with the Quays' calligraphy and illustrations. Music is convoluted in discussions, gestures, and replies. On the topic of music in a 1996 interview, the Quays regarded themselves as "failed composers. What we try to do is create a visualization of musical space—we want you to hear with your eyes and see with your ears. It's like saying, What kind of décor, in what parallel world, would evoke that music?"[1] A feature that permeates almost all of their short films is the liaison of music with objects and textures. The relationship between aural and visual is indeed a composition of carefully planned and executed movements, rhythms, proximities. The images gain a lyricism that is not only inspired by the music, they are complicit with it, and the emotional qualities ascribed to the abstractions of music become musical emotionality of the figures, via accompaniment, under- and overtones, and

counterpoint. The unique musicalized synthesis of image and sound challenges the viewer—and listener—to engage in a different kind of audiovisual experience. The relationship comes to light in a complex, sound-driven orchestration of movements of camera, puppets (and sometimes people), and objects, a choreography between lighting, mise-en-scène, movement, and sound track. This complicity is markedly distinct from the essentially descriptive or mimetic coordination of sound and image used in animation film (and comedy) commonly known as "Mickey Mousing," where the action is music driven and synchronized to the musical movement. The Quays state, "intuitively we're much more drawn to a cinematic mode where a secret, almost pathological drift can be ordained and pushed at a deep musical level—that this flux can be sustained at a kind of lyrical-prose level."[2] This deep musical level is at work in most of their films, including the early music documentaries.

One notable feature that runs throughout all the puppet animation films—exceptions being the animated documentaries—is the almost complete lack of spoken dialogue and, if on the sound track at all, it is muffled or whispered so quietly as to be unintelligible, even discordant, indicating only some obscure presence. This nonvococentricism is prerequisite to understanding the intention of sound's interplay in their formal parameters:

> For us, dialogue is no more important than light or sound; it is one of the elements you can play with. The trouble is it is always the most obvious. In Hollywood, dialogue is preeminent. The script comes first; that gets the funding. And for us it is always the other way around because we work with animation.[3]

This not only makes their work distinct from live-action, dialogue-driven narrative, but it also sets them apart from many animators damned to what the Quays call the "ghetto-ized, anodyne cliché-ridden dosage of children's television, an absolute swamp of banality, where all the characters are inevitably docile bogus flunkies wrapped around well-known actor's voices."[4] Their films often use the nonverbal centrality of music to bring the puppets and objects to life in the film's world, which is not bound to the narrative organizing principle of the spoken word, its cultural specificity, and its anthropocentrism—the absence of the latter being a key determinant for establishing the credibility of the realm's otherness. The Quays are emphatic about not using dialogue: "We don't want a voice. We could imagine almost inaudibly that a puppet could breathe, but his voicelessness

demands and forces you to interpret rather than be supplied."[5] Orienting by the films' nondiscursive soundscapes rather than a narrative primacy of vocal utterances that predominates in most conventional film, the viewer is offered much less guidance and ultimately more exegetic freedom, which allows for a more idiosyncratic interpretation. There are exceptions: intermittent on the sound track of *The Comb,* muted whispers and a voice are heard in varying levels of intelligibility and pitch, but the language (possibly Polish) is garbled and has a musical rather than narrative function. This principled avoidance of dialogue is also evident in *Institute Benjamenta.* The Quays, not wanting to lose the feature's dreamlike quality, opted for voice-overs for longer dialogue passages:

> It gave us a lot more freedom than having a perfect script thrown at us. It was almost finding a musicality—taking dialogue and say[ing], "Let's musicalize it," without making it in its standard conception a musical. The voice-over could be pushed toward the music itself. It is just one of the elements you can play with.[6]

The linking of dialogue—actually more a set of monologues than interpersonal discussion between the actors—with the musicality of the film is also a nod to Robert Walser's writing style. The Quays described the process of *Institute Benjamenta*'s script development with a musical term "to score," a gesture to the musicality of Walser's text.[7] The musical analogy extends into the film's literary source, and considering their express interest in music, it is not coincidental that Walser's writing is often attributed with being full of musical analogies and metaphors. Peter Hamm suggests although Walser's work may be richer in under-, over-, and middle tones, his deepest love was for the "Eintönige"—literally, "one-tonality, monotone," a composite and musical wordplay on mediocrity, daily life, and empty routine.[8] The actors' voices are often monotone, sometimes pointedly musical, and it is Polish composer Leszek Jankowski's score that suggests darker undercurrents and emotional conflicts. Yet there are other, earlier protagonists in the Quay Brothers' oeuvre, animated, voiceless ones that also gain presence and credible existence in their own empty routines via complex and often astonishingly subtle sound tracks. Jankowski's compositions flow through many of the Quays' films, including original scores for *Rehearsals for Extinct Anatomies, Ex Voto, The Comb, Anamorphosis, Institute Benjamenta,* and music composition for three commercials. Their working relationship goes back to 1981, when they heard his music at a performance of the Poznań-based Polish theater group Theater of the

Eighth Day (Teatr Ósmego Dnia). They had also encountered his compositions at an outdoor screening in Berlin and contacted him for possible cooperation in a future project, which became *Street of Crocodiles.* Again the film will be the main focus of this chapter, in part because it reflects on scenes and sequences introduced in previous chapters and because its treatment of sound is emblematic for many of the other sound-driven works.

The Conspiratorial Climate of Music

The Quays were introduced to Jankowski on a children's playground in Stockwell, London; at the time they were working on a project around neuropsychologist Aleksandr Luria's *The Man with a Shattered World.* Communicating through translators, they exchanged letters over the next four years—Jankowski's in Polish, the Quays' in English.[9] They began to listen to cassettes of Jankowski's music for theater and discovered he was also an admirer of Schulz. When the *Street of Crocodiles* project was approved by the British Film Institute in 1984, the Quays contacted him to propose music, effectively giving him carte blanche: "We never said, 'Write a sequence for this.' We said, 'Write six thirty-second pieces.' It was as vague as that."[10] A cassette with three fragments impressed them so much they asked him for more, this time with suggestions and instructions, and a dozen more fragments completed the film's music. While most of the animation sequences had been made before the music arrived, the Quays improvised to the music and reanimated some of the scenes: "We'd tighten or shorten or lengthen the scenes so that they would fit."[11] They listened to the music continuously during shooting; it also accompanied them during reshooting some of the scenes. Having music before the film was completed digressed from the more common production process of adding music after the film is shot. Their own description of the film's development suggests analogies to using central motifs for composing a musical score: "The film grew from its interior outward, with music more often than not being at the very core of the sequence, in particular the film's finale: the elegant, broken 'Automaton Waltz,' which had Leszek [Jankowski] reading the closing lines of the Bruno Schulz story."[12]

This loose, less systematic method of action and reaction bears analogy with the pictorial (and language) collage process of *cadavre exquis* that the Surrealists engaged in collaboratively and which is based on chance (and recalls the Quays' concept of "the liberation of the mistake"). Their associative, organic process of responding to Jankowski's constituent music fragments—that he him-

self did not know what they would be used for—did not provide a causal or temporal order for the choreography of these images or shots. This is apparent in the important role they ascribe to music in their production process:

> In a strange way, when we get Leszek's music, we play it again and again, and you take it deep inside your system. And I am convinced that when you start to animate, you're animating with that music in your film because you've taken it in so deep. And sometimes you fail and you just can't. When [the film] comes back, and it is connected with the music, suddenly there's a revelation and then you know it has worked.[13]

Jankowski's compositions provide none of the stereotype motifs that are often found in emotion-evoking narrative films. Rather, the passages, sounds, and noises create a novel and idiosyncratic audiotemporal space in their own right, one that owes little to traditional music composition for films, and even less to narrative and emotional conventions that explicate and underpin imagery.

The notion of animating with the music *as* they animate is remarkable. A few seconds of film can take hours to shoot, and to choreograph the movements to sound at this level of minute precision requires an ability to work with the relative distension of two seconds to possibly two hours or two days. I'd like to address Michel Chion's assertion that sound temporalizes images, and especially so if we bear in mind the disjunctive temporality of the single-frame technique. Chion describes three ways the image is temporalized: "The first is temporal animation of the image . . . second, sound endows shots with temporal linearization, [and third,] sound vectorizes or dramatizes shots, orienting them towards a future, a goal, a creation of a feeling of imminence and expectation."[14] *Street of Crocodiles'* animated spatial realms are created by a succession of shots, and the objects and their actions and locations are often disparate, disjointed, solitary, nondiscursive (in a narrativizing sense). They often provide neither a sense of temporal succession nor of simultaneity, in some cases because there is no spatial coherence with the shot that precedes or follows. Chion suggests that "the addition of realistic, diegetic sound imposes on the sequence a sense of real time . . . that is linear and sequential."[15] Because the sounds that normally accompany the Quays' images are musical, nondiscursive, and abstract (noise will be treated in more detail below), the sense of time they impose is often not sequential. And while it does pull the images together, in that they share the sounds

that accompany them, it is vectorized with a sense of dramatization toward a future or reflecting upon a past. But this vectorization, which should guide the viewer (and listener), can also be located in an apprehensive lack of knowledge about where the dramatization leads, because there is no a priori knowledge of the realm's laws or the puppets' and objects' behavior. The music, however, does give the realm credence by creating a sense of the passage of time, albeit a musical time that does not correspond to our everyday sense of reality, and one that offers emotional pleasure. Particular auditive tropes and repeating motifs that are associated with specific spaces and objects also give the film periodicity.

Music, Sound, Noise

In his foreword to the 1981 edition of *Theory of Film Practice,* originally published in 1969, Noël Burch excuses himself for writing a book based on an embarrassment—that he invoked formalism in his study, what he calls

> a formalism of the worst kind, which might also be called "musicalism," or, perhaps most precisely, *flight from meaning. . . .* The films of Eisenstein, Resnais, Antonioni, Bergman and others— a certain, rather ingenious, eclecticism was, perhaps, a virtue here— "stood out above the pack" not because of the stories they told— everybody told stories, and theirs were not fundamentally different— but because of Something Else, because of their way in which they organised the formal parameters of their discourse.[16]

Describing the interplay of image, sounds, and music in the Quays' films—which are mostly loose, musical, and experimental narratives—is an exegetic "flight from meaning," and explaining it can be a highly subjective exercise. Burch goes on to describe his initial methodological ideal as musical, and this ideal has affinities to my own.[17] Because the Quays' engagement with sound and music is so extensive and distinct, defining some formal acoustic parameters helps us begin to articulate the interworkings of these with the image track that results in the apprehensive qualities of their work, perhaps explaining the appeal these works have for audiences, the "Something Else" Burch describes. Because of the innate complexity of music image relationships, I choose not to undertake an unsatisfying and more general description of some of the sound track features via a more formal analysis of sound tracks. This would, in fact, require access to the score,

comprehension of dubbing sheets, and musicological expertise. This is not my intention here; much more so I am attempting to isolate some principal elements and motifs of the sound and music tracks that relate to montage systems and support the image track (and vice versa). I therefore believe it is more useful to the reader to undertake a more detailed analysis of sound and image in a selection of scenes and sequences in *Street of Crocodiles* that have been addressed in previous chapters. This synecdochal exploration is both conceptual and practical, and I hope it will provide a way in for listeners and viewers to the dialectics of the relatively unexplored musical and extramusical, immaterial and material, auditive phenomena in this and other Quay films.

Music, sound—and to a far lesser extent, noise—in cinema are increasingly subjects of academic scrutiny. Except for a handful of texts that mainly address music in cartoons, there is as yet rather modest engagement with the sound track in animation-specific studies. Points of reference for my analytical, aesthetic, and formal explorations that follow are therefore Eisenstein, Chion's valuable work toward aesthetics and a theory of sound in film (based in part on groundbreaking work by Pierre Schaeffer), and Doug Kahn's *Noise Water Meat*, a compelling interdisciplinary history of sound and noise in the arts. Also helpful along the way are Karel Reisz's notions of montage and sound and Burch's investigations into offscreen sound. Because sounds and noises are as significant in this chapter as music, for the former I orient myself to Luigi Russolo's definition of sound as the result of a succession of regular and periodic vibrations[18] and to Kahn's encompassing, speculative, and listener-oriented taxonomy of sound, which includes

> all [sounds] that might fall within or touch on auditive phenomena, whether this involves actual sonic or auditive events or ideas about sound or listening; sounds actually heard or heard in myth, idea or implication; sounds heard by everyone or imagined by one person alone; or sounds as they fuse with the sensorium as a whole.[19]

While I am interested in describing elements of Chion's rather broad added value with which "a sound enriches a given image so as to create the definite impression, in the immediate or remembered experience one has of it, that this information or expression 'naturally' comes from what is seen, and is already contained in the image itself," these are less pertinent in the Quays' film for two reasons.[20] Much (but not all) of what their imagery represents does not have an ascribed

"natural sound" in the composition, and because these are animated images of inanimate materials, the information or expression cannot naturally come from what we see (as I will explore later). Chion's concept of "anempathetic sound" is far more promising for analysis of the Quays' nonvococentric, music-driven films. Chion describes this sound—music—as indifferent when it progresses in "a steady, undaunted and ineluctable manner: the scene takes place against this very backdrop of 'indifference.' This juxtaposition of scene with indifferent music has the effect not of freezing emotion but rather of intensifying it, by inscribing it on a cosmic background."[21] This is a quality that forces us to engage with the film's visual fragments and scenes, including solitary hiatuses or hermetic shots that incite apprehension. Chion suggests that "we have reason to consider [anempathetic music] to be intimately related to cinema's essence—its mechanical nature."[22] While this latter proposal has wide-ranging consequences for any sound-based study of animation film, I will explore it only via the mechanistic natural sounds of the metaphysical machines that populate the cosmogony of *Street of Crocodiles*.

Sounds can be invaded by noises, and noises are sometimes invasive, mainly elusive auditory phenomena that often defy description. Chion states that noises are one of many units of a film's sound track and that "the composite and culture-bound notion of *noise* is closely related to the question of materialising indices."[23] This is a notion that I will discuss in more detail in relation to the cinematic representation of extant objects and spaces in puppet animation (as distinct from graphic 2-D animation). Kahn's more useful (i.e., more detailed and imaginative) description of noise calls upon eminent and modernist avant-garde musicologists, composers, and sound theorists, including Hermann Helmholtz and Russolo. The latter asserts that noise is "caused by motions that are irregular, as much as in time as in intensity."[24] Kahn also describes noise as nonperiodic vibrations[25] that can also include percussive sounds made by percussion instruments. Jankowski's use of percussion is not limited to drums, cymbals, or piano; single plucking of string instruments or mouth-resonating instruments add to his percussive noise repertoire. As well, Kahn's more precise definitions of noise actually overlap and further qualify Chion's term "anempathetic music." Because while Chion is describing music, the kinds of music and sound that he singles out as having anempathetic qualities, to which he also attributes mechanical qualities, have something in common with noise created from nonmusical sources.

Also useful in helping us unravel the sound track's poetics are three acoustic properties that Bordwell and Thompson suggest help the spectator to

distinguish sounds.[26] The first is loudness, which "establishes the spatial qualities of the realm: distance, shifting proximities, acoustic foregrounds and backgrounds, off-screen space." While changes in loudness are in part responsible for spatial qualities, because the sounds are not ones that have added value that seem to naturally originate in what is seen, loudness is not a prominent formal property of the *Street of Crocodiles* sound track. The second property is pitch, "the perceived highness or lowness of the sound . . . which can be categorised as 'pure' tones (music) vs. 'complex' tones, a mix of differing frequencies helps to identify properties of materials, densities." Changes in pitch are caused by differences in the periodic vibrations of tone. This is especially important in both Jankowski's score and in the added sounds, because both use materials that are not generally associated with originating from a musical wind or percussion instrument.

The third property Bordwell and Thompson mention, and potentially the most important for understanding *Street of Crocodiles'* complexity, is timbre: "harmonic components of sound [that] give it a certain colour, or tone quality. The recognition of sound is usually based on timbre." Kahn points out how Russolo extends this rather conventional (and music-based) conception of timbre in a remarkable way:

> Russolo pointed out that what were commonly understood as musical sounds were themselves characterised by the acoustical irregularities that produce an instrument's timbral signature and were thus in effect instances of noise in the midst of music. . . . Russolo's argument was not just formulated in formal, acoustic terms but replaced notions of purity with a richness of noise meant to correspond to the richness of life.[27]

This notion and that of auditive materiality are indispensable for understanding the origination of noises and sounds that predominate in certain montage sequences of *Street of Crocodiles,* and also because, according to Kahn, "Russolo's noise presented timbre as a *resident noise* that invoked the world without incorporating it."[28] Resident noise is a complex notion of "noisy correspondences within music [that are] emphasised as themselves bearing traces of the world of true extramusicality."[29] I will articulate specific extramusical resident noises in the Quays' films in a later section, noises that create a world on-screen, distinct from the phenomenal world we experience. The extramusical origins and timbre of many of these noises in both the music and other audio tracks, while originating

from sources in the world we live in, add innate complexity to the exegetic process of sound, music, and image in the realm of *Street of Crocodiles*.

Musical Dialectics

As I've already mentioned, the Quays' experimental narrative strategies are obliged in part to affinities they bear with early cinema: gesture instead of dialogue, juxtaposition and image composition rather than narrative continuity. Karel Reisz suggests that the introduction of sound to early cinema "largely caused film-makers to concentrate on realistic narrative and to discard the silent cinema's methods of indirect visual allusion."[30] According to Reisz, the effect of symbolic juxtaposition combined with realistic narrative continuity irritates the spectator, who is required to adjust her reception from a smoothly flowing story to intellectual, contrived imagery, thus causing a break in continuity. The meandering, elliptical narratives in the majority of the Quays' short films, including *Street of Crocodiles,* rarely aim for continuity and make greater use of early cinema's systems of indirect visual allusion, employing sound as a symbolic counterpart rather than as a descriptive narrative function. Many of the Quays' music and sound effects both enhance and confuse spatial and object organization, creating a musical rhetoric that obeys its own laws. This rhetoric is also responsible for the objects' emotional and material qualities and it locates them as well in the films' unusual worlds. The viewer can acquire knowledge and experience to recognize these defamiliarized relations between music and sound and objects within the diegesis, creating her own version of a narrative. This is also a dominant device in most of their films. We are confronted with odd, strangely beautiful figures and forms in noncontinuous but somehow connected spaces: the music and sounds organize these and also add emotional qualities to the objects in them. Through repetition of sound and music cues, we acquire a posteriori knowledge that also allows us to develop our expectations, and this assuages apprehension.

The introduction of sound to cinema provoked many reactions, and Kahn suggests that when "the principles of montage were applied within the context of asynchronous sound film, sound—once it was no longer tied directly to visual images, speech, and story—was able to exist in a more complex relation with them."[31] As I intend to continue developing dialectical montage concepts, I return to Eisenstein. In the 1928 collective "Statement" on the potential uses and abuses of sound in cinema, Eisenstein et al. asserted that

ONLY A CONTRAPUNTAL USE OF SOUND in relation to the visual
montage will afford a new potentiality of montage development
and perfection. THE FIRST EXPERIMENTAL WORK WITH SOUND
MUST BE DIRECTED ALONG THE LINE OF ITS DISTINCT NON-
SYNCHRONISATION WITH THE VISUAL IMAGES. And only then will
such an attack give the necessary palpability which will later
lead to the creation of an ORCHESTRAL COUNTERPART of visual and
aural images.[32]

Both Kahn, and to a lesser degree Chion, discuss the critique and contribution
of the "Statement" to later development of sound in cinema, Chion noting that
Eisenstein's example of audiovisual counterpoint remains dominant in current
cinema.[33] Kahn engages more deeply with Eisenstein's montage concepts and
syntheses these with Eisenstein's observations on the early Disney cartoon.[34] In
1986, the year *Street of Crocodiles* was completed, the Quay Brothers wrote their
own statement: "In Deciphering the Pharmacist's Prescription 'On Lip-Reading
Puppets.'" The text can be read as a poetic manifesto on creating a particular
mood and function of music and sound, one that has persisted in their works
over the years. It describes some of their aesthetic aims for music and sound track
development that have affinities with Eisenstein's ideas about experimental work
with sound, and both manifestos will be referred to here. I will develop concepts
of contrapuntal image and sound montage of the "Statement" and forays into
other montage writings of Eisenstein about the combinatory powers of image
and sound, as distinct from voice and dialogue, into an aesthetic dialectic for the
sound phenomena in the Quays' films.

As filmmakers, the Quays have a methodology that is an expressly
musical one. "Every element is considered and composed whether it's a pup-
pet or an object. They are conceived physically but also musically, and hence
inseparable."[35] *Street of Crocodiles'* montage sequences develop a complex dialectic
that both enhances the spatial disorientation and provides aural guidance to the
film's world. The movements do not follow the music as much as interact with
it: sometimes this combination satisfies Eisenstein's contrapuntal orchestration;
other times it is polyphonic and harmonious. Another way of understanding this
choreography of rhythms is as a dialectic of montage that extends to the sound
track—that the fluidity of space they seek is achieved by a precise, intentional
counterpoint between music and image, a musical dialectic that creates the other-
ness of the laws of their films' worlds.

One of the Quays' aesthetic aims in their 1986 manifesto is "a climate in keeping with the Schulzian universe, which effectively suspended time and allowed the music to secretly contaminate the image, the images to contaminate the music; and reversely, for the music to be 'seen' and the images to be 'heard.'"[36] While this resonates with visual music as described by Absolute filmmakers who worked with animated film form, the Quays' unique use of music is distinct from visual music that features abstract, geometric, or graphic forms. Their films use puppets, objects, sets, and spaces, and the music is often the main emotional, and sometimes spatial, cue that helps the viewer negotiate these spaces. There are sounds and noises that interrupt the music's guidance, but these interruptions contribute to a coherence as well. Kahn suggests that "it is through interruption that the semblance of a continuous unity is brought to bear on the actual profusion and disparity of phenomena. . . . It is only through noise that the famed ephemerality of music is secured as ephemeral."[37] It is also highly relevant that throughout their work, the music and most of the sounds are for the most part acousmatic—"sounds one hears without seeing their originating cause"[38] as distinct from visualized sound, what Chion describes as sound "accompanied by the sight of its source or cause."[39] I will argue that this reciprocal contamination dovetails with Eisenstein's concepts of montage.

To articulate their aural montage, I distinguish three main dialectical functions of music, sound, and noise in *Street of Crocodiles* that share properties with some dialectical pairs described in chapter 5 (included here in brackets). These are in part based on Lucy Fischer's productive categories for describing Dziga Vertov's *Enthusiasm: Symphony of the Donbas* (1931).[40]

1. *Narrative development and anempathetic apprehension* (narrative and nonnarrative strategies, continuity, and discontinuity). Narrative development occurs when music and sounds provide what Chion calls "added value" and when sounds support actions or incite *emotional or empathetic engagement*. Anempathetic apprehension causes narrative hiatus and occurs when the image is matched with inappropriate sounds, breaks in sound (silence) in moments of self-reflexivity, when association of one sound is made with various images.

2. *Embodied and disembodied sound.* Examples of this are diegetic sound, concrete and metaphoric use of sound, sound distortion

and superimposition, and sound edited to create the effect of an inappropriate physical connection to the image.

3. *Spatial coherence and disjunction* (orientation and disorientation; spatial connectedness and disconnectedness). This includes manipulation of sound temporalities (reversal, slowing down, or speeding up), discrepancy between sound quality and visible space, and discrepancy between sound and visual location.

In the musical montage of *Street of Crocodiles,* compositions, sound, and image are defamiliarized, as the images are so interrelated to the sound track that it does not have a subordinate function. The sound, music, and noises are mainly the nonanthropocentric, auditive "voices" of the spaces, the puppets, and the metaphysical machines that coalesce into a dialectical sound strategy for the film's world.

To explore the first dialectic—*narrative development and anempathetic apprehension*—I describe experiential auditive phenomena in a series of shots at the beginning of the film as it moves between live action and animation, and between more realistic, temporality-inducing sounds and the more abstract, less sequential ones of music. While music-driven montage dominates the film, it can be contiguous with the mixing of conventional and experimental editing systems described in the previous chapter. In some scenes the music follows conventional usage and provides emphasis, aural support of movement and rhythm, melody, harmony, and instrumentation. An example of this is in the black-and-white live-action opening scene in the theatrical stage setting. For the role they cast Feliks Stawinsky, the caretaker at the Polish Club in South Kensington, London, who assisted in the club's small theater. The Quays directed him to do precisely the simple movements his job required—like counting the lights needed for a performance. The film commences with a close-up of a hand flipping a magnifying glass above a map, concurrent with the first sound of a clock ticking— slower than a beat a second. The ticking is joined by slow, almost lazy whistling (Jankowski) from 0:16 that supports the actor's actions as he enters the theater space and counts the lights. These sounds from the phenomenal world—a clock ticking, a human body's breath whistling—are in accord with the spaces he negotiates. The rhythmic, meandering whistling and repetitive clock ticking create an anempathetic tension, but because they are relatively constant and become predictable, they contribute to a linearity of time. These sounds are then joined by

an intermittent harp strum, and as time passes its intervals are less spaced apart. While cyclical, the time period between strums decreases, adding tension and expectation to the viewer who becomes aware of the slight variation in time gaps, increasing apprehension of the realm. As the man climbs onto the stage, a blue film title is superimposed on the image. The actor exits frame right (0:43) and the whistling fades out as string music commences to join the harp (0:47–0:50). The music and ticking continue and at 0:44 the camera cuts to a series of black-and-white macro close-ups of metal objects—a wire mesh, scissors, a pulley, an enameled bowl of screws—and, on a hard cut at 0:57, to a wooden object with a superimposed title "Prelude: The Wooden Esophagus." While the harp is a sound bridge heard in both the live-action and animated realms, the strings signal a change, and the apprehension they create is both heightened and appeased with the striking visual appearance and texture of these objects.

The man then enters the frame in medium close-up and looks through the eyepiece of the Wooden Esophagus. The clock fades out at 1:02 as the image fades out in the live-action realm. After the man looks down into the eyepiece, the music continues and intensifies in a series of crosscuts during a montage sequence between the live-action realm: the Wooden Esophagus interior's machines and pulleys, now in color, and the puppet whose hand is tied to the inside of a lamp fixture. The Quays explain the subtle changes in the music during this sequence and how they are meant to affect the viewer:

> As the music became edgier and darker, we wanted it to seem as though one of the exhibition pieces was secretly luring [the actor]. He intuitively knew that the price of admission for the object to work was not a coin, but a private earthy offering of saliva. We had him think of the Madonna as he worked up his saliva. It was his anointment which set everything into action.[41]

This "anointment," a gob of real spit from the actor's mouth, drops into the Esophagus and is subtly replaced by an animated one when the camera cuts to the color world. The strum of a harp is heard as camera movement down into the Esophagus begins, the flowing sound an aural equivalent to the flowing camera movement. It signals a change in music as the animated spit sets the animated realm in motion and the dramatic music is joined by the sound of squeaks, wheels, rattles, and pulleys as the static machines begin churning and gyrating. Each of these sounds belongs to an object: the squeak to a sewing machine, the

turning wheel to the pulleys, and the rattle we hear is later revealed as caused by the puppet's hand shaking in a glass lantern. The transition to the animated realm is complete when, at 2:14, the puppet is freed by the man's snip of a scissors located at waist height on the Esophagus's exterior that he inserts to cut the string running along the pulleys. This sequence suggests the puppet is somehow tied to the live-action realm, and the snip effectively severs the connection between live action and animation. The puppet then passes through an opening into the main room of the Wooden Esophagus Antechamber, touches the knotted string that unravels and raises a semitransparent screen that he passes under, and leaves the Antechamber to enter the Zone.

What is unusual here is that the live-action sequence has no diegetic sounds to support the actor's movements—no scuffles, breathing, or footsteps—and in the animated realm seemingly diegetic sounds are introduced. Via a series of crosscut short scenes interspersed with two fast pans and varying focal lengths in big close-up, the montage sequence, together with music and sounds that guide our spatial orientation, narrates the shift between the man in the live-action realm and the animated realm. In his reading of "The Statement," Kahn suggests that, for Russian dialectics of silent film montage, "sound threatened to smooth over the conflict by dictating a scene naturalistically at the slower pace set by the synchronisation of speech emanating from bodies and sound from objects and actions."[42] Because the music and sounds in the live-action and animated realm are nonnaturalistic, the first dialectic—narrative development and anempathetic apprehension—can be maintained, in effect smoothly bridging the aural transition from one to the other. Bridging the cut was also a use of sound Eisenstein suggested, which Kahn sees as the way conventional cinema would later adopt for music.[43]

The sound track for the complex montage sequences in the rest of the film follow less conventional musical laws than the live-action sequence. Together with the image composition and montage, sound completes the aural and spatial complexity of *Street of Crocodiles.* In the film's metaphysical theaters the nonhuman actants acquire emotional qualities through a use of music that is far removed from one that aims for illustrative or narrative functions. Eisenstein describes theatrical elements of Kabuki theater as a system that cinema should aim to emulate, "a single monistic sensation," "a single unit of *theatre*" that, "in the place of *accompaniment* it is the naked element of *transfer* that flashes in the Kabuki theatre. Transferring the basic affective aim from one material to another, from one category of 'provocation' to another."[44] The viewer of *Street of Crocodiles* is provoked on two

levels: by the experience of unsettling and beautiful animated objects, melded with musical compositions that are the aural counterpart of these images. An example of this provocation, this transfer of affects from one material to another, takes place and is heard in these theaters in a single shot: the Screw Dance sequence (3:49–4:32), which commences directly after the one described above.

Silence is invaded by a soft, rhythmic, distant hissing as somber blackness fades up to an abstract composition of rough vertical and horizontal rectangular forms that frame thick and mottled glass panes in front of corroded metal forms. The rhythmic hissing becomes the sound of a tram approaching that passes and fades into the distance of an offscreen space as a xylophone's simple, childlike melody begins. The camera pans up, to the left, back to the right, and down a glass pane that is partly covered by a wooden plaque embellished with Polish text. It comes to rest at the bottom of the pane, which is above striations of thick dust, while we hear the faint sound of crackling, dry twigs. Almost imperceptibly, then slowly, a screw emerges from the dust, rotating as it dislodges itself, and we realize the crackling sound is the screw straining against its wooden moorings. A violin begins to play a six-note motif in a cycle, slower than the screw's urgent rotations, yet round like the screw's movements. Behind the mottled glass, a rotating form slowly rises like a behemoth from its fixings, another thick, oily screw, much larger than the first, sluggishly emerges from its invisible position below the visible surface. The fuguelike violin provides an emotional counterpart to this compelling vision; it implores the screw to strain higher, higher, as the spiraled ridges reveal its cylindrical form. The first small screw disengages itself, falls, and rolls off screen right, and a tambourine begins to rattle as a second, smaller screw emerges with a similar, urgent spiral upward that is faster than the rotating column in the background. This pas de trois, a visual fugue, is matched aurally by the three sounds. As the camera pans and cuts to other screws unscrewing themselves from wood, a second string instrument joins the first, higher in pitch and rich in harmonics, more urgent in rhythm than the first violin, suggesting that the screws are in a hurry to free themselves. The last screws we see are in a different space, on a wooden window frame with out-of-focus reflecting-glass bulb forms behind another pane of glass. Hesitating at the last moment before disengaging themselves, the screws then fall on their sides and, one trailing a curled wisp of old twine, another gathering sticky dust, they are joined by others in an exodus offscreen right.

The monistic ensemble Eistenstein describes (which recalls Artaud's notions of hieroglyphic theater) is where "sound, movement, space and voice do

not accompany (or even parallel) one another but are treated as equivalent elements."[45] Sound, music, and objects in the sequence described above—screws of various sizes, in this instance—have a lateral hierarchy and achieve the monistic status described by Eistenstein. Kahn further interprets this:

> Once elements have reached their monistic status through the decomposition of larger complexes, the very process of decomposition has lent them a nonnaturalistic autonomy from which they can combine with other elements outside the conventions of synchronisation.[46]

During this shot, which lasts less than a minute, the individual objects within the composition—windowpanes and screws—seem to achieve a state that far exceeds their inorganic one. The shot contains transitions (fades and fast-track shifts), but the camera remains in the same diegetic space, traveling on horizontal and vertical axes, tapping out the diegetic space for us and, as it comes to rest, establishing the relative autonomy of the as-yet-to-appear screws. As the large screw begins its rotation and emergence, the violin begins. While there seems to be a kind of synchronization, the sound is not imitative; rather, while it also has a repetitive, spiraling motif, it is asynchronous, not enchained to the rhythm of the screw's rotation—and this evokes anempathetic apprehension. Kahn's example of how such nonnaturalistic autonomy functions takes the human body as its object: "For instance, although the action of the pivoting elbow will not normally make noise, if it is isolated with a similarly isolated sound, it will produce a nonnaturalistic effect of the sound animating the action or the action giving rise to the sound."[47] The violin motif is not synchronized to start with the screw's movement; that is underlaid by what sounds like cracking twigs or wood that then stops, so the sound of the violin and the image of the screw moving have individual performative effects. Because of a slight lag in the music's timing and repetition, sound and image retain their status of isolation, yet coexist in the film experience.

In the Watch Death sequence, an open pocket watch is surrounded by a symmetrical organization of its inner parts. We hear a single high-pitched, almost continuous violin, distinct in timbre and color from soft, overtonal guitar pluckings that are joined by the ticking of a clock that sounds like the watch. A hard cut shows a frontal view of the watch in a glass case that then cuts to a close-up of a fragment of it in the lower right-hand corner of the glass. More screws and a nail emerge from the wood casing, climb onto the watch, and we

hear cracking sounds as they penetrate its enamel face. The watch face cover flips up, the watch rotates, and the back metal casing flips open to reveal the nail and screws emerging with a squishy sound from its back, a circular mass of red, soft, moist flesh, to the sound of a full guitar strum and a more resonant, lower pitched violin (see Plate 13). As they wander off to the table edge and disappear, the images fades to black and the music ends. The sounds throughout this sequence—enamel cracking, the clock ticking, metal rolling on wood—are embodied sounds, the voices of the screws and metaphysical machines. This is an example of what Chion calls indifferent or anempathetic music, but with sounds added. The indifferent sounds also have a timbre (Russolo) and it is a factor that endows each of the puppets and metaphysical machines with its own voice, a musical motif, a combination of sounds and music that mirror their collaged construction and strange movements without explanation, and this allows the viewer a much greater exegetic and emotional freedom. This combination of embodied and disembodied sound (the second dialectic) helps us comprehend the complex interworking and lateral hierarchy of the sound and image track.

184

In addition to its anempathetic effect, there is something else at work in this and other sequences that is another example of the second dialectic of embodied and disembodied sound. Costantini highlights an unusual use of sound combining a macro shallow focus image with what he insightfully calls "a 'shallow' sound that lacks perspective or projection in the space (as if the space were defined not by the illusion of depth, like most spaces in cinema, but by the visual/photographic result)."[48] This is found throughout the Quays' works, and a good example of it is the monochrome-to-color sequence that moves between the live action and animated realms in *Street of Crocodiles.* In the Wooden Esophagus at 0:44–0:56, in an L-shaped camera trajectory interconnecting a total of four sets of objects sharing a diegetic space (metal and wire mesh objects, screws in a white bowl, scissors, and pulleys) are filmed in monochrome in varying degrees of chiaroscuro and shallow focus. It is significant to note that none of the objects is animated, although the unusual fast-pan shifts and macro close-ups instill a sense of spatial apprehension. In the sequence, two calibrated pans take us down a vertical, irregular wooden surface (which remains in shallow focus so it is hard to see what it actually is) from two wire mesh objects to a set of pulleys on a wooden construction. At this point a very faint, almost indiscernible sound of violins commences and the strumming and the whistling fade and stop. The camera rests a moment, and after the next downward pan it rests again on a dark compartment of sorts with screws and metal-rimmed glass discs. During this the

single violin is joined by other strings, though their voices are difficult to single out. The camera then makes a fast-pan shift to the right to a white bowl full of screws. This sequence is followed by superimposed blue titles, "Prelude" and "The Wooden Esophagus," and the violin music, along with the ticking clock, that continues uninterrupted into the cut to live action.

The music and sounds throughout this sequence do indeed have a shallow quality for two reasons. The first is that the aural motifs do not seem to belong to any of the objects or the actor; while it is tempting to allocate the whistling to him, he himself is not whistling and the sound continues into the macro realm of objects. The second is that it isn't really clear what music and sound are supporting or enhancing on the visual track, and when more than one sound or music is present, they are more contrapuntal than harmonic. This aural disjointedness, caused by variations in loudness, pitch, and timbre, echoes the camera's wandering character and is an aesthetic of the third dialectic (spatial coherence and disjunction). It contributes a mood of uncertainty and apprehension to the hermetic images in the (pre-)animated realm. While I would not agree with Costantini's observation that the focus blur is a condition of the objects and not a result of working with lenses, he provocatively and rightly proposes that in such scenes, the sound has a "very shallow 'depth of field.'"[49] The experience of these sounds is closer to Laura Marks's description of haptic hearing, "that usually brief moment when all sounds present themselves to us undifferentiated . . . that can be sustained for longer, before specific sounds focus our attention."[50] This undifferentiated sound is intimately related to the anempathetic, indifferent music described by Chion.

There are musical sequences that evoke association of a melody or musical phrase with one of the puppets or objects, or that give a mood to a set in combination with effects of lighting and camera movement. This is an element of the first dialectic—narrative development and anempathetic apprehension—as we watch (and listen to) the film, we can identify developmental temporal patterns between image and sound that provide us with a posteriori knowledge. The music can also create and develop motifs that support and enhance the film's combination of functions and devices to strengthen a sense of a comprehensive formal system, as the Quays explain for *Street of Crocodiles*:

> The final music, which we always referred to (between each
> other, of course) as the "Broken Automaton Waltz," suggested to
> us that the Zone of the Street of Crocodiles—that it too had to

break down, falter like the music, unhinge—and hence, the screws, which, by their nature, hold things together, should unscrew, desert, and flee their moorings, including the moorings of the puppets themselves.[51]

Different fragments of this musical passage occur in the film, helping to cue viewer expectations and providing a partial, faint structure for the film's other visual and aural patterns and systems. The music can also function as a repeating motif from a previous image or scene: in 4:40–5:02, the small screws are accompanied by shrill, squeaking strings; then at 5:11–5:38, we hear a similar music before the screws appear in the frame and screw themselves into the watch face. And in the Hall of Mirrors, the Schulz puppet finds himself in a glassed-in arcade; the music is a kind of waltz, playful, counterpointing the urgency of his attempts to escape. We hear a similar musical passage at 13:47–14:14, when the Tailor cues the three Assistants to the Automaton Waltz.

In *Street of Crocodiles* the absence of dialogue (excepting the spoken Polish monologue at the end of the film) permits the Quays to give voices to Schulz's generatio aequivoca, because music and sound provide the orchestral counterpoint that catalyzes the "fantastic fermentation of matter"—matter that is mute. While the Quays stated in the last chapter that they construct their film around the voiceless puppets' point of view, interaction between the puppets is often cued by music, and often the music begins before eye-line matches, foreshadowing a shift. Bradley Rust Gray asked the Quays if they used what he called point-of-view sound in their films: "Enormously so in *Crocodiles*. Mini-landscapes of sound."[52] While the music and sound landscapes contribute to spatiotemporal understandings of the realm, they also guide us to interpret the puppets' inner states and feelings. There are no facial expressions and few physical gestures that indicate emotion, so the music suggests these attributes and evokes an emotive response. Although this is the music's main attribute, it is not the music alone that develops the puppets' and objects' emotional worlds.

Mutters and Creaks

Street of Crocodiles' sound track includes sounds and noises that are not what would be considered musical in a conventional sense: squeaks, the squeal of metal rubbing on metal, moving hinges, scraping and rustling—sounds that add material qualities to these objects and have a timbre, a quality of Russolo's

description of resident noise. The noises are not simply minor "figures" that support the music and interact with it. They are noises that become significant for a number of reasons, including their pertaining to "a complex of sources, motives, strategies, gestures, grammars [and] contexts."[53] Russolo proposed that "the real and fundamental difference between sound and noise can be reduced to this alone: Noise is generally much richer in harmonics than sound."[54] Harmonics are generally heard as the timbre of a sound, and Jankowski's inclusion of irregular noises and periodic vibrations with the more stable acoustic experience of musical instruments infects the overall sound track. This seems exemplary, for Kahn's description of Russolo's aesthetic project's aims as one that opened music to the plenitude of all sounds that included noise. The film's emotional quality and experimental narrative force is also strengthened by the affinity of Jankowski's unconventional, experimental musical compositions with Schulz's subject: animistic matter. The Quays: "Every object finds and has its own voice—which is a metaphoric voice—not a speaking voice in the conventional sense. It's more likely to be a musical voice—even silence. There's no hierarchy in this respect."[55] The examples of anempathetic music and shallow sound and their timbral voices or color described above are the aural motifs for the metaphysical machines.

In Jankowski's experimental score, pure tones and complex tones add periodicity to the music. He had utilized the different pitch frequencies already, so the added sounds on different tracks were easily integrated into the musical score, giving coherence to both. Jankowski's compositions work with a term that emerged in the mid-1980s—"musicalization of sound"—that Kahn attributes to Canadian audio artist Dan Lander: "a means to identify and supersede techniques in which sounds and noises were made significant by making them musical."[56] The complex sounds emphasize and collude with the "pure" tones of Jankowski's eerie score. The "figures" of these sounds offer satisfying complexities, as does their interaction with both the images and the music. The enormous range of sounds and rhythms in the Quay Brothers' films make sustained use of what Marks calls the relationship between aural textures and aural signs, which she says "can be as complex as the relationship between haptic and optical images."[57] Playing with our typically narrative expectations of the relationship between image, sound, and music, the Quays' aesthetic strategy is one of matching and mismatching textures and signs and giving musical and other sound "voices" to their puppets, sets, and objects. These soundscapes, understood through the three dialectics of sound, result in a remarkably rich aural world.

The Quays engaged sound designer and film editor Larry Sider to create the sound track for *Street of Crocodiles;* his attuned understanding of what they were trying to attain is one of the reasons for the film's great success. The complexity of sound effects in the film does not suggest, exaggerate, or enhance realism; it contributes rather to the associative potential of the visual images, oscillating between the abstraction and emotional qualities of music and the more unsettling (because indeterminate) relationships of captured noises with the images they accompany, noises carefully created, chosen, and edited. Sider is very specific about the intentions underlying his collection of sounds and noises, and how, "very early on we found that the sound had to be as organic as the picture. We couldn't start having synthesised 'whooshes'—it just didn't make sense. So you had wood and paper and cloth and metal and what was around. You had to record often what they used to make their films."[58] The Quays use what I call embodied sounds that trigger a mental image of its material origination. A pulley can sound like a pulley, rolling wheels squeak, a plaster hand rattles in a glass lamp shade. Closely related to the music in pitch, tone, and timbre, subtle differences to the sounds were made that were then assigned to each of the figures and spaces. The film had twenty separate sound tracks that were manually (analog) mixed and then transferred to the film's sound track. Very little time was spent preparing sounds. Sider comments that he did not recall developing a treatment before the mix, and in spite of the complexity and number of tracks, the sound track for *Street of Crocodiles* took about two days:

> These are very complicated tracks when you get done. I mean the average short film will have a bit of synch dialogue, some music, and a few sound effects. . . . [In *Street of Crocodiles*] you go along with one track of music and suddenly you hit a period that covers 10 seconds and it will need 16 tracks.[59]

Some unusual sounds become familiar as they pervade the Quays' sound tracks as aural evocations of spatial motifs. One of these is the sound of a streetcar that originally came from the BBC's sound library for tram effects. They used it for the first time when working on *Nocturna Artificialia* and it reappears in *Street of Crocodiles.* Other sounds were made using elements and objects from the sets themselves or sourced from their working environments: "You're in the studio and you suddenly see something that moves and makes a noise and it's not the sort of object you find every day. So, you can know that this is a unique sound, or not

unique, but it's different. So you use it."[60] Sider's practical description of discovering noises that are "different" becomes significant if considered alongside Kahn's proposal that "with so much attendant on noise, it quickly becomes evident that noises are too significant to be noises."[61] I will explore these two descriptions of noise in a slight digression about diegetic sound.

As it is shot single frame, technically speaking, animation can never have a diegetic sound track.[62] To my knowledge, to date no author has addressed this issue in any depth. Films that aim for hyperrealism or an anthropomorphic or anthropological representation in animation film tend to use empathetic sound and the same sound effects as in live-action film: footsteps, wind in trees, clinking glasses, crying, sighs, laughter, chirping birds, or urban ambient sound. The sounds are recorded in spaces—a hermetically sealed sound studio, a room with furniture and curtains that absorb echoes or one with tile floors that echo sounds, a natural outdoor environment—all of which affects the sound quality and its aural fit with the images it underlays. These are tactile sounds, Russolo's "resident noises": our ears can pick up the distinction between sound recorded in a small room with hard surfaces, which may include echoes, reverberations, and sound recorded in a vast hall or outdoors. In animation films, the spatial quality of descriptive or mimetic sound is often mismatched to the spatial dimensions of the animated films' world, i.e., an intimate interior scene has a sound track that clashes with ambient noises of a much larger space. The inherent discrepancy between the sound source ("real") and artificial, animated images can require a strong flight of fancy to align sounds from the real world with images that are completely fabricated. Technically, the sound track for animation cannot record ambient sound of the scene being shot frame by frame, and timing natural sound is extremely difficult to convincingly synchronize with animated movement.

My two observations—the technical impossibility of animation film having a diegetic sound track and the discrepancy sensed between a sound's original source and its aural/visual (mis)match with an animated image—are compellingly questioned by the sound design in *Street of Crocodiles*. The Quays and Sider circumvent the aesthetic irritation of "real" sound with a highly imaginative use of minimal, atonal, or arrhythmic sounds. By manipulating the sounds and their pitch and timbre, they were able to add a musical quality to natural sounds and noises that complemented and counterpointed Jankowski's music. In a singular way, via the second dialectic (embodied and disembodied sound), the Quays' film challenges my two observations. Some of the sounds they use, which

are aimed to match the texture of the objects and spaces, do have this quality—if not technically, then aurally and emotionally. By using what we could define as pseudodiegetic sounds—embodied sounds—for the metaphysical machines, and by adjusting pitch and timbre to alter the natural recorded sounds, the Quays and Sider increased the credence of the film's world by creating a sound realm of Kahn's "significant noises" that aurally matches the visible textures, densities, and corporealities of the film's puppets, sets, and objects. (This is also one of the few examples in the film of Chion's "added value.") This is especially clear in the Rubber Band Machine sequence (6:45–6:52). The sound was planned to both counterpoint and underpin the images, as well as to foreground the technical and formal properties of shots. For instance, the Quays' technical use of reverse shooting found its complement in the sound; the sound for the Rubber Band Machine (when the Schulz puppet enters the Zone) was recorded and played in reverse.[63]

There are also moments in this film when the sound track is almost silent, creating an aural vacuum that was also used to great effect in *Institute Benjamenta* and *Rehearsals for Extinct Anatomies.* This is a dramatic effect that unrelentingly pulls our attention to the image; it can force us to engage with the image that much more when the music and sounds guide us, round out the image, and define space. These moments are ones of the third dialectic of spatial coherence and disjunction the Quays also use in their editing. At the beginning of the Screw Dance or in the Dark Mutterings sequence (see Plate 5), with the pulley moving off into darkness, there is an almost complete lack of sound, which also means the space is less defined. In his study of John Cage's engagement with silence as a musical form, Kahn suggests that "pitch, loudness and timbre, although they could be heard in musical sound, were not intrinsic to the being or nonbeing of music because they did not require duration, whereas 'silence cannot be heard in terms of pitch or harmony: it is heard in terms of time length.'"[64] These almost silent shots and scenes embed the viewer in an immersive experience, because the temporality of these periods is experienced as the same as her own: without distractions or guidance of sound, noise, and music, and because there are very few camera movements in these quiet scenes, she is also more immersed in the shot's spatiotemporality. The viewer's (and listener's) work with these aural textures encourages a sustained "haptic" hearing and an anempathetic apprehension.

The faint noise and sounds can also convey a sense of mood and space outside the frame—mutters and creaks, the sound of pulleys, or an indiscernible voice that sounds very far away. In the Dark Mutterings sequence there is no music for an extended period as the puppet looks into the dark space right

of the apparatus he is in front of. The sounds and echoes suggest a deep, vast space in the darkness and they are joined by crackling voices and murmurs that sound like (and are) old radio broadcasts, acousmatic sounds that are disembodied and disassociated from their human and spatial origins. This is an example of the third dialectic of spatial coherence and disjunction. It creates a sense of off-screen space that Burch describes:

> Off-screen sound, however, *always* brings off-screen space into play. . . . Even when there is no indication of the *direction* a sound is coming from . . . we are able to tell approximately how far away it is, and this *distance* factor provides yet another parameter, though it is one that as yet has seldom been explored.[65]

But there is something else at play too. These sounds carry over without interruption or pause into the next dense sequence, the Metaphysical Museum. The puppet looks through a small window (see Figure 11) and his face and eye, in close-up, are intercut with scenes of metaphysical machines shot with varying focus pull and macro lenses: the Rubber Band Machine, ice cubes re-forming from pools of water, a dandelion clock's reconfiguration. Because the sound track bridges cuts to new shots and scenes, the sense of coherent space these sounds belong to is undermined; they are shared by the dark recesses and the bright, sealed-off spaces of the metaphysical machines. This sequence is also another good example of shallow sound. Costantini describes another sound strategy in the film that relates to spatial orientation, a strategy

> to make the relation between the sound and the sound source very imprecise. Some objects produce ambiguous sound since it is not clear if the noise is coming from the action or if it is coming from off-screen (in other words, if they are diegetic or non-diegetic).[66]

The *Street of Crocodiles* sound track engenders in listeners an engagement with understanding the causes of sound they hear. Within the three listening modes—causal, semantic, and reduced—Chion describes "another kind of causal listening [in which] we do not recognise an individual, or a unique and particular item, but rather a category of human, mechanical, or animal cause."[67] Although they may be received as diegetic, the pulley sounds, squeaks, rustles, and acousmatic sounds are often not specific to one item moving (or not) in the frame, and we

develop what Chion calls "indices, particularly temporal ones, that we try to draw upon to discern the nature of the cause."[68] This category of causal listening is the one that hears the animated realm itself, the undercurrent vitalist pulse of *Street of Crocodiles,* of the metaphysical machines.

The film also uses acousmatic sound and music to elicit anticipation and anempatheic apprehension; sometimes a sound is heard long before we see the object from which it originates. An example of this in a longer montage sequence in the Zone (5:39–8:31). Throughout the sequence, we hear two connected sounds: an odd, bouncy noise, an extended, pizzicato *doiinnng* of what sounds like a low-tension guitar string (or a taut rubber band) being strummed, followed by repetitive, diminishing reverbration and thunks of what sounds like spring-tensioned wooden parts released from pressure and colliding before returning to a static state. These sounds are first heard when the Boy causes screws to jump using the reflection of his mirror; as they fall to the floor their impact and bounce is acoustically synchronized with these two sounds. We hear the sounds again as the Schulz puppet enters through a side door, and again the sounds are synchronized with movements of what appear to be the sources of these sounds in neighboring shop windows in the Zone. On the left, the vomiting puppet surges forward and in a window to its right there is an apparatus assembled of metal pipes. A fast-pan shift then takes us to a macro shot of a pile of cracked, broken rubber bands. An eye-line match with the Schulz puppet reveals a third metaphysical machine—the Rubber Band Machine—that repeats a movement of stretching rubber bands until they break, and again the apparatus movements are synchronized with the thunks (see Plate 14). While Chion describes this later revealing of the sound's source as a dramatic technique that maintains suspense, the synchronization of these two noises—the *doiinnng* and the thump—with more than the one source—falling screws, the metal pipe assemblage, the vomiting puppet, the Rubber Band Machine—suggests complicity among the machines. Mitry suggests that "rhythm is always rhythm of *something;* it can never be gratuitous. Though music is rhythm in its essence, this is not the case with literature and cinema."[69] This rhythmic "disembodied sound" is a metaphor for the metaphysical machines; it is the heartbeat of the vitalist world of the Zone and the objects that populate it.

Kahn hints at the problematics around describing and interpreting a sound, actually a noise, such as this one: "The interesting problem arises when noise itself is being communicated, since it no longer remains inextricably locked into empiricism but is transformed into an abstraction of another noise."[70]

Regardless of the material and technical sonic origins of this noise, because it takes place in a montage sequence that is almost silent for a long duration, no other music or sound softens or adds information about it. This heightens and emphasizes its strangeness and its distinctness from the musical passages. I interpret this sound sequence as a further example of Chion's other causal listening, where we recognize a "category of human, mechanical, or animal cause." In *Street of Crocodiles,* it is the category of a vitalist cause, one that allows us to experience the Quays' animation of Schulz's fermentation of matter. This challenges Grodal's suggestion in chapter 4 that viewers lose interest when they encounter visual representations of phenomena without anthropomorphic actants because of lack of emotional motivation, because these sounds and others on the sound track stimulate artifact emotion and enchantment. This may explain the emotional fullness some viewers experience when watching (and listening to) the Quays' non-anthropomorphic puppets.

We are not yet done with this unusual sound. The synchronization of the camera movement with the breaking of the rubber band creates what Chion calls a "synch point" in the film, "a salient moment of audiovisual sequence during which a sound event and a visual event meet in synchrony."[71] But this is not just a synchronization between sound and image: the camera itself is implicated. As it films the scene of the metal pipe machine's movements, it jerks upward and shakily comes to rest a number of times in synch with the sound of the series of thunks. After the camera does this the second time, a fast track shift takes us to a pile of broken rubber bands, one of which is just settling after its fall. This is a distinctive example of the Quays' invocation of the camera as the "third puppet." In these instances of synchronization with the sound of the breaking rubber band, its point of view is transformed from omniscient and objective to subjective and it is actively, even physically, involved in the event it is filming. The sound continues throughout the rest of the sequence, much softer, as a violin and guitar are introduced, and as the violin fades, the sounds increase again alongside the guitar plucking. Then both guitar and these two sounds give way to the sounds of pulleys that take us into the next sequence as the Schulz puppet leaves the Zone. Much later in the film (15:04) we hear it again when the Tailor beckons the Schulz puppet to follow him into the back room, and it continues into the shots where the Boy encounters the gynomorphic torso, this time synchronized with the Boy, who turns abruptly as if he has heard the sound behind him, sees the doll, and then looks with the camera as it does a fast-pan shift upward to a close-up of its macabre, painted face. Although

we associate that sound with the machine, and its image is implicated in the scene at hand, its strangeness at being included without an image of its source can incite what Chion calls "reduced listening [that] takes the sound . . . as itself the object to be observed instead of a vehicle for something else. . . . Reduced listening requires the fixing of sounds, which thereby acquire the status of veritable objects."[72] This repetition of sound also conveys a sense of spatial orientation and assists the viewer to locate where she is in the labyrinth. It additionally gives the sequences a sense of temporality and narrative development because we recall the moment when we heard the sounds first. This throbbing and thudding sound is the vitalist undercurrent of the Zone.

Trilectic Montage

This chapter's indicative sequence analyses and explanations are attempts to describe the inextricable melding of sound and image, a stylistic feature that is constant throughout the Quays' work. *Street of Crocodiles'* musical structure guides us spatially, intellectually, temporally, and emotionally through its labyrinth. Kahn contends that "noises that are never just sounds . . . they are also ideas of noise. Ideas of noise can be tetchy, abusive, transgressive, resistive, hyperbolic, scientist, generative and cosmological."[73] The noises described in this chapter, and many others in the Quays' works, do indeed achieve these active attributes of noise, most notably transgressive, hyperbolic, and cosmological. They are the aural conspirators that give voices to the Quays' vitalist cosmogony. Their montage of sound and image follows a method analogous to what Eisenstein terms the monistic ensemble in Japanese theater, in which "sound—movement—space—voice . . . *do not accompany* (nor even parallel) each other, but function *as elements of equal significance*."[74] It also is an animated mise-en-scène of Artaud's hieroglyphic theater, in which "the repertoire of gesture and music create a kind of spiritual architecture made up not only of gestures and sign language but also of the evocative power of a rhythm, the musical quality of a physical movement, the parallel and admirably fused harmony of a tone."[75]

Bearing a musical methodology in mind, there is one paragraph in "The Street of Crocodiles" in which Schulz refers to the inability of the text to transcribe the half-finished and undecided character of the Zone because of the conclusive and established meaning of words—that words cannot describe adequately because they are too fixed: "These words have too precise and definite a meaning to describe its half-baked and undecided reality. Our language has

no definitions which would weight, so to speak, the grade of reality, or define its suppleness."[76] When asked how they approached this passage, the Quays explained how music becomes the secret scenario:

> That [passage] intrigued us. Again, it's like divorcing—letting the image go beyond what the text could ever nail down so it has become more [pause]. It is very hard to say, "It is a noun and a feminine case." You can't say that about an image [laughter]. You can't nail it like that; it sort of drifts off and becomes like music.[77]

This concept of the image drifting off and becoming like music finds its revelation—and its achievement—in the Quays' mélange of montage techniques and poetic dialectics. In his discussion of Eisenstein's montage of attractions, André Bazin describes the common trait "which constitutes the very definition of montage, namely, the creation of a sense or meaning not objectively contained in the images themselves but derived exclusively from their juxtaposition."[78] He goes on to suggest that what happens to the two images is similar to what happens in language when we use metaphor; in other words, montage of attractions contains the essence of written metaphor when the idea is presented in visual images. Costantini suggests that

> ordinary objects can acquire a remarkable quality when the shot invites us to see not the object but its shape and the sound design adds a sound that might be coming from this new status: we no longer think of the object in terms of its primary function. Now we see the associated new form and therefore we accept its new sound possibilities.[79]

This "new status" is the monistic ensemble Eistenstein describes, where "sound, movement, space and voice do not accompany (or even parallel) one another but are treated as equivalent elements."[80] It is in part created by lingering takes of objects and spaces that give us time to hear the sound and understand it belongs to them and the film's world. In keeping with the intention of montage of attractions, recalling the explanation of the puppets' noncomposible portmanteau forms in chapter 4 and the dialectics of discontinuity and spatial logic of *direct connections between discontinuous spaces* described in chapter 5, we can extend the principles of juxtaposition to include the use of sound in the *Street of Crocodiles*. The Quays say

their impulse is much more a lyrical journey: "The metaphors are always musi-cal."[81] The film's visual and aural landscapes and soundscapes, freed of the seman-tic constrictures of spoken and written language, work with contrast and collision. Perhaps the Quays' montage system is not dialectic, but *trilectic*. If based on the analogy of the chord, three notes that sound simultaneously: A/C/F, that is, A the sets, C the puppets and objects, F the music and sounds.[82] This trilectic results in the liquid space of the Quays' films that contributes to what they describe as

> the very slow accretion of layers which combine to line and perpetu-ate one another. For us, [Jankowski's] music offered a conspiratorial climate in keeping with the Schulzian universe which effectively suspended time and allowed the music to secretly contaminate the images, the images to contaminate the music.[83]

These layers are in effect the monistic ensemble of puppets, sets, camera tech-niques, and sound, an ensemble that can be found at work in almost all the short films, from *Street of Crocodiles* or *Rehearsals for Extinct Anatomies, The Comb,* or *In Absentia*, films that are neither narratively motivated nor verisimilitudinous; they are neither dramatically nor psychologically structured. The Quays diverge greatly from the still prevalent cinematic model for sound and image, where sound design and production is often secondary to the visual image and dialogue. Underscored and counterpointed by emotional qualities of the music and sound, the Quays' films attain an aural poeticism unmatched in puppet animation, and this is a result of their exacting and intuitive use of montage, but in a musical sense. The Quays acknowledge that the musicality of their work is a language of their own. Their explanation of the relationship between viewer, text, image, and music:

> If you can get the image to work at the state of where music is, it is a great, powerful intensity and state of mind, and yet at the same time you realize that it's for you only. The viewer can only create that state if he is drawn to that level. It would be something different for every single person.[84]

This intent is achieved if we consider Michael Atkinson's observation: "Flamboy-antly ambiguous, retroactively archaic, obeying only the natural forces of a purely occult consciousness, Quay films are secret, individuated knowledge for each and every viewer."[85]

Besides the intense and ongoing collaboration with Jankowski, the Quays work with other composers on noncommercial and public-funded commissioned films. After *Street of Crocodiles,* during the period of preparing the first feature film, they began collaborating with contemporary musicians, commissioned to create visual tracks for pop music promos. In interviews, these musicians state they were attracted to the Quays' work in film, especially for their surreal and poetic qualities.[86] Their wish to work with the filmmakers may lie in what the Quays themselves have said is a primary method in their work: that "the essential influence is that of a visual aesthetic which doesn't rely upon dialogue."[87] Very soon after *Street of Crocodiles,* they increasingly explored collaborations with arts that have music as a centrality of their aesthetics, and in a shift from miniature to stage sets, the performance arts of ballet, dance, and opera began to infiltrate the Quays' creative works.

THE ANIMATED FRAME

...AND BEYOND

he critical success of *Street of Crocodiles* gave the Quays artistic freedom to explore a shift in subject matter, in part originating in literary and poetic sources that led to exploration of new aesthetic forms, but also because they were able to make extensive experiments in technique, both with cameras and on large stage sets. The Quays are best known for their puppet and feature-length films. Less known, but no less incisive in their creative development, is their intense engagement in stage design for opera, ballet, and theater. Since 1988, the Quays have created sets and projections for performing arts productions on international stages. Reasons for the relative unfamiliarity of many readers with this work lie in the obvious discipline and dissemination differences inherent in film and live performance; others are the geographic specificity, limited-run performance dates, physical presence needed to experience staged performance, the specialist press, and smaller audience access to these ephemeral, usually unrecorded events. The Quays' creative works in arts other than cinema had and continue to have a fundamental impact on their filmmaking, and their work in performance staging translates remarkably well from the small scale of puppet animation to set design for feature films and productions with actors and dancers.

This chapter explores the separate but inseparable interweaving of the prevailing small-scale and emerging grand-scale worlds of the films and

stage designs after 1986. The emphasis remains on their cinematic work, including music videos and commercials, but I aim to convey the close-knit interplay between choreographers, directors, actors, and costume designers with whom the Quays have worked as they progressed toward live-action filmmaking. Unlike films, which are more readily accessible via cinemas and other venues, these performance productions were intermittently staged. I had the good fortune to see a number of these: the stage play of Shakespeare's *A Midsummer Night's Dream* (Jonathan Miller, 1996), an opera, *Mazeppa* (Richard Jones, 1991), and the ballet *Queen of Spades* (Kim Brandstrup, 2001). In all of the performances, the Quays were commissioned to integrate architectural, narrative, and decorative elements into large sets that occasionally included animation projections. Because these contributions to live performance are predominantly limited to the stage designs, my reflections concentrate on specific features of these and their interrelationship with the films that were being made concurrently during this period. Metonymic indices of devices and aesthetic features in the work elucidate the Quays' creative movements between the vitalist worlds of the puppet animation films and the corporeal cinematic and stage presence of living bodies.

Rehearsals and Oneironautics

Before they began exploring large-scale set design, the Quays pursued their enduring interest in Franz Kafka's writings and diaries in the film that followed *Street of Crocodiles*. Originating in a project called "Three Scenes of Kafka," for which Leszek Jankowski had already composed the music, *Rehearsals for Extinct Anatomies* (1987), the Quays' first international coproduction, fully exploits the play with the vitalist experiments they began to make in *Street of Crocodiles*. The Quays regard this film as the most musical and abstract of the shorts, and it is an apt title for one of their least narrative films. A fourteen-minute-long composition of tracking shots that travel between set fragments, it is a visual collection of austere spaces and idiosyncratic objects—metaphysical machines— loosely knit together more by technical and spatial aspects of the camera's point of view than by any narrative source, a combination of the prosaic and the poetic. One is a darkened room lined with striped fabric literally flowing from the walls and populated by two mostly immobile puppets, one reclining and one sitting. The white classicism of the two other flanking spaces, a playground for puppets, balls, and metal forms, is invaded by animated, stark calligraphic lines that, transmogrifying in form between ink, wool thread, and

curved wire springs, climb walls and traverse floors. It is exactly in these fugue-like existential events of nothingness that the "action" of the objects—like a fugue's "voices,"—of the Quays' elliptic narrative takes place. There are other spaces, small theaters populated by strange puppets and objects. One of these, modeled on an anonymous specimen to which the film is dedicated (along with the London Underground),[1] has a pitted and rough deformed head perched on a tangle of metal wire. Its single malicious eye is fixed in a slightly deranged stare and has a lone long, coarse black hair protruding out of a soft, spongy mole on its forehead (see Figure 14). Fascinating and repelling to see, in repeated close-ups a stick prods the mole in a circular motion. The sense of discomfort and revulsion this isolated gesture evokes is part of the fascination: simultaneously drawn to the neurotic repetition and relieved that it takes place on-screen but not on one's own body, we are freed to gaze voyeuristically at this iris shot of the puppet's obsessive behavior.

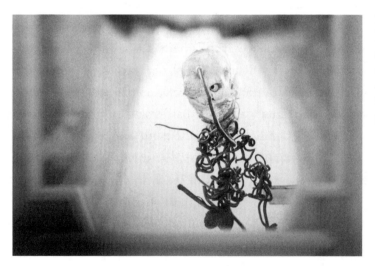

Figure 14.
Homunculus from
*Rehearsals for Extinct
Anatomies* (1987).
Another of the Quays'
noncompossible
puppets.

Montage sequences provide clues to these almost unbearable, yet fascinating macro lens close-ups. Extreme focus pulls are made in almost every scene, creating the effect of landscapes revealed when traveling through fog, sometimes to the extent that forms become gray and pale, blurred abstract forms without outline. The two humanlike puppets, strangely familiar in stature and gesture from earlier films, wait for—what? Perhaps for an illness to run its course, perhaps not. The oppressive atmosphere is momentarily relieved with an existential Beckettian humoresque: the sitting puppet scratches his head in the same gesture as the one-eyed wire homunculus. Atkinson captures the film's mood:

But nowhere is the tension between psychological translation of any stripe and the Quays' ferocious hermeticism more tangible than in *Rehearsals for Extinct Anatomies,* their starkest and most oblique film, free as it is of any (discernible) relationship with outside source material—a surprising move, coming on the heels of the attention-getting *Crocodiles.*[2]

The Quays' experiments with new stylistic elements—high key lighting, blurred animated balls swinging at dizzying frequency, expressionistic décor, and meandering musical scores that occasionally lapse into silence—also enhance the set design. Some of these already familiar elements will reappear in future films.

Rehearsals for Extinct Anatomies is the Quay Brothers' most cinematically self-reflexive film, in which even the camera is subjected to experiments. In one shot we see one of the Quays moving around in accelerated motion in the background, revealing their "tricks" like playful magicians: adjusting the set and, at one point, hitting a ball attached to a string to set it swinging on a blurred arc and then holding it still. In some sequences, the camera is sent on restless, geometrically organized horizontal, perpendicular, and planar tracks and pans that continually change the sets' perspective and spatial relations. In one scene, its point of view is step-arced in the same way as the ball. Using bright lights and a long exposure gave this effect a luminous, blurred quality, and this technique became prominent in the future pop promos and in *In Absentia.* Underlying the entire film is a music track from Leszek Jankowski, also mysterious and hermetic, embellished by whispered monologues that hint at seduction or the disparate and unconnected elliptical experience of solitude, like a one-sided phone conversation.[3]

The Quays' interest in dance that was to eventually emerge in the live-action dance films was first architecturally translated into stage design for a ballet a year after *Rehearsals* was finished. Their first ballet collaboration was with choreographer Kim Brandstrup, who was to become a longtime collaborator on the Quays' later film projects; in turn, they contributed to his dance productions. Brandstrup studied film at the University of Copenhagen and thereafter choreography at the London Contemporary Dance School. His knowledge of cinema and his concern with narrative are two reasons that his affiliation with the Quays has proven so fruitful. *Dybbuk,* directed and choreographed by Brandstrup, premiered in 1988 at The Place in London, one of three performances for the London Contemporary Dance Theatre's "New Worx" dance program. In his 1990 review of a

later performance, Clement Crisp's remarks on the performance and stage design reveal the complementary nature of the collaboration, both in terms of Eastern European set motifs and Brandstrup's choreographic style, which bears comparison with the Quays' puppet performances:

> In a brilliant UFA-style set of a grotesquely leaning interior (The Drawing Room of Dr Caligari) by the Brothers Quay, to an accompaniment of Romanian folk-music, we see the heroine, Leah, prepared by her family for an arranged marriage. . . . Through the most direct means, with repetitions of movement, mimetic austerities, Brandstrup builds up tension to the final moment when Channon finally possesses Leah.[4]

The work with performers and human-scale set design on the projects gave the Quays an advantageous opportunity to engage with builders, carpenters, costume designers, and actors, which proved a valuable experience. The technical and architectural skills required for small-scale set design translated well to larger dimensions.

The engagement with performance intensified to include other genres, and the next was to be opera. The Quays were commissioned for stage design for *The Love for Three Oranges* (Sergei Prokofiev), directed by enfant terrible Richard Jones, and it premiered a year after *Dybbuk* at Opera North Leeds in 1988 (see Plate 15).[5] The Quays developed a deeper working relationship with Jones and created stage design for *A Flea in Her Ear* (Georges Feydeau) in 1989. The third engagement with Jones was designing sets for *Le Bourgeois Gentilhomme* (Molière) that was performed at the London Royal National Theatre in 1992 (see Plate 15). In his review for *City Limits,* Ian Shuttleworth described the set as "a great monochrome etching of a set (complete with 20-legged virginals) [that] draws applause but is soon revealed as a baroque folly which strands even the large *Comédie* performance style in a breathtakingly pretty canyon."[6]

In the 1990s the Quays' work in film began a reorientation toward their immersion in developing the feature-film project and to their increasing involvement in dance, opera, and theater. The Quays:

> Though the puppet films hadn't prepared us for the social aspect
> of ensemble work, we'd worked in theater and opera before . . .
> so we knew the value of collaboration, and we realized that we'd

have to stop mumblng between ourselves and make ourselves intelligible to our team.[7]

They had started to work on a feature-film project, and *The Comb [From the Museums of Sleep]* (1990), their next completed film, was a short that developed initial imagery and narrative structure for the feature. In the previous films there were five female puppet figures in total, four in *Street of Crocodiles* (three Tailor's Assistants and a torso in the Hall of Glass), and one in *Rehearsals*. *The Comb* is the first film that features a live-action female protagonist (Joy Constantinides, who was one of the dancers in Brandstrup's *Dybbuk*). It may be pertinent that the Quays had an interest in dance companies with female performers or choreographers (Pina Bausch, in particular) in contrast to theater and to the literary sources they had been drawing on in the past, in which the majority of figures are male. In the film, the actor/dancer's movements are shot both in live action and single frame, especially the close-ups and small gestures of a hand, a closed eye, a twitching finger, a thumbnail running along the teeth of a comb: some of the visual tropes here reappear later in the gestures, character, sensuality, and framing of Lisa Benjamenta. The dancer's performance is restricted to subtle choreographies of restless movements during fitful sleep that emphasize the textures of fabric and skin.

Figure 15. Dancer Joy Constantinides in a black-and-white sequence from *The Comb* (1990). Note the play of soft spots of light in the room that bear comparison with the later *In Absentia* (see Figure 12).

The Comb was loosely inspired by Robert Walser's writings and the anti–fairy tale "Snowwhite" ("Schneewittchen," 1901) and other texts that revisit fairy tales, notably the Snow White genre. With its ethereal mood and emotional underpinning, Jankowski's score highlights the Quays' visual interpretation of Walser's musical tropes. Careful crosscutting between these shots suggests a harrowing journey of dream-ridden sleep, an oneironautic relation between the sleeper and the puppet (see Figure 15). The erratic movement of the sleeping woman's finger is repeated by a puppet's overlong middle finger, and her shifts, sighs, and twitches trigger actions in the animated realm. The combination of live action and animation is at its starkest so far here. The film's development of linked, yet stylistically distinct worlds uses a familiar method: black-and-white live-action sequences and color animated dreamscape sequences that interpunctuate the film and create a mélange of ladders, anamorphic landscapes, and painted backgrounds (see Plate 15). These are seamlessly constructed into a credible yet impossible arrangement: the Quays' dialectics of spatial connectedness and disconnectedness. Their consistent use of focus pull in *The Comb* underpins their particular concept of spatial incoherence that was discussed in chapter 5. A moving focal plane used in point-of-view shots assists the spatial transitions between dreamer and dreamworld. At the end of the film, she awakens, picks up a comb, runs it through her hair, and then runs her thumbnail along its tines. The color sequences change to black-and-white and the objects become still, as if her waking immobilizes the realm. In the last shot, in big close-up, her mouth speaks the words, "I love the forest."

Following on thematically from *Nocturna Artificialia* and *Street of Crocodiles, The Comb* deals with levels of consciousness in which visual and temporal shifts are bracketed and further developed by nuances in the musical score and sound track. Composed by Leszek Jankowski, the music was completed before the images, and its fitful, erratic horns, strings, and resident noises and voices complete the undercurrent tensions of the images and actions, as do a set of spoken, sometimes shouted *Sprechgesang* (German for "spoken song," a technique that mixes singing and speaking). The Quays were in Poland, accompanying a traveling program of films, and Jankowski gave them a tape that was to become the music for *The Comb*. The Quays: "*Crocodiles* was prose, it has a very literary feel, almost novelistic, but . . . *Rehearsals* was very [much] like writing poetry, and doing *The Comb* was trying to court both these worlds."[8] This was to be the last short animation film commission from Channel Four for the Quay Brothers until 2000. Funding priorities shifted and there was less room for

experimentation, and the renaissance of auteur animation film that this channel had so marvelously initiated at the beginning of the decade came to an end for many independent British filmmakers.

Opera and Artificial Perspectives

The year 1991 was one of involvement in new media and production genres while the Quays continued to prepare the feature-film script: three BBC station graphic interludes, an arts documentary on the painting technique of anamorphosis, and continuation of their work in opera with Richard Jones. His *Mazeppa* (Peter Tchaikovsky) premiered in 1991 at the Bregenzer Festspiele Theatre Festival, Bregenz. *Mazeppa* was an extremely colorful set on a slight upward angle toward the back of the stage from the front of the proscenium (see Plate 15). The walls were also at an angle leaning into the stage, embellished with strong diagonal black-and-white graphics and wooden windows protruding from them; a version of this design resurfaces in the entry to Lisa Benjamenta's crypt. The stage integrated large-scale replicas of trams and was littered with long, angular pieces of wood propping each other up, and the wires and cable from the tram formed a disorienting tangle above the stage. A motif in many of the puppet animation films *(Nocturna Artificialia, Igor: The Paris Years Chez Pleyel,* and *The Cabinet of Jan Švankmajer)*, trams continue to be prominent in the Quays' work. Mexican artist Frida Kahlo was injured in a streetcar accident, and in Julie Taymor's film *Frida* (2002), the Quays' animated sequence (which the Quays call "Day of the Dead") is inserted at this point in the film (it is interesting to note that Taymor has a background as a puppeteer), and for the first feature the Quays said of *Institute Benjamenta* that it "seems to be positioned in a city traversed by trams."[9]

The experience the Quays gained making the artists' biographies over the years filters through in their next film. *De Artificiali Perspectiva, or Anamorphosis* (1991) is akin to a biography of a painterly technique of illusion predominant in the sixteenth century. The project was a joint venture of the Metropolitan Museum of Art and the J. Paul Getty Trust Program for Art on Film, produced by Koninck Studios. Again, the Quays' studio provides some clues: it is filled with bookshelves weighted by antiquaria and paperbacks, from early optical studies and cabalistic science to Della Porta's *Magiae Naturalis. Anamorphosis* is a film-historical documentary on the eponymous technique of subverting vision. Despite its documentary nature, because of the aesthetic complexity of this technique, the Quays' visual style has a great affinity to the subject. Illusion

and subversion of perception is a central element in their works, and although the film concentrates on this particular painting technique, it illuminates the development of later precursors to cinematic techniques of illusion. The experiments in optics that were popularized by the development and marketing of Victorian optical toys and parlor objects is paralleled in the film by its description of how the people commissioning the paintings used them in social settings to impress their friends. Using a selection of artworks from the sixteenth and seventeenth centuries (including a chair by Jean François Niceron [ca. 1638], two woodcuts by Erhard Schön [ca. 1535], and one of the best-known examples of the technique, the painting *The Ambassadors* [1533], by Hans Holbein the Younger), the film demonstrates and interprets these illusory techniques.[10] In this informative and playful documentary, the Quays' talents as illustrators and calligraphers were given free rein in the titles and set design. Besides incorporating images trawled from the history of this technique of painting, the Quays designed some of their own anamorphic images and objects that were used in the film (Niceron's chair), and, as with many of their films, were assisted by Ian Nicholas in building the sets and objects. The film was a trying ground for the technique's use in the set design that figures prominently in *Institute Benjamenta*. One of the scenes in *Anamorphosis* resurfaces almost identically in the feature: a long corridor, with a door on the right-hand side, is decorated with an anamorphic painting of rutting deer.

The Quays directed the film and worked closely with art historian Roger Cardinal on the script (their shared interest in Art Brut, or Outsider Art, was also to find implementation in later films), and he is credited as a presenter of the film in the credits with the Quay Brothers: "[Cardinal] had a brilliant sense of economy to allow the images to breathe. We told him about the images we were aiming for, and he had a sense of where to position the text, where the images fell."[11] The film uses now familiar stylistic tactics: monochrome and color realms, fast-pan shifts, a choreographed camera, chiaroscuro lighting, focus pull, and macro lenses. Rather than the lateral hierarchy of sound, music, image, movement, and lighting prevalent in most of the shorts, *Anamorphosis* is a rare film in the Quays' body of work because of the narrative continuity and aural dominance of a descriptive voice-over. Jankowski's score is almost completely composed of harmonious and commentative harps, acoustic guitar plucks and strums, with minimal digression from its function to accompany and underpin the imagery. It does become edgier, uncontrolled, in the uncommented, voice-free graphic and other interludes.

The didactic elements are separated by graphic intertitles and often introduced by views through a peephole or velvet and gild proscenium stage curtains rising. In a brightly lit space, a gathering of flat paper-and-ink puppets perform demonstrations of the properties and laws of anamorphosis (see Plate 15). Our guide in the film is an anthropomorphic, noncompossible puppet composed of doll parts and multiple thick framed window and camera frames on its arms, chest, and face—as much a machine as the apparatus that it serves and uses in its quest to understand the technique's principles. Its luminous glass eyes lead our gaze into the apertures and openings onto the works of art: paintings, drawings, woodcuts, and objects. Sir Ernst Gombrich acted as an art consultant, and both he and Cardinal were members of an academic board set up by the Getty Trust. The participation of these illustrious art historians ensured that the film would be received beyond the animation critics' community. A synopsis from the Art Film Web site is unusual in that there is no mention of the Quays' style; it foregrounds the subject:

> Animation techniques elucidate the illusional art of anamorphosis, a
> method of visual distortion whereby an image is presented in con-
> fused and distorted form. When looked at from a different angle or in
> a curved mirror, the distorted image appears in normal proportions.
> Using a puppet as master of ceremonies, the animators demonstrate
> the basic effects of anamorphosis and reveal the hidden meanings
> that lurk within. During the sixteenth and seventeenth centuries, the
> practice of creating anamorphic images was an outgrowth of artists'
> experiments with rendering perspective.[12]

Besides festival screenings, *Anamorphosis* was shown on art channels and remains listed in art-course curricula.[13] It is categorized in the Art on Screen Database as a visual essay and suggested for use at university level.

Atelier Koninck QBFZ: *Stille Nächte* and Commercial Interludes

Alongside their interests in opera, dance, and ballet, new types of commissions allowed the Quays to exploit some of their stylistic experiments in the realm of commercial television. Since its inauguration in the early 1980s, the music station MTV made a major contribution to increasing independent animation literacy through exposure to millions of receptive viewers. In the meantime, spin-off

music broadcasters have become a familiar mainstay of the fifteen-to-thirty age bracket of viewers, but when it first began broadcasting, MTV was a phenomenon that dramatically changed the way people watched animation. The main impetus came from MTV Europe's recruitment of Peter Dougherty as creative director (1990–2001), whose interest in animation was instrumental in giving many independent animators around the world access to a wide and young animation-receptive audience. Dougherty sought contact with independents, giving them commissions to help create an attractive identity for his channel. The Quays' work with Dougherty and MTV gave them access to a TV-broadcasting audience that was interested in animation in its many forms. By commissioning relatively underexposed but highly talented animation filmmakers—the likes of Jerzy Kucia, Susan Young, Phil Mulloy, and Run Wrake—MTV became a platform for new as well as established animation artists who no longer had access to the relative financial comfort and artistic freedom of Channel Four funding.

Besides incorporating vast quantities of animation in its corporate identity, MTV realized that the combination of animation and music allows a completely different form of musical interpretation than do taped concerts and live appearances. MTV created new identities for musicians, and part of this identity was to use highly innovative music video as a marketing and publicity vehicle. The Quays collaborated on one of the most groundbreaking early animated pop promos: Peter Gabriel's *Sledgehammer* (1987), directed by Stephen R. Johnson.[14] The producers brought together a group of young and promising animators to work on the project and had the prescience to make a documentary of the process. Gabriel has a preference for animation, and later a compilation video was released that included his music videos, documentaries, and interviews. But *Sledgehammer* remains the most un-Quay-ish work to date, and, collaborating with a host of other filmmakers on different segments, they had little freedom to express their own ideas beyond an Arcimboldo-esque sequence with fruit. The next music-related commission gave them more artistic license.

The Quays began to actively engage with conceptual plans for a live-action feature film (both features will be discussed in chapter 8). This was the period when they began making the *Stille Nacht* shorts, a series of short films (five at the time of writing). The first in the ongoing series, *Stille Nacht I (Dramolet)* (1988) is an eighty-second black-and-white MTV art break distinct from the other high-energy shorts commissioned for this series. In the film, a puppet sits straight-backed in front of a table at a wall, a small bowl in front of it. Bent spoons work their way through the wall around it, and what looks like soft

metallic fur begins to move and pulsate in a circular motion. (How they created this effect remains a professional secret.) The camera grazes over these surfaces, lingering on textures and creating vignettes of strange objects and movements. The Quays' inventive technique creates an extremely soft haptic feel: the "fur," bits of fine metal, travels into the bowl, eliciting a nod to Meret Oppenheim's fur-lined teacup. The set of *Stille Nacht 1* was reinstated for the *Dormitorium* exhibition; Plate 9 shows the glistening textures and also the materials' colors not seen in the black-and-white film. The next short commission was *Ex-Voto,* made in 1989, with music composed by Jankowski (see Plate 15). It used devotional icons and eerie landscapes to communicate environmentalism, in keeping with MTV's "Free Your Mind" series of themed station breaks. The Quays' visual style also attracted other stations and organizations to commission station interludes. The British Film Institute commissioned a cinematic logo that appeared on a number of films as a film leader for current productions and as a means to identify the BFI before the film began. It even appears on some of the Quays' own films. The BBC commissioned the Quays to do three short station breaks for the channel: *The Calligrapher, Parts I, II, III,* 1991, a total of one minute, but they were never broadcast (see Plate 15).

The Quays' growing presence in a wider reception area generated commissions from music groups for music videos. *Stille Nacht II: Are We Still Married?* (1992) is a music video commissioned by 4AD for the band His Name Is Alive. The band had originally wanted to use excerpts from existing films.[15] Shot in black-and-white, the film uses motifs from Lewis Carroll's *Alice's Adventures in Wonderland* and is the tale of a rabbit, a little girl, and a Ping-Pong ball.[16] The experiments they had made with lighting and animating the Ping-Pong ball would also inform the lighting effects in *Institute Benjamenta* and *In Absentia.* The film commences with a shot that is based on the simple optical phenomenon of a thaumatrope, a heart-shaped flat form with eyes on one side and a regalia-type icon on the other, which is later held in the main puppet's hand. An animated, blurred white ball rotates around this object and then flies itchily through the shots, while its vibrations set the main figure, an Alice-like doll, in motion. The doll is positioned in front of a wall with many windows; her ankles extend, in a rhythm of breathing, and the object in her hand is used as a bat for what seems to be the film's main actions: a metaphysical Ping-Pong game, played by her, the rabbit, and other objects in the space. Watching this film frame by frame, it is important to note that the Ping-Pong ball is mostly a blurred arc, and successive frames show it in many different places in the frame: in screening, this dispar-

Figure 16. Still from *Stille Nacht II: Are We Still Married?* (1992). The white blur in the right of the frame results from movement of the ball swinging on an arc during the pixilation speed's longer exposure.

ity of placement merges to the blurring, coherent movement (see Figure 16). Iris shots, extreme close-ups, and focus pulls—familiar from earlier film—are joined by multiple exposures that multiply the rabbit as, defying gravity, it stands on the wall. The set of exterior walls with windows and a figure with its legs swinging is also repeated in *In Absentia*. In 1993, the Quays accepted an unusual commission: a music video for Michael Penn. The music for Penn's *Long Way Down (Look What the Cat Drug In)* is one of the first of their increasing dramatic explorations of color and dynamic tensions (see Plate 15). The same year they were commissioned again by 4AD for a second pop promo for His Name Is Alive. *Stille Nacht IV: Can't Go Wrong without You* (1994) reworks some of the imagery from the past promo *(Stille Nacht II)* they did for the band.

One of the *Stille Nacht* films, however, had a different purpose. Walser's writing had inspired *The Comb,* and his novella *The Institute Benjamenta* (published in German as *Jakob von Gunten* in 1909) was the literary stimulus for the feature. The Quays were busy creating imagery for the film's somber fairy-tale mood to visualize the animistic soul of Institute Benjamenta described by Walser. In 1993 they made (and funded) a short film, a preamble for the feature: titled *Stille Nacht III: Tales from the Vienna Woods [Ich bin im Tod erblüht],* it was used to pitch the feature to potential funders. It is one of the first films that integrates Bavarian ornaments and sylvan settings and features a bullet projectile passing through branches in a stylized forest, hitting pinecones and navigating tree trunks before coming to rest in an interior with a long table with stylized antler legs. They described these objects in an interview with Rust Gray:

The anamorphic table with the antlers and multiple legs is one of those "bachelor machines" you imagine exist in some fictional museum. At night, these objects repeatedly dream [and] replay their former circumstances for having arrived here in this museum. . . . They are only alive at night remorselessly tied to a single dream— it's a permanent death that they rehearse over and over again.[17]

The film ends (or begins again) when a hand appears and picks up the bullet. We hear the sound of shooting and the bullet repeats its course, setting off into the woods again. The themes and motifs the Quays suggest earlier are integrated in the feature. After Koninck secured funding, the short was segmented into animated sequences and some were inserted in the feature film.

The Quays' own filmography lists these films first as *Stille Nacht* (engl. Silent Night) films, followed by the song title. This is indicative of their intentions of these works being part of a larger aesthetic and stylistic concept. In a letter to Michel Atkinson in 1994, they reply to his inquiry on the *Stille Nacht* pieces:

They're all linked by the common thread of Black & White and the belief in oblique salesmanship. *Stille Nacht I* was selling steel wool. *Stille Nacht II* was selling ping pong balls or socks with one vocation in life. *Stille Nacht III* was trying to sell pre-anamorphosised reindeer dining tables with a bullet already fixed in one testicle (which even more accurately & obliquely explains the deformed antlers) (documentary hyperbole). Of course none of all this is really apparent, but it gives us the sublime belief that no one is ever looking. And it's the premise we're most comfortable in starting from.[18]

Figure 17. Brothers Barnaby and Jonathan Stone (Ralf Ralf) in the Quays' performance video *The Summit* (1995). Copyright and courtesy of the Quay Brothers.

None of these are directly selling anything; they are either station breaks or music videos in which they have full artistic control *(Stille Nacht I, II,* and *IV).* But in their remarks the Quays are aware of the unavoidable commercialism inherent in commissioned film, of the ravenous machine that needs its pound of consumer-trimmed flesh. Yet the music-driven quality of these shorts resulted in fruitful explorations and certain freedoms

that had consequences for their later independent films. Costa regards the Quays' work on pop promos as "the first drafts, notebooks, sketches for atmospheres that the animators will develop (or dump) in subsequent projects."[19]

In 1995, after completing *Institute Benjamenta,* they also made *The Summit,* a twelve-and-a-half-minute video "pilot." It was based on a seventy-minute improvisational theater performance of spoken and sung nonsense and other languages by Ralf Ralf (Barnaby and Jonathan Stone). Jonathan Stone had acted as one of the students (Hebling) in *Institute Benjamenta.* Set mainly in a wood-paneled boardroom with a table, the unreleased film convincingly captured the performers' nuanced movements and humor (see Figure 17). In 1996, a busy year for the Quays' décors design, they created scenography for a ballet Brandstrup based on Peter Handke's *The Hour We Knew Nothing of Each Other* that premiered at the Malmö Dramatiska Theatre, Sweden; and director Jonathan Miller, who had seen *Street of Crocodiles,* also requested a set design like the film's glass room sequence for his production of William Shakespeare's *A Midsummer Night's Dream.* Staged at London's Almeida Theatre in 1996, the play was set by Miller in the 1930s, and the coloring and lighting of the stage design were similar to the chiaroscuro and brown and ochre coloring of *Street of Crocodiles.* Critic Geoffrey O'Brien:

> Here was the driest possible reimagining of a play capable of being smothered in ornate fancies: a Dream without fairies or fairy bowers, without even a hint of woodland magic or, indeed, of woodland. In place of palatial pomp and natural wonderland, there is an unchanging set (designed by the animation specialists the Quay Brothers) consisting of rows of receding glass fronts, like an abandoned arcade, and permitting endless variations on the entrances and exits in which the play abounds.[20]

The hide-and-seek theme was well served by the set, and its arcadelike design was similar to the Hall of Mirrors in *Street of Crocodiles.* Actors moved through doors, were visible through rows of dusty perpendicular glass sheets that were set at varying intervals on the depth of the stage or, otherwise out of sight, were seen by reflections off mirrors strategically placed in the set. The stage design worked remarkably well for this frolicking Shakespeare comedy that is part whimsical, part myth and fairy tale, and set in an oneironautic world of supernatural, almost metaphysical settings. Word about the Quays' unusual set and stage design

circulated, and they were approached by Simon McBurney (cofounder of
the Complicité theater group when it began in 1983). Directed by McBurney,
Ionesco's *The Chairs* premiered at the Bath Theatre Royal in 1997, forty years
after its English premiere at London's Royal Court. McBurney's working methods
to approach the absurd qualities of the play reveal qualities similar to the Quays'
attempts at transforming literary inspirations into visual imagery. McBurney:
"Out of the absurd mire of Ionesco's language we had to painstakingly unearth a
sober sense before we could then let ourselves loose on the ridiculous, and trans-
form it once more. We had to find a common language with Ionesco, which could
be transformed into theatre."[21] The play toured England and went to New York in
1998, where the Quays won the Drama Desk Award for best design. It comes as
no surprise that McBurney's Complicité staged *The Street of Crocodiles,* a produc-
tion based on Bruno Schulz's stories that began as a workshop for the company
and evolved into a coproduction with the National Theatre in London.

The Quays continued making pop promos and created *Black Soul
Choir* for the group 16 Horsepower in 1996. In black-and-white, moving between
a stage set and animated realms, it featured a choreographed piece of chalk leav-
ing its trails on a blackboard familiar from *Institute Benjamenta* (completed the
year before). Instead of animating the entire film, shots of the band playing were
interspersed with animated vignettes, and the band played in front of background
projections of small chalk pyramids. The white chalk is later joined by a piece of
black, and the flowing forms that these two cavorting monochromatic objects cre-
ate develop into a wide range of grays, bearing affinities with Walter Ruttmann's
flowing forms in *Lichtspiel Opus 1* (1921). Clouds of chalk dust that rise from the
stage set echo the glowing chalk dust of the games played by *Institute Benjamenta*'s
students in the corridors. The film's events do not in any way follow the music's
rhythms; they are independent. Their most recent commission was for Sparkle-
horse: *Dog Door/Stille Nacht V* (2001) reuses some of the imagery from *Stille Nacht
III;* the anamorphic room, the table, and lighting and color are similar. The film
features a voyeuristic fox/dog and a shiny doll spread-eagled on a table covered
only at her groin by frothy lace: rich colors bleed into the prevailing blackness,
and the camera effects—jagged multiple exposures and close-ups of throbbing,
soft folds of fabric—insinuate a morbid eroticism. In the last minute of the film,
the hard-edged music and voice of Tom Waits subside to gentler music, and the
intertitle "On n'est jamais trop Jeune pour être Débauché(e)" precedes lingering
shots of fabric folds and crescending glass ampoules. The Rotterdam Film Festival
online archive contains the following synopsis:

Originally a music video for a song by Sparklehorse, and at the same time a perverted variation on fairytales like those of Fontaine, a childlike and innocent homage to the painting "Origine du monde" by Gustave Courbet and a funny satire on the fashionable music video. A puppet show filled with unashamed eroticism and rebellious repetition.[22]

The Quays' pop promos inspired homages from other artists in the music industry. Their films were emulated by pop video directors, most notoriously in Fred Stuhr's *Sober* (1993) for the band Tool. But MTV wasn't the only option available to them to reach wider audiences.

As is true with other successful animators, numerous commercials punctuate the filmography of the Quay Brothers. Because of its ability to compress ideas and create visual puns, animation has always held a special attraction for advertising. Besides providing a substantial income, commercials are also the playing ground for trying out new ideas or generating commercial profit from imagery originally created for independent shorts. The Quays had started making commercials produced by Griffiths and Koninck Studios and soon realized that, since the commercials were commissioned and increasingly produced by a company delegate, it was time to adapt accordingly. Griffiths continued to run Koninck Studios and in 1988 the Quays formed a new company, Atelier Koninck QBFZ, and commercials were made with a freelance producer (see logo on Plate 15). The commissions came in partly as a result of Griffith's promotion of the films. Critics, film commissioners, and advertising professionals tend to gather in the bars, screening houses, and pubs around Wardour Street in London's Soho, the heart of the filmmaking industry in the UK, and they were recommended initially by word of mouth. Things picked up very quickly for the Quays, and they could afford to be selective:

Commercials just fly in out of nowhere, and if you are free and it is interesting, you do it. We turned down some because they were ridiculous, you couldn't do anything with them—or if we were doing another project. But usually they are pretty interesting. [Clients] invariably know our work, so there isn't really any competition. And usually they've written it for us and then if we are given free hand, we go for it.[23]

The unique signature style they had developed over the years began to be lucrative in commercials' marketing strategies, which also gained them access to a wider public, albeit in the form of promoting a product. In contrast to the music videos, Costa regards the Quays' commercials as "the least exciting aspect of their work" and proposes that in the world of advertising "the Quays serve as extravagant artisans, not artists."[24] But the commercials included spoken dialogue that allowed them to express their fine and nuanced sense of humor and irony, from the dead-pan Westernesque pathos of a pesticide-doused dying weed to parody and slapstick, and the opportunity to direct actors in a number of live-action scenarios. They made animated commercials for Nikon (see Figure 18), Pitney Works, Coca-Cola, BBC2, Slurpee, Honeywell Computers, ICI Woodcare, Roundup Weed Killer (three), and three for Northern Rock (shot mainly in live action in breezy Victorian interiors with a woman or a clock familiar from *Institute Benjamenta*). Some commercials were made available on the Believe Media and Academy films company Web sites.[25] A selection of them is briefly described here as representative indicators of the kind of commercial work they were engaging in.

Figure 18. One of the Quays' first commercials made for Nikon cameras that introduces a new pocket-size camera at a drinks party for older models.

ICI Woodcare initiated a campaign for Dulux Wood Protection, and the Quays made a short commercial that used materials, surfaces, and colors all suggestive of the qualities of wood. Shot in color but treated to have a brown, yellow, and beige effect, the film has a color scheme reminiscent of some of their earlier films. The puppets and sets are constructed entirely of pieces of wood and have an angular quality. The film becomes what looks like a billboard and the

commercial is appended by a live-action shot of a dog (Dulux's mascot in most of their commercials) that approaches the billboard and sits in front it. The Walkers Skips crisps commercial is probably the least Quay-ish of the animated commercials. In a living room that makes style references to a 1950s domestic setting, two puppets are watching TV and eating crisps (potato chips). The commercial has some faint similarities with the artists' documentary shorts in terms of the colors and the bright lighting and also in the angular design of the walls and objects, but otherwise there is very little in the film's style that suggests it was made by the Quay Brothers.

The Quays had more opportunities to work in live action when they made a commercial for Doritos. Shot in a cinema, it features a young boy sitting in the front row of a raised balcony, a woman who arrives in the cinema late, a projectionist visible through the window of the projection booth, a couple watching the film, and an usherette. There is no animation in the film. The Murphy's Instant Stout commercial "Warriors" was both an homage to and a parody of Akira Kurosawa's 1954 *The Seven Samurai* (the Quays are longtime admirers of Kurosawa) and shot in live action on black-and-white film stock. It begins with an extreme long shot in the outdoors. A group of samurai come running over the Irish countryside. Tension rises and ultimately they arrive at a local pub, satisfying their thirst with deep swigs of Murphy's stout. The French mineral water company Badoit also commissioned two commercials. In the first, the narrative basis seems to be Aesop's fable of "The Fox and the Crow." The two animals, quite realistic in their puppet design, converse in French. Set in a naturalistic picnic setting, the crow is perched in a tree made of the spiky blooms of Scottish thistles and the fox sits on the ground. The film is brightly lit and the only stylistic hint that this is a Quay Brothers' film is that the armatures of the fox are exposed. The second commercial is similar to the first, only this time a zebra introduces a mangy lion to the pleasures of Badoit mineral water. The setting is a dry, savannahlike open space. Again, there are few indications that the film carries any trademark of the Quays' signature style. The only element that could be suggested is the moment when the zebra begins painting stripes on the lion's belly in a beautiful pattern that is a reminder of the Quays' illustration talents.

By now the Quays' studio equipment was enhanced with a new technology: the blue glow of computer screens, digital cameras, and state-of-the-art equipment joined the 16 mm Bolex and other analog apparatus that were used to make the first films. The digital technical equipment in the back section of the studio provides a sharp visual contrast with the *Wunderkammer* atmosphere. The

Quays began to utilize the practicalities and innovation of digital cameras and computer programs in commercials. The new technologies were also exploited to create many of the visual spaces in their first feature film. They describe one of these, used in a commercial for Kellogg's Rice Krispies Treats called "Float":

> It was the first time we really started post production using plates. We'd have a locked-off camera. There was a sliding board that went on to a raft; we shot that separately. Then you'd make the next scene, subcamera there, the little girl doing something in the water. Then you'd have five plates and put them together in postproduction.[26]

The Quays also did an AIDS public service announcement for the Partnership for a Drug-Free America to be broadcast on MTV America, with music composed by Jankowski.[27] It was produced in 1996 by the National Institute on Drug Abuse and the Advertising Council as part of the "Get High, Get Stupid, Get AIDS" national media campaign in the United States. The brightly colored film has three sections and uses rapid, hard cuts: "Get high" shows puppets at a table littered with drug paraphernalia and condoms. "Get stupid" suggests an intoxicated state of mind. "Get AIDS" shows a bed with two puppets on it. The iron fur from *Stille Nacht I* also resurfaces in the film's third segment, "growing" in the corner of a doorway and virally swarming over the two puppets in bed that, it seems the film suggest, didn't use a condom. The Quays were given a scenario, but after the film was completed, the MTV board wouldn't agree to show the film because for American standards (and prudery) it was too explicit in its sexuality. The Quays had adhered to the scenario provided: "The original storyboard was passed, and they knew there was a condom in it. But 'not on prime-time TV'! The Finns do some fantastic [AIDS commercials]. Ours was conservative and it still didn't get on American prime-time TV."[28] To date, the film has not been aired. To promote the National Hockey League broadcasts for the Fox Sports television channel, the Quays made two commercials: "Library" and "Laundromat." Both mark a playful return to an earlier style of mise-en-scène, and "insecticity" is evident in the characters: the puppets appear to be made of stag beetle parts on armatures, dressed in hockey clothes. However, they had some difficulties with the final result:

> We hooked them with the idea on the telephone on an initial conference call. It was like pulling teeth, and we said, almost as a joke, we could do it for insects. It was fun to animate, it looked interesting,

and the live action was nice, but they messed with the editing. We walked out of the editing room. They took it over.[29]

Despite occasional run-ins, on the whole the combination of reputation, resourcefulness, humor, and innovation allowed the Quays to access and experiment with expensive equipment and postproduction processing methods. After the interregnum between their golden years of UK public funding and their last commissioned experimental narrative—*The Comb* in 1990—the Quays, like many independent animators, were not averse to the substantial financial rewards for commercials and exploited the commissions as trying grounds for their development as filmmakers.

The Dance Films

The distinct choreography of objects and spaces is one of the most striking formal features in the Quays' puppet animation films: the Tailor's Assistants in *Street of Crocodiles,* the impetuous, intertwining lines in *Rehearsals,* the lithe fork tines in *Institute Benjamenta.* The strong penchant for dance precedes the choreographed live-action films by at least a decade. No doubt the Quays' experience on opera and ballet productions influenced their later work with actors and refined their abilities to work with dancers, evident from the emphasis on choreography in *Institute Benjamenta.* The Quays: "Puppet animation is much closer to dance and music, which are our biggest sources of inspiration."[30] When they were working on *This Unnameable Little Broom,* they went to see a performance by Pina Bausch's Tanztheater Wupperthal ensemble. Griffiths:

> I'm pretty sure at about that time was our first encounter with seeing Pina Bausch, her first ever visit to England with her company, where the twins and I saw all of it at Sadlers Wells. We were pretty influenced by what she was doing at that time—the influence she had is still phenomenally present in the work.[31]

The Quays are great admirers of Bausch, who "uses the most extraordinary range of music [we] have ever heard."[32] The twins' attraction to the emotional and aesthetic qualities of dance and choreography, which they had convincingly transmuted into the grace and timing of their puppets' gestures, was given opportunity to mature in the form of two live-action dance films. In 1999, Channel Four

commissioned a series of dance films called "Dance for the Camera" that united choreographers with filmmakers. *Duet: Variations on the Convalescence of "A"* (1999) is an eighteen-minute-long film directed by the Quays in collaboration with choreographer William Tuckett, Kandis Cook (décors), cameraman Nik Knowland, among others. It was produced by Gordon Baskerville through Landseer Film and Television Production for Channel Four. This work is cardinal to the Quays' continuing development as filmmakers and in their work with actors, as it introduced an intimacy and dialogue between set, dancer, and music that had not been available in the large opera productions or the dialogue-driven plays. *Duet* takes place in a breezy studio space that is spatially organized by long, semitransparent fabric hangings, a small cupboarded table, and two chairs. The dancers explore their developing relationship and their movements and gestures are lyrical and occasionally humorous, beautifully and sensitively supported and guided by three musical movements from Arvo Pärt. The first movement of the film ballet is monochrome and commences with music; long, gossamer embroidered curtains, a chair, and table are lingered over by the camera as much as the dancers (Adam Cooper and Zenaida Yanowsky, both of the English Royal Ballet), who enter the set and walk slowly and thoughtfully through the space. They meet and a playful courtship commences, with leaps and skips through the space, the woman licking the man's thumb or each dusting off the other's torso. In the silence before the next piece of music, the image transforms slowly as it bleeds from black-and-white into color. As the woman stands beside the table, a drawer opens and a scarf (animated) slithers out and she arranges it around her neck. Then a hat (also animated) comes out of the cupboard and the man puts it on. The number of curtains is now six, and they form a pale white background, filling the frame.

The mood of the third movement is altered and a dusky, side-lit space suggests the emotional and sensual tone of the dancers. As well, the curtains are billowing, moved by an unseen source of wind. Light falls into the stage from two bright and low lights, and an atmospheric effect is achieved by artificial fog that makes the light ethereal. The dancers take over the whole space, moving between the curtains from left to right. The chiaroscuro lighting is at its starkest here, with the visibility of the dancers' bodies sometimes reduced to a glowing outline by the side spots. Their movements range from great leaps and runs across the stage to slow, less space-consuming action to stillness. In this part, the curtains seem to be part of the choreography, heightening the lyrical and emotional feel of the piece. A range of visual motifs is familiar from the previous films. Most prominent are chiaroscuro lighting and the shift within

the film from monochrome to color. But there are others: Yanowsky's repeated backward bend from her waist with her arms held outstretched at the level of her head (see Figure 19) is almost identical to a Tailor's Assistant's animated arch in *Street of Crocodiles* when the screw is pulled out of the Schulz puppet's box (see Plate 11). This is a painfully beautiful movement, and Yanowsky holds the extreme backward angle with effortless strength and grace. In the same year the Quays created set designs for *Bählamms Fest,* staged at the Wiener Festwochen 1999 in Vienna. The opera was composed and directed by Olga Neuwirth, who did the music for the BBC *Calligrapher* idents; the libretto was based on Elfriede Jelinek's reworking of a theater version of the "Baa-lamb's Holiday" (1940), an anti–fairy tale from Surrealist artist and author Leonora Carrington. A review in the Salzburger Nachrichten describes the production's mood:

> The theme is the unspeakable, the netherworldly, threat, fear, and insanity—the stuff of English gothic novels. Behind every figure one presumes a symbol, behind every action a drive, and since nothing must be concrete, everything can slither into madness.[33]

This description shows affinities with the Quays' own narrative and thematic interests. Although László Molnár's review is somewhat scathing in terms of performance, his description of the set recalls visual elements from *Street of Crocodiles, Stille Nacht III,* and the final scene in *Institute Benjamenta:*

> Pale faces: scary! Bright red blood smears: shudder! Snowflakes in a forest of dry papier-mache fir trees: shiver. . . . At the utmost a stopgap for acceptable images from a school play's bag of tricks, this is developed to an embarrassing degree in the central scene when

Theodora's nursery opens and with it the core to her soul, with the appearance of round, colourful animal spirits (that were tortured to death by Mrs. Carnis). This is the betrayal to the seriousness with which Olga Neuwirth seeks the vestiges of the mood of the uncanny.[34]

Molnár's review highlights themes and tropes that figure throughout the Quays' artistic output: images usurped from childhood innocence and swathed in psychopathological sensuality, bestowed with eerie lighting, and populated with familiar objects that evoke a sense of the uncanny. At the end of *Institute Benjamenta*, Herr Benjamenta and Joseph disappear in a cloud of snowflakes; in *Street of Crocodiles,* blood-smeared machinery, flesh-filled watches, and livers and kidneys populate the sets; and *Stille Nacht III* is a dense thicket of fir trees and automata.

A further Channel Four commission, *The Sandman* (2000), was also choreographed by Tuckett, who is likewise credited as codirector with the Quays. This forty-one-minute piece, a beautiful classical dance film with elements of theater, was made by Koninck for the "Dance on Film" Channel Four scheme and coproduced by Griffiths. The film was based on Jacques Offenbach's opera *Tales of Hoffmann* (1881), with musical underlay by György Kurtág and Leoš Janáček. The film commences with a long, calm shot of a veiled woman sitting at a table, followed by a short series of animated shots, the only ones in the film. With a change of scene, a man appears and walks through various sets and past figures who are suspended in time; even a sheet is frozen in its upward billowing effect of being laid on a bed. In the next scene, in Hoffmann's bedroom, where he lay dying, the dancing commences, and the remainder of the film is made of dance sequences in loosely connected open sets, repeatedly returning to Hoffmann's bedroom. Solos, pas de deux, and pas de trois dominate the movements and support the subnarratives: a relationship between Hoffmann's nurse and doctor (Cooper and Yanowsky from *Duet*), a man (Nathanael?) obsessed with a woman/automaton (Olimpia?), and other figures standing on the fringes (including Alice Krige, who played Lisa in the first feature). Not a word is spoken throughout the film. Shot in a monochrome-effect color, the design, cameras, and lighting echo the aesthetic and formal features of *Duet.* Glowingly lit embroidered cloth draped around Hoffmann's nurse as she showers closely resembles the billowing curtains, set lighting, soft fog effects, and chiaroscuro in *Duet.* And there is a subtle foreshadowing: a nonfunctioning Scandinavian pedestal clock in this film will be part of the set design for *In Absentia.* The film was premiered at the Rotterdam Film

Festival, and it is a lovely example of interplay between dancers and the Quay Brothers' sets.

If we contemplate how little the Quays implement spoken narrative in their films, and how the narratives are, on the whole, music driven, the explorations in the dance films seem to be a natural progression for their interests in aesthetic, emotional, and sensual expression through gesture, set design, and narrative spaces. Having worked with actors on the feature and the ballet, opera, and theater productions, which also provided valuable experience for the first feature, they became more familiar with live action's architectural requirements of scale and proportion that were necessary for dancers moving through spaces that were to be filmed. Although they seem to be a digression from the animation films, the stage designs and visuals in the dance films represent the Quays' capacity to move between performance genres and media.

Shattered Sound and Light: The World of *In Absentia*

The Quays' choreographic work with cameras, puppets, and actors of the past years culminated in a shift to a new form of poetic aesthetics in film that came out in the same year: choreographed light. In the Barbican Theatre in London in 2000, a screening of a BBC-commissioned series called "Sound on Film International" took place in front of a full house. The series' concept was to select filmmakers and match them with contemporary music pieces that should be the inspiration for a short film. The audience experienced collaborations from Hal Hartley and Louis Andriessen, Werner Herzog and Sir John Taverner, Nicholas Roeg and Adrian Utley of Portishead, and the Quays, who were paired with a musical score by Karlheinz Stockhausen: "Zwei Paare." The musical pieces were in part performed onstage. *In Absentia* was screened in Cinemascope format, and the Quays fully exploited the format to present the stunning interplay of Stockhausen's music and the unsettling, pathological gestures of a solitary woman's battle with a pencil, sharpener, and paper. *In Absentia* is perhaps the closest the Quays had yet come to combining their array of artistic talents in one film: choreographing or orchestrating music with gestures of puppets, actors, and lighting.

As with previous films, significant research into the inspirational fragments lies behind the finished work. At the Hayward Gallery in 1996, an exhibition titled "Beyond Reason: Art and Psychosis—Works from the Prinzhorn Collection" presented a fascinating range of sculptures, texts, drawings, embroideries,

and paintings by men and women who suffered from various forms of dementia praecox (hereafter referred to as schizophrenia, the contemporary medical term) and other mental disturbances. In a corner of the exhibition, two sheets of paper were crammed with claustrophobic and dense lines of writing, each line the same. These were the tortured love letters written by Emma Hauck, inmate in a psychiatric hospital (*In Absentia* is dedicated to E. H.). Kahn describes varieties of noise that are found on the written page, what he calls "a silent figure of significant noise [that] exists in handwriting . . . the legibility of an apparent illegibility."[35] Besides their material existence as ink on pages, Hauck's scrawls, graphic writing style, and repetition are full of desperate passion and a bizarre sensuality. In Stockhausen's composition, the Quays' quite literally found a sound-based aesthetic conspirator to Hauck's method of expressing her demons.

The Quays have a long-standing interest in Art Brut, what Roger Cardinal has called "the art of the repressed" in his seminal *Outsider Art*, another term for works made by psychiatric patients. In contemporary usage, the latter term has been expanded to include artworks by people with mental disabilities and low levels of education. The Quays' main area of interest, however, concentrates on the works of artists and authors who were patients in psychiatric clinics in the first half of the twentieth century. In 1995, I accompanied the Quays and Richard Weihe on an excursion to Herisau, in the Swiss Canton of Appenzell, where the Herisau sanatorium is located. Walser was committed in 1933 to the sanatorium, where he stopped writing, and died in 1956. He had previously been in the Waldau sanatorium (Canton Berne), where Adolf Wölfli was held for the last thirty-five years of his life. I asked the Quays if they considered Walser's own psychiatric problems when they worked on the feature script:

> Yes, it is us sort of making a reading, particularly of Jakob's character. But then it must be the same trying to imagine the first premonition someone might have had of him drifting to so-called clinical schizophrenia. If he wrote something, did he reread it and say, "I must be mad?" Because it's mellifluous; he writes beautifully about that sort of thing. I know of the lovely little story that he based *The Comb* on originally, and he arrives at this little fairy tale house, and looks up and sees himself looking down, I think, or [sees] a couple in a room and one resembles him, and then he goes into the place but nobody is there. He makes this comment about what freedom really is.[36]

Although the Quays have made only two films with an acknowledged reference to Art Brut, elements and inspiration of this artistic production seep into a number of their later works. Already in *This Unnameable Little Broom,* the Quays were inspired by Art Brut.

> We wanted to make a very stylized universe. Keith [Griffiths] wanted us to make a fantastic desert and things like that and quite realistic, anatomic men with real anatomies. . . . It was after the little Švankmajer film, but we wanted to make something very grotesque. The drawing for Gilgamesh was based on one of the mad artists in Switzerland [Adolf Wölfli], and it was just one of those impulses.[37]

Wölfli was one of the best-known Art Brut artists whom the Quays acknowledge as an influence.

Art Brut is an aesthetic practice that evolved out of therapeutic programs developed by medical doctors, including psychiatrists, who themselves had a developed sense of aesthetics. In spite of fascinating publications such as *Genio e Follia* from Cesare Lombroso (1864), Walter Morgenthaler's 1921 book about Adolf Wölfli *Ein Geisteskranker als Künstler,* or Hans Prinzhorn's now standard work *Artistry of the Mentally Ill* (*Bildnerei der Geisteskranken,* 1922), the thesis that fine arts and creations of schizophrenic patients were incompatible concepts was long upheld. In the meantime this attitude has changed significantly and has been replaced by fine arts' informed new evaluation of these artistic works. The term Art Brut was coined by Jean Dubuffet, who in the 1940s developed a keen interest in artistic works by mentally ill patients. According to Colin Rhodes: "Dubuffet's concept of Art Brut grew out of Surrealism's interest in phenomena that lie outside of individual prejudice and expectations and in the commonplace of experience that is too often overlooked."[38] This connection to surrealist practice in image production, whether film or otherwise, is key to understanding the Quays' stylistic development, both because their interest in surrealism is well documented and because their films often present phenomena that transcend expectations and develop new ways of seeing inner worlds.

In an essay on Švankmajer, whose animation films exhibit a strong relationship to the unconscious processes and question the reliability of reality, Roger Cardinal, one of the field's defining scholars (who collaborated with the Quays on *Anamorphosis* and is listed in *Street of Crocodiles'* credits), suggests that "the whole ideal of animated film is to suppress the categories of normal

perception; indeed its logic might even be to suppress all differential categories, and annihilate the very conditions of rationality."[39] As the Quays have long been fascinated by this genre of artistic production, it seems a natural development if we consider their strong interest in Surrealism, a movement that was deeply inspired by the works of schizophrenic patients. Many of their puppet films also display images of sexual pathology reminiscent of those described by Berlin sexologist Magnus Hirschfeld in the early part of the twentieth century.[40] The gently stroked kidney or the nails penetrating the pocket watch face in *Street of Crocodiles* (see Plates 10 and 13), the wiggling fingers of the woman and the puppet in *The Comb,* the thimbles sewn on to the back of Lisa Benjamenta's sleeping attire or her tight corset—many of these originated in the Quays' inspiration from the works of Wölfli, Emma Hauck, and other Art Brut artists in combination with surrealist imagery.

In the final chapter of his book, Prinzhorn muses on the meaning of schizophrenic art in the context of his own times:

> The particularly close relationship of a large number of our pictures to contemporary art is obvious. Furthermore, experience shows that people of very different characters, ages, and occupations were powerfully and lastingly impressed by these pictures and were not infrequently compelled to ask themselves fundamental cultural and philosophical questions.[41]

Art Brut continues to have an intense attraction for a wide range of people, and in light of contemporary engagement with this genre of art, Prinzhorn's assertion that the images force us to reconsider certain cultural and attitudinal concepts continues to be fulfilled. The imagery in the Quays' films that draws on inspirations from Art Brut has also opened the worlds of the mentally ill and helped embed them more strongly in an art-historical, aesthetic context.

Script development for *In Absentia* was initiated in a similar way as many of the Quay Brothers' films; music has always been "the primary, if not major, instigator of the scenarios. And like always in all the films it is also the dramaturgical blood."[42] A difference to previous films was that instead of choosing the music themselves, the Quays were given a piece of music before production began. The visual track grew out of their encounter with Hauck's letters from the Prinzhorn Collection, and so they developed another, written scenario: "The day we listened to the piece for the first time there was a release within us of a

torrent of ideas and visual flashes. We then started immediately with the direction of the film without having a real and proper work plan, but developing it as we went along."[43] The Quays recount that Stockhausen wept when he saw the film at an avant premiere: "He just came to us afterward and said: 'How did you know?' And we replied: 'Know what?' And he said 'My mother . . .' It's as if we had tapped into his psyche."[44] Only later they learned that his mother had been imprisoned by the Nazis in an asylum and she died there. The composer's approach to composition and instrumentation chimes quite astonishingly with the Quays' experimentation in juxtaposing image and sounds. He uses electronic and traditional instruments, and does not shy from integrating recording machines that alter sound into his work. In his creative practice, Stockhausen also seems to share with the Quays an interest in the "liberation of the mistake," in that he develops new approaches to uniting disparate elements of music:

> In some such works, such as Klavierstück XI (1956; Piano Piece XI), Stockhausen gives performers a choice of several possible sequences in which to play a given collection of individual moments, since they are equally interesting regardless of their order of occurrence. Chance decisions thus play an important role in many of the compositions. . . . In Stockhausen's electronic music these juxtapositions are taken still further. In the early work Gesang der Jünglinge (1956; Song of the Youths), a recording of a boy's voice is mixed with highly sophisticated electronic sounds. Kontakte (1960) is an encounter between electronic sounds and instrumental music, with an emphasis on their similarities of timbre.[45]

Stockhausen's methodology of chance and improvisation has affinities with the Quays' musical methodology discussed in chapter 6. His radical openness to alterations in performance allows unexpected outcomes and combinations to take a place in finished compositions and performances. In *In Absentia,* the complexity of Stockhausen's music and soundscapes is counterpointed and harmonized by images that elicit an emotional state of the main figure, a woman in an asylum. Most striking is the way the shattering, knifelike brilliance of the animated light functions in harmony as visual analogy to the clashing, high-pitched agonies of Stockhausen's composition.

The film commences with a fog-shrouded fantastic, distorted landscape. Liquid patches of brightness shift across horizontal planes, sliding over,

almost caressing the objects and architectural fragments that litter the landscape. As the light shifts farther into the distance, it starts to move upward, revealing a vertical background plane that changes the initial impression of a horizon. After ninety seconds a new space is revealed after a hard cut—a thick, smeary atmospheric emptiness with an elliptical sun struggling to send its rays through the dark atmosphere. The camera pans down to reveal a house between two trees. The light gradually rises, and we see more of the house, climaxing with a bright white flash on the right. Other sets include a conservatory-like room lined with windows (see Figure 12) and an exterior wall with window shutters. These spaces and objects are invaded and revealed by focused spots, sharp beams, swathes, and bursts of animated sunlight. The main part of the film takes place in a 1:1 scale room in what seems to be an institution. Scenes of E. H. (Marlene Kaminsky) at a desk writing are intercut with animated sequences. The ones in black-and-white show windows, rooms, a wall with a platform from which a pair of booted legs rhythmically swing, pencil lead tips rolling across surfaces. Besides the light—one of the film's main protagonists—and E. H., there is another animated figure: a grotesque, horned, half-humanoid, half-insect/beast apparition, which we first see at 5:02, that inhabits a bluish-tinged animated realm. The two worlds are connected by the lead tips that break off of E. H.'s pencils. We see them scattered on the floor in black-and-white and on a windowsill; and, in the color sequences, at a table in a gesture reminiscent of the actor's pose, the beast's hooves crush them to fine black powder. The color realm is E. H.'s inner world: the puppet embodies her madness, contrasting her troubled mind with her monochrome physical institutional existence. In the ensuing scenes, some extremely rapidly cut pencil leads move around. E. H.'s lead-smeared fingertips—actually the Quays' own fingers appear in these shots—are shot in extreme close-up with macro lenses.

At 11:46 we see E. H. from behind, sitting. A head enters from the right and moves out of frame, and then a hand reaches into the frame and strokes her neck. She collapses in her chair and the following sequences are cut with an increased urgency. At 16:41, we see for the first time what she is writing: an entire sheet of cramped, dense lines of unintelligible pencil writing in longhand. At 17:30, the landscape from the start of the film appears for the first time in color (see Plate 16). The next sequence shows someone at a Victorian writing desk, pulling a drawer open that is full of pencils. A man's hand takes out two of them. Then E. H., from behind, turns her head, as if listening. At 18:20, we see a close-up of a gap beneath a door, then a shot of E. H. turning her head. We then see a

man's lower legs in the corridor heading toward the door. A body bends down and, in three ensuing shots intercut with black frames, the hand rolls two pencils under the door's gap. The film ends with white titles on a black background: "To E. H., who lived and wrote to her husband from an asylum 'Herzensschatzli komm' ('sweetheart come')".

In Absentia was shot in anamorphic widescreen—a first for the Quays. With a decent budget they were able to create an enhanced visual experience and the special qualities of projection lenses could show far more detail if used with 16 mm or 35 mm film. The aesthetic of the analog worlds of black-and-white and color, live-action and animation, is a recurring stylistic element in the Quays' films. It was used in the *Janáček* film, in *The Comb,* and in *Street of Crocodiles,* where the exposition begins with a black-and-white live-action realm with a spit-guided transition to the animated color one through the Wooden Esophagus. In Absentia is stylistically closer to *The Comb,* in that the realms and figures are distinctly separate: the woman's world is black-and-white, the puppet's is dazzling color. This is a new kind of color from the Quays' palette; instead of the muted browns, ochres, and reds of the previous films, there are sharply distinct and vivid blues, reds, and brightness. This is the same palette they used for some of the commercials they were making at the time. It is possible that the compactness and intensity of thirty-second spots demanded more dynamic color and that this experimentation found its way back into the films.

The next ballet collaboration was premiered at the Place des Arts Theatre Maisonneuve in Montreal in 2001. *The Queen of Spades (La Dame de Pique)* was choreographed by Brandstrup for Les Grands Ballets Canadiens. The ballet was inspired by Alexander Pushkin's "The Queen of Spades" (1833) and the musical score composed by Gabriel Thibaudeau, based on Peter Tchaikovsky's opera. The Quays created a number of short cinematic visual décors that were video projected on to a semi-opaque screen placed in front of the stage, fully covering the proscenium for the period of projection. They were dissatisfied with the pale and flat projection that did not achieve the effect they intended:

> I wish we had been able to be in Montreal during the projection, to adjust the technical side. We arrived on the night before the premiere and things couldn't be sorted out. . . . Unfortunately, nothing turned out the way it should have. I think there was a lot of politics involved. But it wouldn't stop us from trying again.[46]

The set design and visuals were, however, well received. Steve Howell reviewed the production for the *Press Republican* Online: "The innovative multimedia mix of film animation, video imagery and special effects by The Brothers Quay, Sylvain Robert and Jimmy Lakatos magically create images of rushing waters to Russian propaganda posters right before our eyes."[47] In the following year, the Quays did the designs for Tuckett's 2002 production *Wind in the Willows,* when Tuckett was a dancer and choreographer at the Royal Ballet. The performance was based on an adaptation of Kenneth Grahame's book, the score was by Martin Ward, after George Butterworth, and rhyming narration scripted by British poet laureate Andrew Motion. The Quays were responsible for set design and costumes were designed by Nicky Gillibrand, who worked with the Quays on *Institute Benjamenta* and is a longtime collaborator with Richard Jones. The production ran at Linbury Studio Theatre, Royal Opera House, London. For children and families, *Wind in the Willows* featured dancers as animals and incorporated dancing, singing, and talking, so the dancers had acting roles as well as the choreography to deal with. Adam Cooper, who played Badger, was a principal dancer in *Duet* and *The Sandman.*

The Phantom Museum and Recent Short Films

In 2003 the Quays completed a film that benefited from the success of the documentary-like *Anamorphosis,* which had attracted the attention of art historians and museums. This was no doubt due to the Quays' ability to meld factual art historical documentary with animated shots and scenes. *The Phantom Museum: Random Forays into Sir Henry Wellcome's Medical Collection* (2002) was commissioned by the Wellcome Institute for their exhibition "Medicine Man: The Forgotten Museum of Henry Wellcome" at the British Museum in 2003.[48] The Quays were given access to the wealth of the collection, and in the film a white begloved actor playfully negotiates a spiral stairwell and explores the boxed, racked archival treasures, mostly in black-and-white. Besides occasional brief sequences of hands or of them setting up equipment in *The Cabinet of Jan Švankmajer* and *Rehearsals for Extinct Anatomies,* it is the only film to date that features one of the filmmakers: there is a credit of "Librarian" for Stephen Quay.

Wellcome was an American born in 1853 who lived the American dream, working his way from poverty to amassing a great fortune from medical supplies. He used some of his money to support scientific and archaeological research; he was also a great collector of medical curios, books, artworks, and religious paraphernalia. It seems he also had a special interest in erotic toys.

Automata figure in his collection, as do prostheses that bear a strong similarity to the armatures used in puppet animation. His curiosity was spurred by the workings of disease and its prevention through human hygiene until his death in 1936. Sir Henry Wellcome was a true collector, and during his lifetime he accumulated one of the world's largest medical collections. To help gain a sense of the curious diversity of the exhibition, in an exhibition preview Emma Crichton-Miller singles out six of six hundred artifacts on display:

> a lock of George III's hair, Van Gogh's sole etching, a selection from the vast Hildburgh collection of amulets, a shrunken head from Ecuador, a set of prosthetic devices made for a double amputee and a sixteenth-century French manuscript describing marvels and monsters. . . . The sheer extent and diversity of Wellcome's forgotten collection speaks of a more interdisciplinary, even chaotic, intellectual world than has held sway since Wellcome's death.[49]

The Phantom Museum is anamorphic 16:9 shot on 8 mm and 35 mm film stock and animated in the museum and in the Quays' studio. There is the familiar interplay of black-and-white and color imagery, and most of the film is shot in live action, interspersed with colored animated sequences that document the details of the objects. It features a selection of Wellcome's collection, including surgeons' instruments and prostheses, with an especial focus on artifacts of a sexual nature (copulating dolls, chastity belts). One of the images in the film, a drawing of a cross-section of a body and erect penis that the Librarian "covers" with a condomlike sheath (see Plate 17), closely resembles a wall illustration in the Tailor's back room in *Street of Crocodiles* (see Plate 11). A wood homunculus/fetus is painstakingly unpacked from the layers of a woman's body, carved in minute detail, including removable labia that reveal the physical structure of the womb. At the end of the film the Librarian takes off his sock and shoe to reveal a wooden prosthetic foot that extends like the ankles of the Alice puppet do in the *Stille Nacht II* and *IV* films.

The decision to commission the Quays was no doubt in part due to their profound expertise of assembling and animating puppets and objects that are detailed and minute, since the collection is replete with such artifacts. Through a carefully made selection of museum pieces, some of the Wellcome collection's artifacts acquire metaphysical qualities similar to the metaphysical machines in the Quays' other films, and this adds a charm to the otherwise

straightforward presentation of the objects. The film has an exploratory, almost didactic feel and structure, documenting the interiors both of the collection and of the objects as their layers and wrappings are incrementally removed. A recurring motif is an armaturelike animated metal hand; its elongated fingers make a slightly sinister, clackety movement that seems to suggest its desire to explore the boxes too. Gary Tarn's score does not add the auditive complicity that most of the Quays' other films have; it is rather thin and bloodless, but appropriate for the film's straightforward subject matter. It was produced for the Arts Council England, Channel Four, and Koninck by animate!, a production company (run by the late Dick Arnall) that specialized in animation and experimental filmmaking. The Quays' fascination with automata continues: in 2010 they were making a new film using Philadelphia's Mütter Museum medical collections.

The Quays were commissioned for visuals for the multimedia performance "Death and Resurrection" at Tate Modern. *Poor Roger, Oranges and Lemons, Green Gravel,* and *Jenny Jones* (all 2003) form a series of four short films to accompany a musical performance sponsored by the series "Tate and Egg Live for Easter." The event was composed of two parts in two starkly differing London venues: St. Paul's Cathedral and Tate Modern's Turbine Hall. The Web site advertising claims that "the evening contrasts a sublime and unquestioning expression of Christian belief with an exploration of the inner world and feelings of children, in two iconic London settings that most powerfully represent the religious and the secular."[50] Cantatas from Johann Sebastian Bach were conducted by John Eliot Gardiner and featured the Monteverdi Choir and the English Baroque Soloists at St. Paul's. On conclusion of this part, the audience walked over the Millennium Bridge to Tate Modern for the second part of the performance: Steve Martland's "Street Songs," which combine a theme of traditional children's rhymes with the darker side of fairy tales and children's stories. The Quays' shorts were titled after four selected songs performed by the Monteverdi Choir. Martland regarded the film for the last song, "Jenny Jones," as the most moving for him. The Quays used one of the anatomical artifacts from *The Phantom Museum.* Martland:

> The Quays use this doll to create a visionary anatomy that reinforces the humanity that is the message of "Street Songs." The model is so exact and detailed that the sex organs are displayed and from the womb comes a tiny baby. This tiny model carved from ivory symbolises the rebirth, or resurrection, that follows death (in this case that of the child Jenny Jones) or archetypally, all that is human. In this song,

as with the others, the Quays so beautifully elucidated the themes that despite our limited time together on the project I am very happy to call them my collaborators.[51]

Recycling of objects and images is an approach the Quays have used with success in the past, and this film was no exception. By placing the anatomical puppet in a narrative setting, they managed to elicit, or at least to suggest, a possible world of the puppet in the sets and designs.

More projects followed: the next was a commission from the Hans Christian Andersen Foundation for *The Anatomy of a Storyteller,* a full-length dance piece about Andersen that was one of many events in Denmark celebrating the two hundredth anniversary of his birth. The cinematically inspired stage set projections designed by the Quays were, according to the official Hans Christian Andersen Web site, "a visual landscape of artificial, animated models constantly undergoing transformation both textually and rhythmically."[52] The performance premiered at the Royal Opera House in London in 2004 before international touring. For a new Richard Ayres opera *The Cricket Recovers,* they created a wood-themed stage design (including enormous Scotch pine needle twigs and pinecones and sloping chairs and tables) and a video, which was also projected on a semi-opaque triangular screen in front of the stage. It premiered at the Aldeburgh Festival in the Snape Maltings Concert Hall, UK, in June 2005. In 2007, the Quays returned to Bregenz, Austria, to work again with Nicholas Broadhurst for his staging of Benjamin Britten's operetta *Paul Bunyan,* and in the same year they created set designs commissioned by Brandstrup for the opera *She So Beloved* (with Zenaida Yanowsky from *Duet*) at Opera North, Leeds. Inspired by a poem by Rainer Maria Rilke, their contribution included trademark anamorphic paintings, portholes, and an eight-minute film projection *Eurydice—She So Beloved* that have been screened and displayed alongside the touring "Dormitorium" exhibition.

The Quays' collaboration with ballet, dance, and theater continues. They created dazzling projections for two April 2008 performances of *Bring Me the Head of Ubu Roi* at the Queen Elizabeth Hall in London's Southbank Centre. The adaptation of Alfred Jarry's seminal *Ubu Roi* was written and performed by Pere Ubu (in their own words, an "expressionist avant-garde garage band"). Working with these and other large-scale projects over the years nurtured and gave confidence to the Quays' interest in the challenge of feature-length films, and the two they have made to date are remarkable transpositions of the vitalist themes of the puppet animation films into work with actors.

THESE THINGS NEVER HAPPEN

Then, after the purely trick-picture is disciplined till it has fewer tricks, and those more human and yet more fanciful, the producer can move on up into the higher realms of the fairy-tale, carrying with him this riper workmanship.

Vachel Lindsay, *The Art of the Moving Picture*

BUT ARE ALWAYS

his chapter explores the Quay Brothers' two completed feature films as both variations on and culminations of their other creative works. It also proffers a summary of their poetics in works completed when this book was finished. The chapter's (and this book's) conclusion is an open one; the Quays have projects currently in development and no doubt more will follow. In 1995, they completed their first full-length live-action film, *Institute Benjamenta, or This Dream People Call Human Life.* The *Stille Nacht* shorts, *The Comb,* and the dance films had been a trying ground for the transition from animation to live-action that was a quiet evolution to a larger scale. The Quays also wanted to preserve a belief in their previous experience with animation, and that there should be no reason why the animation technique should suddenly become irrelevant. They were spurred on by the simple knowledge that not everything can be animated or achieved by animation alone.[1] The process of getting the film funded was arduous, and via producer Keith Griffiths the Quays fought against being hired as directors for their own script, negotiating between producers wanting to imprint their own narrative ideas on the film and the filmmakers' intent to realize their vision. As the shooting progressed, these relationships improved. A significant part of the shift from animation and stage design to feature films was the desire to find a way to sustain imagery and concepts from the animated films in a feature-length film.

8.

This meant developing a script with stronger and sustaining narrative coherence, but not in a conventional way. The Quays: "Since we've always maintained a belief in the illogical, the irrational, and the obliqueness of poetry, we don't think exclusively in terms of narrative, but also of the parentheses that lay hidden behind the narrative."[2] The script was written together through a number of revisions with Alan Passes, who has published two novels and several short stories (Passes has also worked for the stage, radio, and film; scripted television documentaries; and worked in film production in France and England). It was the first film with dialogue the Quays had done since the artists' documentaries for Channel Four (excluding the commercials) and this posed some challenges: "We had to use dialogue, but we still wanted to maintain the power of the images. We took on only so much that would never sabotage all the imagery and vice versa. The very notion of taking on a feature film means you've got to take on the dialogue. It's like adding another layer."[3] The Quays found a balance between these layers, and spoken, diegetic dialogue does not dominate. Referring to Bausch and the Kirov ballet, the Quays speak of dance "as a possibility to eliminate dialogue—and why can't a feature film, if carefully done, do the same?"[4] The film includes a number of short animated sequences and incorporates many of the stylistic, spatial, rhythmic, and technical features of their animated works. These were transposed into live-action set design, shooting, and direction that marked a radical development for the Quays, from immersion in their interest in dance to working with actors. The mastery of miniature scale achieved in their animation films made an elegant transition to the life-size décors and live-action technical parameters.

We have seen that since the Quays left Philadelphia in 1969, a European aesthetic beckoned them into a locus of literary and poetic fragments, wisps of music, the play of light, and morbid textures. Critic Jonathan Romney visited the shooting set of *Institute Benjamenta* and described Hampton Court House's atmosphere and twisted architectures as belonging to the "fossilised phantom Europe that is the true location of the Quays' fictions."[5] As with their short films, *Institute Benjamenta* draws its inspiration from fragments and whispers of literary material. The film places a hermetic and baroque cloak over Walser's novel *Institute Benjamenta* and other texts by Walser: "We wanted the text, the monologues, the inner voice-overs to sort of float and be suspended in order to evoke the fairy-tale-ish and that Walserian realm of half-waking, half-sleeping world-in-between"[6] (see Plate 18). The film knots a tapestry of myth, choreography, and symbolic and literary reference, located in what Atkinson

describes as "a fever dream vision of Mitteleuropa," which aptly describes the Quays' realization of this world.[7]

Institute Benjamenta

Lezsek Jankowski's music and a spoken, lilting riddle from a Bavarian folktale (which originated in a musical piece from Karl Orff) are the aural foreshadowing that accompany *Institute Benjamenta*'s exquisitely stylized opening credits graphics and fleeting animation sequences. At dusk, a small man approaches a door, pulls at his heavily starched, blindingly white collar, and hesitatingly knocks. Jakob von Gunten (Mark Rylance), a thirtyish, delicate man who has escaped his upper-class origins and "wants to be of use to someone in this life" enters Institute Benjamenta, an old perfume factory transformed into a school for domestics. He embarks on a dreamlike voyage through an anti–fairy tale world, embodied by the Institute itself. Assisted by her devoted and enigmatic model student Kraus (Daniel Smith), doe-eyed, Victorian-corseted Fräulein Lisa Benamenta (Alice Krige) runs the Institute with her melancholic, phlegmatic older brother, Herr Benjamenta (Gottfried John). She guides her students through a curriculum of cryptic signs, absurd gestures, and unbearable detail—"practice-scenes-from-life"—mechanical repetition, self-castigation, monotony, and submission. Jakob's arrival awakes in Herr Benjamenta an obsessive hope of a savior, an obsession rendered more intriguing by the film's discreet homoerotic undertones. The disturbed and erotically ambiguous relationships between brother, sister, and Kraus are disrupted by Jakob's arrival. His behavior sets him apart from the other students: fleeting moments of stifled confession and unarticulated emotion in his presence initiate a series of sensual epiphanies in Lisa. Jakob has awakened Walser's sleeping beauty and stirred Lisa from a loveless existence from which she realizes there is no escape.

A terrifying sublime simultaneously haunts and mystifies the Institute and its inhabitants. Unable to respond to her desire, bound up in the suffocating atmosphere of the Institute's labyrinth, Lisa succumbs to an increasingly horrific recognition of something unspeakable that gnaws at her until she can no longer bear it: a longing born of awakened, unfulfilled desire—"Doing without love, yes, that is loving"—her unfulfilled longing for the sensual world.[8] Clad in a pale, silken Victorian camisole, Lisa is reclined on a curlicue-worked iron chair, as if poured into it. In extreme close-up, delicate, light-reflecting beads of perspiration gather on her sculptured face. In the background, rivulets of water begin to trickle

down the walls of her sanctuary, gathering momentum and turning into streams. Delirious but still, she slumps in the chair, sighing faintly, and her delicate foot sensually slides along the floor. The camera cuts to Kraus in another room, emptying the contents of a bucket of water onto where a floor meets a wall. Back in Lisa's retreat, the water streams down the walls, connecting her sanctuary with the strange workings of silent and cunning Kraus. Lisa's inner decline climaxes in her decision to stop living; she is, in her own words in the film, "dying from those who could have seen and held me—dying from the emptiness of cautious and clever people." After a confession to Jakob, sealed with a fleeting brush of her lips on his, Lisa expires. On her bier "Snow White" is mourned by her "dwarves"; her brother bends in grief over her pale body. Lisa's eyes open once and, unseen by the others, sparkle darkly into the camera, a gaze directed at Jakob's point of view. Held aloft, she is borne through the Institute's inner chambers and through a mystical portal in the wall, an entrance to another world. Herr Benjamenta leaves the Institute and, with Jakob, walks off, surrounded by floating flakes in a snow-globe winter world. Kraus remains behind, guardian of the fish bowl, the riddle, and the sleeping beauty. He is the constancy who seems to guarantee that rituals and fossils like the Institute will never fully expire.

During *Institute Benjamenta,* cinephiles are rewarded with scenes of elusive cinematic and literary reference. Through the film's lighting design, one is obliquely reminded of silent filmmakers Dimitri Kirsanov and F. W. Murnau and the Russian film poet Tarkovsky; and, in its use of silences, of Kafka, and of essential myth and the anti–fairy tale. Continuing collaboration with Jankowski supports and counterpoints the careful visual choreography of the objects and actors. Stunning light design endows this film its ethereal quality. Short, almost fleeting animated sequences punctuate the film and complete the anti–fairy tale environment, suspending time; they are minute and discreet visual hiatuses, reminders of a vitalist presence that rumors throughout the Institute. Like Lisa Benjamenta, the images are simultaneously fragile and immortal. The film's epiphanic moments and dreamscapes provide a momentary orientation but are themselves even greater enigmas within the film's poetic fabric.

In isolation the film's visual leitmotifs and iconography are exquisite: totemistic cloven hooves, deer antlers, flowing waters, tightly laced boned corset—in their sublimation and appropriation in a world of suppressed Victorian eroticism, they become obsessive and ambiguous. Lisa's cane, with which she guides and masters her students, is tipped with a tiny hoof (initially the Quays thought of giving her cloven shoes); in a close-up at the beginning of the film,

when Jakob is brought to Herr Benjamenta, we see a hoof-tipped foot surreptitiously drawn back out of sight. Herr Benjamenta's office is set up like a hunting den: antlers spring from the wall, old clocks tick, wood textures dominate; the lighting is like setting sun spilling through trees. These décors have a distinct purpose in the film's narrative: "But all the time it's the surrounding décor that's telling you other things, and Herr Benjamenta sizing [Jakob] up like a young deer, like an animal, measuring how many points he has on his head . . . very animalistic behavior."[9] And later we glimpse Herr Benjamenta, out of focus, naked and acting out rutting movements in front of a steam-streaked mirror, a majestic set of antlers in his arms. The film's décors are replete with Bavarian and alpine imagery from the era of Walser's writing: pinecones and pine needles littering floors seem to suggest that the forest is inside the Institute, anamorphic paintings of copulating deer, Jakob's small schnapps liquor bottle, painted wooden panels and armoires, the stiff costumes, hunting equipment. These are the trophies of the Quays' wanderings in Walser's Swiss *Heimat* and their Bavarian forays; the objects' history and secret life seep into the film's stylization. The Quays describe some of the motivational ideas for the décors that were inspired by Walser's description of the Institute as a former perfume factory: "We also imagined that the man who had run this factory had had a *Wunderkammer* room where he collected somewhat pathological deer imagery. This is the museum that Jakob discovers."[10] And the snowflakes at the end of the film: Walser died on Christmas day during one of his walks in the forest. The forensic photograph taken of him shows him faceup on the snow with one arm flung out, his eyes half-open in a frigid, unquiet slumber, a more tragic sleeping beauty.

When asked why they chose to do a film with actors, the Quays replied, "It just seemed time to try a new form—just as a composer might think 'Now it's time to do a symphony.'"[11] Their explanation of why they cast the Institute before the actors also shows why and how they chose to work with what they call a lateral hierarchy of cinematic formal aspects, not led by dialogue or narrative. The description resonates to a great degree with their concepts for *Street of Crocodiles*:

> In order to score something of, as Walser called it, the "senseless but all the same meaningful 'fairy tale,'" we started by casting the décor as the main actor. We felt that the essential "mysterium" of the film should be Institute itself, as though it had its own inner life and former existences that seemed to dream upon its inhabitants

and exert its own conspiratorial spell and undertows. That time and space should be ambiguous, that the locale of the film would be less geographical than spiritual.[12]

This is the intersection with the Quays' approach to visualization of Walser's literary music: microscopic views and poetic fragments of what Walser immortalized in his writing—the banal, self-denial, maps of frustrated desire and longing. Choreography was the overarching poetic gesture in the film's conceptualization, a principle of the Quays' lateral hierarchy that I compared to Eistenstein's monistic ensemble in chapter 6—"Transferring the basic affective aim from one material to another, from one category of 'provocation' to another."[13] A gesture to their loyalty to puppet film aesthetics, the Quays remark that they "treated the actors with as much respect as we treated our puppets."[14] This is a playful reversal of Ficowski's description of the servant Adela in his foreword to *The Street of Crocodiles*, that she "believes that tailors' dummies should be treated with as much respect as human beings."[15] With the help of Kim Brandstrup, the Quays choreographed students and forks with equal finesse (see Figures 20 and 21). The six-week production schedule was itself a choreography of objects, actors, and technologies. As the Quays worked with a crew of more than forty people—an exponential increase from a team of two with few collaborators—their experience in theater, opera, and ballet proved crucial. It was obvious to me, a week-long observer at the Hampton Court shoot, that the Quays had handpicked the technical team and actors and were working with longtime collaborators from film, theater, and dance (see Plate 18): "The production was blessed with a real generosity of spirit. . . . It was a genuine collaboration with the actors *and* the technical crew, who trusted us with our vision, in particular our cinematographer, Nic Knowland."[16]

Animated sequences taken from *Stille Nacht III* punctuate the film. They cause hiatuses in the live-action narrative and introduce haptic interludes that link the live-action world and the Institute's vitalist undercurrent. The Quays declare: "We are attracted to that realm between live action and animation where one can use one domain to amplify another and vice-versa."[17] These brief, cryptic scenes reveal the Institute's textures and histories and its own secret life. An example is in the animated sequence of a glass cloche decorated with antlers, a "Please Sniff" plaque and small fragments of white powder scurrying about. The powder was meant to be dessicated stag semen, and the visuals suggest a musty odor lurking behind the glass, the promise of new life waiting to be freed. Laura

Figure 20. Kim Brandstrup's chore-
ography for the *Institute Benjamenta*
(1995) with students acting out "scenes
from life" for their future role as
servants.

Figure 21. Close-up of forks and
string in *Institute Benjamenta* choreo-
graphed with the same exactitude and
finesse as the students.

Marks reads the film's olfactory qualities: it "takes smell, and the knowledge afforded by smell, as a theme, and it employs the Quays' trademark uses of miniature photography and haptic imagery to convey the sense of smell to viewers."[18] The object is another of the Quays' metaphysical machines; this time, however, it is a stag's machine, a motif that endows a homoerotic taint when we see Herr Benjamenta's rutting motions in the shower, and an incestuous one to Lisa's thin, fragile, hoof-tipped cane.

Besides the animated sequences, a set of special effects were composited in postproduction at The Mill, an optical effects company in England. The Quays created seven opticals for the film, working over the images that cameraman Nic Knowland had already softened with a change to the processing bath temperature. Getting The Mill to match the camera original was challenging, as the monochrome 5321 film stock used required special treatment and many tests. The seven shots varied in length from 170 frames to one of 2,500. The 35 mm film stock was transferred to Beta, then digitally reworked; each frame was individually rendered and the mattes adjusted. The scene in Lisa's inner chamber, a baroque concave waterless "pool," is a composite of a set built in the Hampstead Court mansion (the walkways around the central hollow) and a small-scale set of the pool, with gossamer banners haphazardly drifting over its basin. (This image is included in the book cover the Quays designed for a 1995 republication of Walser's *Institute Benjamenta;* see Figure 3.) The lighting effects in this shot were animated: one of the "epiphanies of light" described in chapter 5 was used in a composite of a shot of Kraus walking on the edge of the pool and of a smaller set. This shot and the one of the students carrying Lisa on her bier at the end of the film were composites of live action and a model shot. The Quays gave The Mill the model shot to use as a frame for the live-action set, and although they were using the newest digital technologies, the main challenge for postproduction was matching the lighting effects of both shots.

On the large set decorated with silver birch trees, a pool of water was lit with strong lighting, and the effect of shadow and light on the walls was created by assistants stirring the water, breaking the reflection into shimmering, moving waves on the walls of the chamber (see Figure 22). This set was inspired by baroque churches (and served as an example of the Quays' research process described in chapter 3). This surprisingly creative take on extant architecture, combined with digital special effects, achieves the mystical and anti-fairy-tale-like mood Walser evoked. There is an increasing tendency in the Quays' work to use digital effects, as in the meantime digital generations of media technology are

Figure 22. Lisa Benjamenta's watery sanctuary, filmed in the Quay Brothers' studio as a model shot with animated sunlight and then composited.

replacing analog at a breathtaking pace. The next feature project originally had more than one hundred digital shots that were estimated at £700,000—almost a third of the provisional budget.

Institute Benjamenta was not the first feature-length live-action project. The Quays had been working on a feature with Passes provisionally titled *The Sleepwalker;* the project was proposed in 1993 but got no further than the script. Like *Institute Benjamenta,* it was planned to be mostly live-action. Keith Griffiths provided me with a media release on the film that was also published on one of the countless Web sites devoted to the Quays:

> The film centres on the quintessential romantic—E. T. A. Hoffmann, and the romantic composers Hugo Wolf and Anton Bruckner. It is a fiction, and is more concerned with the attempted visualisation of the romantic mind and the imagination than with literal truth. Like Hoffmann's literature, the film aims to depict an imagined world in which both the banal and the commonplace are infused with the exotic and the incomprehensible.[19]

Although the film never got past the treatment stage, many of its themes found their expression in *Institute Benjamenta* and in the Hoffmann-based *The Sandman* film ballet. Others—the baroque, automata, the imagined worlds, madness, and incomprehensibility—filtered obliquely into *In Absentia,* and some are reworked and woven into the Quays' second feature-film project. In 2006 the Quays also published a selection of as yet unfinished projects titled *Ten Unproduced*

Scenarios.[20] Unintroduced and uncommented, this publication is a beautiful and insightful example of their research process, authorship, illustration, and calligraphy. Besides the dialogues, which have a good peppering of erotics and of the Quays' delectable sense of humor (one of the scripts is called "The Adventures of an Avon Lady"), the scenarios are replete with mise-en-scène and music descriptions and directions for actors (and objects and puppets). Besides offering a rare opportunity for a wider audience to access the filmmakers' working materials, the texts also develop themes of automata, the sacral, and the baroque. After *Institute Benjamenta,* there was a five-year hiatus in short-film production at Koninck Studios. They began developing a treatment for a script collaboration with Alan Passes that also was to be infused with themes from *The Sleepwalker.*

The Piano Tuner of EarthQuakes

Years ago, the Quays gave me a bound script for a new film. On the cover was a black-and-white image of a man in what, judging by his apparel, appeared to be a nineteenth-century drawing room with a telescope, wooden globes, and other scientific instruments. Titled *The Mechanical Infanta,* the script was developed together with Passes for Channel Four. The fifty-five-page scenario described a fantastic tale of love, abduction, madness, and deliverance taking place in the permeable, somewhat sinister borders between nature, imagination, and artifice. The story abounded with metaphysical elements intermingled with scientific experiment set in a world commanded by a demiurge. For more than ten years, while making films, designing stage sets, and engaging in other collaborations, the Quays continued to refine the script. Originally inspired by *The Invention of Morel,* a slim text of sixty pages written by Adolfo Bioy Casares (a contemporary of Jorge Luis Borges) for which the Quays could not obtain the film rights, the project shifted to a story about a Wagnerian character called Droz,[21] who abducts an opera singer to be his "philosopher's stone" and the key to immortality.

Other authors the Quays engaged with at the time are exemplified by French author Raymond Roussel (whose 1914 *Locus Solus* was also an inspiration for the film), and the Latin American magic realists, including Gabriel García Márquez. Magic realism originated in the 1920s in visual arts and painting, incorporating elements of Surrealism and Art Brut. In its literary form, it is similar to writings of Kafka and Schulz in that its authors illuminate the secret lives of everyday objects and events. The innate difference between the Quays' puppet animation films and the features is that these illuminations—the animated

sequences in both features—do not take place in a separate realm but are incorporated into the narrative and the realism implicit in photoindexical live-action filmmaking. The dreamy, almost sublime sets and lighting and the visual styles of the film are populated by actors. The poetics of their puppet animation gives way to new visual and narrative themes transmuted into a cinematographic tour de force of directorial professionalism with the international cast.

The PianoTuner of EarthQuakes was a European coproduction of the German Mediopolis film and television production (Alexander Ris), Illumination Films and Koninck (Keith Griffiths), and Lumen Films France (Hengameh Panahi), supported by other funders in France, Germany, and the UK.[22] Terry Gilliam, a longtime animation co-conspirator, friend, and admirer of the Quay Brothers, was an executive producer. The Quays managed to keep to their ensemblelike working methods by ensuring that many of those involved in the film had collaborated on Institute Benjamenta. Key crew members included screenplay author Passes, choreographer Brandstrup, costume designer Kandis Cook (who worked with them on the dance films and some of Brandstrup's ballets), and cameraman Nic Knowland.[23]

The PianoTuner of EarthQuakes is more linear and easier to relate than the synopsis for Street of Crocodiles in chapter 1, perhaps in part because actors are more central than metaphysical machines. The film's overarching automaton theme is embedded in an amour fou set in an indeterminate period of the first quarter of the twentieth century, and the juxtaposition of scientific logic and metaphysical alchemy is a fertile terrain for the Quays' visual and lyrical imaginations (see Plate 19). Commencing with a text phrase in the frame—"These things never happen, but are always"—the film opens in an opera house, and in the course of the performance, singer Malvina van Stille (Amira Casar) is abducted by Dr. Emmanuel Droz (Gottfried John, who played Herr Benjamenta in the first feature). Droz transports the apparently lifeless Malvina to his isolated Villa Azucena, where he plans to bring her back to life using mysterious methods he has discovered. Her fiancé, Adolfo Blin (César Sarachu, the student Inigo in Institute Benjamenta), searches for her in vain. Droz's villa is surrounded by gardens and forest and Malvina reappears, though only half-alive. Her gaze is blank yet painful, her movements lifeless and uninspired as she wavers in an automaton state. Droz's plans are slowly revealed: an unsuccessful opera composer, in his megalomaniacal love for her and her voice, he puts her through endless nights of rehearsal for an opera of his own that he plans to use to celebrate his hubristic, distorted vision of himself. At the performance in front of his guests, he intends

to transfer his own life force into the half-alive Malvina for two selfish reasons: to unite himself forever with her (and her voice) and to revenge himself on the opera world that has rejected his own musical compositions.

To help with his plans, Droz recruits an unwitting piano tuner, Felisberto (also played by Sarachu), to tend to his automata. Felisberto is shown around by Droz's housekeeper and lover Assumpta (Assumpta Serna), who initiates him into the workings, routines, and laws of Droz's realm. Felisberto, whose voice-over thoughts also provide narrative for the film (like Jakob in *Institute Benjamenta*), hears a voice and discovers it is from a woman (Malvina), whom he is forbidden to have contact with. Droz shows him that the instruments are actually hydraulically driven automata that rely on tidal currents and have a strange influence on the flow of life in Droz's villa, affecting the island's inhabitants in their dreams and movements (as in *The Comb's* oenerics). The film features a number of mechanical automata, built by longtime collaborator Ian Nicholas (see Plate 20). Droz says his seven automata contain the dream of music, "the most rational irrationality of all, of which I—Droz—am the heart." Unlike metaphysical machines in earlier Quay Brothers' films, they are not purposeless without a point; their purpose is to serve or create music. (An exquisite example is a single wetted digit that evokes a high-pitched extending peal as it comes in contact with a mechanically raised revolving glass rim.)

Repartees between the two men play on the level of mysterious knowledge and power. Droz tells Felisberto about a bizarre biological phenomenon involving a spore that parasitically feeds on an ant's brain; at the end of the fungus's life cycle, a spike protrudes from the ant and new spores released so the cycle repeats itself—an allegory that resurfaces in Felisberto's dream (see Figure 23) and in the film's finale.[24] Felisberto surprises Droz when he alludes that his piano-tuning skills are the reason he knows the island's baroque grotto was ruined by the 1755 Lisbon earthquake (the only mention of the titular earthquake in the film). Assumpta begins to take more than a passing interest in Felisberto when sexual innuendos fly in the shadowy birch forest. Becoming aware of his intentions, she oscillates between good and bad, between helping him, and her feelings of jealousy for Malvina, Droz's new object of desire. In time, Felisberto discovers that the automata can capture human voices and sounds (one steals his whistle and part of his reflection). Droz, in the meantime, is proceeding with his villainous plans, and Felisberto realizes he must rescue Malvina at all risks. Because he resembles her betrothed so much, he is able to pull her into a higher level of consciousness and eventually falls in love with her.

Figure 23. Still from Felisberto's cryptic dream after listening to Dr. Droz's macabre cautionary tale of ants, spores, and fungus in *The PianoTuner of Earth-Quakes* (2005).

The day of performance arrives, and clouds gather in the troubled sky as the opera guests arrive, including Malvina's betrothed, Adolfo. The performance begins with Felisberto, blindfolded and with a beard that makes him identical to Adolfo. His blindfold is removed, an eclipse of the moon begins, and Malvina enters the stage dressed as a bride, singing. Adolfo, speechless, rushes to the stage and is separated from Felisberto by a semi-opaque gauze divider (the Quays have also used these in set décors). As Malvina whispers Adolfo's name, the wind begins to blow and the building trembles as the eclipse causes tidal shifts. Felisberto removes his disguise and moves toward Malvina. As they fall into a hole in the stage floor, chaos breaks loose and we see Droz in anguish with a growing spike protruding from his forehead (like the one he described in the fungal cycle with ants) that sprays white spores into the air. In the next scene, in daylight, Assumpta is in a boat floating over the flooded island and sees Malvina, soon to be joined by Felisberto, within one of the automata (see Plate 21). He says: "I never saved Malvina—I never made it past the sixth automaton" (the one he and Malvina are trapped in surrounded by floating white flakes, echoing the final scene of *Institute Benjamenta*). Instead of Droz being united with Malivna, it is Felisberto.

There are themes in this film that revisit those of the first feature. The *amour fou* between Droz and Malvina recalls the erotic undertones between Herr Benjamenta, Jakob, and Lisa in *Institute Benjamenta*. Felisberto's character reminds us of Jakob, who was also the innocent initiate into a bizarre and sinister world dominated by a madman (Herr Benjamenta). The "living" architectures of Droz's villa and the Institute are both controlled by invisible undercurrents, albeit differently (one by vitalist means, the other by Droz's manmade system). The

247

clutch of detached, silent gardeners (inmates of the island sanctuary/asylum) is similar to Lisa's flock of devoted pupils, and both of the madmen's "realms" are either laid to waste or abandoned at the end of both films. Central visual motifs reappear in a new form here, and the aesthetic design of the Quays' dance films seems to coalesce in *The PianoTuner of EarthQuakes:* flowing fabrics, generous spaces shot with deep focal planes, light that penetrates umbrous corners and caresses Assumpta's curves. Yet even with these correspondences the film is manifestly distinct from the first feature. Shot mostly in color, this is a crisper film, less geographically tied to a particular cultural space-time, and it is one of the few films by the Quays that seem to have a representation of nature that is not under a glass bell jar. There is a horizon, and the spatial disorientation of the shorts has given way to spatial continuity.

Perhaps the most striking difference that sets this film apart from all previous Quay films, which often have the cinematic feel of silent cinema, is that *The PianoTuner of EarthQuakes* is not dominated by complicit images and music. Dialogues and human interaction endow a more linear narrative that is driven by voices, whispers, and breathing, and periods of no music but ambient sound allow the dialogue to gain a more central narrative aspect. Costantini suggests:

> This auditory container of sounds is possibly present is in all the short films with an integration of live action and puppets, and in *Institute Benjamenta. The PianoTuner of EarthQuakes* does not abandon this sound perspective, but the size of the scenarios and the diversity of locations and places—plus a beautiful but more conventional score by Trevor Duncan and Christopher Slaski (far from the exoticism of Leszek Jankowski)—make the film lack homogeneity in that respect.[25]

The score is heavier on rhythms, melodies, and harmonies than Jankowski's past work for the Quays. Although it retains a strong strings presence, it is mainly baroque guitar that underpins the figure's emotions, and in scenes with Malvina it suggests the inner turmoil not evident in her automatonlike appearance. It also includes a number of voice pieces and experimental compositions that have affinities with Jankowski's nonnarrative sound tracks. Besides the music, sounds of cicadas and loons and crispy undergrowth add a naturalistic element that is the voice of an albeit highly artificial nature, and not of metaphysical machines.

The visual texture of *The PianoTuner of EarthQuakes* is both ornate and subdued. Besides a few other short scenes, including the opera house sets

and a scene of Felisberto during his train journey to Droz, most of the film takes place in a theaterlike setting in and around Droz's villa on the island. The theme of two worlds persists in this film as well: outside, in the gardens and forest, similar olfactory qualities Laura Marks described for *Institute Benjamenta* are in the dry, coniferous, airy Mediterranean atmosphere that dominates, while within the villa's various chambers and rooms, architectural elements meld with ornate furniture, automata, and weathered walls. The seven sets were fragments that could be moved around and collaged together; the Quays' familiarity with the 1:25 scale for opera design was significant in this, and perhaps more significant is the use of green screen for most of the interior scenes. Occasionally inside and outside seem to meld, as in the scenes when Malvina is sitting at the edge of a pool of water that, in its lighting and mise-en-scène, exudes the artificiality of stage design.

What is most striking is the essential baroque quality of the film in the interiors and presentation of the film's characters, and the stylistic complexity of this seventeenth-century style has much in common with the Quays' own aesthetic and poetic interests. This is especially notable in the set designs of operatic grandeur and the combination of differing art forms. The painterly quality of the images is remarkable, with a range that includes and reaches beyond the baroque, especially in the Quays' treatment of light that resonates with scenes from *Duet* (see Plate 22). Compositional elements of the Spanish painter Diego Velásquez seem to be palimpsested in interior scenes, and the group shots with the gardeners, indoor scenes, and medium shots of Malvina and Felisberto are suffused with a quality like that of the Dutch masters of light Jan Vermeer and Rembrandt van Rijn. The more umbrous scenes remind one of Michelangelo Merisi da Caravaggio and Francisco de Goya. All of these painters were alive during the Baroque period. This is not to say the film is derivative; it appears much more to be a new rendering of light that can align the film to contemporary neo-baroque manifestations in cinema. Angela Ndalianis's reflections on the baroque are seemly descriptions for the film's world:

> Not only is nature a teacher, but past emblems of human creation serve to reignite the human imagination to conjour new creations. Reflecting a specifically baroque attitude to art, the *kunstkammer* and *wunderkammer* embodied the baroque function of the fragment and the ruin: References to the past that existed within this microcosmic space coexisted with objects and creations of the present.[26]

A "Twist Point"

In *Institute Benjamenta,* Marks suggests that eroticism is reserved mostly for objects, while the humans in the Quay Brothers' films experience sexual repression or frustration.[27] The Quays' second feature does continue with this theme but breaks with it as well. The metaphysical machines are not central figures and treatment of some of the humans, Assumpta in particular, revels in sensual abundance of her liquid eyes, pillowy lips, inviting shoulders, and erotically charged stocking-clad thighs. The way the camera rests on Malvina's stillness elicits a sense of divination that can be related to the baroque, to neoplatonism, and to what Victoria Nelson terms Neoexpressionism: "Consciously or (most often) unconsciously, the New Expressionism revives the system of a living cosmos in which all things in this world exist in a hierarchy of interconnections with one another and with a timeless, invisible otherworld."[28] The vitalist and animistic concepts that have been invoked throughout this book for the Quays' work develop to coalesce in Nelson's descriptions of New Expressionism. Her list of authors includes Will Self and Steve Weiner, whose 1994 *Museum of Love* was inspired by the Quays (and for which they designed the book cover), and she names Tim Burton, David Lynch, and other filmmakers with an explicit focus on Lars von Trier. She suggests that European New Expressionists "remain within the high-art tradition."[29]

Moving toward a conclusion, I will explore some of Nelson's defining features of New Expressionism that underpin what I regard as the Quay Brothers' current shift in style and thematics toward cinematic magic realism and the neo-baroque. Reification—concretization of an abstract idea or the inspiration for an object, a space, or a movement—is a prominent feature of their puppets and objects, perhaps best exemplified by their transmutations of Schulz's generatio aequivoca. I would like to speculate on another progression that seems to be emerging in their development as artists and filmmakers: a transition from literary-inspired metaphysical concepts from the later puppet animation films into a poetic live-action cinema that reveals the platonic otherworldliness of not only objects, but also the live-action characters. In particular it is *PianoTuner's* Malvina who most clearly marks this progression from non-human object to living automaton, a synthesis of the material and immaterial worlds. But it is also in the highly artificial and stylized mise-en-scène of the garden that takes former miniaturized theaters and makes them accessible to humans in the film, and the live-action shooting adds a realism to the film that is distinct from the vitalist animated realms.

In the past, the Quays, in their own words, have treated actors with as much respect as their puppets. What seems to be a new direction is their imbuement of the living actors' emotional expression with vitalist and animistic concepts that heretofore were reserved for animated puppets and metaphysical machines. Brian Massumi suggests "The new expressionism derivable from a rethinking of beauty is not a spontaneist individualism, far from it: it is impersonal Matter that does the expressing."[30] Instead of hapless machines and non-compossible puppets that act out the generatio aequivoca of inanimate matter, human beings are caught in a fraught tension of undercurrent forces of logical and illogical possibilities that introduce a philosophical notion of contingency in terms of what cannot be discerned as true or false. The new direction the Quays have taken with this film is material exemplification of a concept in living actors rather than in objects and spaces. The beauty of Malvina and her transformation into an automaton, living but "impersonal Matter," is a new development moving on from the Quays' earlier works that achieved what Herbert Marcuse addressed about reification in the contexts of artistic works: "All reification is a forgetting. Art fights reification by making the petrified world speak, sing, perhaps dance."[31] In magic realism, metaphor is reified but in human form; Droz's intent is to unite his soul with Malvina's body, and throughout most of the film we see her almost immobilized in a sort of living, breathing death. Her inner stasis, caused by Droz's resuscitation of her, is apparent in her movements and actions, and she becomes a reification of Droz's concept of immortality.

Magic realism also aims to subvert established and accepted discourses in Western science and knowledge. Anne C. Hegerfeldt suggests "the fantastic elements in the magic realist text cannot be explained away, reduced or reconciled to realism . . . magic realism blends elements of the marvellous, the supernatural, hyperbole and fabulation, improbable coincidences and the extraordinary with elements of literary realism."[32] By invoking a metaphysical *live-action* realm, the Quays' film undermines expectations of logic, physical laws, and the rejection of nonempirical knowledge that abounds outside of positivistic science and thought. Nelson discusses the ringing bells suspended in the air at the end of von Trier's *Breaking the Waves* (1996), stating that "not just the inner, but the transcendental, is made visible in the physical landscape."[33] In some ways this is akin to magic realism's technique that concretizes, or reifies, immaterial ideas. In an interview with Jonathan Romney, the Quays state: "The film starts with a quote from Sallust (ca. 86–34 B.C.), which really encapsulates everything: 'These things never happen, but are always.' It's the idea that there are powerful forces which are controlling

and shaping people's destinies."[34] This is a shift from powerful forces controlling puppets to controlling people that began with *The Comb* and dance films through to *In Absentia* and *Institute Benjamenta*. With *The PianoTuner of EarthQuakes* the Quays achieve a fantastic that is simultaneously of this earth: Malvina is an automaton, but at the same time she is able to respond emotionally to Felisberto. Another feature of magic realism that relates to Nelson's ideas is that psychological and emotional concepts have ontological equivalents, ontological in a metaphysical sense, for what Nelson calls the transcendental. Droz's plan to literally unite himself with Malvina suggests this, and the end of the film, with Malvina and Felisberto united in an automaton depicts a concrete example.

Nelson also highlights the supernatural: "The supernatural is no longer only the grotesque."[35] Again it is Malvina: an automaton, but somehow half-alive, she is beauty incarnate distinct from the noncompossible, souless female puppets in the Quays' earlier films. In *The PianoTuner of EarthQuakes,* the supernatural is no longer a pairing of animal and human attributes or the animation of dead matter that conjures vitalist metaphysical machines. Malvina is imprisoned, living sensuality, a Snow White in a Hoffmannesque arrested state. And in magic realism's terms, the natural and realistic setting of the forest and gardens is at a tension with the fantastic nature of Droz's world. Because the garden retains a link to the natural world, and at the same time is located in Droz's realm, it upsets the realist connection to this link. Nelson suggests further that *"a high-art edifice is constructed on a low-art foundation. . . . The best New Expressionists do not engage with the repetition compulsion of formula narrative, either within or across stories."*[35] The previous chapters should have made it clear that the Quays' narratives (if we can call them that) are not formulaic in Nelson's sense, although they have developed their own poetic formula for films' structures. The Quays were asked to respond to divisions between high and low art, and to the view that they are often elitist:

> Neither of us maintains that high/low barrier. We've always worked across a wide range of projects and commissions, whether it was MTV stings or interludes, pop promos, commercials or to designing décors for the theater, opera, or ballet or even doing a feature film. Clearly each project has its own parameters which you try to solve and acquit. However, there is in us a more public vs. private side, i.e., certain works are intended for a private shade as opposed to public sunlight.[37]

The Quays' narrative in the second feature is not only rooted in Hoffmann, Kleist, and Jules Verne (*Le Château des Carpathes,* 1892). It combines a breadth of genres, including significant elements of the fantastic, the supernatural, and science fiction, and which indicate an expansion on the predominantly animistic and vitalist features of earlier works. It also retraces themes of H. G. Wells's *The Island of Dr. Moreau* (1896), a dystopic literary allegory that was appropriated by the pulp presses as science fiction and was the subject of a number of what are now considered cult pictures.

The literature the Quays chose to work with has clear affinities in subject with others discussed by Deleuze and Guattari, who, describing their concept of "celibate machines," refer to Michel Carrouges's *Les machines célibataires* (1954):

> [Carrouges] identified a certain number of fantastic machines—
> "celibate machines"—that he has discovered in works of lit-
> erature . . . : Marcel Duchamp's painting "la mariée mise à nu
> par ses célibataires, même" ("The Bride Stripped Bare by her
> Bachelors, Even"), the machine in Kafka's "In the Penal Colony,"
> Raymound Roussel's machine, those of Jarry's *Surmâle (Supermale),*
> certain of Edgar Allen Poe's machines, Villiers's *Eve future (The
> Future Eve)*, etc.[38]

(Carrouges also cites Verne's *Le Château des Carpâthes.*)[39] The Quay Brothers' automata, especially the central automaton (Plate 20), is one of the many references they make in this film to "celibate" machines in literature and art. Deleuze and Guattari describe the celibate machine as a certain kind of machine: "Everything about it is different: its cogs, its sliding carriage, its shears, needles, magnets, rays . . . it manifests something new and different, a solar force."[40] Droz's automata, set in motion by the solar force of a tidal eclipse, are to unite Droz and Malvina during the final performance. They could be viewed as celibate machines, in that "this transfiguration cannot be explained by the 'miraculating' powers the machine possesses."[41] Unlike the vitalist machines of the Quay Brothers' earlier films, "[the machines achieve a pleasure] that can rightly be called autoerotic, or rather automatic: the nuptial celebration of a new alliance, a new birth, a radiant ecstasy, as though the eroticism of the machine liberated other unlimited forces."[42] Droz's celibate machines have a single purpose: to satisfy his desire for Malvina by capturing her voice and melding it with him.

Yet another defining feature of New Expressionism, according to Nelson: "*Cliché is likewise deliberate, nonironic, and serves a higher purpose as allegory. Within a culture based on a materialist worldview, cliché is the only avenue back to allegory, because it is the sole arena in which hyperstylization, a precondition of allegory, is possible.*"[43] A cliché the Quays use is perhaps best embodied in the part in the Dr. Moreau/mad scientist stereotype of Droz: he is convinced of the magical properties of his inventions and his plan to integrate his own life essence into Malvina's shell. In a sense, Droz's convictions and the unquestioned acceptance of them by his servants and Assumpta establishes his fantastic world as realistic in the film's diegesis. Communicating the narrative through Droz, who is brazenly hubristic of his hyperstylized world, makes the spectator unsure as to who is mad—Droz or Felisberto. In planning to rescue Malvina, Felisberto represents a link to the real world outside of Droz's, but at the same time he must believe in Droz's inventions and "magic" if he feels the need to rescue her.

In her introduction, Nelson proposes that "Expressionism and Surrealism both based their aesthetics on the notion of an identity between internal and external realities."[44] At this point in the continuing trajectory of their creative practice, one that has shifted from exclusively animated films to live-action interpunctuated with animation sequences, the Quay Brothers have moved far from the initial buttonholing of neosurrealism to unequivocally establish their own unique poetics. The current venture into related but new fields of neoexpressionism and neo-baroque are evident in the visual, stylistic, and narrative excess in the works. The Quays have a clear sense of the freedom they want to maintain from critical and commercial compartmentalization:

> No one likes to be pigeonholed. What some people dislike is "slippage" over the edge. They want you to remain numbered and compartmentalized in your box; otherwise it is unfair to others. On top of that, they'll convince you that you are totally free inside your pigeonhole—i.e., the one that's been allotted to you by them.[45]

Years ago, Nichols Goodeve suggested to the Quays that they are really materialists, not surrealists: Their reply: "Yes, because the material is generated, not invented. We just *see* it. People do sort of want to stick the label 'surrealist' on us, but the world gives these things up to us—they really happen."[46] The last phrase of this statement endures in the Sallust quotation they mentioned earlier. Their work in film does continue to mediate the invisible world of objects—the

generatio aequivoca of Schulz and Schopenhauer—but enfolds this into an environment that is a mélange of live action and animation, a form of media hybridity that, as with their earlier films, continues to draw on interdisciplinary sources for inspiration. That "these things really happen" may provide a clue to where the Quays work will continue to evolve—exploring things that never happen but are part of a rich tradition of perception, experience, fantasy, and imagination.

Moving from inside to outside, from the film set to the urban environment, and, perhaps, into concerns that would suggest the Quays are postmodernist filmmakers, Vidler remarks on some of the strategies architects are using for what he calls a "posturbanist sensibility":

> Preoccupied with traces and residues—the material of dreamwork—
> rather than with the new, writers and architects have increasingly
> found ways to chart the underground reverberations of the city. In
> their ascriptions, territoriality becomes unfixed, camouflaged and dug-
> in . . . subjectivity is rendered heterogeneous, nomadic, self-critical in
> vagabond environments that refuse the commonplaces of hearth and
> home in favour of the uncertainties of no-man's land.[47]

The Piano Tuner of EarthQuakes is a continuation of their creative and astonishing exploration, using their own uniquely developed parameters and poetics of cinema, of ways to make visible the powers of imagination using elements from the world around us. In the current opus as it stands, the Quays are "authentic trappers," stalkers on an artistic hunt of discovery both in a multiplicity of styles that is developmental and in terms of how they transform inspirational literary sources into their experimental narratives.

CONCLUSION

Toward a Poetics

The Quay Brothers' live-action and puppet animation films are informed by a conceptual dialectics rooted in profound knowledge of the histories and aesthetics of painting, illustration, performance, literature, and architecture, including the –isms of modernist art practice, poetry, and cinema. The eclectic iconography of the Quays' cinematic world—its meandering narrative structures and unique cosmogony—hinders an assured or exclusive classification to a genre or a movement. If anything, their works belong to a hybrid category of poetic-experimental film that operates at a liminal threshold between live action and animation. In a discussion of the spectator's sensual and emotional response, Turvey's words ring true for viewers trying to describe the Quays' works:

> To speak of being struck, overwhelmed, saddened, or horrified *by* a film, to express the feeling of total absorption, rapt attention, or loss of consciousness *in* a film, to venerate films, like photographs and paintings, as special, fetishized objects in their own right, is to describe a sensuous experience in which the film itself, as a concrete object, plays a major if not determining role.[1]

The sensuousness of the Quays' films lies both in their haptic qualities and in their selection and treatment of the materials they use in puppet animation that elicit artifact emotion as described in chapter 4.[2] Nelson suggests that "consuming art forms of the fantastic is only one way that we as nonbelievers allow ourselves, unconsciously, to believe."[3] It may not be an overstatement to say that the fantastic element in the Quays' films (and indeed, in other puppet animation films) can also contribute to fending off Freud's "manifest prohibitions of reality," redeeming the last state of belief in contemporary secular experience, providing solace from Bennett's "disenchantment tale" of modernity. In their substance and their encyclopedic references, the Quay Brothers' films represent a cinematic analogy or embodiment of the cinema activist concepts proposed by Zielinski in the Introduction. I hope my tentative investigations into the why, the what if, and the how come of their poetics may provide some explanation for the "wow" their films evoke in their viewers and critics.

This book has described, contextualized, and explicated prominent cinematic, aesthetic, and technical parameters and systems that are unique features of the Quay Brothers' work in animated and live-action cinema. My analysis has not emphasized communication models, nor been concerned with the films' ideological underpinnings or questions of genre and ideology, nor attempted to place the films in a general continuum of filmic practice. Its greater focus lies on the poetics implicit in creation of the cinematic artwork and the way the viewer is actively involved in film reception.

I have attempted to describe a thematic, conceptual, and praxis-based poetics of the Quays' system of style as it currently stands. Yet I have been caught in a hermeneutic circle to some degree. I have undertaken a synecdochal analysis: relating parts of the Quays' artistic practice in *Street of Crocodiles* to their work as a whole, and how the particular world of this film is constructed by exploring its uniqueness and how certain techniques continued to be refined in later works. Without being prescriptive or making definitive statements or claims, I have attempted to clarify what their innovation constitutes, what sets the work apart from its contemporaries and its historical predecessors, and how the Quays' works after *Street of Crocodiles* continued exploring this film's innovations by developing new creative systems and methods.[4] I also hope it has become clear how the spectator's co-creational engagement with the Quays' audiovisual works helps to develop skills and refine schemata toward understanding how the films are constructed and what their artistic contexts are. The approaches and methods used in this study hope to sensitize awareness about the specificity and the very

real differences in the experience of watching, perceiving, and understanding these films, and to refine a language to describe the universe, world, realm, or region they create (and, perhaps, one that can be used for the many other worlds of animation). But the Quays, as cinematic poets, will continue to develop more enigmas and puzzles as their work continues, providing ample material for future viewers and scholars. Whether the points I made are valid for other kinds of animation films has not been my concern here; it may prove that some hypotheses can hold true for other films, but the approach has not intended to produce these, although it may ultimately do so.

I have described a disjunctive poetic system that, while in continuous development in the course of their filmmaking, is prevalent throughout their works. It can be summarized by the following features and devices:

- Vitalist and animistic cosmogonies
- Reification of a generatio aequivoca via automata, vitalism, and animism
- Puppet typology of portmanteau puppets, metaphysical machines, and insecticity
- Labyrinthine space, spatial collage, and spatial uncertainty
- Systematized dislocutory spatial logic
- Animated light, macro lenses, and a choreographic camera
- Musical montage dialectics
- Disruptions of the miniature
- Small scale to grand scale
- Magic realism and Neoexpressionism

The formal properties and aesthetic devices are not unique to any one of the films explored; it is their particular combination throughout the Quays' continuing body of work that results in their poetics, which must also be described as analogous to the world of the films.

The interdisciplinary artistic and creative contexts and backgrounds I have described as influential in the Quay Brothers' praxis places them in a historical continuum of artists, authors, and filmmakers concerned with revealing and creatively interpreting human experience that is not present or tangible in the phenomenal world, experience that is communicated via cinematic metaphor, animated imagery, and dislocutory dialectics. My analysis has not been concerned with subordinated, automatized devices, nor with functions that are found in

many animation films. It has centered on the foregrounded, nonautomatized devices in *Street of Crocodiles* that originate in techniques the Quays discovered and cultivated before this film's release in 1986 that were subsequently refined and expanded upon in the ensuing productions.

The Quays have called Schulz's "apocryphal thirteenth month" (described in the first pages of "The Night of the Great Season")[5] the greatest metaphor for them: "It's everything that animation embodies and where its greatest freedom lies. Creating a realm, a universe that is totally self-sufficient in its freakiness."[6] This trope is present in many of the films. It also exhibits a cinematic analogy to a number of the primary processes of language events as described by Freud, whereby the primary process is mainly visual: shortening, condensation, replacement, asyntactic blending, contextlessness, meaninglessness, and symbol building.[7] The self-sufficient, vitalist universe is a key poetic device in their work. In the Introduction I referred to Deleuze's idea that "a work of art is a new syntax, one that is much more important than vocabulary and that excavates a foreign language in language."[8] The Quay Brothers employ a stylistic and aesthetic visual language, one that excavates a complex range of imagery from cinema and plastic and literary arts to create visual neologisms I have described in the particular animated space-times that are the true characters of the films. The understanding of this language varies from viewer to viewer, and a spectator initiated in these references may be better equipped to participate in ordering apparently unrelated images or spatialities.

This intertextuality, this "new syntax," is in part created by the palimpsest qualities of the Quays' work with redundant and salvaged materials. In her essay on the ephemeral, mnemonic, and haptic qualities of QuickTime internet films, Sobchack draws parallels between experiencing the Quays' films and the works of Joseph Cornell, in particular his boxes:

> Both QuickTime "movies" and Cornell boxes also salvage "the flotsam and jetsam" of daily life and redeem it as "used" material whose re-collected and remembered presence echoes with bits and traces of an individual yet collective past: personal memories, narratives, histories that were, from the first, commodified and mass-mediated.[9]

Sobchack's observations on the redemption of materials resonates both with the motifs in the triumvirate of authors discussed in chapter 2 and with the Quays' collage aesthetic. In a sense, the process of reification—that is, of transforming

an idea or concept into a material thing—is reversed, in that the origins and histories of these objects shimmer through, like the overwritten or erased palimpsest, as they return to the fore. Decommodified from their original purpose, they are remediated by the Quays through their integration into a vitalist narrative. Toward her conclusions, Sobchack ponders the half-life feature of QuickTime "movies" that she relates to animation film and to Quays' films in particular:

> I associate [QuickTime "movies"] with those forms of animated film that foreground the cinema's usually hidden struggle to achieve the "illusion of life"[10]—with the works of Jan Svankmajer or the Brothers Quay in which kinetic objects inhabit miniaturized worlds and achieve a laboriously animated life that somehow (and at some deep and molecular level) reminds us of the labor of our own.[11]

These remarks are extremely apposite for puppet animation, and especially for the Quays' poetics—that is, a combination of homage to appropriated art-historical and literary inspirations and a distinct artisanship in their transmutation of these into singular cinematic works of art. Unlike Cornell's boxes, Duchamp's readymades, or Schulz's or Walser's texts, the Quays' cinematic works are time-based visual media. This adds to their complexity, in that the viewer is not only confronted by the exquisite, sometimes ravaged beauty of the constructions, but she also must be capable of entering into the "deep molecular level" that is made accessible by the vitalist animated expression of the Quay Brothers' films. Their transformation of literary metaphors into objects, and then cinematic images, is ultimately a specifically poetic process of reification, in that they interpret them through concrete, material forms and constructions. Literary daydreams and perceptual epiphanies become the sets and fragmented spaces, the "dwelling places" of the puppets and metaphysical machines.

This brings us to the concept of motivation. Discussing artistic motivation, Kristin Thompson suggests two types that are meaningful in the present context:

> *Transtextual motivation,* the third of our four types [compositional, realistic, transtextual, and artistic] involves any appeal to conventions of other artworks, and hence it can be as varied as the historical circumstances allow. In effect, the work introduces a device that

is not motivated adequately within its own terms, but that depends on our recognition of the device from our past experience.[12]

Less concerned with compositional and realistic motivation, most of the Quays' works originate in transtextual and artistic motivation. Devices that we can allocate to transtextual motivation are the references they make in their films to other artists, filmmakers, and authors. Their films make reference to or are explicitly inspired by other artworks; this is why this book has explored other creative disciplines, including literature, music, illustration, and architecture. The Quay Brothers' transtextual motivation is informed by their artistic choices to transform and embed motifs familiar from these other artworks into their own style. Because of the filmmakers' intimate knowledge of the artworks they refer to in the films, the spectator's aesthetic involvement is challenged and rewarded in moments of recognition of these references. But this requires a certain familiarity with these works. Yet I would like to take this further and propose that in their disjunctive synthetic system, which incorporates the inseparable interworking of the films' devices during screening, is not simply transtextual motivation. In that the works cannot be read simply as texts, they are more transdiscursive in a Foucauldian sense, in that this concept suits the different and wide range of modalities and discourse formation and the enigmatic nature of the work.

Thompson suggests that "the *proairetic* aspect of the narrative is a chain of causality that allows us to understand how one action is linked logically to others. The hermeneutic line consists of the set of enigmas the narrative poses by withholding information."[13] *Street of Crocodiles* and other Quay Brothers' films are less committed to providing a causal chain or a logic of actions than they are to presenting a set of musically interlinked enigmas. This is the disjunctive and labyrinthine quality of their films. Since the enigmas are strongly aesthetic and poetic, the spectator's initial apprehension gives way as she engages in the pleasure of the hermeneutic and co-creational work. The Quays provide the spectator with cues that help her develop comprehension of the defamiliarized functions and new devices that are relevant for understanding films they made after *Street of Crocodiles* (as well as reflecting on earlier films). This lies in their use of conventions of live-action film, the foregrounding of the constructedness of their materials, and self-referential animation techniques. This ultimately provides a set of a posteriori knowledge for watching the Quays' other films. The vitalist, animistic aspects of their set and puppet design result from the filmmakers' deep knowledge of the related artistic and literary contexts they

are working in and to which they often refer. The labyrinth is created by innovative use of light and a disorienting montage of dialectics that leans on live-action cinema editing. And finally, tone, music, pitch, and timbre develop relational juxtapositions and emotional alliances between the music score, the organic sounds, and the imagery. This trilectic montage choreographs the interplay between the objects and spaces and suggest an abstract, yet emotionally laden musical narrative. I would put forth that these, combined with complex montage sequences to construct the realms, result in the "something completely different" that surprises their viewers.

Seen as a whole, the Quay Brothers' works are independent of any definable genre; indeed, the imitation of their style that can be observed in films of other animators are complimentary gestures to the poetics they have developed. But I suggest they do and will continue to occupy a privileged position in contemporary culture, a culture that Nelson describes:

> In our officially postreligious intellectual culture, we miss the idols, too. Just as the mad scientist still carries the negative but still highly charged projection of the holy man who would otherwise have no place in our living culture, the repressed religion is also visible in representations of puppets, robots, cyborgs, and other artificial humans in literature and film.[14]

Nelson's description has correspondences with Bennett's alternate tale to her "disenchantment tale" of contemporary life discussed in chapter 4. The Quays' figures, whether metaphysical machines, animated puppets, or actors, can and do provide access to the many meanings related to metaphysics and neoplatonic thought as discussed by Nelson that have been lost but not forgotten in our increasingly secular culture. Their films are unbound by contemporary settings, preferring to investigate what they call "a poetry of shadowy encounters and almost conspiratorial secretness." As in some of the other films Nelson mentions, the heroes of their pointedly nonreligious, yet pointedly compelling films may offer an experience of enchantment and wonder as described by Bennett.

In his recent *Deep Time of the Media,* Zielinski suggests that

> the spectrum of what is currently still referred to as media art is a training ground for mixtures of the heterogeneous. It is, therefore, a chaotic space, if one understands chaos to mean that dynamic linkage

of multifarious elements, out of chance and necessity, which is by nature opaque and out of which arise phenomena and processes that we can understand.[15]

His description of media art as a "training ground" is germane to the Quay Brothers' working method of "the liberation of the mistake." In their metaphysical playrooms, the Quays continue (to cite Benjamin from chapter 3) to "bring together, in the artifact produced in play, materials of widely differing kinds in a new intuitive [volatile] relationship." A statement from a 2001 interview holds true for the present: "What still concerns us is the language of things: the hidden . . . the invisible . . . the withheld, and how to articulate them. . . . Novalis said that in the genuine fairy tale, everything must be strange, mysterious and incoherent."[16] The formal possibilities inherent in animation can lend visualization to the dreams, inner vision, and narrative meanderings that are essential components of the Quays' cinematic transformations of text, poetry, and imagination. For the Quays, the realm of animation will continue to be a favored locus of future cinematic sojourn, expanded by other cinematic experiments, that all have human experience at their core: "Human perceptions function at such infinitely deeper and more complex levels than merely through our little intellectual, emotional or instinctive powers, and for us music is this 'otherness' that begins to carry this fabulous range. . . . But there are many meanings, not just one."[17]

The Beatification of Zero

Moving into their fourth decade of filmmaking, the Quay Brothers continue to engage with a number of early central concepts and influences. Their first encounters with Polish graphics art in the 1970s engendered an ongoing deep relationship with Poland's culture, and its film culture and production facilities were a central locus for the Quays in 2008–10. I will briefly mention a few of their projects that have recently been completed or are in production. They are great admirers of Polish director Wojciech Has's *Saragossa Manuscript* (1965), based on Polish author Jan Potocki's monumental *The Manuscript Found in Saragossa (Rękopis znaleziony w Saragossie),*[18] which convolutes and transmutes arts, cultures, genres, and the cabala in a narrative made up of multiple subnarratives. In 2008 they shot *Inventorium of Traces: Jan Potocki at Castle Łańcut (InventOrium śladów—Jan Potocki na Zamku w Łańcucie),* a film about Jan Potocki (1761–1815) set in the

Łańcut Castle that was owned by the Potocki family. The twenty-three-minute color film, inspired by Has's film, was coproduced by Polish animation filmmaker Marek Serafiński, the Polish Institute of Film Art, and Łańcut Castle with music from Krzysztof Penderecki (whose music was used for *Ein Brudermord*) and premiered in Łańcut Castle in January 2009. The Quays had access to many of the rooms closed off to visitors and the film includes about five minutes of animated sequences. In 2009 they also began work on a thirteen-minute film *Maska*, produced by the Polish Cultural Institute London and Se-ma-for Łódź. Based on a short story, "Mask" ("Maska"), by Stanisław Lem, it also features music from Penderecki. A translated synopsis announcing the Polish Film Institute funding awards suggested the Quays will pursue their interests in automata: "A fusion of poetical science-fiction, doll theater, and automates with the stylish world of opera and the music of Krzysztof Penderecki. In this universe, an automate-woman appears in a form of a robot-insect with a mission to kill her lover and fulfill her destiny"[19] (see Plate 23). *Maska*'s world premiere was March 27, 2010 at the Barbican, London. Its set design and color schemes have some affinities with the last feature film, but it has a distinctly new visual aesthetic and introduces explorations of montage and narrative.

For more than thirty years Bruno Schulz has remained a source of inspiration for the Quay Brothers. Around 1976 they made a pencil drawing that eventually translated into a scene in *Street of Crocodiles*' Antechamber (see Plate 24), and the original drawing is integrated into the set design (in the eighteenth minute). They are currently working on a new feature-length project based on his text *Sanatorium under the Sign of the Hourglass* (*Sanatorium pod klepsydrą*, 1937), which also will be made in Poland. Wojciech has filmed a version of this, known as *The Hour-Glass Sanatorium* in 1973. An eight-minute, twenty-second-long pilot film called *Fragments for Bruno Schulz* (2006) features two women: soprano Alison Bell, who performed in *The Cricket Recovers*, and dancer Zenaida Yanowsky from *Duet*, *The Sandman*, and *Eurydice—She So Beloved*. Other figures are Dr. Gotthard (Ian Nichols), a puppet (designed to be Bruno Schulz), noncompossible puppets, and a rubber band (shot in a familiar way as in *The PianoTuner of EarthQuakes* and *Eurydice*). Sets and designs include coniferous thickets, chiaroscuro-lit interiors, and endless cosmoslike skies (see Figure 24). The film is shot in widescreen in black-and-white chiaroscuro and combines live action, stop motion, and digital animation. An intertitle declares "Hommage à Walerian Borowczyk," whose influence on the Quay Brothers persists.[20] The Quays' excursion into feature films and live-action dance films are by no means an indication of a move away

Figure 24. Still from the short pilot film for *Sanatorium under the Sign of the Hourglass*, based on the eponymous text from Bruno Schulz. Copyright and courtesy of the Quay Brothers.

from animation and the literature that inspires them. On the contrary, this next film explores the potential that slumbers in the combination of these cinematic techniques.

In the 1970s, the Quays read an article in the *Times* Literary Supplement by Christopher Middleton about Robert Walser called "Portrait of a Nobody," which stimulated them to start reading Walser's short stories (that they were familiar with from Kafka's diaries). Throughout their opus, there is a progressive continuity in their artistic devotion to the marginal, to the insignificant and the unnoticed, quietly and poetically elevated and, occasionally, sublime. This is deeply informed by Walser's concept of "The Beatification of Zero," which is given form in a sculpture in *Institute Benjamenta* and given a voice in Walser's text through his protagonist Jakob. Having entered a school for servants, he comes to terms with his potential and concludes: "One thing I know for certain: in later life I shall be a charming, utterly spherical zero."[21] Provocatively, his intimate self affirms as it self-dismisses. "I feel how little it concerns me," he muses in Walser's *Institute Benjamenta*, "everything that's called 'the world,' and how grand and exciting what I privately call the world is to me."[22] The Quays suggest that "each film was a journey that had no end point, other than being at the center of it. . . . And there were all the vague impulses and tuggings in which you hope to snag some tiny fragments of some deeper, elusive form."[23] Like the "Dormitorium" exhibition of their set décors, currently touring the world,[24] the Quays also continue to travel and explore literary,

geographic, and metaphysical macro- and microcosms that find their ways into their remarkable cosmogony: "We like going for long walks, metaphorically, into whatever country we go to—we could disappear in any country"[25] (see Figure 25). On all their geographic and cinematic wanderings, the Quay Brothers, on their own or with like-minded companions, continue to pursue their own particular commitment to "The Beatification of Zero."

Figure 25. The Quays and Richard Weihe in Herisau, Switzerland, 1996. Photograph copyright of the author.

NOTES

ACKNOWLEDGMENTS

1. Eliot, "'Ulysses': Order and Myth," 175.

INTRODUCTION

1. Atkinson, "The Night Countries of the Brothers Quay," 36.
2. This is the "technic" Joyce used to describe the semantic play in "Circe," an experimental, cinematically stylistic episode of *Ulysses*.
3. Lindsay, *The Art of the Moving Picture*, 63.
4. Rancière, *Film Fables*, 8.
5. Zielinski, "Supervision und Subversion," 173–88.
6. Coates, *The Story of the Lost Reflection*, 2.
7. Deleuze, cited in Flaxman, *The Brain Is the Screen*, 370.
8. Lewis, foreword to Mitry, *Aesthetics and Psychology of the Cinema*, vii.
9. Griffiths interview, 2003.
10. Hammond, "In Quay Animation," 54.
11. Coates, *Story of the Lost Reflection*, 9.
12. See bibliography.
13. Habib, "Through a Glass Darkly: Interview with the Quay Brothers."
14. These factors are described by R. S. Crane in "Critical and Historical Principles of Literary History," in *The Idea of the Humanities,* vol. 2 (Chicago: University of Chicago Press, 1967), 45–156, cited in Bordwell, "Historical Poetics of Cinema," in Palmer, *The Cinematic Text,* 376.
15. I thank Sean Cubitt for giving me confidence in this.

16. Carroll, *On Criticism,* 13.
17. Ibid., 9.
18. I am grateful to Thomas Lamarre for his insightful suggestion of these concepts.
19. Deleuze and Guattari, *Anti-Oedipus,* 11.
20. Ibid., 13–14.
21. Schreber, "Daniel Paul Schreber," 301–12.
22. Quay Brothers, "In Deciphering the Pharmacist's Prescription," 1.
23. Andrew, "The Neglected Tradition of Phenomenology in Film Theory," 47.
24. Ibid., 49.
25. Ibid., 45.
26. Ibid., 46.
27. Merleau-Ponty, *Phenomenology of Perception,* xxii–xxiii.
28. Sobchack, *Address of the Eye,* xvii.
29. Ibid., xviii.
30. Deleuze, cited in Flaxman, *The Brain Is the Screen,* 370.
31. Jarvie, *Philosophy of the Film,* 54.
32. Ibid., 55.
33. Mitry, 1965, 453–54, in Sobchack, *Address of the Eye,* 5. Translation Sobchack.
34. Thompson, *Breaking the Glass Armor,* 43.
35. Shklovsky, in "Art and Technique," in Lodge, *Modern Criticism,* 20.
36. Andrew, "Neglected Tradition of Phenomenology in Film Theory," 45.
37. Bordwell, in Palmer, *The Cinematic Text,* 371.
38. Moran, *Introduction to Phenomenology,* 5.

1. AUTHENTIC TRAPPERS IN METAPHYSICAL PLAYROOMS

1. Robinson, interview with the Quay Brothers.
2. McClatchy, "Movie Magic: The Quay Brothers," 93.
3. Nichols Goodeve, "Dream Team," 83.
4. Griffiths interview, 2003. Unless otherwise indicated, all quotations of Griffiths without references in this book are from three interviews with Griffiths in August and November 2002 and September 2003.
5. McClatchy, "Movie Magic," 94.
6. For example, a review from Maureen Callahan in the *New York Magazine,* 1996.
7. Quay Brothers' correspondence with Chris Robinson.
8. Ibid.
9. McClatchy, "Movie Magic," 94.
10. Ibid.
11. Ibid., 93.
12. Quay Brothers interview, 1992.
13. Ibid.
14. McClatchy, "Movie Magic," 93.
15. Robinson, interview with the Quay Brothers.
16. Le Fanu, "Modernism, Eccentrism," 135.
17. Ibid.
18. Nelson, *Secret Life of Puppets,* 97.
19. Ibid., 77.
20. Griffiths interview, 1996.
21. *Screen* was initially established as *Screen Education* in 1969 and remains an influential film studies journal that emerged concurrently with the film cooperative movements.

22. Nichols Goodeve, "Dream Team," 85.
23. Quay Brothers' correspondence with Chris Robinson.
24. Quay Brothers interview, 2003.
25. Promotional flier for the film, BFI, undated, author uncredited.
26. Correspondence with the author, July 2003.
27. Le Fanu, "Modernism, Eccentrism," 136.
28. Aita, "Brothers Quay: In Absentia."
29. Le Fanu, "Modernism, Eccentrism," 136.
30. Wyver is currently head of Illuminations Media, an association of independent production companies (including Griffiths's) that specialize in television, film, and multimedia productions.
31. Dickinson, *Rogue Reels,* 62.
32. Quay Brothers' correspondence with Chris Robinson.
33. Collaboration with schemes such as the Museum of the Moving Image and the Arts Council of Great Britain (from which Arts Council England sprung in 1994, emphasizing experimental and independent animation) also ensured that all types of animation from all parts of the community—large and small studios, independents, low-budget work—would be represented.
34. Quay Brothers' correspondence with Chris Robinson.
35. See Kitson, *British Animation,* for a detailed account of this and other Channel Four productions.
36. Quay Brothers interview, 1996.
37. H. Stewart, *BFI Animation Catalogue 1993/94,* 45.
38. Quay Brothers interview, 1996.
39. Ibid.
40. E-mail from Keith Griffiths, 2009.
41. Marks, *Touch,* 129.
42. Nelson, *Secret Life of Puppets,* 61.
43. Definition of entelechy from Merriam-Webster Online, sourced April 3, 2010.
44. Lawson-Tancred, in Aristoteles, *De Anima,* 59.
45. Ibid., 68–69.
46. Plantinga, "The Real Meaning of Kant," unpaginated.
47. See Safranski, *Schopenhauer und die wilden Jahre der Philosophie,* 299–312.
48. Schopenhauer, "Essay on Spirit Seeing and Everything Connected Therewith," 301.

2. PALIMPSESTS, FRAGMENTS, VITALIST AFFINITIES

1. Petley, "The Cabinet of Jan Svankmajer," 34–35.
2. Quay Brothers interview, 2000.
3. Atkinson, "The Night Countries of the Brothers Quay," 36.
4. Nichols Goodeve, "Dream Team," 85.
5. Quay Brothers' correspondence with Chris Robinson.
6. Quay Brothers interview, 1992.
7. Some of these ideas evolved in conversation with Richard Weihe, to whom I am grateful.
8. Hayman, in Rowell, *Antonin Artaud,* 20–24.
9. Artaud, *Collected Works,* vol. 2, 197.
10. Anderson was fascinated by Hoban's anarchic experimentation with language and used a variety of techniques to visualize Hoban's transgendered, destructive character Deadsy.

11. This remark was transcribed from an interview that is part of a *Connoisseur* video compilation on David Anderson's works.
12. Arnheim, *Film as Art*, 170. Author emphasis.
13. S. Stewart, *On Longing*, xi.
14. Ibid., xi–xii.
15. Quay Brothers, "On Deciphering the Pharmacist's Prescription," 1.
16. Benjamin, in *Selected Writings*, 408.
17. Habib, "Through a Glass Darkly."
18. PONS Englisch-Deutsch Kompaktwörterbuch, 1991.
19. Eisenstein, *Film Form*, 48–63.
20. Schulz, *The Street of Crocodiles*, 102.
21. Whittock, *Metaphor and Film*, 25–29.
22. For an explanation of Joyce's cineantics (his literary/cinematic antics), see Buchan, "Graphic and Literary Metamorphosis: Animation Technique and James Joyce's *Ulysses*."
23. Ellmann, *James Joyce*, 561.
24. Ricoeur, *Time and Narrative*, 77.
25. E-mail correspondence with Fritz Senn, 2009.
26. Senn, *Joyce's Dislocutions*, 211. The reference (FW 419.25) within the quote is to page and line numbers of Joyce's last work, *Finnegans Wake*.
27. Ibid.
28. For an extended treatment of Joyce's cinematic language, see Buchan, "Literary Cineantics: Cinematic Metamorphosis in James Joyce's *Ulysses*."
29. Senn, *Nichts Gegen Joyce*, 33. Author translation.
30. Deleuze, *The Logic of Sense*, 46.
31. Joyce, *Ulysses*, 126.
32. Deleuze, *Logic of Sense*, 83.
33. Costa, *Quay Brothers*, 45.
34. In narratology, the actant has a range of definitions. I am using it here in the sense that an actant may be a character or a participant, or a system of participants, in a story.
35. The book was inspired by Baltasar Gracián's *Oráculo manual y arte de prudencia* (1647, *The Art of Worldly Wisdom*) that Schopenhauer translated into German as *Hand-Orakel und Kunst der Weltklugheit* (1862).
36. Schopenhauer, *Die Kunst, Glücklich zu Sein*, 28.
37. S. Stewart, *On Longing*, xi.
38. Nichols Goodeve, "Dream Team," 85.
39. Dutsch, in *Bruno Schulz (Band 2)*, 361.
40. Dutsch, in *Bruno Schulz (Band 1)*, 349ff.
41. Ficowski, *Regions of the Great Heresy*, 72.
42. Reitz, "Liberating the Critical in Critical Theory" (undated, unpaginated).
43. Adorno, *Minima Moralia*, 33.
44. Costantini, "De Artificiali Perspectiva."
45. McClatchy, "Movie Magic," 93.
46. Gide, cited in Wagenbach, *Kafka*, 144. Author translation.
47. Wagenbach, *Kafka*, 50–56. Author translation.
48. Ibid., 135. Author translation.
49. Kierkegaard, cited in Wagenbach, *Kafka*, 76.
50. Middleton, in Walser, *Institute Benjamenta*, 137.
51. Hamm, "Ich bin nichts als ein Horchender," 17. Author translation.
52. Ibid.
53. Middleton, in Walser, *Jakob von Gunten*, 13.

54. Nelson, *Secret Life of Puppets,* 107.
55. Ibid., 110.
56. Goldfarb, "A Living Schulz," 28.
57. Compared to Celina Wieniewska's rather thin English translation of *Sklepy cynamonowe* into the English *The Street of Crocodiles,* Josef Hahn's superlative German translation is a beautifully rendered version that expresses Schulz's rich use of description and his lyrical style.
58. Aita, "Brothers Quay: In Absentia."
59. Schulz, *Letters and Drawings,* 47.
60. Ibid., 11.
61. Quay Brothers interview, 1992.
62. Goldfarb, "A Living Schulz," 27–28. Footnote 10 in Goldfarb's text. Notable exceptions are Teresa and Jerzy Jarzębski, "Uwagi o semantyce przestrzeni i czasu w prozie Brunona Schulza," in *Studia o prozie Brunona Schulza* (Katowice, 1976), 49–73, and Jerzy Jarzębski's Introduction to Bruno Schulz, *Opowiadania, wybór esejów i listów,* ed. Jerzy Jarzębski, B.N., ser. I, nr. 264 (Wrocław, 1990).
63. At the Fantoche Animation Festival's preselection in 2003, fourteen of the entered films could be described as Quay-derivative.
64. Atkinson, "The Night Countries of the Brothers Quay," 36.
65. Quay Brothers interview, 1996.
66. Schulz, *The Street of Crocodiles,* 100.
67. Wollen, *Signs and Meaning in the Cinema,* 113.
68. Nelson, *Secret Life of Puppets,* 110–11.
69. S. Stewart, *On Longing,* xiii.
70. Deleuze, *Logic of Sense,* 83.
71. Goldfarb, "A Living Schulz," 33. Footnote 23 refers to Jerzy Jarzębski's Introduction to Bruno Schulz, *Opowiadania, wybór esejów i listów,* ed. Jerzy Jarzębski, B.N., ser. I, nr. 264 (Wrocław, 1990).
72. Nelson, *Secret Life of Puppets,* 112.
73. Schulz, *The Street of Crocodiles,* 100.
74. Goldfarb, "A Living Schulz," 34.
75. Jarvie, *Philosophy of the Film,* 55.
76. Quay Brothers interview, 1992.
77. Schulz, *The Booke of Idolatry,* 115–16.
78. Quay Brothers, "In Deciphering the Pharmacist's Prescription," 1.
79. Goldfarb, "A Living Schulz," 43–44.
80. Aita, "Brothers Quay: In Absentia."
81. Goldfarb, "A Living Schulz," 35.
82. Quay Brothers interview with Jo Jürgens (undated).
83. "Treatise on Tailors' Dummies, or the Second Book of Genesis"; "Treatise on Tailors' Dummies: Continuation"; and "Treatise on Tailors' Dummies: Conclusion," in Schulz, *The Street of Crocodiles,* 51–71.
84. Nelson, *Secret Life of Puppets,* 71.
85. Schulz, *The Street of Crocodiles,* 59.
86. Quay Brothers, "In Deciphering the Pharmacist's Prescription," 1.
87. Schulz, *The Street of Crocodiles,* 66.
88. Quay Brothers, "In Deciphering the Pharmacist's Prescription," 1.
89. Schulz, *The Street of Crocodiles,* 66.
90. Rosenfeld, "The Last Alchemist," 1755.
91. Oklot, "Maturing into Childhood," 34. Cf. Jarzębski, *Bruno Schulz, Opowiadania,* xxx.
92. Schopenhauer, *The World as Will and Representation,* vol. 1, 350.

93. Ibid.
94. Ficowski, *Regions of the Great Heresy,* 76.
95. Schopenhauer, *The World as Will and Representation,* 349.
96. Goldfarb, "A Living Schulz," 30.
97. Ibid., 43.

3. TRAVERSING THE ESOPHAGUS

 1. Ficowski, *Regions of the Great Heresy,* 84.
 2. Goldfarb, "A Living Schulz," 33.
 3. Ramirez, cited in Affron, *Sets in Motion,* 31.
 4. See Buchan, "The Animated Spectator: Watching the Quay Brothers' 'Worlds.'"
 5. Quay Brothers' correspondence with Chris Robinson.
 6. Quay Brothers interview, 1992.
 7. Brooke, *Quay Brothers: The Short Films 1979–2003,* 10.
 8. Quay Brothers interview, 1996.
 9. Quay Brothers interview, 1992.
10. Grodal points out that this is a means to manipulate by montage and argues there are finer nuances in facial expressions that inform our understanding of a subject actant (89ff).
11. Quay Brothers interview, 1996.
12. Bachelard, *The Poetics of Space,* 86.
13. Baudelaire, "The Philosophy of Toys," 16.
14. S. Stewart, *On Longing,* 54.
15. Ibid., 46.
16. Ibid.
17. Sontag, *On Photography,* 15.
18. S. Stewart, *On Longing,* 55.
19. Quay Brothers interview, 1992.
20. Marks, *Touch,* 13.
21. Marks, *The Skin of the Film,* 193.
22. Stewart, *On Longing,* 55.
23. Todorov, *The Fantastic,* 31–33.
24. Ibid.
25. Quay Brothers interview, 1992.
26. Burch, *Theory of Film Practice,* 17–21.
27. Quay Brothers interview, 1992.
28. Burch, *Theory of Film Practice,* 21.
29. Ibid., 21–22.
30. Weihsmann, *Cinetecture,* 56. Author translation.
31. A. Souriau, "Fonctions filmiques des costumes et des décors," 100.
32. Nelson, *Secret Life of Puppets,* 16.
33. Vidler, *The Architectural Uncanny,* ix.
34. Sontag, *On Photography,* 19.
35. Sanders, *Wörterbuch der Deutschen Sprache,* 729.
36. Vidler, *Architectural Uncanny,* 24.
37. Freud, "The Uncanny," *S.E.* 17:219–56.
38. Vidler, *Architectural Uncanny,* 11.
39. Bordwell, *Making Meaning,* 2.
40. I am indebted to Mark Bartlett for this observation.

41. E-mail exchange with Mark Bartlett, 2007.

42. Vidler, *Architectural Uncanny,* ix.

43. Ibid., xi.

44. In 1953 UPA made *The Tell-Tale Heart,* based on the eponymous story by Poe, whose Gothic horror also evokes the uncanny. The expressionistic graphic design is entirely in keeping with the vertiginous sense of Poe's tale.

45. Vidler, *Architectural Uncanny,* 27–28.

46. Ibid., 28.

47. Schulz, *The Street of Crocodiles,* 101.

48. Foster, *Compulsive Beauty,* 21.

49. Ibid.

50. Freud, "The Uncanny," *S.E.* 17:241.

51. Ibid., 240.

52. O'Pray, "Eisenstein and Stokes on Disney: Film Animation and Omnipotence," 200.

53. Freud, "The Uncanny," *S.E.* 17:247–48.

54. Ibid., 249.

55. Nelson, *Secret Life of Puppets,* vii.

56. Atkinson, "The Night Countries of the Brothers Quay," 39.

57. Nichols Goodeve, "Dream Team," 84.

58. Quays, in Rust Gray, *The Audible Filament [Hearing the Brothers Quay],* unpaginated.

59. Hollingsworth, ThingReviews.

60. The exhibition has been displayed at venues around the world, recently in New York's Parsons The New School for Design, July–October 2009.

61. Quay Brothers interview, 1996.

4. PUPPETS AND METAPHYSICAL MACHINES

1. Schulz, *The Street of Crocodiles,* 51–71.

2. Weihe, *Die Theater-Maschine,* 39.

3. Quay Brothers, "In Deciphering the Pharmacist's Prescription," 1.

4. E-mail correspondence with the Quay Brothers, 2009.

5. Quay Brothers' correspondence with Chris Robinson.

6. Goodman, *Languages of Art,* 33.

7. Nelson, *Secret Life of Puppets,* xi.

8. Ibid., 64.

9. "Über das Marionettentheater," first published December 13, 1810, in the *Berliner Abendblätter.*

10. Kleist, "On the Marionette Theatre," 3.

11. Mitry, *Aesthetics and Psychology of the Cinema,* 45.

12. Weihe, "Strings of the Marionette," 41.

13. Kleist, "On the Marionette Theatre," 5–6.

14. Ibid., 7.

15. Ibid., 12.

16. Mitry observed that "animation, because it is composed to the rhythm of a score, is opening up promising areas of exploration" (*Aesthetics and Psychology of the Cinema,* 254.) Considering the original French text was published in 1963, it is remarkable how little critical exploration has been done in this area.

17. Ibid., 254–55.

18. Ibid., 255.

19. Bordwell and Thompson, *Film Art,* 157–58.

20. Mitry, *Aesthetics and Psychology of the Cinema,* 50.
21. Arnheim, *Film as Art,* 170.
22. Wollen, *Signs and Meaning in the Cinema,* 105.
23. Ibid., 106.
24. S. Stewart, *On Longing,* 60.
25. Artaud, in Sontag, *Selected Writings of Antonin Artaud,* 215–27. I thank Mark Bartlett for suggesting this text to me.
26. Ibid.
27. Foster, *Compulsive Beauty,* 21.
28. Habib, "Through a Glass Darkly."
29. Atkinson, "The Night Countries of the Brothers Quay," 44.
30. Schulz, *The Street of Crocodiles,* 102.
31. Quay Brothers interview, 1992.
32. Ibid.
33. Ibid.
34. Atkinson, "The Night Countries of the Brothers Quay," 40.
35. Aita, "Brothers Quay."
36. This is also one of a few sequences where it is apparent that the Quays animated in reverse: the pinholes in the Tailor's dressmaking paper are visible in rows *before* the pins are inserted, i.e., as the pins are inserted into the puppet and the liver, the holes "disappear" below them.
37. Quay Brothers interview, 1992.
38. Grodal, *Moving Pictures,* 110.
39. For a more detailed discussion of this, see Wells, "Body Consciousness in the Films of Jan Švankmajer."
40. Schulz, *The Street of Crocodiles,* 59.
41. Goodman, *Languages of Art,* 50.
42. Ibid., 25.
43. Brinckmann, *Die anthropomorphe Kamera,* 265. Author translation.
44. Tan, "Geschichtsausdruck und Emotion in Comic und Film," in Brütsch, Hediger et al., 2005, 265. Author translation.
45. Tan, *Emotion and the Structure of Narrative Film,* 2.
46. Grodal, *Moving Pictures,* 89.
47. Nelson, *Secret Life of Puppets,* 86.
48. Ibid., 205–6.
49. Grodal, *Moving Pictures,* 93.
50. Ibid., 92–93.
51. The behavioral anthropologist Konrad Lorenz suggested that human perception of infantlike appearance that is dominant in higher animals and humans triggers an instinctual urge to care.
52. Quay Brothers interview, 1992.
53. Viennese psychiatrist Richard von Krafft-Ebing was one of the founders of scientific sexology, and he is credited with coining the terms *sadism* and *masochism.* His *Psychopathia Sexualis* (1882) documents abnormal aspects of sexuality.
54. Grodal, *Moving Pictures,* 92.
55. Ibid., 106.
56. Ibid.
57. Ibid.
58. Ibid.
59. Bennett, *The Enchantment of Modern Life,* 3–5.
60. Ibid., 4.

61. Press kit, *The PianoTuner of EarthQuakes*.
62. Bennett, *The Enchantment of Modern Life*, 5.
63. Ibid.
64. Greco, "On the Vitality of Vitalism," 18.
65. Bennett, *The Enchantment of Modern Life*, 17.
66. Ibid.
67. Quay Brothers interview, 1996.
68. Vidler, *Architectural Uncanny*, xi.
69. Ibid., 69–70.
70. Müller-Tamm, *Puppen Körper Automaten*, 67. Author translation.
71. Romney, "The Same Dark Drift," 25.
72. Ferrell, "Life-Threatening Life: Angela Carter and the Uncanny," 133.
73. Baudrillard, *Simulations*, 93.
74. Quay Brothers interview, in Wright, *Navigating a Metaphorical Zone*, 13.
75. This movement was inspired by the Quays' observation of an aquatic salamander called the axolotl. See "A Quay Brothers Dictionary" in Brooke, *Quay Brothers*, 2.
76. Quay Brothers interview, 1992.
77. Schulz, *The Street of Crocodiles*, 61–62.
78. Ibid.
79. Whittock, *Metaphor and Film*, 50.
80. Ibid., 15. Author emphasis.
81. Short, cited in Bradbury, *Modernism*, 302–3.
82. Ibid.
83. Carroll, *Theorizing the Moving Image*, 214.
84. Ibid., 213.
85. Joyce, *Ulysses*, 252.
86. Carroll, *Theorizing the Moving Image*, 213–14.
87. Deleuze and Guattari, *Anti-Oedipus*, 2.
88. Carroll, *Theorizing the Moving Image*, 217.
89. Ibid., 216.
90. Quay Brothers interview, 1992.
91. Carroll, *Theorizing the Moving Image*, 219.

5. NEGOTIATING THE LABYRINTH

1. Quay Brothers interview, 1992.
2. Deussing, "The Brothers Quay."
3. Quay Brothers interview, 1992.
4. Ibid.
5. Ibid.
6. Dieckmann, "Double Visionaries," 31.
7. Quay Brothers in Wright, *Navigating a Metaphorical Zone*, 2.
8. Ernst, Max. "Au delá de la peinture," 31.
9. Kinetic sculptures such as those in Laszló Moholy Nagy's films or Gregory Barsamian's extracinematic strobe-lit sculptures are examples of kinetic art, but the movement is not animated. See Barsamian, "Extracinematic Animation: Gregory Barsamian in Conversation with Suzanne Buchan," *Animation: An Interdisciplinary Journal* 3 (no. 3): 288–305.
10. Quay Brothers interview, 1992.
11. Lamos, *Deviant Modernism*, 20.

12. Quay Brothers, "In Deciphering the Pharmacist's Prescription," 1.
13. Reisz, *Technique of Film Editing,* 112.
14. Ibid., 113.
15. Monaco, *How to Read a Film,* 183.
16. Reisz, *Technique of Film Editing,* 36. Eisenstein's quote is from *Film Form,* 62.
17. Atkinson, "The Night Countries of the Brothers Quay," 13.
18. Quay Brothers interview, 1992.
19. Ibid.
20. Atkinson, "The Night Countries of the Brothers Quay," 13.
21. Quay Brothers interview, 1996.
22. Ibid.
23. Atkinson, "The Night Countries of the Brothers Quay," 37.
24. Burch, *Theory of Film Practice,* 13.
25. Ibid., 44.
26. Quay Brothers interview, 1996.
27. Ibid.
28. Nichols Goodeve, "Dream Team," 84.
29. Deleuze, cited in Flaxman, *The Brain Is the Screen,* 368.
30. Quay Brothers interview, 1996.
31. Ibid.
32. Ibid.
33. Quay Brothers interview, 1992.
34. Ibid.
35. Quay Brothers interview, 1996.
36. Nichols Goodeve, "Dream Team," 84.
37. Quay Brothers interview, 2003.
38. Nichols Goodeve, "Dream Team," 84.
39. Aita, "Brothers Quay."
40. Ibid.
41. These and other animated techniques used by the Quays (single-frame oscillation, animation of sunlight) makes it almost impossible to isolate indicative stills of these scenes.
42. Wees, *Light Moving in Time,* 75.
43. Marks, *Touch,* 131.
44. Brinckmann, *Die anthropomorphe Kamera,* 280. Author translation.
45. Marks, *Touch,* 8.
46. Costa, *Quay Brothers,* 46.
47. Marks, *Touch,* 3.
48. Quay Brothers, "In Deciphering the Pharmacist's Prescription," 2.
49. Bordwell and Thompson, *Film Art,* (1993), 247.
50. Examples include Alain Resnais's 1961 *L'année dernière à Marienbad (Last Year at Marienbad),* many of Paul Sharits's structural and flicker film experiments, and Robert Breer's collage film *Recreation* (1956–57).
51. Stam et. al., *New Vocabularies in Film Semiotics,* 34.
52. Quay Brothers, "In Deciphering the Pharmacist's Prescription," 2.
53. Quay Brothers interview, 1992.
54. Manovich, *The Language of New Media,* 262.
55. Correspondence with the author, 2003.
56. Quay Brothers interview, 1992.
57. Costa, *Quay Brothers,* 46.
58. Quay Brothers interview, 2003.

59. Griffiths interview, November 2003.
60. Quay Brothers, "In Deciphering the Pharmacist's Prescription," 2.
61. Quay Brothers interview, 1992.
62. Matthews, *Languages of Surrealism,* 133.

6. THE SECRET SCENARIO OF SOUNDSCAPES

1. Nichols Goodeve, "Dream Team," 83.
2. Quay Brothers, "In Deciphering the Pharmacist's Prescription,"1.
3. Quay Brothers interview, 1996.
4. Quay Brothers, "In Deciphering the Pharmacist's Prescription," 1.
5. Quays Brothers interview, 1996.
6. Ibid.
7. Ibid.
8. Hamm, "'Ich bin nichts als ein Horchender': Robert Walser und die Musik." Author translation.
9. Quay Brothers, "In Deciphering the Pharmacist's Prescription," 2.
10. Quays Brothers interview, 1992.
11. Ibid.
12. Quay Brothers, "In Deciphering the Pharmacist's Prescription," 3.
13. Quay Brothers interview, 1994.
14. Chion, *Audio-Vision,* 13.
15. Ibid., 17–18.
16. Burch, *Theory of Film Practice,* vi–vii.
17. Like Burch, I also read *Finnegans Wake* "aloud for the sound." Burch, *Theory of Film Practice,* viii.
18. Russolo, *The Art of Noises,* 37.
19. Kahn, *Noise Water Meat,* 3.
20. Chion, *Audio-Vision,* 5.
21. Ibid., 8.
22. Ibid.
23. Ibid., 115.
24. Russolo, *The Art of Noises,* 37.
25. Kahn, *Noise Water Meat,* 82.
26. Bordwell and Thompson, *Film Art* (2008): 267ff.
27. Kahn, *Noise Water Meat,* 80.
28. Ibid., 81.
29. Kahn, in Clarke and Dalrymple Henderson, *From Energy to Information,* 179.
30. Reisz, *The Technique of Film Editing,* 64.
31. Kahn, *Noise Water Meat,* 11.
32. Eisenstein et al., in Eisenstein, *Film Form,* 257–60.
33. Chion, *Audio-Vision,* 91.
34. Kahn, *Noise Water Meat,* 148–51.
35. Quay Brothers interview in Rust Gray, *The Audible Filament [Hearing the Brothers Quay],* unpaginated.
36. Quay Brothers, "In Deciphering the Pharmacist's Prescription," 3.
37. Kahn, *Noise Water Meat,* 43.
38. Schaeffer, *Traité des objets Musicaux,* 91–99.
39. Chion, *Audio-Vision,* 72.
40. Fischer, "Enthusiasm," 247–64.

41. Quay Brothers interview, in Rust Gray, *The Audible Filament,* unpaginated.
42. Kahn, *Noise Water Meat,* 146; emphasis in original.
43. Ibid., 147.
44. Eisenstein, *Film Form,* 21.
45. Eisenstein, *Selected Works,* 119.
46. Kahn, *Noise Water Meat,* 155.
47. Ibid.
48. Costantini, "De Artificiali Perspectiva," 45.
49. Ibid.
50. Marks, *The Skin of the Film,* 183.
51. Quay Brothers interview, in Rust Gray, *The Audible Filament,* unpaginated.
52. Ibid.
53. Kahn, *Noise Water Meat,* 20.
54. Russolo, *The Art of Noises,* 37.
55. Quays Brothers interview, in Rust Gray, *The Audible Filament,* unpaginated.
56. Kahn, *Noise Water Meat,* 18.
57. Marks, *The Skin of the Film,* 183.
58. Larry Sider interview, in Rust Gray, *The Audible Filament,* unpaginated.
59. Ibid.
60. Ibid.
61. Kahn, *Noise Water Meat,* 21.
62. Singular exceptions to this may be Oskar Fischinger's sound scrolls or Norman McLaren's, and more recently, Richard Reeves' scratching directly onto film's sound track to create optical sound.
63. Quays Brothers interview, 1996.
64. Kahn, *Noise Water Meat,* 181. Citation within quote is from John Cage, in Kostelanetz, *John Cage,* 81.
65. Burch, *Theory of Film Practice,* 26–27.
66. Costantini, "De Artificiali Perspectiva," 47.
67. Chion, *Audio-Vision,* 27.
68. Ibid., 27.
69. Mitry, *Aesthetics and Psychology of the Cinema,* 255.
70. Kahn, *Noise Water Meat,* 25.
71. Chion, *Audio-Vision,* 58.
72. Ibid., 29–30.
73. Kahn, *Noise Water Meat,* 20.
74. Eisenstein, *Film Form,* 20.
75. Artaud, in Sontag, *Selected Writings of Antonin Artaud,* 216.
76. Schulz, *The Street of Crocodiles,* 108–9.
77. Quay Brothers interview, 1992.
78. Bazin, *What Is Cinema?,* 27.
79. Costantini, "De Artificiali Perspectiva," 47.
80. Eisenstein, *Selected Works,* 118.
81. Quay Brothers, "In Deciphering the Pharmacist's Prescription," 3.
82. I am indebted to Mark Bartlett for this analogy.
83. Quay Brothers, "In Deciphering the Pharmacist's Prescription," 3.
84. Quay Brothers interview, 1994.
85. Atkinson, "The Night Countries of the Brothers Quay," 36.
86. http://www.16horsepower.com/videovision1998.html, http://www.fembot.com/content/live/97-09-05/chat/Penn,_Michael.html, http://www.triskaidekaphobia.com/one.php/one/hnia/10/.
87. Deussing, "The Brothers Quay."

1. The dedications read: "These décors have been engraved with great modesty and dedicated to London Underground as part of its present evangelical rampage" and "And to the anonymous anatomical specimen—to the single still dreaming hair on its brow with its desire to disturb the wallpaper O INEVITABLE FATUM."
2. Atkinson, "The Night Countries of the Brothers Quay," 39.
3. One wonders if the Quays were familiar with Jean Cocteau's 1927 play *La voix humaine,* a stage monologue for a single actress that was staged as a one-sided phone conversation with an absent departing lover.
4. Crisp, "The Dybbuk."
5. The production toured thereafter, including at the English National Opera, in London 1989 and was revived in 1990.
6. Shuttleworth, "Le Bourgeois Gentilhomme."
7. Nichols Goodeve, "Dream Team," 84.
8. Wright, *Navigating a Metaphorical Zone,* 45.
9. Nichols Goodeve, "Dream Team," 84.
10. Art on Screen Database.
11. Quay Brothers interview, 2003.
12. See Art on Screen Database for the full record.
13. *Anamorphosis* won an honorable mention at the American Film and Video Festival in 1992, and was nominated for an award at the British Academy of Film/Television Arts Animation Category in the same year.
14. The segment they worked on is well documented in Noake, *Animation.*
15. Brooke, *Quay Brothers,* 7.
16. *Stille Nacht II, Stille Nacht IV,* and *Stille Nacht V* can be viewed at http://www.academyfilms.com.
17. Quay Brothers interview, in Rust Gray, *The Audible Filament,* unpaginated.
18. Atkinson, "The Night Countries of the Brothers Quay," 37.
19. Costa, *Quay Brothers,* 46.
20. O'Brien, "The Ghost at the Feast."
21. McBurney, "The Chairs."
22. Synopsis, International Film Festival Rotterdam.
23. Quay Brothers interview, 2003.
24. Costa, "Quay Brothers," 2001.
25. See Believe Media and Academy Films Web sites.
26. Quay Brothers interview, 2003.
27. Director's report to the National Advisory Council on Drugs, September 1995.
28. Quay Brothers interview, 2003.
29. Ibid.
30. Comment on VHS cover of the BFI *Connoisseur* VHS publication.
31. Griffiths interview, 2003.
32. Quay Brothers interview, in Rust Gray, *The Audible Filament,* unpaginated.
33. Molnáar, "Nicht Wolf und nicht Mensch in der Klang-Geisterbahn." Author translation.
34. Ibid. Author translation.
35. Kahn, *Noise Water Meat,* 26.
36. Quay Brothers interview, 1996.
37. Ibid.
38. Rhodes, *Outsider Art,* 22.
39. Hames, *Dark Alchemy,* 89.

40. See Hirschfeld, *Sexual Anomalies.*
41. Prinzhorn, *Artistry of the Mentally Ill,* 270.
42. Quay correspondence with Chris Robinson, 2001.
43. Aita, "Brothers Quay."
44. Habib, "Through a Glass Darkly."
45. The Ensemble Sospeso New York.
46. Habib, "Through a Glass Darkly."
47. Howell, "Chekhov's Shorts and The Queen of Spades soar."
48. The exhibition was curated by Ken Arnold and Danielle Olsen and designed by Caruso St. John.
49. Chrichton-Miller, "Welcome to Wellcome."
50. "Tate and Egg Live" Web site.
51. Martland, "Life after Death."
52. Hans Christian Andersen, 2005 Web site.

8. THESE THINGS NEVER HAPPEN BUT ARE ALWAYS

1. Quay Brothers' correspondence with Chris Robinson, 2001.
2. Quay Brothers interview, 1996.
3. Ibid.
4. Ibid.
5. Romney, "Life's a Dream," 12.
6. Quay Brothers' correspondence with Chris Robinson, 2001.
7. Atkinson, "The Night Countries of the Brothers Quay," 38.
8. Walser, *Institute Benjamenta,* 87.
9. Quay Brothers interview, 1996.
10. Nichols Goodeve, "Dream Team," 85.
11. Quay Brothers interview, 1996.
12. Ibid.
13. Eisenstein, *Film Form,* 21.
14. Quay Brothers interview, 1996.
15. Ficowski, in Schulz, *The Street of Crocodiles,* 10–11.
16. Quay Brothers' correspondence with Chris Robinson, 2001.
17. Ibid.
18. Marks, *Touch,* 127.
19. "Sleepwalkers of Daylight.'"
20. Quay Brothers, "Ten Unproduced Scenarios."
21. The character is named after Swiss Pierre Jaquet-Droz, creator of numerous automata in the eighteenth century. Best known is "The Writer" (ca. 1768).
22. Arne Höhne. Presse und Öffentlichkeit Web site.
23. This is the first time the Quays collaborated with an art director; this role was assigned to Eric Veenstra.
24. In the permanent exhibition of the Magical Museum of Jurassic Technology in Los Angeles, there is a display of *Megolaponera foetens* (stink ant of the Cameroon of West Central Africa). The description of its encounter with a fungal spore is almost identical to Droz's story.
25. Costantini, "De Artificiali Perspectiva."
26. Ndalianis, *Neo-Baroque Aesthetics and Contemporary Entertainment,* 62.
27. Marks, *Touch,* 132.

28. Nelson, *Secret Life of Puppets,* 214.
29. Ibid.
30. Massumi, "(Involuntary Afterword)," 748.
31. Marcuse, *The Aesthetic Dimension,* 73.
32. Hegerfeldt, *Lies That Tell the Truth,* 51.
33. Nelson, *Secret Life of Puppets,* 215.
34. Press kit, *PianoTuner of EarthQuakes.*
35. Nelson, *Secret Life of Puppets,* 216.
36. Ibid.
37. Quay Brothers' correspondence with Chris Robinson.
38. Deleuze and Guattari, *Anti-Oedipus,* 19.
39. Bogue, *Deleuze on Literature,* 69.
40. Deleuze and Guattari, 2004, 19.
41. Ibid.
42. Ibid.
43. Nelson, *Secret Life of Puppets,* 216.
44. Ibid., x.
45. Quay Brothers' correspondence with Chris Robinson.
46. Nichols Goodeve, "Dream Team," 118.
47. Vidler, *The Architectural Uncanny,* 13.

CONCLUSION

1. Turvey, in Allan and Smith, *Film Theory and Philosophy,* 433.
2. The themes of sensuality, pathosexuality, and eroticism in their films have only been touched upon here, and I plan to engage with them more intensely in the future.
3. Nelson, *Secret Life of Puppets,* vii.
4. I thank Sean Cubitt for his observation, of my intent, namely, that this book does not attempt to make a definitive statement about the Quays' work.
5. Schulz, *The Street of Crocodiles,* 125–39.
6. Habib, "Through a Glass Darkly."
7. Goeppert and Goeppert, *Sprache und Psychoanalyse,* 79.
8. Deleuze, cited in Flaxman, *The Brain Is the Screen,* 370.
9. Sobchack, "Nostalgia for a Digital Object."
10. Footnote 8 in Sobchack, 1999: "The phrase here, as well as thoughts about the animated film's struggle to achieve—and to not achieve—this illusion, is derived from Alan Cholodenko, ed., *The Illusion of Life: Essays on Animation* (Sydney: The Australian Film Commission/Power Publications, 1991)."
11. Sobchack, "Nostalgia for a Digital Object."
12. Thompson, *Breaking the Glass Armor,* 18.
13. Ibid., 39.
14. Nelson, *Secret Life of Puppets,* 20.
15. Zielinski, *Deep Time of the Media,* 277–78.
16. Quay Brothers' correspondence with Chris Robinson.
17. Quay Brothers, in Rust Gray, *The Audible Filament,* unpaginated.
18. The complete novel's first publication, in French, was after Potocki's death and the date remains unclear. A Polish translation was made in 1847, and an English translation published in 1995.
19. Filmneweurope Web site.

20. At the Aurora 2006 festival in Norwich, UK, Daniel Bird discussed Borowczyk's genius and influence with the Quay Brothers and Andrzej Klimowski.
21. Walser, *Institute Benjamenta,* 6.
22. Ibid., 96.
23. Quay Brothers' correspondence with Chris Robinson.
24. The exhibition has been displayed in Rotterdam, Riga, Exeter, Lisbon, the Festival D'Avignon, Tokyo, Brighton, Philadelphia, and New York.
25. Buchan, "The Quay Brothers: Choreographed Chiaroscuro, Enigmatic and Sublime," 15.

BIBLIOGRAPHY

Academy Films Web site. http://www.academyfilms.com/commercials.

Adorno, Theodor W. *Minima Moralia: Reflections from a Damaged Life.* Translated by E. F. N. Jephcott [1974]. London: Verso, 2002.

Affron, Charles, and M. J. Affron. *Sets in Motion: Art Direction and Film Narrative.* Piscataway, N.J.: Rutgers University Press, 1995.

Aita, Roberto. "Brothers Quay: In Absentia." (Text translated from original Italian by Donato Totaro.) *Off-Screen* (2001). http://www.horschamp.qc.ca/new_offscreen/quay.html.

Allan, Richard, and Murray Smith, eds. *Film Theory and Philosophy.* Oxford, UK: Oxford University Press, 1997.

Andersen, Hans Christian. http://www.hca2005.dk/HCA2005/HCA2005++Projects/Dance.

Andrew, Dudley. *Concepts in Film Theory.* Oxford, UK: Oxford University Press, 1984.

———. "The Neglected Tradition of Phenomenology in Film Theory." *Wide Angle* 2 (1978): 44–49.

Aristotle. *De Anima (On the Soul).* Ca. B.C. 350. Translated and with an introduction and notes by Hugh Lawson-Tancred. London: Penguin, 1986.

Arne Höhne Presse und Öffentlichkeit Web site. http://www.hoehnepresse.de/german/pianotuner/pianotuner.shtml.

Arnheim, Rudolf. *Film as Art.* 1958. London: Faber and Faber, 1969.

Artaud, Antonin. *Collected Works,* vol. 2. Originally published as *Antonin Artaud: Oeuvres Completes,* tome II. Paris: Editions Gallimard, 1961. Translated by Victor Corti. London: Calder and Boyars, 1971.

Art on Screen Database, copyright 1985–1997, Program for Art on Film, Inc. http://www.artfilm.org/rec-anam.htm.

Atkinson, Michael. "The Night Countries of the Brothers Quay." *Film Comment* (September/October 1994): 36–44.

———. "Stirrings in the Dust." *Afterimage* 13 (1987): 4–9.

———. "Unsilent Night: The Brothers Quay." *Film Comment* 30, no. 5 (September/October 1995): 25–38.

Bachelard, Gaston. *The Poetics of Space.* Translated by Maria Jolas, 1964. 1958. Boston: Beacon Press, 1994.

Barsamian, Gregory. "Extracinematic Animation: Gregory Barsamian in Conversation with Suzanne Buchan." *Animation: An Interdisciplinary Journal* 3 (no. 3): 288–305.

Baudelaire, Charles. "The Philosophy of Toys." 1853. Translated by Paul Keegan. In *Essays on Dolls,* edited by Idris Parry 13–25. London: Syrens, 1994.

Baudrillard, Jean. *Simulations.* Translated by Paul Foss, Paul Patton, and Philip Beitschman. New York: Foreign Agents Series: Semiotext(e), 1983.

Bazin, André. *What Is Cinema?* Vol. 1. Los Angeles: University of California Press, 1967.

Believe Media Web site. http://www.believemedia.com.

Benjamin, Walter. "Old Forgotten Children's Books," [translation of "Alte vergessene Kinderbucher" (1924)]. In *Walter Benjamin: Selected Writings,* Vol. 1: 1913–26. Translated by Rodney Livingstone. Copyright 1996, 406–13. Cambridge, Mass.: Harvard University Press, 1996–2003. 4 vols.

Bennett, Jane. *The Enchantment of Modern Life.* Princeton, N.J.: Princeton University Press, 2001.

Beyond Reason: Art and Psychosis; Works from the Prinzhorn Collection. London: Hayward Gallery, South Bank Centre, 1996.

Bogue, Ronald. *Deleuze on Literature.* New York: Routledge, 2003.

Bordwell, David. "Historical Poetics of Cinema." In *The Cinematic Text: Methods and Approaches,* edited by R. Barton Palmer, 369–98. New York: AMS Press, 1989.

———. *Making Meaning: Inference and Rhetoric in the Interpretation of Cinema.* Cambridge, Mass.: Harvard University Press, 1989.

———. *Narration in the Fiction Film.* 1985. London: Routledge, 1988.

Bordwell, David, and Kristin Thompson. *Film Art: An Introduction.* 4th ed. New York: McGraw Hill, 1993.

———. *Film Art: An Introduction.* 8th ed. New York: McGraw Hill, 2008.

Bradbury, Malcolm, and James McFarlane, eds. *Modernism: A Guide to European Literature, 1890–1930.* 1976. London: Penguin, 1991.

Brinckmann, Christine N. *Die anthropomorphe Kamera.* Edited by Mariann Lewinsky und Alexandra Schneider. Zürich: Chronos Verlag, 1997.

Brooke, Michael, ed. *Quay Brothers: The Short Films, 1979–2003.* London: BFI, 2006.

Buchan, Suzanne, ed. "The Animated Spectator: Watching the Quay Brothers' 'Worlds.'" In *Animated "Worlds,"* edited by Suzanne Buchan, 15–38. Eastleigh, UK: John Libbey Publishing, 2006.

———. *Animated "Worlds."* New Barnet, Herts, UK: John Libbey Publishing, 2006.

———. "Graphic and Literary Metamorphosis: Animation Technique and James Joyce's 'Ulysses.'"*Animation Journal* 7, no. 1 (1998): 21–34.

———. "Literary Cineantics: Cinematic Metamorphosis in James Joyce's *Ulysses.*" Master's thesis (Lizentiat) in English and cinema studies, University of Zurich, 1994.

———. "The Quay Brothers: Choreographed Chiaroscuro, Enigmatic and Sublime." *Film Quarterly* 51, no. 3 (1998): 2–15.

———. "Uncanny Space, Narrative Place: The Architectural Imagination of Animation." In *What Is Architecture?/ Text Anthology (Co To Jest Architektura?/Antologia tekstow),* edited by Adam Budak, 354–91. Krakow: Bunkier Sztuki Contemporary Art Gallery, RAM, Goethe Institut, 2002.

Budak, Adam, ed. *What Is Architecture?/Text Anthology (Co To Jest Architektura?/Antologia tekstow.* Krakow: Bunkier Sztuki Contemporary Art Gallery, RAM, Goethe Institut, 2002.

Burch, Noël. *Theory of Film Practice.* 1969. Princeton, N.J.: Princeton University Press, 1981.

Cardinal, Roger. *Outsider Art.* New York: Studio Vista, London and Praeger, 1989.

Carroll, Noël. *On Criticism.* Oxford: Routledge, 2009.

———. *Theorizing the Moving Image.* Cambridge: Cambridge University Press, 1996; Cambridge [et al.]: Press Syndicate of the University of Cambridge, 2001.

Carrouges, Michel. *Les machines célibataires.* Paris: Arcanes, 1954.

Chion, Michel. *Audio-Vision. Sound on Screen.* Translated by Claudia Gorbman. New York: Columbia University Press, 1994.

Clarke, Bruce, and Linda Dalrymple Henderson, eds. *From Energy to Information: Representation in Science and Technology, Art, and Literature.* Palo Alto, Calif.: Stanford University Press, 2002.

Coates, Paul. *The Story of the Lost Reflection: The Alienation of the Image in Western and Polish Cinema.* London: Verso, 1985.

Combs, R. "Ein Brüdermord." *Monthly Film Bulletin* 53, no. 630 (1986): 219–20.

Costa, Jordi, ed. *Quay Brothers.* Sitges: Sitges Festival Internacionale de Cinema de Cataluna, 2001.

Costantini, Gustavo. "De Artificiali Perspectiva: The Brothers Quay's Use of Sound and Music." *Filmwaves Magazine* 32 (2007): 43–47.

Crichton-Miller, Emma. "Welcome to Wellcome." Copyright RA Magazine, 2003. http://195.172.125.151/03SUMMER/prev-wellcombe.htm.

Crisp, Clement. "The Dybbuk" (review). *Financial Times,* 20 April 1990. http://www.arcdance.com/pages/historydybukkreviews.html.

Deleuze, Gilles. *The Logic of Sense* [Logique du sens]. 1969. Translated by Mark Lester. London: Athlone Press, 1990.

Deleuze, Gilles, and Félix Guattari. *Anti-Oedipus: Capitalism and Schizophrenia.* Translated by Robert Hurley, Mark Seem, and Helen R. Lanel. London: Continuum, 2004.

Deussing, Ryan. "The Brothers Quay." Interview. February 9, 1996. http://www.thing.net/ttreview/febrev.02.html.

Dickinson, Margaret, ed. *Rogue Reels: Oppositional Film in Britain, 1945–90.* London: BFI, 1999.

Dieckmann, Katherine. "Double Visionaries." *Village Voice* 27 (December 1988): 31.

Director's Report to the National Advisory Council on Drugs, September 1995. http://www.nida.nih.gov/dirreports/dirrep995/DirectorReport11.html.

Durgnat, Raymond. "Igor: The Paris Years Chez Pleyel." *Monthly Film Bulletin* 53, no. 629 (1986): 189–90.

———. "Leos Janácek—Intimate Excursions." *Monthly Film Bulletin* 53, no. 629 (1986): 190–91.

Eisenstein, Sergei. *Film Form.* Edited and translated by Jay Leyda. 1949. New York: Harcourt, Brace, and World, 1977.

———. *Selected Works,* vol. 1. Edited and translated by Richard Taylor. London: BFI, 1988.

Eistenstein, Sergei, Vselovod Pudovkin, and Grigory Alexandrov. "A Statement." 1928. In *Film Form* [1928], edited and translated by Jay Leyda, 257–60. 1949. New York: Harcourt, Brace, and World, 1977.

Eliot, T. S. "'Ulysses,' Order and Myth." In *Selected Prose of T. S. Eliot.* London: Faber and Faber, 1975.

Ellmann, Richard. *James Joyce.* 2nd ed. New York: Oxford University Press, 1982.

The Ensemble Sospeso New York. http://www.sospeso.com/contents/composers_artists/ stockhausen.html.

Ernst, Max. "Au delá de la peinture," *Max Ernst: Oeuvres de 1919 á 1936, Cahiers d'Art* (1937): 13–46.

Ferrell, Robyn. "Life-Threatening Life. Angela Carter and the Uncanny." In *The Illusion of Life: Essays on Animation,* edited by Alan Cholodenko, 131–44. Sydney, Australia: Power Publications, 1991.

Ficowski, Jerzy, ed. *Letters and Drawings of Bruno Schulz: With Selected Prose.* Translated by Walter Arndt. New York: Harper and Row, 1988.

———. "*Regions of the Great Heresy: Bruno Schulz, a Biographical Portrait* [*Regionz wielkiej herezji i okolice,* 2002.] Translated and edited by Theodosia Robertson. New York: W. W. Norton and Company, 2003.

Filmneweurope Web site. http://www.filmneweurope.com/poland/grants/polish-film-grants-announced

Fischer, Lucy. "*Enthusiasm*: From Kino-Eye to Radio-Eye." In *Film Sound: Theory and Practice,* edited by Elisabeth Weis and John Belton, 247–64. New York: Columbia University Press, 1985.

Flaxman, Gregory, ed. *The Brain Is the Screen: Deleuze and the Philosophy of Cinema.* Minneapolis: University of Minnesota Press, 2000.

Foster, Hal. *Compulsive Beauty* [An October Book]. 1993. Cambridge, Mass.: MIT Press, 1995.

Freud, Sigmund. *The Standard Edition of the Complete Psychological Works of Sigmund Freud.* Edited and translated by James Strachey. 24 vols. London: Hogarth Press, 1953–74. (Original work published 1918 [1914].)

———. "The Uncanny." In *The Standard Edition of the Complete Psychological Works of Sigmund Freud.* Edited and translated by James Strachey. Vol. 17: 217–56. London: Hogarth Press, 1953–74.

Gaudin, Collette. *Gaston Bachelard. On Poetic Imagination and Reverie.* 1987. Woodstock, N.Y.: Spring Publications, 1998.

Goeppert, Sebastian, and Herma C. Goeppert. *Sprache und Psychoanalyse.* Hamburg: Rowohlt Taschenbuch Verlag, 1973.

Goldfarb, David A. "A Living Schulz: 'Noc wielkiego sezonu' ['The Night of the Great Season']." *Prooftexts: A Journal of Jewish Literary History* 14, no. 1: 25–47. Baltimore, Md.: Johns Hopkins University Press, 1994.

Goodman, Nelson. *Languages of Art.* 2nd ed. Indianapolis, Ind.: Hackett Publishing Company, 1976.

Greco, Monica. "On the Vitality of Vitalism." *Theory, Culture, and Society* 22, no. 1: 15–27.

Greenaway, Peter. "Street of Crocodiles." *Sight and Sound,* no. 155 (1986): 182–83.

Griffiths, Keith. E-mail from Keith Griffiths, April 2009.

———. Taped and transcribed interviews with Suzanne Buchan, December 1996, August 2002, November 2002, September 2003.

Grodal, Torben. *Moving Pictures. A New Theory of Film Genres, Feelings, and Cognition.* Oxford, UK: Clarendon Press, 1997.

Grossman, David. *See Under: Love.* New York: Farrar Straus Giroux, 1989.

Habib, André. "Entretien avec Stephen et Timothy Quay. Partie 1." http://www. horschamp.qc.ca/cinema/jan2002/quay.html.

———. "Entretien avec Stephen et Timothy Quay. Partie 2." http://www.horschamp.qc.ca/ cinema/jan2002/quay2.html

————. "Through a Glass Darkly: Interview with the Quay Brothers." 2001. http://www.sensesofcinema.com/contents/01/19/quay.html.

Hames, Peter, ed. *Dark Alchemy. The Films of Jan Svankmajer.* London: Flicks Books, 1995.

Hamm, Peter. "'Ich bin nichts als ein Horchender': Robert Walser und die Musik." *Neue Zürcher Zeitung* (December 23, 1996), no. 299: 17.

Hammond, Paul. "In Mystery, Shrouded: On the Quays' New Film." *Vertigo* 1, no. 5 (1995): 18–20.

————. "In Quay Animation." *Afterimage* 13 (Autumn 1987): 54–67.

Hayman, Ronald. "Antonin Artaud." In *Antonin Artaud,* edited by Margit Rowell, 17–24. New York: Museum of Modern Art, 1996.

Hegerfeldt, Anne C. *Lies That Tell the Truth. Magic Realism Seen through Contemporary Fiction in Britain.* Amsterdam: Rodopi, 2005.

Hirschfeld, Magnis. *Sexual Anomalies: The Origin, Nature and Treatment of Sexual Disorders.* London: Francis Alder, 1948.

Hollingsworth, Dell Anne. ThingReviews, NYC. http://www.thing.net/ttreview/febrev.02.html.

Howell, Steven. "Chekhov's Shorts and the Queen of Spades Soar." *Press Republican Online,* 2001. http://www.pressrepublican.com/Archive/2001/10_2001/10252001 oafeat2.htm.

International Film Festival Rotterdam. http://www.filmfestivalrotterdam.com/en/film/10537.html.

Jarvie, Ian. *Philosophy of the Film: Epistemology, Ontology, Aesthetics.* London: Routledge and Kegan Paul, 1987.

Jarzębski, Jerzy, ed. *Bruno Schulz. Opowiadania: Wybor esejow i listow.* Wrocław: Ossolineum, 1989.

Joyce, James. *Ulysses. The Corrected Text.* Edited by Hans Walter Gabler. London: Penguin, 1986.

Kafka, Franz. *The Complete Short Stories of Franz Kafka/Franz Kafka.* Edited by Nahum N. Glatzer. London: Vintage, 1999.

Kahn, Douglas. *Noise Water Meat: A History of Sound in the Arts.* Cambridge, Mass.: MIT Press, 1999.

"Karlheinz Stockhausen." http://www.sospeso.com/contents/composers_artists/quay.html.

Kitson, Claire. *British Animation: The Channel 4 Factor.* London: Parliament Hill Publishing, 2008.

Kleist, Heinrich von. "On the Marionette Theatre." ["Uber das Marionettentheater," 1812.] Translated by Idris Parry. In *Essays on Dolls: Heinrich von Kleist, Charles Baudelaire, Rainer Maria Rilke,* edited by Idris Parry. London: Syrens, 1994.

Kostelanetz, Richard. *John Cage.* New York: Praeger, 1970.

Lamos, Colleen, *Deviant Modernism: Sexual and Textual Errancy in T. S. Eliot, James Joyce, and Marcel Proust.* Cambridge, UK: Cambridge University Press, 1998.

Le Fanu, Mark. "Modernism, Eccentrism: The Austere Art of Atelier Koninck." *Sight and Sound,* no. 53 (1984): 135–38.

Lindsay, Vachel. *The Art of the Moving Picture.* 1915, revised edition 1922. New York: Liveright Publishing Corporation, 1970.

Manovich, Lev. *The Language of New Media.* Cambridge, Mass.: MIT Press, 2001.

Marcuse, Herbert. *The Aesthetic Dimension: Toward a Critique of Marxist Aesthetics.* Boston: Beacon, 1978.

Marks, Laura. *The Skin of the Film: Intercultural Cinema, Embodiment, and the Senses.* Durham, N.C.: Duke University Press, 2000.

———. *Touch: Sensuous Theory and Multisensory Media.* Minneapolis: University of Minnesota Press, 2002.

Martland, Steve. "Life after Death." *The Guardian,* April 4, 2003. http://www.guardian.co.uk/arts/fridayreview/story/0%2C12102%2C929088%2C00.html.

Massumi, Brian. "(Involuntary Afterword)." *Deleuze, Guattari, and the Philosophy of Expression: Canadian Review of Comparative Literature/Revue Canadienne de Littérature Comparée* 24, no. 3 (1997).

Matthews, J. H. *Languages of Surrealism.* Columbia: University of Missouri Press, 1986.

McBurney, Simon. "The Chairs." http://www.complicite.org/productions/detail.html?id=8#reviews.

McClatchy, J. D. "Movie Magic. The Quay Brothers: The Toast of Eight Film Festivals." *Connoisseur Magazine* (1989): 91–95.

Merleau-Ponty, Maurice. *The Phenomenology of Perception* [Phénomènologie de la perception]. Paris: Gallimard, 1945. Translation copyright 1958 Routledge and Kegan Paul. London: Routledge Classics, 2002.

Mitry, Jean. *The Aesthetics and Psychology of the Cinema.* Translated by Christopher King. Bloomington: Indiana University Press, 1997.

Molnáar, László. "Nicht Wolf und nicht Mensch in der Klang-Geisterbahn." *Salzburger Nachrichten* 21 (June 1999). http://www.kug.ac.at/iem/f_e/iem_report/report08_99/sn210699.htm.

Monaco, James. *How to Read a Film: The Art, Technology, Language, History, and Theory of Film and Media.* New York: Oxford University Press, 1977.

Moran, Dermot. *Introduction to Phenomenology.* London: Routledge, 2000.

Müller-Tamm, Pia, and Katharin Sykora, eds. *Puppen Körper Automaten. Phantasmen der Moderne.* Köln: Oktagon, 1999.

Museum of Jurassic Technology Jubilee Catalog. West Covina, Calif.: Society for the Diffusion of Useful Information Press, 2002.

Ndalianis, Angela. *Neo-Baroque Aesthetics and Contemporary Entertainment.* Cambridge, Mass.: MIT Press, 2004.

Nelson, Victoria. *The Secret Life of Puppets.* Cambridge, Mass.: Harvard University Press, 2002.

Nichols Goodeve, Thyrza. "Dream Team." *Artforum* (April 1996): 82–85, 118, 126.

Noake, Roger. *Animation: A Guide to Animated Film Techniques.* London: Macdonald and Company, 1988.

O'Brien, Geoffrey. "The Ghost at the Feast." *New York Review of Books* 44, no 2 (1997). http://www.nybooks.com/articles/article-preview?article_id=1286.

Oklot, Michal. "Maturing into Childhood: An Interpretive Framework of a Modern Cosmogony and Poetics." *Alif: Journal of Comparative Poetics* (January 2007), http://www.thefreelibrary.com.

O'Pray, Michael. "Eisenstein and Stokes on Disney: Film Animation and Omnipotence." In *A Reader in Animation Studies,* edited by Jayne Pilling, 195–202. London: John Libbey and Company, 1997.

Palmer, R. Barton, ed. *The Cinematic Text: Methods and Approaches.* New York: AMS Press, 1989.

Parry, Idris, ed. *Essays on Dolls: Heinrich von Kleist, Charles Baudelaire, Rainer Maria Rilke.* Translated by Idris Parry and Paul Keegan. London: Syrens, 1994.

Petit, Chris. "Picked-up Pieces." *Monthly Film Bulletin* 53, no. 629 (1986): 164–67.

Petley, Julian. "The Cabinet of Jan Svankmajer." *Monthly Film Bulletin* 53, no. 629 (1986): 188–89.

———. "Panic, Boredom, and Melancholia." AIP and Company, no. 79, Nov/Dec 1986.

Pilling, Jayne, and Fabrizio Liberti, eds. *Stephen e Timothy Quay.* Bergamo: Stamperia Stefanoni, 1999.

Plantinga, Theodore. 1972, "The Real Meaning of Kant," unpaginated. http://alpha. redeemer.ca/~tplant/p/YAM.HTM#.

Press kit, *PianoTuner of EarthQuakes.* http://www.zeitgeistfilms.com/films/ pianotunerofearthquakes/pianotunerofearthquakes.presskit.pdf.

Prinzhorn, Hans. *Artistry of the Mentally Ill.* 1972. New York: Springer Verlag, 1995.

Program for *Art on Film. Art on Screen Database.* http://www.artfilm.org/rec-anam.htm.

Quay Brothers. Correspondence with Chris Robinson, June 2001. Provided to the author.

———. "In Deciphering the Pharmacist's Prescription 'On Lip-Reading Puppets.'" London, 1986. Unpublished manuscript.

———. Interview with Jo Jürgens, undated. Provided to the author.

———. Taped and transcribed interviews with Suzanne Buchan, November 1996, December 1997, May 2000, March 2001, May 2005, September 2007.

———. "Ten Unproduced Scenarios." *Conjunctions 46. Selected Subversions: Essays on the World at Large.* New York: Bard College, 2006, 347–97.

Rancière, Jacques. *Film Fables (Talking Images).* Translated by Emiliano Battista. Oxford, UK: Berg, 2006.

Reisz, Karel, and Gavin Millar. *The Technique of Film Editing.* 2nd ed. Oxford: Focal Press, 1991.

Reitz, Charles. "Liberating the Critical in Critical Theory: Transcending Marcuse on Alienation, Art, and the Humanities." Undated. http://www.bu.edu/wcp/Papers/Educ/ EducReit.htm.

Rhodes, Colin. *Outsider Art: Spontaneous Alternatives.* World of Art series. London: Thames and Hudson, 2000.

Ricoeur, Paul. *Time and Narrative.* 3 vols. Vols. 1–2 (1984) translated by Kathleen McGlaughlin and David Pellaur. Vol. 3 (1988) translated by Kathleen Blamey and David Pellaur. Chicago: University of Chicago Press.

Robinson, Chris. Interview with the Quay Brothers.

Romney, Jonathan, "Brothers in Armature." *City Limits,* no. 446 (1990): 16–17.

———. "Life's a Dream." *Sight and Sound* (August 1995): 12–15.

———. "The Same Dark Drift." *Sight and Sound* 1, no. 11 (1992): 24–27.

Rosenfeld, Louis. "The Last Alchemist, the First Biochemist: J. B. Von Helment (1577– 1644)." In *Clinical Chemistry* 31, no. 10 (1985): 1755–60.

Rowell, Margit, ed. *Antonin Artaud: Works on Paper.* New York: Museum of Modern Art, 1996.

Russolo, Luigi. *The Art of Noises.* 1916. Translated by Barclay Brown. New York: Pendragon Press, 1986.

Rust Gray, Bradley. *The Audible Filament [Hearing the Brothers Quay].* Unpublished Thesis (undated, no pagination).

Safranski, Rüdiger. *Schopenhauer und die wilden Jahre der Philosophie. Eine Biographie.* Hamburg: Rowohlt Taschenbuch Verlag GmbH, 1990.

Sanders, Daniel. *Wörterbuch der Deutschen Sprache.* 3 vols. Leipzig: Otto Wigand, 1860.

Schaeffer, Pierre. *Traité des objets musicaux.* Revised edition. Paris: Seuil, 1967.

Schopenhauer, Arthur. *Die Kunst, glücklich zu sein. Dargestellt in fünfzig Lebensregeln.* Herausgegeben von Franco Volpi. München: C. H. Beck, 1999.

———. "Essay on Spirit Seeing and Everything Connected Therewith." 1851. In *Parerga and Paralipomena,* vol. 1, translated by E. F. J. Payne, 225–309. Oxford, UK: Clarendon Press, 1974.

———. "*The World As Will and Representation,* vol. 1 (1819). Translated by E. F. Payne. New York: Courier Dover Publications, 1966.

Schreber, Daniel Paul. "Daniel Paul Schreber: From Memoirs of My Nervous Illness." 1903. In *Imagining Language: An Anthology,* edited by Jed Rasula and Steve McCaffery, 301–12. Cambridge, Mass.: MIT Press, 2001.

Schulz, Bruno. *The Booke of Idolatry.* Edited and with an introduction by Jerzy Ficowski, translated by Bogna Piotrowska. Warsaw: Interpress, 1990.

———. *Bruno Schulz: Die Wirklichkeit ist Schatten des Wortes. Aufsätzen und Briefe. Gesammelte Werke in zwei Bänden. Band 2.* Herausgegeben von Jerzy Ficowski. Aus dem Polnischen von Mikolaj Dutsch and Josef Hahn. Munich: Karl Hanser Verlag, 1992.

———. *Die Zimtläden und alle anderen Erzählungen.* 1966. Translated by Josef Hahn. *Bruno Schulz: Gesammelte Werke in zwei Bänden. Band 1.* Herausgegeben von Mikolaj Dutsch and Jerzy Ficowski. Aus dem Polnischen von Josef Hahn. Munich: Carl Hanser Verlag, 1992.

———. *Letters and Drawings of Bruno Schulz with Selected Prose.* Edited by Jerzy Ficowski, translated by Walter Arndt. New York: Fromm International Publishing Corporation, 1990.

———. "The Mythologizing of Reality." In *Letters and Drawings of Bruno Schulz with Selected Prose,* edited by Jerzy Ficowski, translated by Walter Arndt, 115–16. New York: Fromm International Publishing Corporation, 1990.

———. *The Street of Crocodiles.* 1963. Translated by Celina Wieniewska, introduction translated by Michael Kandel. New York: Penguin, 1977.

Senn, Fritz. *Joyce's Dislocutions: Essays on Reading as Translation.* Edited by Jean Paul Riquelme. Baltimore, Md.: Johns Hopkins Press, 1984.

———. *Nichts Gegen Joyce: Joyce Versus Nothing.* Aufsätze 1959–1983. Hrsg. von Franz Cavigelli. Zurich: Haffmanns Verlag, 1983.

Shklovsky, Victor. "Art as Technique" [1917]. Translated by Leman and Reis, reprinted in: David Lodge, ed., *Modern Criticism and Theory: A Reader,* 16–30. London: Longman, 1988.

Short, Robert. "Dada and Surrealisms." 1976. In *Modernism: A Guide to European Literature, 1890–1930,* edited by Malcolm Bradbury and James McFarlane, 292–308. London: Penguin, 1991.

Shuttleworth, Ian. "Le Bourgeois Gentilhomme." Review. 1992. http://www.cix.co.uk/~shutters/reviews/92049.htm.

"Sleepwalkers of Daylight." http://www.awn.com/heaven_and_hell/QUAY/quay7.htm.

Sobchack, Vivian. "*The Address of the Eye: A Phenomenology of Film Experience.* Princeton, N.J.: Princeton University Press, 1992.

———. "Nostalgia for a Digital Object: Regrets in the Quickening of Quicktime." *Millennium Film Journal,* no. 34 (Fall 1999). http://mfj-online.org/journalPages/MFJ34/VivianSobchack.html.

Sontag, Susan, ed. *Selected Writings of Antonin Artaud.* Translated by Helen Weaver. New York: Farrar, Straus and Giroux, 1976.

———. *On Photography* (1977). London: Penguin Books, 1979.

Souriau, Anne. "Fonctions filmiques des costumes et des décors." In *L'univers filmique,* edited by Etienne Souriau. Paris: Flammarion, 1952.

Souriau, Etienne, ed. *L'univers filmique.* Paris: Flammarion, 1952.

Stam, Robert, Robert Burgoyne, and Sandy Flitterman-Lewis. *New Vocabularies in Film Semiotics: Structuralism, Post-structuralism, and Beyond.* London: Routledge, 1992.

Stewart, Heather, ed. BFI Animation Catalog 1993/94. Middlesex, UK: BFI, 1994.

Stewart, Susan. *On Longing: Narratives of the Miniature, the Gigantic, the Souvenir, the Collection.* 1984. Durham, N.C.: Duke University Press, 1993.

Tan, Ed S. *Emotion and the Structure of Narrative Film: Film as an Emotion Machine.* Mawah, N.J.: Lawrence Erlbaum Associates, 1996.

———. "Geschichtsausdruck und Emotion in Comic und Film." In *Kinogefuhle: Emotionalität und Film,* Matthas Brütsch, Vinzenz Hediger, Alexandra Scheider, Margrit Tröhler, Ursula Von Keitz (Hrsg.), 265–87. Marburg: Schüren Verlag GmbH, 2005.

Tate and Egg Live. http://www.tateandegglive.com/event3_d%26r.html.

Thompson, Kristin. *Breaking the Glass Armor: Neoformalist Film Analysis.* Princeton, N.J.: Princeton University Press, 1988.

Todorov, Tzvetan. *The Fantastic: A Structural Approach to a Literary Genre.* Translated by Richard Howard. Ithaca, N.Y.: Cornell University Press, 1973.

Turvey, Malcolm. "Seeing Theory: On Perception and Emotional Response in Current Film Theory." In *Film Theory and Philosophy,* edited by Richard Allan and Murray Smith, 431–57. Oxford, UK: Oxford University Press, 1997.

Vidler, Anthony. *The Architectural Uncanny: Essays in the Modern Unhomely.* Cambridge, Mass.: MIT Press, 1992.

Wadley, Nick. "Masks, Music, and Dances of Dream." *PIX 2* (January 1997): 126–43.

Wagenbach, Klaus. *Kafka.* 1964. Hamburg: Rowohlt Taschenbuch Verlag GMBH, 1996.

Walser, Robert. *Institute Benjamenta.* Translated by Christopher Middleton. 1967. New York: Serpent's Tail, 1995.

———. *Jakob von Gunten,* 1909. Translated by Christopher Middleton. 1969. New York: First Vintage Books, 1983.

Wees, William C. *Light Moving in Time: Avantgarde Aesthetics.* Berkeley: University of California Press, 1992.

Weihe, Richard. "Die Theater-Maschine: Motion und Emotion." Ph.D. diss., University of Zurich, 1992.

———. "The Strings of the Marionette." In *Animated "Worlds,"* edited by Suzanne Buchan, 39–48. New Herts, UK: John Libbey Publishing, 2006.

Weihsmann, Helmut. *Cinetecture: Film Architektur, Moderne.* Vienna: PVS-Verlag, 1995.

Weis, Elisabeth, and John Belton, eds. *Film Sound: Theory and Practice.* New York: Columbia University Press, 1985.

Wells, Paul. "Body Consciousness in the Films of Jan Švankmajer." In *A Reader in Animation Studies,* edited by Jayne Pilling, 177–94. London: John Libbey and Company, 1997.

Whittock, Trevor. *Metaphor and Film.* Cambridge, UK: University of Cambridge Press, 1990.

Wollen, Peter. *Signs and Meaning in the Cinema.* London: Marti Secker and Warburg and the BFI, 1969.

Wright, Philippa Shirley. *Navigating a Metaphorical Zone: A Consideration of the Work of the Brothers Quay.* B.A. thesis, fine art, Loughborough College of Art and Design, 1994.

Zielinski, Siegfried. *Deep Time of the Media: Toward an Archaeology of Hearing and Seeing by Technical Means.* Translated by Gloria Custance. Cambridge, Mass.: MIT Press, 2006.

———. "Supervision und Subversion: Für eine *Anarchäologie* des technischen Visionierens." In Jörg Huber and Martin Heller, *Interventionen 6: Konturen des Unentscheidenen,* 173–88. Stroemfeld/Roter Stern/Museum für Gestaltung Zurich. Basel/Zurich, 1997.

WORKS OF THE QUAY BROTHERS

FILMOGRAPHY

Der Loop der Loop, Il Duetto, Palais en Flammes, 1970s.

Nocturna Artificialia: Those Who Desire without End, 1979, color, 16 mm, 20 minutes.

Punch and Judy: Tragical Comedy or Comical Tragedy, directed by Keith Griffiths and the Quay Brothers, 1980, color, 16 mm, 47 minutes.

Ein Brudermord, 1980, color, 16 mm, 5 minutes.

The Eternal Day of Michel de Ghelderode, 1898–1962, 1981, color, 16 mm, 30 minutes.

Igor: The Paris Years Chez Pleyel, 1982, color, 16 mm, 26 minutes.

Leos Janáček: Intimate Excursions, 1983, color, 16 mm, 26 minutes.

The Cabinet of Jan Švankmajer, 1984, color, 16 mm, 14 minutes.

The Songs of the Chief Officer of Hunar Louse, or This Unnameable Little Broom, 1985, color, 16 mm, 11 minutes.

Street of Crocodiles, 1986, color, 35 mm, 21 minutes.

Rehearsals for Extinct Anatomies, 1987, black-and-white, 35 mm, 14 minutes.

Stille Nacht 1 (Dramolet), 1988, black-and-white, 35 mm, 2 minutes.

Ex Voto, 1989, color, 35 mm, 1 minute.

The Comb [From the Museums of Sleep], 1990, color and black-and-white, 35 mm, 17 minutes.

De Artificiali Perspectiva, or Anamorphosis, 1991, color, 35 mm, 14 minutes.

The Calligrapher, Parts I, II, III, 1991, color, 1 minute.

Stille Nacht II: Are We Still Married? 1992, black-and-white, 35 mm, 3 minutes.

Long Way Down (Look What the Cat Drug In), 1992, color, 35 mm, 4 minutes.

Stille Nacht III: Tales from the Vienna Woods [Ich bin im Tod erblüht], 1993, black-and-white, 35 mm, 4 minutes.

Stille Nacht IV: Can't Go Wrong without You, 1994, black-and-white, 35 mm, 4 minutes.

Institute Benjamenta, or This Dream People Call Human Life, 1995, black-and-white, 35 mm, 105 minutes.

Duet: Variations on the Convalescence of "A," 1999, choreography by William Tuckett, color, 35 mm, 18 minutes.

In Absentia, UK, 2000, black-and-white and color, 35 mm (Cinemascope), 19 minutes (music: Karlheinz Stockhausen).

The Sandman, UK, 2000, choreography by William Tuckett, 35 mm, black-and-white, 41 minute.

Dog Door (Stille Nacht V), UK, 2001, color, 4 minutes.

Day of the Dead, 2001, black-and-white and color, 1 minute, animated sequence for Julie Taymor's *Frida* (2002).

The Phantom Museum, UK, 2002, color, 35 mm, 12 minutes.

The PianoTuner of EarthQuakes, UK, Germany, France, 2005, color, 35 mm, 95 minutes.

Poor Roger, Oranges and Lemons, Green Gravel, and *Jenny Jones* (Songs for Dead Children), UK, 2003.

Fragments for Bruno Schulz, (pilot for *Sanatorium Under the Sign of the Hourglass*), UK, 2006, black-and-white, 8 minutes.

Alice in Not So Wonderland, for Live Earth, UK, 2007, color and black-and-white, 3 minutes.

Eurydice—She So Beloved, UK, 2007, choreography by Kim Brandstrup, color and black-and-white, HD, 11 minutes.

Inventorium of Traces—at Castle Łańcut (Inventorium śladów—Jan Potocki na Zamku w Łańcucie), Poland, 2009, color, HD, 23 minutes.

Maska, Poland, 2010, color, 12 minutes.

SCENOGRAPHY AND DÉCORS FOR THEATER, OPERA, AND BALLET

Love for Three Oranges. Prokofiev. Opera directed by Richard Jones. Opera North Leeds/ English National Opera, London, 1988.

Dybbuk. Ballet by Kim Brandstrup. The Place, London, 1988.

A Flea in Her Ear. Feydeau. Theater directed by Richard Jones. Old Vic, London, 1989.

Mazeppa. Tchaikovsky. Opera directed by Richard Jones. Bregenz Festival/Nederlands Opera, 1991.

Le Bourgeois Gentilhomme. Moliére. Theater directed by Richard Jones. Royal National Theatre, London, 1992.

A Midsummer Night's Dream. Shakespeare. Theater directed by Johnathan Miller. Almeida Theatre, London, 1996.

The Hour We Knew Nothing of Each Other. Peter Handke. Theater ballet directed by Kim Brandstrup. Malmo Dramatiska Theatre, Sweden, 1996.

Cupid & Psyche. Ballet by Kim Brandstrup. Royal Danish Ballet, Copenhagen, 1997.

The Chairs. Ionesco. Theater directed by Simon McBurney. Theatre de Complicite and Royal Court, London, 1997.

Baa-Laamsfest. Olga Neuwirth. Opera directed by Nicholas Broadhurst. Wiener Festwochen, Vienna, 1999.

Queen of Spades. Ballet by Kim Brandstrup. Les Grands Ballets Canadiens, Montreal, 2001.

The Wind in the Willows. Ballet by William Tuckett. Royal Opera House, London, 2002.

Death and Resurrection. J. S. Bach and Steve Martland. Conducted by Sir John Eliot Gardiner, Steve Martland. Four short films illustrating Martland's Street Songs. Tate Modern and St. Paul's Cathedral, London, 2003.

The Anatomy of a Storyteller. Ballet by Kim Brandstrup. Royal Opera House, London, 2004.

The Cricket Recovers. Richard Ayres. Opera directed by Nicholas Broadhurst. Aldeburgh/
Almeida Opera, London, 2005.

Paul Bunyan. Benjamin Britten. Operetta directed by Nicholas Broadhurst. Theater am
Kornmarkt Bregenz/Theater Luzern, 2007.

Bring Me the Head of Ubu Roi. Color film projections for performance by Pere Ubu. Queen
Elizabeth Hall, London, 2008.

EXHIBITIONS AND INSTALLATIONS (A SELECTION)

Dormitorium. Rotterdam. The exhibition is currently touring and has been exhibited in Riga,
Exeter, Lisbon, the Festival D'Avignon, Tokyo, Brighton, Philadelphia, New York City,
Ithaca, N.Y., and Wrocław.

Coffin of a Servant's Journey. Belsay Hall, Northumberland, UK, 2007.

Eurydice, She So Beloved. Leeds Art Gallery, Leeds, UK, 2008.

VHS AND DVD (A SELECTION)

Licenses for some editions have expired and are no longer available for purchase, but they
may be found in libraries.

The Brothers Quay, Vol. 1. VHS Region 2 / PAL. Connoisseur Video. Release date 2000.

The Brothers Quay, Vol. 2. VHS Region 1 / NTSC. 1991.

The Brothers Quay Collection: Ten Astonishing Short Films 1984–1993. DVD Region 1 / NTSC.
Kino Video. Release date 2000. 120 minutes. ISBN 6305957681.

Quay Brothers: The Short Films, 1979–2003. DVD (2 discs) Region 2 / PAL. Published and
distributed by the BFI. Release date 2006. 134 minutes (disc one) + 183 minutes (disc
two). 24-page booklet. ISBN/EAN 5035673006535.

Quay Brothers: Die Kurzfilme, 1979–2003. (2 discs) DVD Region 2 / PAL. Absolut Medien
GmbH. Release date 2008. 134 minutes (disc one) + 183 minutes (disc two). ISBN 978-
3898488420.

Phantom Museums: The Short Films of the Quay Brothers. (2 discs) DVD Region 1 / NTSC.
Zeitgeist Films. Release date 2007. 134 minutes (disc one) + 183 minutes (disc two).
24-page booklet.

Courts métrages des frères Quay. (2 discs) DVD Region 2 /PAL. E.D. Distribution. Release
date 2008. 134 minutes (disc one) + 183 minutes (disc two).

The Brothers Quay: de korte films, 1979–2003. PAL / REGION 0. Release date 2008. 135 mins
(disc one) + 119 mins (disc two). 24-page booklet. ISBN 9789059391239.

Quay Brothers: Short Film Collection. DVD (2 discs boxed with booklet) Region MPEG - 2 /
NTSC Tohokushinsha Film Corporation, Japan. 2 discs with booklet. Color and black-
and-white. Release date 2009.

Institute Benjamenta, or This Dream People Call Human Life. (1995) VHS PAL. ICA Projects
Ltd. Release date 1996. Black-and-white. 104 minutes.

Institute Benjamenta, or This Dream People Call Human Life. (1995) DVD Region 1 / NTSC.
Kino. Release date 2000. Black-and-white. 104 minutes. ISBN 630595769X.

Institute Benjamenta, or This Dream People Call Human Life. DVD and Blu-ray. BFI. Release
date April 2010.

The PianoTuner of EarthQuakes. (2005) Zeitgeist Films. Region 1 / NTSC. Release date 2007.
Color and black-and-white, 99 minutes.

The PianoTuner of EarthQuakes. (2005) DVD Region 2 / PAL. Artificial Eye. Release date
2006. Color and black-and-white, 99 minutes.

L'Accordeur de tremblements de terre. DVD Region 2 / PAL. E.D. Distribution. Release date
2007. Color and black-and-white, 99 minutes.

The Piano Tuner of EarthQuakes. (2005) DVD (boxed with booklet) Region
MPEG – 2/NTSC. Tohokushinsha Film Corporation, Japan. Release date 2009.
Color and black-and-white.

INDEX

INDEX

Suzanne Buchan is professor of animation aesthetics and director of the Animation Research Centre at the University for the Creative Arts, England. She is the editor of *Animation: An Interdisciplinary Journal.*